D0312514

KNOW THYSELF

*

WESTERN IDENTITY
FROM CLASSICAL GREECE
TO THE RENAISSANCE

*

INGRID ROSSELLINI

DOUBLEDAY
New York

www.doubleday.com

DOUBLEDAY and the portrayal of an anchor with a dolphin
are registered trademarks of Penguin Random House LLC.

Book design by Maria Carella
Jacket design by John A. Fontana
Front-of-jacket images: (details, clockwise, left) *The School of Athens*
by Raphael, akg-images; *Piraeus Apollo,* 530 B.C., De Agostini/
Getty Images; *David* by Michelangelo, Alinari/Art Resource, N.Y.;
The Good Shepherd by Philippe de Champaigne, SuperStock
Spine-of-jacket image: *Portrait of Solon* by Merry-Joseph Blondel,
Christophel Fine Art/Getty Images

Library of Congress Cataloging-in-Publication Data
Names: Rossellini, Ingrid, author.
Title: Know Thyself : Western identity from classical Greece to the
Renaissance / by Ingrid Rossellini.
Description: First edition | New York : Doubleday, [2018]
Identifiers: LCCN 2017045163 |
ISBN 9780385541886 (hardcover) | ISBN 9780385541893 (ebook)
Subjects: LCSH: Civilization, Western—History. | Religion and civilization—
History. | Philosophy and civilization—History. | Identity (Philosophical concept)
Classification: LCC CB245 .R6625 2018 | DDC 909/.09821—dc23
LC record available at https://lccn.loc.gov/2017045163

MANUFACTURED IN THE UNITED STATES OF AMERICA

1 3 5 7 9 10 8 6 4 2

First Edition

*To my husband, Richard,
and my children, Tommaso and Francesca,
who fill my life with a reassuring sense of belonging
within a "cosmos" kept afloat
and spinning by the ever-present sunlight of their love*

History does not study material facts and institutions alone; its true object of study is the human mind: it should aspire to know what this mind has believed, thought, and felt in the different ages of the life of the human race.

—NUMA DENIS FUSTEL DE COULANGES, *THE ANCIENT CITY*

CONTENTS

PART THREE: THE EARLY MIDDLE AGES

PART FOUR: THE LATER MIDDLE AGES

PART FIVE: HUMANISM AND THE RENAISSANCE

Who are you?

If someone asked that question today, most people would offer answers that, aside from general references to gender, nationality, and ethnicity, would essentially focus on their personal characteristics, choices, and preferences. The common assumption is that the individual self is a fully autonomous and original entity, capable of selecting whatever path he or she decides to entertain in a way that is completely independent from traditional views and expectations. Individual identity, as we conceptualize it today, is something like a kit whose parts can be chosen, styled, and assembled at will: a do-it-yourself enterprise.

Although that is for the most part true, psychologists never fail to remind us that what we experienced as children remains an essential factor in the shaping of our adult selves. In order to understand our present, we need to revisit our past. The same thing could be said about our collective history: understanding who we were remains an essential component in understanding who we are today.

Do I mean to imply that *Know Thyself* is a sort of psychological guide to a more rewarding and fulfilling relation with our true selves? Yes, in fact, but definitely not in a *conventional* way. What I mean is that this is not a book about psychology but a book about history *with a psychological slant:* in other words, a book that, besides describing crucial moments of history from Greek antiquity to the Renaissance, highlights how the different definitions that the "self" has received contributed to the creation of the values and ideals that, down the

centuries, have shaped and motivated the choices and actions of people and the makeup of their society.

In choosing this particular lens for observation, I was inspired by the nineteenth-century French historian Fustel de Coulanges, who claimed that recollecting facts is an insufficient way to look at history without an equal focus on the nature and development of the human personality. What that perspective reveals is that history is a complex tapestry woven from actual events but also from the narratives that we humans have imposed upon those facts to try to make sense of ourselves and our reality.

This book is meant to be not an academic treatise but a guide addressed to the lay reader who, while genuinely curious to explore the past, often feels intimidated by the excessive complexity of scholarly studies. Things have only gotten worse in these last decades: because as the disciplines we generally label humanities have become increasingly neglected in our academic curricula, understanding earlier ways of thinking has become, for many, ever more difficult and frustrating.

To try to remedy that confusion and make this book as clear and accessible as possible, I chose to avoid the over-detailed style typical of specialized approaches, to offer instead an interdisciplinary overview that, although simplified, still provides a comprehensive map of major patterns of history and culture. To clarify the discussion, I have also included many references to the visual arts. This choice is based on the fact that for thousands of years—at least until the invention of the printing press, in the middle of the fifteenth century—visual art was the only available means of mass communication capable of conveying, to a population that was largely illiterate, the models of excellence that the political, philosophical, and/or religious ideology of the times considered best fitted to exemplify what a human being was expected to be.

An important theme that we will explore while looking at the ideals that different epochs nurtured concerns the recurrent creation of legendary and mythical facts—the narratives that, for the sake of inspiration, tradition fostered with an intensity that often appears

much too exuberant for the rigorous test of credibility as Joseph Campbell indicated when he wrote that a "myth is something that has never happened, and is happening all the time."

To begin, let me bring you back to Delphi of ancient Greece, where people went to consult the oracle of Apollo: the Greek god of reason who was also the only pagan divinity who appeared willing to respond to the people who came to seek his advice.

I use the verb "to appear" because how Apollo's oracle worked was more ambiguous than revelatory, in the sense that rather than offering clear guidance, it only provided cryptic hints and scattered pieces of information. These were as confusing and indirect as the language of his messenger—the priestess, called Pythia, who in delirious fits of trance channeled the voice of Apollo, by whom she claimed to be possessed. The paradox of the oracle was that because it forced people to interpret the vagueness of those utterances, the ball was implicitly returned right back to those who sought its guidance. That way, rather than having the god clearly telling them what to do, people were indirectly led to use their own intellectual faculties to come up with the answers best fitted for their particular challenges and problems.

The key to that clever strategy was expressed in the motto etched at the top of Apollo's temple: "Know thyself." The dictum essentially meant this: because the meaning you give to your life is what propels your actions, before asking *what to do,* ask yourself *who you are.*

This was (and is) by no means an easy endeavor, as proven by the endlessly varied answers that we humans have come up with all along the centuries.

Take our modern view of identity, for example. To encourage self-awareness in a child, we say, discover the talents and qualities that make *you* the very special and original person that you are. The corollary idea is that only by developing one's distinct and unique identity can one become a good member of the "larger self" that society represents.

If confronted with such an example of fierce individualism, the Greeks of early times would have recoiled in horror. To the Greeks,

attributing ultimate value to choices and preferences that focused on the singular over the collective *self* would have been considered an absolutely unethical, if not completely unthinkable, proposition. For the Greeks, one's place of origin represented not simply a geographic setting but rather the place of one's family and community and as such the overriding source of one's identity. Where you were born and the social group to which you belonged determined who you were and consequently what was expected from you. Individual freedom of choice, the way we understand the term today, had little to do with that older mentality. For that reason, the command to "know thyself" essentially meant that you should use the guidance of reason to fulfill, in the best way possible, the ethical duties and obligations that your role as a member of the larger community entails.

This dramatic difference of interpretation may lead us to think that between that past and our present no direct connection can be drawn. As this book will show, however, that's not at all true. Even if our balance has dramatically shifted toward the singular self, finding a point of convergence between the individual and the collective still remains a very pressing concern of our contemporary existence. What that tells us is that despite the ever-evolving patterns of history, the concept of identity has always involved two fundamental dimensions: who we are independently, and who we are in relation to one another.

The latter aspect has prompted endless debate throughout our cultural history. Are we naturally predisposed to live with others, as Aristotle believed, when he famously stated that man is a "political animal"? Or is society a useful but totally unnatural artifice only created and maintained to increase our chance of survival? Although no definite conclusion has been reached (or is ever likely to be), we can all agree that even if we consider our socially inclined character instinctual, that instinct has nothing to do with the inflexible, unvarying spirit of communal collaboration that rules the life of an ant or a bee. In fact, our all-too-human tendency to favor self-interest well above communal purposes has always been the most consistent obstacle to the creation of a fully harmonic and unified society.

Of course, in the small and culturally cohesive communities of

early historical times, keeping the individual in line with the greater identity that society represented was far easier than in the free, diversified, and fast-changing reality of our globalized and technologically connected world. Given such complexity, fostering a civic-minded identity has become more difficult than ever, as we see in the polarization of opinions and ideas that characterize our contemporary world.

What to do about this? This book does not pretend to offer an answer to such a difficult problem. All it proposes is to return to the early times of our history with the intention of rediscovering the building blocks of our contemporary personality. My belief is that only by exploring the ways in which past generations have looked at our inner landscape and the narratives they developed to cope with the contradictions of our nature can we acquire a better understanding of how we got here and what made us who we are today. Even if that alone would not solve our contemporary problems, improving our critical capacity to look within can contribute to increasing, even by just a few degrees, the clarity our present needs in order to find the best way to progress toward the future in a fruitful and positive manner.

Know Thyself is divided into five parts: ancient Greece, ancient Rome, early Middle Ages, late Middle Ages, and humanism and the Renaissance.

The first part of the book explores the Greek belief that man was a creature occupying a point in between an animal and a god. Reason, which was considered the principal quality of human life, was meant to maintain that central balance through the control of all passions, including the excessive expressions of pride and ambition that the Greeks defined as hubris. From Homer's epics to the development of the polis, the birth of philosophy, and the creation of democracy, the immense faith that the Greeks placed in their understanding of human reason produced one of the most vibrant civilizations the world had ever seen. Yet, despite all their brilliance, the Greeks also imbued culture with some of the sturdiest seeds of bias and prejudice—as in disparaging all non-Greeks as uncivilized barbarians (when in fact Greece owed an enormous debt to much older Eastern cultures, like

the Egyptian and the Babylonian) and attributing a gender quality to the concept of rationality. This was a quality that only men were believed to possess to the total exclusion of women, who, as symbols of sensuality, were seen as the embodiment of the irrational passions and appetites belonging to the material body. Assuming that the mind of a woman was too weak to harness the impulses of the body had long-lasting consequences in Western culture. Barring women from all social and political activities was the most damaging effect of that prejudice. Significantly, the word "virtue" derives from *vir,* which means "man" in Latin, while the word "hysteria," which was used up to the nineteenth century to indicate emotional instability, derives from *hystera,* meaning "uterus" in Greek.

One of the most influential views that the Greek philosophical tradition established was to identify in *reason* the governing force of the entire universe: as the mind ruled the body, the cosmos was believed to have received its harmony and order (*kosmos* in Greek meant "order") from a divine and superior rational Mind. To live in agreement with that divine force, man had to apply to himself and to his society the same rules of harmonic collaboration that regulated all other aspects of nature. This view led the Greeks to passionately despise all tyrants and despots: people who, allowing pride to override judgment and rationality, arrogantly assumed that their talent alone was sufficient to rule society. Ironically, the end of the polis era was brought about by what the classical times had feared most: the rise of the monarchic absolutism of the Macedonian king Alexander the Great.

The second part of the book describes the enormous influence that the Greek concept of polis (which is the root of the word "politics") had on its Roman conquerors—most important, the view that man, as a rational being, could realize his full humanness only through the military, civic, and political participation that the city demanded. For the Greeks, as well as the Romans, civilization (from *civitas,* "city" in Latin) could be attained only by men who, by fully assuming their role of citizens, brought to full fruition their inner talents and potentialities.

Of all of Roman history, the period that most political think-

ers, from Cicero to the American Founding Fathers, considered the best example of an ideal society was the time of the Roman Republic, which came to an end with the ascent to power of Augustus and the creation of the Roman Empire. To give the impression that his rule did not contradict but rather fulfilled the earlier ethos of Roman times, Augustus tried to instill in his subjects the belief that in following his leadership, Rome would have fulfilled its destiny as ruler of the world—a role assigned to the city by the gods in recognition of its extraordinary contributions to law, culture, and civilization. Despite the considerable boost that the narrative received from Roman writers and artists, that positive image did not withstand the test of time, especially when the corruption of so many emperors who followed Augustus caused the unraveling of the moral fabric that had once sustained the greatness of Rome.

The third part of the book analyzes the rise of Christianity (an offshoot of Judaism, which was also greatly influenced by the Hellenistic tradition and the mysticism of Eastern cults) amid the havoc brought about by the barbarian invasions and the fall of the Western Roman Empire. The Greeks and the Romans had optimistically believed, with Aristotle, that men, being rational, were naturally inclined to coexist with others to create a just and balanced society. Christianity sharply refuted that view, affirming that humanity, having suffered irreparable damage after the original sin of Adam and Eve, could not have functioned without the assistance of faith and the intermediary action of grace. The fall of Rome was used as evidence that given the sinful defectiveness of man, no attempt to create a perfect society would have succeeded because human egotism would have always prevailed over communality and hate over empathy and justice. Within that new, pessimistic mind-set, the world was transformed into a place of sorrow and hardship: a locus of trial for a sinful humanity whom God would judge at the end of time. As religion became entrenched with every aspect of the human existence, the church, filling the void left behind by the secular state, assumed a role of leadership and preeminence that, next to spiritual, was also cultural, political, administrative, and institutional.

The fourth part of the book shows how the pessimism that pervaded the early part of the Middle Ages started to lift in the eleventh century, when, with the end of the barbarian invasion, a period of peace and prosperity slowly began. The main characteristic of those times was the rebirth of cities and the rise of a new merchant class eager to establish its place in society independent of the aristocratically led hierarchy of the previous feudal era.

The greatest contribution that those new market towns gave to culture was the creation of universities that allowed learning to spread beyond the cloistered control of the religious orders. The most obvious beneficiary of that revival of learning was the secular state, whose administrative and legal functions were now greatly improved by the service of many educated lawyers and officials. As the secular powers became stronger and better organized, a collision with the ecclesiastic apparatus, which for centuries had kept a tight control over society, became inevitable, making the tug-of-war between the state and the church one of the main characteristics of the late Middle Ages. With the discovery of the Greek heritage (ironically preserved and returned to the West by the Muslims, against whom Christian Europe had launched so many Crusades), a major transformation in views and ideas occurred. Within that dynamic, the revival of Aristotle assumed particular importance, especially when Thomas Aquinas managed to reconcile the principles of Christianity with the optimistic views about human nature advocated by the Greek philosopher. As a consequence, man's role was radically transformed to become, from a sinful and morally crippled creature, God's superior and talented collaborator charged with bringing to realization the potential inherent in His magnificent creation.

This new view is at the root of humanism and the Renaissance.

To facilitate the comprehension of a period as complex and geographically sprawling as the Renaissance, I chose to limit my analysis to the Italian Renaissance, focusing in particular on the two cities that most emblematically embodied the spirit of the time: Florence and Rome. In Florence, the development of the city-state gave way to a nostalgic return to the political ideals of classical times that, in

contrast with Augustine's view, now enthusiastically revived the value and importance of the city of man. The narrative that prevailed was that by applying the wisdom that the Greeks had associated with the polis and the Romans with the republic, the Italian city-states could finally realize the dream of a just and stable society reflecting, as a microcosm, the encoded order impressed by God upon the entire macrocosm of His creation.

Unfortunately, the optimistic confidence that man's uniqueness and exceptionalism could assure the permanence of a stable and free society was short-lived, overcome as it was by the despotic rule of the Medici family, who brought to an end the dream of the republic. With the cultivation of beauty that the new masters of Florence fostered, art was given an aesthetically pleasing quality that, rather than promoting civic virtue, was now directed at enforcing a court mentality principally devoted to the celebration of the monarchical power that the Medici represented.

The sense of bewilderment that many people felt when the sweeping republican passion that had animated Florence was suffocated by the Medici reached new dramatic heights when Byzantium (present-day Istanbul) fell into Muslim hands in 1453 and when Martin Luther, rebelling against the widespread corruption of the church, initiated the Protestant Reformation that forever split the Christian world. For the wealthy and powerful papacy that by now had become a monarchical power in its own right, the most devastating event occurred when a German division of mercenary soldiers, sympathetic to Luther, sacked Rome in 1527.

As the pendulum of history swung again in the direction of pessimism and disenchantment, new doubts were cast about the much-praised greatness of man. Hope seemed to be gone, but as history repeatedly shows, it is always within the darkness of winter that spring prepares its return.

What that tells us is that identity, rather than a fixed and crystallized reality, has been, and will always be, a work in progress. The fact that the word "culture" evokes the concept of agriculture is revealing in that sense. Ideas are like any other living thing: once planted, they

never remain the same. They grow, they mature, they change. Most of all, as this book repeatedly points out, they travel just like seeds blown by the wind. The point is important also because it reminds us that despite all ideological divisions between West, East, North, and South, identity remains the result of the most fruitful and enriching of all phenomenon—the cross-pollination of peoples, cultures, and ideas.

PART ONE

ANCIENT GREECE

THE BIRTH OF THE POLIS

The first civilization that came to light within the area we generally refer to as Greece was the Minoan, which developed on the island of Crete around 2000 B.C., followed by the Mycenaean, which took its name from the dominant town of Mycenae on the mainland and reached the peak of its splendor around 1500 B.C. Whether the competitive pressure exercised by the Achaeans (who were Mycenae's predominant tribe) or a natural disaster pushed the Minoan civilization to extinction is still a matter of debate among scholars. What seems certain is that around 1400 B.C., Crete rapidly declined, while the highly structured Mycenaean society continued to prosper until 1100 B.C. The affluence and sophistication that Mycenae's society proudly displayed in its imposing palatial fortresses derived from a well-organized feudal-like system capable of avoiding the stagnancy of a pure agrarian mentality, thanks to the enriching input that its seafaring activity produced, especially through trade and commerce. The abundance of foreign motifs—like griffins, lions, gazelles, palm trees, and lotus flowers—that appears in the art of Mycenae reveals, in a very tangible way, the tremendous cultural debt that since its beginning the Hellenic* world has owed to the much older civilizations of the Near East, particularly the Egyptian and the Babylonian.

* When we talk about ancient Greece, it is important to stress the difference between the terms "Hellenic" and "Hellenistic." "Hellenic," from "Hellas," the ancient name of Greece, is used to describe the period that precedes Alexander the Great, the Macedonian king who in the fourth century B.C. conquered the city-states and absorbed their rich culture within the melting pot of his immense

According to some scholars, the collapse of the Mycenaean world was caused by a wave of primitive and violent conquerors, called Dorians, descending from the north. Displaced by the newcomers, many local tribes were forced to abandon their land and disperse across the Aegean: some founded new settlements on adjacent islands; others relocated on farther shores, such as the western coast of today's Anatolia, in Turkey, the region then known as Ionia.

Before the havoc caused by the northern invaders lost its impetus, with the final merging and fusion of different tribal and ethnic identities, many centuries of unrest were to elapse with corrosive consequences on the cultural heritage of early Greece, including the disappearance of the Mycenaean written language, known as Linear B (so called because it was the second example of Mycenaean writing felt to be less pictorial or "linear" than hieroglyphic or photographic). Those three hundred years of long and steady decline are referred to as the Dark Ages (1100–800 B.C.) to underscore *our* contemporary ignorance about that remote historical era due to the absence of any written records and documents.

The only traces of the past that managed to survive the Dark Ages were preserved in songs: popular tales orally kept alive by scores of professional, itinerant storytellers who, with the help of their lyres, used a mix of memory and improvisation to celebrate the heroic exploits of the once-powerful Achaeans. (The term, used by Homer to indicate the Mycenaean Greeks, remained in use to indicate the oldest natives of the Balkan Peninsula.) In a world torn apart by centuries of turmoil, violence, poverty, and famine, exploiting a highly dramatized narrative to evoke the ancestral origin was a way to draw beauty out of sorrow and ugliness, fostering a sense of enduring pride toward a distant past made venerable by the brilliant actions of its warriors— the legendary heroes whose exemplary deeds were revived over and over through the eternal voice of the poetic remembrance.

empire. That new phase of history is referred to as Hellenistic, meaning Greek-like, rather than simply Greek.

With the gradual rebirth of the Greek world, which began to take place toward the beginning of the eighth century B.C., that fluid chain of songs, ever morphing in its telling and retelling, was finally given a fixed and cohesive unity by a mysterious bard by the name of Homer, who was said to have composed the *Iliad* and the *Odyssey*. These two compelling epics would provide a common ancestral past to many generations of people in need of a cultural mold with which to recast anew the basic traits of their recently reawakened political and military identity.

Because of the collective knowledge they provided, Homer's epics have often been referred to as the "Bible of antiquity." The term is meant to express the fact that, rather than fictional stories, the *Iliad* and the *Odyssey* were believed to be the accurate account of an awesome, primeval era, filled with larger-than-life heroes—heroes whose edifying actions were to remain exemplary models for the character building of future generations.

With the revival of trade in the eighth century, and the rich cultural interaction that the mercantile exchange produced, a new written language was eventually acquired. It was based on the consonant-only alphabet used by the Phoenicians, who lived in the eastern part of the Mediterranean, to which, for practical reasons, the Greeks added the use of vowels. Exactly when that written language was used to write down Homer's work remains unclear; some scholars believe that the task was accomplished during the poet's lifetime, while others assign it to later dates.

While many cities, especially in Ionia, claimed to be Homer's birthplace, no definite biographical information has ever been found to dissipate the mystery that shrouds the life of the most famous poet of Western literature. Who was the man who seemed to have surpassed all others in giving final shape to the ancestral past and for that reason was granted the title of "educator of Hellas"? Considering the stylistic and thematic differences that characterize the two epics, many since antiquity have wondered whether more than one author had been involved in the composition of the lengthy sagas. The fact that no definite answer has been found does not change the fact that

both poems, just as rocks formed stratum after stratum by the slow accumulation of sediments, resulted from the stitching together of episodes and narratives put together by a long, anonymous succession of performing bards, or rhapsodists (from the Greek *raptein oide,* meaning "to stitch together a song").

Until the middle of the nineteenth century, scholars labeled as purely fictional the monumental drama evoked by Homer's epical accounts. The assumption was put to rest by the German archaeologist Heinrich Schliemann (1822–1890), who with stubborn determination was able to locate the remains of the city of Troy on the western coast of Asia Minor. Helen, Hector, Ajax, Achilles, and many other characters described in the *Iliad* and the *Odyssey* were, most likely, just products of the imagination, but the general subject matter around which so much poetry had been woven was based on real historical events—namely, the war that the Achaeans had waged against the powerful Asian city of Troy, almost four hundred years before Homer's times, for the control of the strategic trade routes that, through the Hellespont (today called the Dardanelles), connected the Mediterranean to the rich lands surrounding the Black Sea.

The princely sumptuousness of the Mycenaean Age had long faded away, but the dazzling memory of that awesome past, enhanced by the nostalgic backward glance of myth and folklore, never ceased to nourish the civic and moral ideals that accompanied the reawakening of the Greek political universe. Parents who in their youth had memorized the *Iliad* and the *Odyssey* to learn, through the commendable actions of Homer's heroes, the values and norms that their militaristic societies required recited the same verses to their offspring to imprint in them the honorable examples of their forefathers. Inspired by that great past, people became more accepting of the military commitment that the defense of the homeland demanded: the young soldier, who was taught to bravely defend the honor and freedom of his land, felt a sense of purpose and pride when he compared his actions with those of the ancestral heroes celebrated by Homer.

The time that the *Iliad* and the *Odyssey* were composed coincided

with an era of transition of great historical importance: from the twilight of the Dark Ages to the dawn of the Archaic Age, which, as mentioned, witnessed considerable progress in commerce, trade, and industry and, as a consequence, a great improvement in living conditions and opportunities. The most notable event of the Archaic Age was the birth of the city-states, or poleis, which were independent centers of power extending political and administrative control over adjacent territories and small neighboring villages that had willingly coalesced around their sphere of influence for protection and defense. In most cases, a ring of walls surrounded the urban domain of the polis. The agora, which was the open space at the center of the city, was also the site where the bones of the founding heroes were said to be buried. The flame that burned on the city's main altar in memory of the forefathers evoked the fire that burned in each home in memory of the family's ancestors. Privately and publicly, making sure that the sacred fire never died was a major obligation. A fire that ceased to glow was like a heart that ceased to beat.

The arid, mountainous, and often inhospitable terrain typical of the southern Balkans had a lot to do with the small size of the city-states and their failure to develop any kind of national unity: because they settled in valleys or along shorelines separated by insurmountable ranges of rocky barriers, the poleis grew isolated from one another. As such, rather than a unified nation, Greece developed as a patchwork of independent and self-sufficient mini-nuclei of power, irregularly distributed across the sun-bathed stretch of the Aegean archipelago. (As we will see, the many colonies that were eventually founded considerably expanded the Greek presence within, but also beyond, the Mediterranean basin.)

The tribal-like communities of the Dark Ages had been mostly led by single clan chieftains, each called *basileus,* or "king," advised by a council of elders. A radical change occurred with the expansion in territory and in population that occurred with the creation of the polis, when the rule of a single *basileus* was abolished, to be replaced by an oligarchy of aristocratic landowners whose families could trace

their origins to the very beginning of the city. Because of that ancient ancestry, those leading families saw themselves as fathers of the land with exclusive right of representation within the government of the polis.

Because war remained the principal activity of the city-states, the ethos that those ruling aristocrats maintained showed a great deal of similarity to earlier times, particularly in regard to the virtuous code of honor and responsibility that military engagement demanded. Hence the willingness to invest personal funds to buy the armor and weapons necessary to serve in the army. (Contributing a horse allowed membership in the more prestigious ranks of the cavalry.) Such service was considered not a duty but the greatest of all privileges. To be an aristocrat, in ancient Greece, meant to be a civically and politically committed individual immune to the alluring temptations of power, ambition, comfort, and luxury. The term "aristocrats," from *aristoi,* the "best ones," meant to indicate that the pedigree that distinguished the landed gentry gave them a degree of integrity and uprightness that made them the members of society most deserving of leadership.

Major social and political changes occurred with the introduction of coinage that the Greeks adopted from Lydia (today western Turkey) between the seventh and the sixth centuries B.C., which favored the rise of a new class of rich and entrepreneurial merchants who, defiant of the aristocratic landowners, sought and eventually attained more prominent and influential posts within the political and military arenas. The contempt that the aristocrats always nurtured vis-à-vis the mercantile class was based on the belief that the accumulation of money, which trade promoted, would corrupt the old noble tradition, making private luxury and personal ambition more appealing than public obligations and selfless intents.

※

SPARTA AND ATHENS

When we talk of ancient Greece, we should always keep in mind the great political and cultural diversity that characterized the Hellenic world. The two major city-states, Athens and Sparta, well exemplify that diversity.

When the northern conquerors, at the onset of the Dark Ages, invaded the small village of Sparta, they imposed upon the natives (called Helots) a condition that could be compared to that of serfs in medieval times. The military campaigns that the Spartans regularly undertook to contain and suppress any rebellion on the part of the Helots assured the dominance of a small body of people over a large number of small farmers bound to the cultivation of the land. Even if the use of slavery was widespread throughout the Hellenic world, Sparta was the only city-state that subjugated native people with the excuse that the Helots belonged to an inferior tribe. That practice was opposed by other poleis, where slavery was limited to non-Greek people captured in war.

The peculiarity of Sparta's society also rested on an oligarchic form of government based on the rule of two leaders, whose authority was mitigated by the policy-making influence of a senate composed of twenty-eight elders. As in all other city-states, an army per se did not exist, inasmuch as all citizens, with no exception, were automatically considered military recruits. At seven years old, every male child was forced to leave his family to be raised by the state in a military camp. Here the boys, who were taught to recite Homer by heart, were subjected to a rigorous training aimed at the creation of a perfectly obedient, diligent, and dedicated citizen-soldier unafraid to die on behalf of the country. Military duty lasted until the age of sixty, if one was lucky enough to reach such an advanced age. The loyalty that linked the individual to the polis was so pronounced that a father was given the right to kill a child who, at birth, appeared defective or too weak to become a future warrior.

To describe the Spartans' devotion to the state, the writer and biographer Plutarch (A.D. 46–120) recalled the story of a mother who killed her own son out of shame when he returned home from war to report that he was the only survivor among a group of fellow soldiers who had died honorably on the battlefield. Another account told the story of a mother whose five sons had gone to war. When the messenger arrived at the city to bring news from the battlefield, he was confronted by the mother, who, rather than expressing concern about her sons, asked with trepidation if the Spartans had been victorious.

To cultivate Sparta's rigorous ethos, a life of sparse and austere simplicity was imposed upon all citizens, rich and poor alike. All Spartans were made to walk barefoot, bathe in icy water, and eat coarse food in the communal facilities in which they lived. All slept in simple beds made of straw, and all wore the same rough tunic provided yearly by the state. To harden the personality, discipline and sacrifice were highly regarded, while luxury and leisure were vehemently denounced for their mind-polluting effects. The emphasis on restraint was such that even loquacity was condemned as a frivolous trait. (The modern word "laconic" derives from Laconia, a region of Sparta.) Within Sparta's agrarian society commerce was actively discouraged and traveling forbidden because of the poisoning consequences that new currents of thought could have produced on the purity of the Spartan spirit.

In Athens's wholly masculine and paternalistic society, the life of the citizen also involved a great number of obligations and responsibilities, including the duty to personally contribute for the armor and weapons needed for war. In Athens, until the fifth century B.C., military service remained an unpaid task. As in the rest of Greece, nothing was considered more honorable than military prowess and nothing more admirable than giving one's life in defense of the fatherland. To accentuate virtue, a life of bare essentials was recommended, as well as the willingness to endure all sorts of hardship and sacrifice in defense of the state. Being a citizen was a jealously guarded privilege. To maintain its mark of exclusivity, Athens in the fifth cen-

tury B.C. adopted a law that granted citizenship only to males whose fathers and mothers were both natives of the city.

In spite of these limitations, Athens, unlike the isolationist Sparta, developed a culturally open society that actively pursued the advantages offered by commerce and welcomed the circulation and elaboration of new ideas. In contrast with the poverty of Sparta's cultural life, Athens's bountiful production of art, architecture, philosophy, and theater gives us a sense of the fertile quality that the city derived from its lively exchange of knowledge and ideas. At a political level, the innovative spirit that fueled Athens's mode of thinking was made evident by the expansion of political rights that progressively followed the demands of larger and larger segments of society. The first significant change was introduced by Solon, who in 594 B.C. was elected archon, a position that gave him almost exclusive power over the city but only for one year. Solon, who was an aristocrat, did not consider mercantile activity beneath his status. That attitude, which allowed him to gain great wealth through trade, also gave him the mediation skills necessary to appease the civil tension that the city was experiencing through the passing of laws aimed at reducing the monopoly of power held by the landed aristocracy. Thanks to Solon, debt slavery was suspended, and wealth became recognized as the main requisite for office holding. After Peisistratus, who increased the power of Athens by unifying the entire region of Attica, came Cleisthenes, who established the pioneering system known as democracy (507 B.C.), in which all male citizens were given an equal right to participate directly in the political life of the city, independent of any distinction of money, class, or prestige.

Even if from today's point of view, Athens's democracy (from *demos*, "people," and *kratos*, "rule") may appear far from perfect, because it involved only men to the total exclusion of women and slaves (in the fifth century B.C., only 40,000 adult male citizens ruled the polis, out of a population of 300,000), the importance that Athens's political system had in promoting the impartial rule of a law above the arbitrary will of any single individual, or any single feudal-like elite, cannot be

denied. Especially if we compare Athens with the rest of the ancient world, like Egypt or Persia, for example, where supreme masters ruled uncontested over a multitude of poor and ignorant people passively accepting their condition as if it were a fact of life, intimidated, rather than enraged, by the enormous wealth that their rulers flamboyantly displayed as proof of their divinely sanctioned position.

Not so in the Greek universe, where, at least until the advent of Alexander the Great, no single ruler ever dared to attribute to himself such a super-mundane status. For the Greeks, divine nature belonged to the gods alone, and no man was allowed to assume a title for the sole purpose of coercing the blind obedience of others. State affairs were communal matters, and no single individual dared to place himself above the rule of the many that the polis as a whole represented. In contrast with the Eastern empires, where the authority of the king was said to be divinely ordained, the Greeks' greatest contribution to civilization was the tremendous respect they nurtured toward the state and its government, which, in turn, was seen as a direct outcome of man's ability to use reason to pursue, in a collaborative manner, common good and common justice. Praising the value of such a superior political system, the great tragedian Aeschylus (ca. 525/524– ca. 456/455 B.C.), in his drama *The Persians,* contended that unlike the rest of the world the Greeks alone could claim to be "their own masters."

When the Greeks compared their social system with the anonymity of the rights-deprived subjects who populated the vast kingdoms of the East, they came to the conclusion that the reduced scale of the polis was essential for the preservation of a just and free society. Plato, who discussed the issue in the fifth century B.C., claimed that to maintain a vital bond of fellowship among the citizens, the ideal polis was to be inhabited by no more than five thousand people. Later Aristotle, who increased that ideal number to ten thousand, explained that the city needed to be big enough to be self-sufficient but never large to the point of curbing the friendly bond of kinship that was to be preserved among all citizens, "for acquaintance begets mutual confidence," as he wrote in his *Politics.*

The inseparable link between individual and society was implicit in the Greek term for "person," which was *prosopon,* meaning "he who stands in front of someone else's eyes." The subjective "I" only found validation through the reciprocal glance of a fellow other. Within the small and highly interconnected reality of the city-state, where the roles of observer and observed were never separated, identity was ratified and kept in place by the scrutiny exercised by the civic-spirited aggregation of citizens who culturally, ethically, and politically reflected one another as in a mirror. The best metaphorical representation of the interpersonal relationships that animated the polis was the agora: the commercial, political, and cultural opening placed at the heart of the city, where the ancestral heroes were buried and where people met, talked, and interacted face-to-face.

The respect of freedom and independence that the Greek states so intensely nurtured remained a priority even during the process of colonization that the various poleis entertained, especially between 750 and 500 B.C. When, with the surge of wealth, the population of the city-states began to swell to unacceptable proportions, many native Greeks, relying on their skillful seamanship, left home in search of lands. Because arable plains were so scarce in the dry and rocky areas they already occupied, the Greeks, competing with other major maritime populations like the Phoenicians and the Carthaginians, pushed their expansion as far as Asia Minor, North Africa, southern France, and eastern Spain, as well as Sicily and southern Italy (which came to be known as Magna Graecia). All that the colonists brought from the native land was a handful of dirt to be symbolically dispersed upon the new soil and a spark, taken from the fire burning on the main altar of their mother city, to be kept forever alive at the center of the new settlement. Besides a natural feeling of friendship, which came in handy for future mercantile interactions, no forced collaboration with the city of origin was demanded. When a new colony was established, full autonomy was immediately granted, with no monetary debt toward the mother city, nor any other ties of political dependence.

For that reason, even if historically the process has been referred to as "colonization," the Greeks' experience should not be confused

with the imperialistic ambition that in later times pushed the expansionist drive of great political powers like the Romans. The word for "colony," *apoikia* in Greek, literally means "home outside." The term suggests that the vast dissemination of Greek colonies in the Mediterranean region—that Plato, with unusual humor, described as a multitude of "frogs around a pond"—didn't hide any expansionist intention on the part of their founders. Colonization was simply a way to give people new opportunities, while freedom, independence, and self-rule remained the constant terms of that equation.

<div align="center">✳</div>

REASON, THE IRRATIONAL, AND THE DANGER OF HUBRIS

As a tightly knit community of citizens linked by free agreement to the rule of law, the polis was believed to represent the highest expression of man's intellectual nature and, as such, the most viable place for the human personality to prosper and bloom. From its dawn, in the eighth century B.C., to its eclipse four hundred years later, the tremendous belief that men, united by reason, could establish a free and just society guided, as a polestar, the cultural and historical progress of Greece.

According to the Greeks, the human creature occupied a middle point between an animal and a god. At birth, a child was considered closer to an animal than a human. Real humanity was achieved only gradually, through the day-to-day process of education exercised by the family and the state that inculcated in the child respect for ancestral values and the need to conform to the norms upon which society was founded. Once childhood gave way to adulthood, guidance was left to reason, man's highest faculty.

The two major imperatives that appeared on the ancient temple of Apollo in Delphi, "Know thyself" and "Nothing in excess," addressed the point very clearly. Self-realization occurred when reason estab-

lished an equilibrium between two dangerous extremes: the weakness of bestial irrationality and the folly of attempting to transcend the limits intrinsic to human nature to become like a god.

The writings of Plato and Aristotle, who lived between the fifth and the fourth centuries B.C., and represent the more mature phase of Greek culture and civilization, are indispensable to understanding the value that the Greeks attributed to the ideal of the polis, seen as the crowning achievement of human talent and rationality. In the *Republic,* Plato used the character of his teacher Socrates to affirm that, because human needs are many and no one, alone, is self-sufficient, man, led by reason, entered into partnership with others to form a society. Aristotle stressed the same concept when he stated that reason, which was man's greatest asset, was at the origin of the social instinct that drove all human creatures. By famously affirming that man, by nature, "is a political animal," Aristotle meant to say that collaborating with others in creating a communal context was not an acquired behavior but an innate human characteristic. As he asserted in his *Politics,* "Hence it is evident that the state is a creation of nature, and that man is by nature a political animal." A man without a polis, he continued, was "more or less than human" inasmuch as only a beast lacking speech and reason or a self-sufficient god could have survived alone independent of others. Unlike Jean-Jacques Rousseau, who in the eighteenth century characterized the rules and conventions of society as artificial restraints imposed upon the freedom of the individual, Aristotle concluded that the polis was not a human invention but a direct outcome of man's most natural inclination: "A social instinct is implanted in all men by nature."

Man's rational and entirely natural tendency to form a community appeared validated by his unique capacity to use language for communication—a word that the Greeks translated as *Logos,* directly relating the gift of human utterance to rationality.

To further emphasize the value of reason, Aristotle went on to affirm that "it is a characteristic of man that he alone has any sense of good and evil, of just and unjust, and the like, and the association of living beings who have this sense makes a family and a state."

Aristotle's view, which voiced the belief that the Greeks had held true since the beginning of their civilization, was that man's natural instinct to create a society also endowed him with the moral capacity to distinguish good from evil. Good conduct derived from rationality, which, in turn, was the propeller of civic engagement. Virtue was the code of honor with which each man actively responded to the public demands of the polis.

While today we consider the individual prior to the state, for the Greeks the state, as a whole, was always more important than its single parts. As Aristotle in his *Politics* declared, "The state is by nature clearly prior to the family and the individual, since the whole is of necessity prior to the part." A harmonious society was one in which a group of rational, and therefore morally and civically committed, individuals willingly placed the collective good above their private interests, electing the well-being of the city as the ultimate purpose of life.

Because they fervently trusted the ability of the mind to attain valid truths, and because they believed that reason led man's natural disposition to live with others, the Greeks came to the conclusion that the polis represented not simply a practical means of survival but the greatest of all human accomplishments. As Aristotle, once more, summarized in his *Politics,* "Political society exists for the sake of noble actions, not of mere companionship," and elsewhere, "For man, when perfected, is the best of animals, but when separated from law and justice, is the worst of all." To bring to fruition his best talents, man needed the nourishing terrain of social and political interaction. Private and public spheres overlapped, to the point that being rational, being moral, and being civically engaged came to denote the exact same thing.

In an opposite fashion, irrationality defined someone who stressed singularity over plurality—in other words, someone who brutishly pursued egotistical motivations over the enlightened wisdom of a socially cohesive society. That negative trait was called by the Greeks *hubris:* a charged word that described the inflated dimension that the single ego was capable of reaching when infected by irrational,

and therefore amoral and asocial, dreams of self-aggrandizing ambitions. Like a destructive genie popping out of the bottle, hubris was considered a mental deformity acting against the natural order of things. Hubris was the malady of a person deficient in self-control and self-restraint; in other words, all the shortcomings of a socially disconnected and self-involved "I."

As we will see later in more detail, the Greek practice of ostracism, established for the first time in Athens in 488 B.C., addressed precisely that dangerous trait: the individual who threatened to upset the collective spirit of collaboration was expelled from the polis and sent into exile. The gravity of the punishment was enormous: by losing the connection with the place of origin, the individual was literally stripped of his identity and his life deprived of all purpose and meaning.

Behind the obsessive concern with the irrational excesses of personal ambition, there was, of course, the fear of despotism: the improper influence that any single individual could have assumed in relation to the many. To curb that pernicious tendency, military education drilled the need to pursue excellence but always tempered by humility, frugality, and moderation. What gave value to man's existence was the readiness to accept patriotism as the greatest and most rewarding virtue. In practice, this consisted in serving the homeland with total loyalty and devotion, even amid the most testing and dangerous circumstances. As Homer taught, a hero was a man who bravely marched to his death with the sole purpose of enriching his community, which, in turn, granted him immortality through the eternal gift of remembrance. No tribute was deemed greater: the true hero died for *kleos*—a word that literally meant "fame that is heard." In a society where the group was more important than the individual, real death only occurred when one was denied remembrance within the collective psyche of the community. A life worth living was a life worthy of the ever-expanding echo of admiration and respect that, generation after generation, filled that precious repository of collective wisdom that was at the base of legends and myths.

The reverence that surrounded the cult of the athlete was very

closely related to the excellence immortalized through Homer's symbolic heroes. The word used by the Greeks to define the athletic games was *agon,* meaning "contest/contrast." If Achilles in the *Iliad* is repeatedly called "swift-footed," it is because running, wrestling, boxing, jumping, throwing, riding, and so on were activities invariably related to military strength, efficiency, and preparation. The ritualized performances that the agonistic contest represented belonged to a warlike society whose citizens, acting as soldiers, could be recruited at any time in defense of their soil.

Because physical strength prepared men for war, the beauty of a naked and perfectly fit body was considered the most obvious sign of a civically devoted individual. The success of many agonistic festivals, based on the model first established by the city of Olympia in 776 B.C., highlights the sacred respect that was accorded to physical stamina and prowess. The fights that so often divided the city-states were regularly suspended on the eve of an athletic festival. The truce came to an end as soon as the festival was over.

To define civic and military virtue, the Greeks used the expression *kalos kagathos,* meaning "beautiful/good." The individual who through discipline and training achieved a beautiful muscular body was also praised as a patriotic and therefore good citizen-soldier. Aesthetics and morality coincided: beauty and good were considered two inseparable and fully interchangeable characteristics.

Within that warrior mentality, that lofty ideal did not exclude, when necessary, the use of cruelty: using tricks to outwit the enemy (as Ulysses did by devising the Trojan horse) or slaughtering the adversary with unflinching determination was considered a good and just act, like sacking, raiding, and leveling to the ground a foe city to then subjugate into slavery all of its inhabitants. Apathy and indifference were vigorously condemned, to the point that under Solon, in Athens, idleness came to be listed as a crime against the city. Patriotism was the true religion of ancient Hellas.

HESIOD AND THE
COSMIC ORIGIN OF THE WORLD

A man without a polis was an unthinkable proposition for the Greeks. For that reason, when asked, a person would have immediately identified himself as an Athenian, a Spartan, a Corinthian, and so on. (Often the name of the city was used as an actual surname, as, for example, Apollodorus of Athens.) Yet in spite of Greece's geographic and political fragmentation, and the frequent rivalries between city-states, a general sense of affinity with a wider cultural milieu existed, as proved by the Panhellenic sports festivals, which were conceived for the sole participation and enjoyment of the Greek people.

What created that sense of cultural affinity was the acknowledgment of a common ancestral origin, a similar language (dialects among the Greeks existed but did not impede communication), and a similar set of beliefs concerning the many gods who appeared to inhabit every nook and cranny of reality. Before the advent of philosophy, which, as we will see, brought Greek culture to a whole new level of sophistication, the author who, with Homer, best embodied the archaic spirit of Hellas was Hesiod (*fl.* c. 700 B.C.), who, in his book the *Theogony* described the intricate universe of the pagan gods. Unlike the Judeo-Christians, the Greeks thought of their gods not as creators of the world but as powerful creatures who had given shape and order to the primordial magma of the universe. Hesiod called that primordial magma "Chaos." In his *Theogony,* he writes that Gaia (Earth), who was the first divinity to spontaneously burst out of Chaos, gave birth to an equal and opposite god called Uranus (Sky). Their offspring were the gigantic Titans: a bunch of ugly and violent creatures whose envy toward their father was as outsized as they were. The victory of the younger generation over the older occurred when one of the Titans, Cronus, castrated his father, Uranus, in order to replace him by snatching his power away. Curiously, the myth also relates that it was from Uranus's bloody genitals, which Cronus threw

into the sea, that the beautiful Aphrodite (Venus in Latin) emerged. In later times, Cronus married his own sister Rhea. Their union produced the Olympians. Remembering the feelings of competition that he had nurtured toward his father, Cronus began to worry: What if his progeny had inherited the same antagonistic feelings and thirst for power that he had felt toward his own father? Pushed by that fear, Cronus decided to devour one by one all of his children. But Rhea, who wanted to save at least one, tricked Cronus into eating a stone wrapped in a blanket instead of baby Zeus. When he grew up, Zeus, full of resentment toward his father, forced him to vomit back up all his brothers and sisters—who had mysteriously grown into maturity in his belly—and went on to live with them on Olympus, the highest mountaintop in Greece.

To the twelve main gods who resided with Zeus on Olympus, as well as the many semidivine beings who inhabited the world, the Greeks attributed all sorts of natural powers. Those powers included human traits: Aphrodite, for example, represented love and sensual desire, Artemis modesty and virginity, Athena wisdom. Among the male divinities were Ares, the god of war, and Dionysus, the god of fecundity and wilderness. Apollo was particularly important because he was the god of rationality, clarity, measure, and moderation.

Although the convoluted and at times even contradictory quality of Greek religion may appear to us quite confusing, the Greeks were able to discern in their mythology a linear logic which indicated that when the Olympians came to power, the functional laws of nature were established so that the world, from "chaos," was finally transformed into an orderly "cosmos," meaning "order" in Greek.

But if the cosmic laws of order had finally prevailed over chaos, how could natural disasters be explained? And why was the human race condemned to lead an existence so rife with pain, hardship, and sorrow? Lacking the knowledge that modern science offers, those ancient people could only conclude that, notwithstanding the functional organization of nature that the regents of Olympus had established, those superior beings possessed the same volatile qualities that characterized all earthly despots cruelly unaware of the painful

struggle of the disenfranchised. When a storm crashed over land or sea, Zeus's capricious moods or those of his brother Poseidon were readily evoked and, with them, the set of propitiatory rituals designed to appease the gods and the unpredictable and at times also destructive forces of nature.

Despite all the abuses, the respect that people maintained toward the gods stemmed from the belief that, without their influence, the world would have lost the balance necessary to preserve the rules of nature that life demanded.

The order that humans were expected to impose on themselves and on their communal existence expressed the need to reflect, at a micro level, the same patterns that regulated, at a macro level, the harmony inherent in the rest of the universe. In that sense, any excess that would have disrupted the balance of society was considered abnormal and unnatural—a threat against the most fundamental rules of nature.

The many stories involving the hefty price paid by humans who, having lost the measure of balance and self-control, aspired to a power as unlimited as that possessed by the gods were known to all: the main characteristic of those quick-tempered super-beings was an enormous amount of jealousy and pride, as the historian Herodotus (ca. 484–ca. 425 B.C.) confirmed when he said, "Zeus tolerates pride in none but himself."

To be just and rational, man had to be conscious of his limitations and accept the place and purpose that his human reality envisioned. If hubris, understood as overreaching and lack of moderation, prevailed, the implacable nemesis of divine retribution would inevitably follow.

It is critical to note that apart from the centrality given to hubris, the Greeks didn't place much emphasis on human culpability. In fact, more often than not humans were depicted as innocent victims unjustly forced to endure the cruelty of amoral gods who kept interfering with their lives, either by creating adverse circumstances or by inducing humans to lose their way through irrational passions. That ambiguity was justified by the fact that the gods were not the creators of mankind: Why should the gods show compassion toward

an unrelated being who, in his frail condition, was only a pale copy of their immortal selves? No, if for those superior beings, so eerily similar to their inferior, terrestrial copies, humans had any value at all, it was only because, through them, the gods were able to channel the petty and often hysterical rivalries they relentlessly maintained with one another.

Reflecting on the privileges that the gods enjoyed, which consisted of eternal youth and flawless beauty, in contrast with the inexorable destruction and disfiguration to which time condemned the human race, the famous lyric poet Pindar (ca. 518–ca. 438 B.C.) sadly concluded,

> There is one
> race of men, one race of gods; both have breath
> of life from a single mother. But sundered power
> holds us divided, so that the one is nothing, while for the
> other the brazen sky is established
> their sure citadel forever.
>
> (SIXTH NEMEAN ODE)

Although men and gods were said to share a similar origin (having both mysteriously sprouted out of Mother Earth), the human race, in comparison with the never-fading youth of the happy gods, is defined as "nothing."

In spite of that tragic conclusion, an important exception remained: the very brief moment in time when the splendor of youth made humans as dazzling as the divinely beautiful gods. That tantalizing quality was confirmed by the riveting passions that human beauty was capable of igniting even among the celestial beings. The myriad myths describing the king of Olympus, Zeus, falling head over heels when aroused by the attractiveness of terrestrial creatures (male and female alike) prove the almost sacred importance that beauty held in the Greek mind. If it was true that humans were condemned to a vortex of destruction and disfiguration by the inexorable fury of time,

it was also true that during the brief span of years in which the inno-
cence of childhood turned into the sexual maturity of adolescence and
early adulthood, men and women could boast a blissful time of health
and beauty that was considered as glorious as the one enjoyed by the
eternally young, beautiful, and privileged gods.

But that precious moment didn't last long: as soon as the fresh-
ness of youth withered away, the implacable course of time set in
motion an unforgiving process of pain and decay governed by the cold
and unflinching indifference of the gods, as well as that of the *moira:*
the random destiny that ultimately overrode all things, mortals and
immortals alike.

Death brought no consolation. Because the concept of redemp-
tion, as a spiritual form of moral rehabilitation, had not yet been
formulated—how could that principle be enforced when the gods
were the first to violate all ethical rules of decency and respect?—the
afterlife was simply envisioned as a desolate waiting place where the
impalpable psyche, expelled from the body with the exhalation of the
last breath, aimlessly wandered like a sad, immaterial ghost, await-
ing the future reappropriation of a terrestrial body. That troublesome
realization was made even more unsettling by the fact that, unlike
the narrative later elaborated by Judaism and Christianity, no primor-
dial wrongdoing or original sin was stressed to somehow justify the
pain inherent in the human condition.

Only Hesiod, in his *Theogony* as well as in his other famous poem,
Works and Days (which describes the farmer's noble struggle to con-
trol, to his advantage, the forces of nature), adduced a primordial
justification for man's misfortunes. In a distant Golden Age, Hesiod
predicated, the human race had lived in perfect harmony with the
gods. Within that state of Eden-like grace, nature acted like a gener-
ous mother who provided sustenance and nourishment to all without
any need for work and travail. Things gradually degenerated during
the following ages: from the Silver, the Bronze, and the Heroic Age
(which coincided with the Achaean era) to the final Iron Age. In the
latter age, according to Hesiod, man, having fallen victim to the jeal-

ous Olympians, was condemned to toil and suffer in order to survive within a nature that, from generous mother, had transformed into a tough and hostile adversary.

It was at that point that Prometheus, who belonged to the race of Titans, moved by the hardship and pain to which the human race had been subjected, decided to rebel against the rule of Zeus and give mankind the gift of fire and the technical abilities that made possible the advancement of progress and civilization. (It is likely that the flame kept perennially alive on the main altar of every city contained the echo of that initial mythical spark.) Enraged by Prometheus's defiance, Zeus had him chained to a very high mountain, where his liver, repeatedly devoured by an eagle, endlessly regenerated itself.

A later storyteller, Aesop (ca. 620–564 B.C.), went as far as to attribute to Prometheus the creation of the human race that the Titan god had put together by mixing his own tears with the dirt of the earth. Even if Aesop's narration was not confirmed by other writers, the story appears quite suitable for a god so full of empathy toward a creature (man) that the majority of the gods considered irrelevant and insignificant.

In a way that is strangely anticipatory of Christ's saving mission, Aeschylus in *Prometheus Bound* described Prometheus as a defender of humanity, condemned to suffer for having "loved men too well." As with Christ, writes Carl Kerényi, the close bond that Prometheus establishes with humanity is explicated in the paradox of a god who "suffers injustice, torment, humiliation—the hallmarks of human existence."

After proudly defending his choice—"Nothing I deny / I helped men and found trouble for myself"—Prometheus, in response to the chorus, says that, besides fire, he also gave man language, mathematics, medicine, and divination, and taught him how to build houses, cultivate the land, make tools, and tame and yoke animals.

Hesiod wrote that Prometheus also contributed to the creation of rituals that endowed humans with a means to appease, at least to a certain degree, the unpredictable moods of their divine masters. Hesiod reported that Prometheus, having killed a cow, made two

packages: one contained the bones of the animal wrapped in succu-
lent fat, while the other, which was full of the best parts of the meat,
was wrapped in an unappetizing layer of skin. Offered the choice,
Zeus did not hesitate to choose the inviting smell of the first package.
From that moment on, men always maintained that vital advantage:
even if the sacrifice of animals was said to be a tribute to the gods,
men continued to keep for themselves the best parts of the meat,
leaving to the Olympians only the smell of the burning fat that, as
Hesiod writes, their "aromatic altars" brought up to the sky.

Angered by the defiance of man, Zeus devised the trap of a beau-
tiful woman, Pandora, crafted from a mix of earth and water by
the divine blacksmith Hephaistos (Vulcanus in Latin). To make her
look like a goddess, Athena and Aphrodite adorned Pandora with
the tricks of cosmetics and all sorts of dazzling jewels, clothes, and
ornaments. Born to fulfill Zeus's thirst for vengeance, Pandora had
a seductive beauty that attracted with irresistible force man's desire.
Zeus's diabolical plan was completed when Pandora, having become
man's steady companion, opened the jar that had been given to her
before being sent to earth with the command never to open it up. In
the short amount of time in which Pandora, moved by an irresistible
curiosity, held the lid of the jar open, all sorts of disasters spread into
the world. By the time Pandora closed the jar only Hope remained
trapped within the container.

Although women, per se, were not viewed as bad creatures, their
sensuous presence was considered an agent provocateur of men's most
dangerous and destructive impulses. Women, Hesiod wrote, belonged
to a "pernicious race" from which "great hurt" could befall men. In
ways that appear to be evocative of the Christian description of man's
fall from paradise, that dangerous attribute was linked with the wom-
an's sensual appeal, which unleashed man's most visceral and therefore
irrational and animal-like passions. Struck by the intense power that
erotic attraction produced when solicited by beauty, the Greeks turned
the focus of their sharp mental attention toward the experience of love
as the most significant example of life's thrilling but also highly unset-
tling ambiguity. E. R. Dodds, in *The Greeks and the Irrational,* writes,

"The Greek had always felt the experience of passion as something mysterious and frightening, the experience of a force that was in him, possessing him, rather than possessed by him. The very word *pathos* testifies to that: like its Latin equivalent *passio,* it means something that 'happens to' a man, something of which he is the passive victim."

If the rational mind was the master of the soul, why, the Greeks wondered, did men so often become passive victims of passion? Because Freud's discovery of the subconscious with all its contradictory impulses was aeons away, the ancient Greeks justified that unsolvable contradiction by blaming the gods. By creating the woman, as a tricky retribution and a deceiving gift, the gods clearly revealed the antagonistic feelings they nurtured toward mankind.

But why was Zeus so concerned with man's intellectual talent, and why did he spend so much energy in trying to sabotage it? Mythology remains vague and enigmatic on the point, but the tenacity with which the king of the heavens and his divine entourage tormented the human race cannot be ignored. What if the leader of Olympus, despite all of his fanfare of lightning and thunderbolts, was, deep down, an insecure king aware of the limits of his royal privileges? The hypothesis is plausible, especially considering that Zeus had none of the attributes we are used to associating with the divine: he was not the creator of the world, nor an omnipotent or omniscient being, as proven by the tricks he was often subjected to. As we have seen, even his rise to power had been the result of a generation-long struggle. Within a family ridden with so many power struggles between fathers and sons, remaining vigilant against the rise of all possible adversaries became almost second nature among the gods. Could the regents of Olympus have also regarded humans among their most feared contenders? As I said, even if mythology does not explicitly address the point, the suspicion that the gods could have resented human curiosity and ingenuity appears quite valid, especially when we consider man's desire to control, and subjugate for his own needs, the forces of nature—just as Prometheus symbolically does, opening the way to the titanic advancement of human progress and civilization. The mix of pride and fear that man's attempt to control nature could ulti-

mately violate some sort of divinely imposed limit has haunted man since those early times.

Discussing the contradictory nature of the Greek character, Bertrand Russell in his *History of Western Philosophy* writes, "They had a maxim 'nothing too much,' but they were in fact excessive in everything—in pure thought, in poetry, in religion, and in sin." Pindar, who dedicated most of his poetic writing to the beauty of athletic games and winning athletes, seems to validate Russell's observation: "Man: a shadow's dream. / But when god-given glory comes / a bright light shines upon us and our life is sweet" (Pythian 8). As the hero earns a never-fading glory, the winning athlete redeems, in the sweet and bright memory of his brilliant performance, what would otherwise have remained a shadowy and insignificant existence.

Notwithstanding the gloomy tone of the first line, Pindar's triumphal celebration of the athlete ends up endowing the human condition with an aura of timeless recognition that is almost as dazzling as the one accorded to the divine: when the athlete, having pushed his body to the utmost, gains a state of extraordinary magnificence, the line of demarcation between mortals and immortals appears suddenly blurred, as if the two races had become an indistinguishable one. The anonymous author of the *Homeric Hymn to Apollo* reported that if a person saw, for the first time, the performance of a group of Ionian athletes and the way they danced and sang in celebration of the games, "he would have taken them for immortal beings immune from death and old age, as if full of grace."

Life is a fleeting affair, the early Greeks appear to say, but the moment in which man, having developed to its fullness his potentiality, becomes as beautiful as a god remains an awe-inspiring miracle well deserving of the eternity of memory and art.

The fact that the athletic competitions were made part of the funerary ceremony reveals the religious meaning that games were attributed: because the physical and psychological intensity displayed by the athletes represented human excellence, it came to be seen as the best possible homage to the soul of the deceased en route toward the silent darkness of death.

The pessimism that is so often attributed to the Greeks assumes, in this light, an ambiguous connotation: even if they defined human existence as "nothing," that no one before had made that "nothing" the focal point of all mythical narratives and all artistic celebrations remains one of the most monumental tributes ever rendered to that fleeting speck of dust that is the human condition.

The essence of the early Greek mentality resides entirely in this paradox: instead of allowing death and its wrenching contradiction to belittle them, the Greeks used that awareness as the most valid reason to pursue, with a defiant sense of courage, larger-than-life ideals. The passive acceptance of senseless necessity was overcome by the soaring flight of idealism: the more the universe appeared hostile and indifferent, the more man's unconquerable determination to give life a noble meaning heroically stood out.

> Great danger
> does not come upon
> the spineless man, and yet, if we must die,
> why squat in the shadows, coddling a bland
> old age, with no nobility, for nothing?
>
> (PINDAR, *FIRST OLYMPIAN ODE*)

Don't turn your eyes away from death, Pindar seems to urge, but use the awareness of that final moment to take charge of your existence. Death should not erase the value of life but rather make its finitude all the more precious.

THE HEROIC IDEAL

Even if the society described by Homer was led by aristocrats and hereditary kings, as in the old Mycenaean era, the poet's celebration of a military mentality, morally and civically regulated by reason,

already contained, in a nutshell, the ethos that was to produce the great experiment of the polis.

At the opening of his work, Homer, just like Hesiod in his *Theogony,* invokes the Muses, the divine daughters of Mnemosyne (Memory), to grant him inspiration and assistance in order to truthfully recall the glorious events of the past. The solemn tone seeks to confirm the special mission of the poet, who, by transferring the divine message in the creative vessel of his poetry, will be able to turn into an intelligible human discourse the words of the divinity. The alleged blindness of Homer was considered symbolic of his extraordinary capacity to hear and see what others could not.

Plato in his dialogue *Ion* compares the spellbinding force of poetry to a magnet. The song enchants because the poet who inflames with his riveting verses the hearts and minds of his listeners is himself possessed by the god (*en-theos*) who fills with *enthusiasm* his creative abilities.

The extraordinary capacity of poetry to transform the ethereal quality of words into vivid and poignant visions is described in book 8 of the *Odyssey,* where Odysseus, after a devastating shipwreck, ends up on the shores of the idyllic land of Phaeacia. Found by the beautiful princess Nausicaa, Odysseus is brought to the palace of the girl's father, King Alcinous. To entertain his guest, Alcinous, who has organized a festive banquet, invites the blind minstrel Demodocus to sing. When Demodocus, plucking his lyre, starts to recall the events that took place during the sack of Troy, Odysseus has the impression of directly reliving his past. At the end of the scene, Odysseus, incapable of suppressing his tears, tells the bard that only someone instructed by the Muses could have been able to recall, with such terse precision, events exactly as they had occurred.

By praising Demodocus, Odysseus expresses his admiration for the amazing vision that the bard's song has been able to convey. Odysseus's observation directly confronts the role of the listener, as if to say: despite the precarious nature of all terrestrial things, each time someone succumbs to the alchemic spell of poetry, the past reappears as tangible and concrete as the present.

To describe the searing vision that the ritualized recitation of Homer's verses was believed to impress on the audience, Carl Kerényi mentions the Spanish philosopher and essayist Ortega y Gasset (1883–1955), who wrote that the ancient Greeks "before doing anything, took a step backward like the bullfighter posing himself for the death stroke." Stepping back into the past before proceeding into the future metaphorically underlines the formative function that far beyond entertainment antiquity associated with Homer's influence: by reviving the heroic past, poetry aroused in each new generation the passion necessary to match, in ideals and actions, the prototypical model that had formed the Greek identity since its mythical beginning.

To define virtue and merit, the Greeks used the word *arête*. *Arête* described virtue as a potential quality that each individual had the duty to actualize. *Arête* involved the fulfillment of one's telos, which meant the ultimate goal or purpose that was assigned to each by destiny. Aristotle, in his *Ethics,* affirmed that the purpose of a "good state" was to create an environment in which each individual could express his *arête* by becoming the best he could be and, in so doing, reach a state of excellence for the benefit of the city.

To achieve the full realization of the self, resilience and discipline were required. Comprehending virtue, Aristotle maintained, did not suffice. To become real, virtue had to be exercised repeatedly to the point of becoming second nature, just like a garment worn over and over until it fully became part of the self. "We are what we do repeatedly," Aristotle wrote. "Excellence, therefore, is not an act but a habit." Good character was not a given but a reward gained through dedication, discipline, and the habitual practice of good actions.

The happiness that human flourishing or *eudaimonia* (from *eu,* "good," and *daimon,* "spirit") produced belonged to those who, following the rule of reason, learned to experience virtue as the greatest of all pleasures. Happiness, according to the Greek political ideal, was linked not to the achievement of private and personal likes and desires but to the realization of what the collective identity valued most. Physical strength alone was not sufficient: what the ethos of the polis required was the rejection of all common expectations in the

name of an uncommon display of rectitude, whose ultimate expression was the willingness to accept with moral fortitude what duty and destiny called for. For the military mentality that characterized the Greeks, that included the sacrifice of one's life in the name of an ideal considered much larger than the self. Tragedy for the Greeks resided not in death but in the rational and moral failure to transform the gray and prosaic reality of daily life into the poetic brilliance of a worthy cause.

The body armor of the Greeks, which fully mimicked the shape of the body, with details such as muscles, belly buttons, nipples, and breasts, shows how far the Greeks were willing to go to turn life into myth. As we read in Homer, there was no greater shame and humiliation for a warrior than being defeated and then deprived of the honor that the armor symbolically represented. If that occurred, a man would feel literally stripped of his true self as if he had been torn away from his own skin.

The same metaphor could be applied to the process of recollection to which Homer's poetry was subjected: by being repeated so habitually, the heroic ethos became fused with the Greek character until, figuratively, it almost became a second skin.

With these observations in mind, the core message of the *Iliad* can be extracted. As the story goes, the goddesses Athena, Hera, and Aphrodite ask the Trojan prince Paris to judge who among them is the most beautiful. Because Paris cannot make up his mind, the three goddesses bribe him with different promises: Hera promises the gift of power, Athena wisdom, and Aphrodite the love of the most beautiful woman on earth—Helen, the wife of the Spartan king, Menelaus. As soon as Paris chooses the third option, Aphrodite uses her power to make Helen fall in love with Paris. Having won such a prize, Paris does not hesitate to snatch Helen away from Menelaus, who has been his host for months. Honoring hospitality was among the most sacred duties of antiquity. Paris's cavalier attitude about the consequences that such a horrendous transgression would inevitably unleash demonstrates the grave limits of his rational rectitude. That extraordinary flaw sparks a ten-year war between the Trojans and the

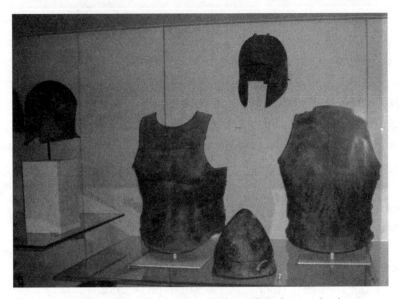

Greek body armor. Note the precise mimicry of the human body.

Achaeans, whose army is formed by the alliance of all Greek princes and kings, who, in order to restore Menelaus's honor, respond to the call for battle launched by his brother Agamemnon, king of Mycenae. From above, the gods follow the events with the same kind of cold and cruel excitement that Roman spectators would centuries later exhibit when attending the bloody events in the arena of the Colosseum. The goddess Aphrodite supports the Trojans; Hera, the wife of Zeus, the Greeks.

When, in *Iliad* 6, Helen (who now resides in Troy as the wife of Paris) expresses her sorrow for the war that divides Greeks and Trojans, the listener is caught by surprise. Rather than assuming responsibility for what happened, Helen strongly denounces the gods and their deceiving machinations as the real cause of the tragic events that are unfolding in front of her sorrowful eyes: Zeus, Helen says, assigned to us a terrible destiny so that "we may become a song for men that are yet to come" (*Iliad* 6.357–358).

Helen's words describe human existence as a painful drama in which men and women, often unaware of the gods' intrigues, are compelled to participate and perform. Despite the devastating course

of events that her love affair with Paris has unleashed, Helen's intellectual and emotional freedom remains intact, as testified by the compassion she expresses toward herself and all those who, with her, are now condemned to suffer to become, one day, the legendary subjects of epic songs.

In comparison with Helen's noble dignity, the gods' behavior appears childish and trivial, like the cruel amusement they display when contemplating the tears and pain that their actions inflict upon mankind. Within the theater of life, the Greeks believed, it was the human experience that deserved center stage, not the superficial and quarrelsome gods with their happy yet sterile lives, uncontaminated by the wounds of time and the hardship of survival that marked as a scar, but also as a badge of honor, the courageous journey of the human existence.

Helen's capacity to place herself outside the events that are occurring evokes and mirrors the observing role of the spectator. The literary device draws the listener closer to the story. Even if Helen has erred, her empathy for the sorrow of others solicits a strong emotional response: in witnessing her anguish, the audience recognizes the pain and vulnerability that all human beings are condemned to experience.

Like Helen, the two main protagonists of the story, the Trojan prince Hector and the Greek hero Achilles, also claim some sort of personal freedom despite the sacrifice of life that they will inevitably have to endure. Most emblematic, in this sense, is the choice given to Achilles at a very tender age: to grow old peacefully after a long and uneventful life, or to die young, as a hero of war, in order to live forever in the glorious eternity of fame. Achilles's brave decision to pursue what the Greeks called the "beautiful death" is profoundly revealing of that archaic culture. Deliberately choosing to fight on behalf of the homeland and die at the peak of youth, health, strength, and beauty—in other words, when one's resemblance to the gods was at its zenith—was considered the most significant gesture that one could oppose to the inexorable pace of time and the cruel indifference of destiny.

The aim of the "beautiful death" was the long-lasting memory of

a *soma* ("body" in Greek) forever celebrated through a glorious *sema,* meaning "tomb"—the same *sema* that Homer's verbal tribute represented. (*Sema,* in fact, also indicated a verbal sign.) The aim of poetry was to elevate the transitory nature of life into the eternity of the collectively shared memory.

The hero who, fiercely defiant of the cruelty of fate and the pettiness of the gods, freely selected a glorious death over a peaceful life personified the qualities that the Greeks considered most sacred: the steadfast courage of someone who did not hesitate to give his life in defense of his soil, consoled by the thought that his fame, his *kleos,* would live forever through the verbal monument that the community would faithfully preserve for future generations of warriors.

Prince Hector, who, contrary to his brother Paris, always honors reason and rectitude before the irrational call of the senses, represents the perfect embodiment of all the qualities necessary to obtain *kleos:* faithful husband, tender father, devoted son, as well as valiant and courageous citizen-soldier. But because all good stories need the tension of conflict and contrast before a final redemption, it is the irrational fury of the exceedingly proud Achilles, the strongest warrior among the Achaeans, that the poet chooses as the overriding theme of the *Iliad.*

Achilles's severe moral flaw emerges when he suddenly decides to withdraw from the battlefield because his pride is hurt by the refusal of the commander Agamemnon to give him back his slave Briseis. Blinded by anger, Achilles, who seems to know no moderation, proves the extent of his hubris when he fails to recognize the horrific price that the badly battered Achaeans have to pay for his selfish and capricious choice. (The Greeks are aware that without Achilles, the greatest soldier of all, victory would be unlikely.)

Things deteriorate even further when Achilles learns that his beloved friend Patroclus—who has gone to battle wearing Achilles's armor with the intent of deceiving the enemy—has been killed by the Trojan prince Hector, who has also taken possession of his armor. The intense sorrow that seizes Achilles shakes him from the long state of stubborn and capricious inertia into which he has fallen. Struck to the

core, he weeps uncontrollably, he pulls his hair, he throws himself to the ground, promising to avenge at all costs the death of his beloved friend.

With a wrenching scream that is meant to anticipate the savage nature of his brutish, bestial folly and, consequently, the mental and verbal distortion of his broken Logos, Achilles, who has been given a new armor by his mother, Thetis, returns to the battlefield as an unstoppable killing machine, fueled by an unquenchable thirst for blood and vengeance. The principal aim of that raw outburst of violence is Hector, the noble son of the king of Troy.

Plummeting from irrational anger to full-fledged moral degradation, Achilles reaches the nadir of irrationality when, having mortally wounded Hector, he defies all rules of honor by refusing to return his slain body home for proper burial. The disgrace associated with such reproachable behavior (at one point, Achilles even claims that he would like to eat Hector's flesh!) is heightened when Achilles rips the armor from the corpse of his enemy and then shamefully disfigures Hector's body by dragging it, facedown, behind his chariot. With that gesture of defiance, Achilles violates one of the most fundamental rules of Greek war: allowing a suitable funeral to all soldiers, friends and foes alike.

During the night, back in his tent, Achilles dreams that Patroclus asks him for an appropriate funerary ritual, without which his ghost will not be permitted to enter the realm of the dead. In the morning, Achilles orders the preparation of a pyre that will purify Patroclus's body, until his "white bones" will be ready for burial in the *sema*, or "tomb"—the symbol through which the name of the deceased was to remain forever inscribed within the cultural heritage of the community that he so bravely served. As was customary, Patroclus's funeral lasts many days filled with games and athletic competitions: boxing, racing, wrestling, discus throwing, archery, and so on. During that time, Hector's body is left exposed and naked to the ravages of vultures and stray dogs. By defacing and abusing the body of the enemy, Achilles wants to deprive Hector of the appropriate funeral that that hero's "beautiful death" has so valiantly earned.

Undaunted by the danger, Hector's elderly father, Priam, the king of Troy, bravely decides to take advantage of the darkness of the night to slip into the enemy camp in order to reach Achilles's tent. Once he faces Achilles, King Priam humbly kneels and, after kissing the hand of his son's murderer, begs for the return of Hector's body. To soften Achilles's pride, Priam, with tears in his eyes, urges the Greek hero to think of the pain that his own father would have felt if placed in a similar situation. Touched by the memory of his father, Achilles is suddenly gripped by an uncontrollable wave of empathy and emotion. After lifting the old man from the ground, Achilles weeps with Priam, mourning the terrible loss of a loved one that both of them have had to endure. The feelings that Helen expressed when she lamented the tragic destiny of all human beings are now reiterated by Achilles, who uses the pettiness of the gods to magnify the nobility of men: "the gods spun the thread for wretched mortals, / that they should live in pain, and themselves are sorrowless" (*Iliad* 24.525–26).

Achilles's selfish behavior and immoderate fury, which until this moment have been lacking the measure and restraint that reason had to maintain over passion, are finally redeemed when, through the profound lesson of sorrow, Achilles is able to overcome the egotism of his self-involved reprisals and regain his full humanity. The idea of winners and losers suddenly loses all meaning. Life doesn't spare anyone: even the greatest heroes, Homer's epic seems to conclude, are ultimately only victims of the ruthless indifference of destiny. Faced with such a tragic truth, all that remains for men is to hold on to a sense of shared solidarity that goes beyond all tribal boundaries and divisions.

After returning Hector's slain body, Achilles grants twelve days of truce, during which the Trojans can honor their hero with a funeral ceremony similar to the one that Patroclus has received. The celebration closes with the image of a beautiful dawn rising over the sandy stretch of the Hellespont, where the entire population of Troy has gathered to pay final tribute to Hector's immortal *sema*. As poignant as it may be, that solemn moment is only a parenthesis within the gruesome events of war that readily resume as soon as Hector's funeral is over. Within the enormous cost of life that the

fall of Troy will ultimately claim, the brutal death of King Priam is included (ironically killed by Neoptolemus, Achilles's son), as well as the capture and enslavement of his wife and all his daughters. On the Greeks' side, the greatest moment of drama is offered by Achilles, who, having regained his full dignity as a rational and therefore moral individual, is finally ready to fulfill his telos by dying as a true hero on the battlefield. That moment occurs when the unimpressive Paris, Priam's son and Hector's brother, guided and empowered by Apollo, hits Achilles in the right heel, the only vulnerable spot on his body. (As legend told, Achilles's mother, Thetis, had tried to make her son immortal by dipping him, as a baby, in the river Styx. However, she inadvertently left him vulnerable in the right heel, by which she had held his body.)

For the ancient Greeks, man's realization was always an arduous conquest, with no final rest in any consoling Eden of peace and contentment. Achilles and Hector were considered heroes precisely because they both chose to sacrifice their lives for honor, notwithstanding their visceral and absolutely uncompromising attachment to life.

While Achilles, in the *Iliad,* symbolically represents the taming of the irrational animal, Odysseus (or Ulysses), in the *Odyssey,* embodies what true humanness looked like when man used reason to harness all immoderate passions, including the excessive ambition to compare himself to a god. The story narrated in the *Odyssey* occurs ten years after the end of the Trojan War. While all other Greeks have returned home, Odysseus is held captive on the island of Ogygia by the nymph-sorceress Calypso. Never relinquishing his desire to return to the island-kingdom of Ithaca, of which he is the ruler, Odysseus enters the story as an unwilling lover who sleeps by Calypso's side at night but sits on the shore during the day, "rocking his soul" with tears of longing for his faraway family and homeland. Nothing deters Odysseus from his final purpose, not even Calypso's offer to grant him a godlike form of immortality in exchange for his love.

Only the intervention of Hermes, sent by Zeus, finally induces Calypso to let Odysseus build a ship and leave. But the journey back

home is not as easy as the hero might have wished, given the many troubles unleashed against him by Poseidon, the ruler of the sea, who resents Odysseus for the killing of his son, the one-eyed Polyphemus. Following a storm that wrecks his ship, Odysseus finds himself in the land of the Phaenicians. In the palace of King Alcinous, where he is brought by the princess Nausicaa, Odysseus narrates the many risky adventures that have accompanied his wanderings: the apathy and forgetfulness that his men experienced in the land of the lotus-eaters; the tricks of the enchantress Circe; the blinding of Polyphemus, the giant son of Poseidon; the deceiving songs of the Sirens who falsely promised the gift of superhuman knowledge; the descent to Hades. When Alcinous eventually proposes that Odysseus marry his daughter Nausicaa, the hero nobly refuses, placing his return home before the prospect of becoming the future king of the rich and prosperous kingdom of Phaeacia.

Odysseus's *nostos* ("return," from which derives the word "nostalgia") finally comes to an end when, having landed in Ithaca, he brutally kills all the suitors who had taken over his palace and were planning to murder his son Telemachus. The event comes as a relief to Penelope, who, faithful to her husband, had been able to delay the marriage to one of the suitors with the excuse that she had to complete the weaving of the burial shroud of Odysseus's father, Laertes. (Each night she would undo her day's labor, postponing its completion indefinitely.) The very last step, before Odysseus can reconquer his full identity, involves the signs of recognition that he offers his family (who cannot recognize him after so many years of separation): to his old father, whom he meets in the fields working the land, Odysseus lists all the fruit trees that they planted together when he was a child; to his wife, he recalls the secret of their matrimonial bed, built at the center of the house on the gigantic stump of an ancient olive tree.

The values that the archaic mentality cherished most are fully expressed by these humble and organic images. Odysseus's return to Ithaca taught the Greeks that no value was more sacred than the land that preserved the ancestors' bones: the land of one's origin to which

each individual felt viscerally connected, generation after generation, like a tree growing higher and higher toward the sky in direct correlation to the depth of its roots and the rings of growth of its firmly grounded trunk.

After all the pathos, what ultimately crowns the greatest epic of antiquity is the precious ethos of the ordinary, the unassuming, the unexceptional: the vernacular simplicity of the farmer's existence. We can conclude by saying that what makes Odysseus the perfect prototype of the Greek hero is his extraordinary determination to become the best he can be without ever trying to trespass the limits assigned to him by destiny. Odysseus is a hero because, despite his accomplishments, he is able to resist all inappropriate desires for excessive power and recognition. That truth becomes evident when Odysseus, having regained his kingdom, finds full contentment in a life that appears to be the perfect opposite of what he had previously experienced: the completely unglamorous existence of a king-farmer devoted to an island-kingdom that is no more than an arid and rocky dot within the sprawling vastness of the Mediterranean Sea.

Homer's closing theme appears identical to the one that Hesiod had spelled out in his poem *Works and Days,* where the concept of *arête* is expressed by the humble and patient dignity of the farmer's life. Michael K. Kellogg, in *The Greek Search for Wisdom,* writes that, after the Age of Heroes sung by Homer, a new kind of virtue, or *arête,* arose—not just the one won on the battlefield but also the one that the "peasant-hero" gained through the "quiet endurance" of his hard work.

Happy and blessed is the man who knows all this
and does his work without offending the immortals,
ever watching birds of omen, ever shunning transgression.

(II. 826–28)

What Hesiod wants to celebrate is not the peace of an ignorant state of mind but the greatness that comes from a life made exceptional by the respect of the virtues that the Greeks considered most sacred: the wisdom of moderation, hard work, courage, endurance,

and discipline—in other words, the wisdom of accepting one's place in the world without ever transgressing the boundaries assigned to the human existence.

<p style="text-align:center">✳</p>

GREEK ART:
REASON VERSUS PASSION

Until the eighth century B.C., the Greek world, which still lacked any form of writing, also lacked any distinctive system of figurative representation. The single term *graphein* was used to convey the idea of writing, drawing, and painting, as if all forms of visual expression were equivalent.

Except for the geometric decorations placed on vases and various other objects of daily use, which developed as early as the ninth century B.C., no other major artistic innovations were introduced until the middle of the sixth century B.C., when, with the rapid blooming of the polis, a striking new form of visual expression, very closely related to the values and intents expressed by poetry, appeared—the art of sculpture. The first freestanding, life-sized models crafted in stone were called kouroi.

In the stocky rendering of the vigorous naked body depicted with stiff legs slightly parted, stretched arms, clenched fists, and a wig-like display of curly hair, the Egyptian influence appears very obvious. But the stylistic similarity hides a very important difference when the subject matter is highlighted: while the Egyptians' statues invariably depicted the divine pharaoh, the Greek ones, just like the Homeric epics, principally celebrated the dignity of the human subject. The choice is extraordinary, especially considering that no other culture before the Greeks had ever made man himself the most central subject of art.

The kouroi, which were produced in the aristocratic and oligarchic society of the sixth century B.C. (less than a century before the estab-

lishment of Athenian democracy) were funerary tributes built in honor of upper-class young men, represented as legendary heroes or winning participants in athletic contests, depicted in the nude as was customary among athletes. Revealing in that sense is the word *gymnasium,* which was the place where athletic preparation took place and which derived from *gymnos,* meaning "naked."

The impersonal character of the kouroi's facial expression derives from the fact that those statues were intended to provide not a realistic portrait of specific individuals but a generalized and idealized one meant to celebrate the resemblance that linked the human form—captured at the

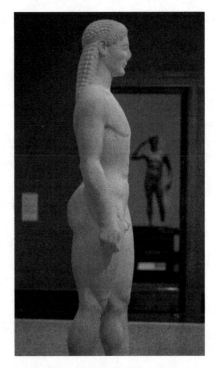

An example of kouroi, the earliest life-sized renderings of actual human figures

highest degree of youth and strength—to the ideal beauty of the divine. For that reason, even if they were built as funerary tributes to specific individuals, the narrative selected for the kouroi remained mythical rather than historical. Instead of focusing on recognizable features, art responded to the funerary event with a standardized model meant to highlight the eternal value of beauty (physical as well as moral, civic, and military) that the deceased possessed.

In choosing an impersonal and idealistic style over a realistic one, the Greeks expressed, yet again, the strong repulsion they felt toward the cult of celebrity that, they believed, could have seriously put at risk the basic sense of communality that was to be preserved within the polis.

The way the winner of an athletic competition was rewarded shows the point very clearly. Even if the winner was the subject of great

praise, the reward he received (which, in most cities, only amounted to a crown of olive or laurel leaves or, as in Sparta, to the privilege of being deployed on the front lines of the army) was always valued in relation to the collective success: in other words, not for the way it fed the ego of the individual, but for how it enhanced the overall prestige of the city.

Honoring their gilded youth through an impersonal athletic model was for the Greeks a way to pay homage to the greatness of man's organic reality, which, at the peak of its perfection, was felt to compete with that of the gifted gods. The smile that animates the kouroi reminded the viewer of that connection: excellence endowed man with a beauty as splendid as that enjoyed by the blissfully ageless and therefore eternally "happy gods."

As the scholar Werner Jaeger writes in his book *Paideia,* "By discovering man, the Greeks did not discover the subjective self, but realized the universal laws of human nature. The intellectual principle of the Greeks is not individualism but 'humanism' . . . the process of educating man into his true form, the real and genuine human nature."

Choosing to represent the kouroi naked had a similar intent: while for the Egyptians nudity was associated with a degraded status, like that of a slave, the representation of unclothed men was for the Greeks a way to elevate the heroism of the warrior to a universal and timeless plane, free from attributes linked to social rank and status.

Completely antithetical to this approach was the hierarchically structured mentality of the Egyptians, whose artistic production was for the most part hidden in tombs for the sole benefit of the dead king. For the Greeks, on the other hand, art always assumed a public function, which was simultaneously civic, ethical, and didactic. The kouroi represented the ideal prototype of beauty and good to which all citizens had the duty to conform. Art belonged to the city, which, in turn, was seen as the fundamental unit of civilization.

Although less common than the male, a female version of the kouroi existed: it was called kore (maiden) and served a similar commemorative function. The difference with the male representation

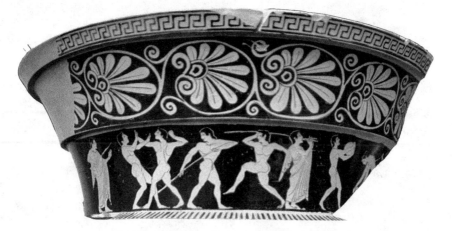

Dynamic depictions of human action were characteristic of ancient Greek pottery painting.

was that these maiden figures were always sculpted with their clothes on. The ideological and psychological makeup of the Greek mind, which we have discussed before, reveals the motivation behind that choice: a naked man was believed to inspire heroic thoughts; a naked woman, only lusty desires of a purely carnal nature.

The reason the model of the kouroi was soon discarded, despite its emblematic significance, was its failure to express the lively quality of the human form that sixth- and fifth-century pottery paintings had so successfully achieved.

But how could a sense of dynamism, similar to the one expressed in paintings, be applied to a rigid and heavy piece of stone?

The brilliant solution, achieved a century and a half after the first appearance of the kouroi, is exemplified by a statue known as the Kritios Boy (see page 44), which was discovered among the ruins of the Athenian temple that the Persians destroyed in 480 B.C. (We will return to that crucial event later.)

The subtle difference that distinguishes the Kritios Boy from the kouroi is the asymmetrical bearing of the body, which is emphasized by the slightly bent right knee and the redistribution of the weight that the irregular position of the hips articulates. The minimum twist imposed upon the central axis of the figure suffices to give the figure

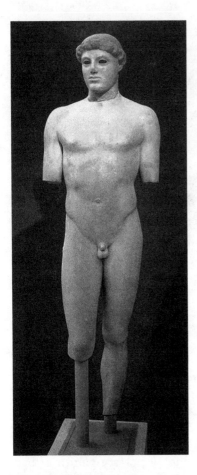

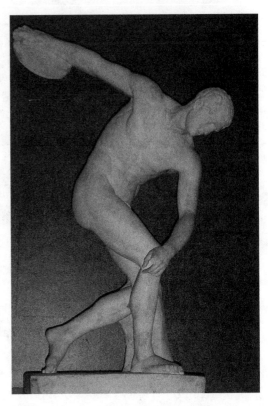

LEFT: The Kritios Boy (ca. 480 B.C.)
ABOVE: The *Discobolus,* or Discus Thrower

the plasticity that is completely absent in the tree-trunk rigidity of the kouroi. The technical adjustment is known as *contrapposto*. The *contrapposto,* with its simultaneous stress on movement and stillness, perfectly caught the sense of composure and self-restraint that was supposed to accompany human awareness and action.

The dramatic improvement that was achieved, just two or three generations later, is expressed by the statue known by the generic denomination of the *Discobolus,* the Discus Thrower, which was produced by the artist Myron between about 460 and 450 B.C.

The bulging muscles, the rib cage emerging under the stretched pull of the skin, the throbbing veins: the originality of the statue consists in capturing the buoyant energy of a young athlete whose powerful body briefly coils just before the swift unfolding of the action.

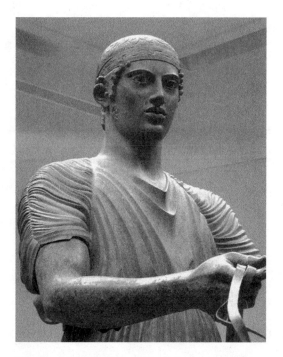

Charioteer of Delphi (ca. 470 B.C.), a supremely
self-possessed figure

What catches the viewer's attention is the masterful balance of
two opposing forces: the dynamic expressed by the upper torso stren-
uously twisted versus the solidity of the right leg that firmly roots the
body to the ground. The column-like effect that the support of the
right leg provides appears to be a perfect corollary to the calm com-
posure of the athlete's facial expression, which appears free from any
sign of strain and effort. The choice indicates that what sustains the
absolute precision of the athlete's performance is the vigor of a concen-
trated rational mind uncontaminated by the distracting interference
of unruly passions and emotions.

A similar emphasis on Logos rather than pathos is present in the
famous bronze statue called the *Charioteer of Delphi* (ca. 470 B.C.).
What gives this male athlete the highest mark of recognition is a
poised, self-possessed, and emotionally controlled dignity completely
devoid of pathos because it is filled with rational rigor and calm
determination.

What qualities define the classical approach to art? The answer is complex. If one considers the increasingly accurate depiction of the human body, we can certainly use the terms "realism" and "naturalism," but the fact that the actual people of the times were rather stocky and short (as studies of ancient skeletons have determined) shows that what the artists strove to depict was not a faithful replica of reality but an idealized vision of beauty and perfection. The impersonal facial expression that all statues were given further underscores the fact that classical art, more than being descriptive and aesthetically pleasing, aimed at being instructive and inspirational—demonstrating how to achieve perfection in body and soul, through the gift of rationality.

※

FROM MYTHOLOGY TO PHILOSOPHY

The most important outcome that the Greeks' emphasis on human reason produced was the development of philosophy. After the parenthesis of the Dark Ages, the first Greek city-states that experienced a significant revival in culture were the ones that reestablished regular commercial contacts with other civilizations, like the Egyptians, the Babylonians, and the Persians. It is not a coincidence that it was in Miletus, an active port in Ionia on the western coast of modern Turkey, that in the sixth century the first Greek school of philosophy was established. The three main philosophers of the school of Miletus were Thales, Anaximander, and Anaximenes. The common objective that these three "investigators of nature," as Aristotle later called them, set for themselves was to identify the unifying stuff out of which the diversity of the world had derived. Thales, a mathematician and an astronomer who famously predicted an eclipse that occurred in 585 B.C. and also calculated the height of one of the Egyptian pyramids from the length of its shadow, proposed water as the foundational substance of the world. In contrast with Thales, Anaximenes stated that air was the most basic element of reality, while Anaxi-

mander, using a more abstract argument, said that at the origin of all material things was an infinite and indestructible entity capable of differentiating itself into the various expressions of the world while maintaining intact its original essence.

Even if, according to these philosophers, the world maintained an overall animated quality, the willingness to abandon the naive approach of early mythology to pursue rational and empirical conclusions represents a very important step in the journey of the Western mind.

The unity of philosophy and science that had characterized the school of Miletus was later re-proposed by Leucippus and his successor, the Thracian philosopher Democritus (ca. 460–ca. 370 B.C.), who described reality as the shifting combination of a multitude of invisible and imperishable particles endlessly clashing and interacting with one another, which he called "atoms," meaning something "that could not be divided." Even if tempting, we should not assume that Democritus discovered the atomic structure. Anthony Gottlieb in *The Dream of Reason* underlines the point when he says that Democritus's conclusion was basically a lucky guess reached without the slightest support of scientific observation, test, and experimentation. Furthermore, Democritus "had no inkling of most of the important properties and forces" that are connected to the atoms—namely, the fact that they are subjected to electromagnetic forces and, unlike what the Greek philosopher thought, they are not solid, nor indivisible, nor eternal. Gottlieb's argument is that Democritus's true modernity should rather be associated with his conception of an impersonal universe governed by purely mechanical laws. The view, which included the denial that the soul was immortal, was filtered a century later in the materialism of Epicurus that, in turn, influenced the famous Latin atheist Lucretius (ca. 94–ca. 55 B.C.), author of *De rerum natura* (*On the Nature of Things*). Anthony Gottlieb explains that the limited recognition that those philosophical currents of thought received was caused by the ascendancy of Plato, Aristotle, and in later times Christianity, which claimed that a divine and providential principle was at work in the universe and rejected all theories that, by being devoid of

metaphysical implications, failed to give life any kind of spiritual and religious meaning. The wheel of change slowly began to turn from the Age of Enlightenment on. Only in the nineteenth century did science cease to be defined as "natural philosophy" to finally gain full autonomy from religion and philosophy. The branching out of science into ever more specific and detailed fields of specialization, like biology, physics, and psychology, took place only in the nineteenth century.*

While the philosophers mentioned above principally focused their inquiry on the natural world, the fifth-century Parmenides, who founded a school in Elea in southern Italy, was the first thinker to shift the interest of the new discipline toward the observing subject in his double role of a rational and sensory-led observer. Noting that man's sensory perception was gravely insufficient, Parmenides concluded that contrary to the apparent multitude of things, the world was an indivisible "One" and that change was only an illusion. Parmenides was not the first thinker to address the deceiving quality of the human senses, but he was definitely the first one to claim that reason alone could reach higher truths without the support of any physical and tangible evidence. The point, as we will see, became a cornerstone of Plato's philosophy.

In contrast to Parmenides, Heraclitus (active between the sixth and the fifth centuries B.C.), who, due to the enigmatic quality of his writings, was labeled "the obscure," ventured onto yet another line of thinking when he asserted that the world was a permanent flux of opposite forces. *Panta rhei,* he declared: "Everything flows." Despite his insistence on the ever-changing quality of reality, Heraclitus, sharing a belief that was becoming increasingly popular, affirmed that an eternal and absolutely impersonal being, which he called *Logos*

* Scholars believe that Democritus came up with the idea that the world was composed of small particles of invisible matter to oppose Zeno of Elea (490– 430 B.C.), who claimed that, because matter was infinitely divisible, reality was a paradox that was always going to defy man's desire to square reality within the parameters of rationality.

(simultaneously meaning "word" and "reason"), reigned untouched and unmoved above the impermanence of all terrestrial things. Heraclitus's view also included the following definition of the soul: "You could not find the ends of the soul though you travelled every way, so deep is its *logos*." Addressing the statement, Bruno Snell, in *The Discovery of the Mind,* writes: "In Heraclitus the image of depth is designed to throw light on the outstanding trait of the soul and its realm: that it has its own dimension, that it is not extended in space."

Although profoundly different in their philosophical assumptions, Parmenides and Heraclitus agreed on a main point: the rejection of the anthropomorphic characteristics previously attributed to the gods by folk tales and poetry. As we have seen, for many centuries people had equated the role of the poet with that of an inspired prophet whose verses were to be honored as carriers of high and ineffable truths. Firmly challenging that tradition, Parmenides condemned the poets' songs, affirming that like the Sirens who lured sailors to shipwreck by their irresistible songs, they only lulled the mind toward fanciful yet false and dangerous illusions. Sharing a similar kind of skepticism, Heraclitus denounced the poets as creators of beautiful and seductive but also totally false and deceiving truths. The Ionian poet and philosopher Xenophanes (ca. 570–ca. 480 B.C.) resorted to a similar criticism to denounce Homer and Hesiod: "Homer and Hesiod have ascribed to the gods all things that are a shame and a disgrace among mortals, stealing and adulteries and deceiving of one another. . . . Mortals deem that gods are begotten as they are, and have clothes like theirs, and voice and form." Dismissing as absurd that old mythological mentality, Xenophanes mockingly went on to declare that "if oxen and lions could produce works of art as men did, horses would paint the form of gods like horses and oxen like oxen." For that reason, he concluded, "Ethiopians make their gods black," while "the Thracians give them red hair and blue eyes." Just like Parmenides's and Heraclitus's, Xenophanes's intention was to negate not the existence of the gods but the ignorant tendency to give them anthropomorphic characteristics.

A rejection of the old myths was also adopted by Empedocles,

born in Sicily around 490 B.C., who affirmed that it would have been ludicrous to describe in ways so similar to man the ineffable mystery of the divine: "We cannot bring God near so as to reach him with our eyes and lay hold of him with our hands. . . . For he has no human head attached to bodily members, nor do two branching arms dangle from his shoulders; he has neither feet nor knees nor any hairy parts. No; he is only mind, sacred and ineffable mind, flashing through the whole universe with swift thoughts." Empedocles, who also claimed that the basic elements of reality were fire, air, earth, and water, introduced the concept of Love to define the divine energy that gave unity and harmony to all the elements of nature, against the disruptive dynamic of Strife, which represented disunity and discord. Empedocles's emphasis on Love and Strife as the two basic forces of the universe reveals that Empedocles was familiar with the theory of Zoroaster, also known as Zarathustra (ca. 628–ca. 551 B.C.), the prophet of ancient Persia who described the world as a constant battle between Good and Evil.

The need to find more fulfilling ways with which to address the fundamental questions of life also found expression in mystical sects that in many cases were connected with Eastern cults and traditions. Among them were the Eleusinian Mysteries, which were dedicated to the cult of Demeter the corn goddess, and the Orphic Mysteries, which were based on the legend of Orpheus—the magical poet who enchanted all creatures with his songs and who dared to descend into the underworld to beg its king, Hades, for the return of his beloved Eurydice, who had been killed by the bite of a snake. Although little is known about these mystery cults because of the tight bond of secrecy that their participants maintained—the word "mystery" derives from the Greek *myo,* meaning "keep the mouth shut"—scholars have determined that it was from these movements that the idea of an immortal soul imprisoned in the material world and longing to return to its heavenly home became so predominant in philosophical and religious thoughts.

A branch of Orphism also included the ancient cult of Dionysus. In contrast with Apollo, who was the god of reason, measure, light,

clarity, and harmony, Dionysus (Bacchus in Latin), whose Thracian origin was probably linked to fertility myths, was the orgiastic god of wine, madness, darkness, wilderness, and ecstasy. The Dionysian worshippers gathered at night on mountaintops to perform communal dances to the wild music of drums, cymbals, and flutes. The state of frenzy reached in those gatherings was meant to break all barriers and inhibitions: the cult members tore animals to pieces and ate their flesh raw while consuming wine and other intoxicants that allowed them to dissolve their sense of self into the greater, undifferentiated flow of nature that Dionysus represented.

Bertrand Russell writes that as the "sober civilization" of the polis advanced, the shamanic idea that truth could be found by stepping outside one's reality was gradually sanitized in order to give the Dionysian cult a more ascetic and mystical quality. In that transition, the wine intoxication that characterized Dionysian rituals was transformed to become an abstract symbol of "enthusiasm"—that is, union with the god. As we will see later in the book, in the Christian Eucharistic ritual, which no doubt had Dionysian roots, wine came to be associated with the blood of Christ that produced the sober drunkenness of the mystical experience.

PYTHAGORAS: THE DIVINE REASON AND THE IMMORTAL SOUL

The philosopher who best succeeded in finding a point of convergence between mystical aspirations and scientific conclusions, and used that synthesis to exalt the value of the immortal soul, was Pythagoras, who was born around 570 B.C. on the island of Samos, on the eastern part of the Aegean Sea. From the accounts of contemporary witnesses, we know that he traveled extensively, reaching perhaps even Egypt, before settling in Croton, in southern Italy, where he founded a school that, more than a center of culture, resembled a mystical sect

dedicated to the illumination and salvation of the soul. The school, which was composed of a limited and highly selected group of initiated disciples, women included, was based on an austere and humble communal life whose rules, such as celibacy and vegetarianism, were strictly enforced.

Pythagoras's originality consisted in pinpointing in the invisible presence of numbers the laws with which a mysterious, divine Reason had ordered the primordial magma of chaos into the harmony of the cosmos. By attributing a sacred quality to the Greeks' long-standing trust in reason, Pythagoras affirmed that because the rules of arithmetic and geometry were obtained through an intellectual process operating independently from empirical proofs, the mind was superior to the senses, making man a privileged creature attuned, like no other, to the creative powers of the all-pervading Reason.

To explain man's unique ability to unlock the hidden laws that regulated the cosmos, Pythagoras theorized a primordial time in which the human soul had been one with the divine. If human intelligence was able to discern the mathematical language of the divine, it was because it somehow still contained within the spark of the superior Reason to which it had once belonged.

By demonstrating that the pitch of a note varied in relation to the length of a musical string, or the weight of a hammer striking a piece of metal, Pythagoras also concluded that music was connected with numerical measures that were at the core of all natural relations, including the motion of the celestial spheres that, in their dance, produced a magnificent musical harmony. This harmony, however, was inaudible to man due to the crippling obstructions caused by his earthly bondage.

To rekindle the memory of his cosmic origin, man had to expose himself to the inspirational influence of music. As the notes soothed the discordant grip of earthly passions, they would reawaken in the soul the memory of the melodious consonance with which the divine had permeated the whole of his creation. As medicine cured the body, music helped the healing of the soul, reattuning it to the rhythm of the celestial spheres.

Pythagoras's theory was probably influenced by the Mysteries practices that had regarded the lyre as the symbol of the human constitution: the body represented the instrument, while the soul was the magic musician capable of giving a melodic voice to what would otherwise have remained a purely material, mute, and inanimate object.

According to Pythagoras, man's existence had to undergo a process of successive reincarnations designed to gradually purify his nature from the polluting effects of all physical instincts and desires. Depicting humans as imperfect creatures aiming at regaining a primordial state of bliss, Pythagoras reversed the core belief of many centuries to affirm that, rather than in the mortal body, the essence of the human creature resided in a soul made immortal by its sacred bond with the divine.

With Pythagoras, the naturalistic approach that the first philosophers had pursued branched out in a mystic direction that pushed the elaborations and conclusions of the rational mind further and further away from the secular concreteness of the material world. The desolate and shadowy attributes that were previously associated with the afterlife were now transferred onto the reality of the world that Pythagoras dismissed as an insignificant, opaque, and deceiving dimension.

To be reunited with the divine Mind, Pythagoras contended, man had to reattune his existence to the kindred order belonging to the melodious symphony of the celestial realm. Telling is the answer that Pythagoras gave to the following question: Why does man, unlike all other animals that keep their heads low toward the ground, stand up straight? Reflecting on that puzzling characteristic, Pythagoras, who knew nothing about modern discoveries such as Darwin's law of evolution and natural selection, came to the conclusion that man's unique, upright position mirrored the natural proclivity of the soul to redirect upward, toward the splendid movements of the stars, the inner vision of the mind.

To reach the plenitude of his humanness, man was taught to look at the choral order of nature as expressed by the harmonic symphony of the spheres. Verbs such as "to desire" and "to consider" (from the Latin *de sidus,* "from stars"; *cum sidus,* "with stars") still reflect the echo

of that old creed, as if to say: All those who ponder the Truth should aspire to an ultimate realignment with the rational order that the luminous stars manifest amid the darkness of the night.

As we will see, the laws of symmetry and proportion that Greek sculpture and architecture pursued at the peak of classical times, between the fifth and the fourth centuries B.C., derived from Pythagoras's belief that humans were meant to re-create, within their reality, the same balanced collaboration between the parts and the whole that the divine Mind had imposed on the harmony that governed the entire cosmos. The idea that, being the work of a divine Craftsman, the universe was like a symphony organized in perfect mathematical order kept a position of absolute prominence in Western thought almost up to the nineteenth century.

With Pythagoras, the fickle and capricious gods of archaic times came to be replaced by a remote and abstract entity that, in perfect opposition with the past, was now considered wholly rational, good, and just. To realign his reality with the divine rules of that superior Mind, man had to sever the umbilical cord that had kept him viscerally connected to the material world. Pythagoras, and later Plato, used a very descriptive metaphor to illustrate the point. As we have seen in Homer's epic, Odysseus built his nuptial bed on the stump of an ancient olive tree. That symbolic image, which was meant to link the hero's identity to the tangible concreteness of the land, was radically inverted by Pythagoras's and Plato's allegorical description of man as an upside-down tree with roots stretching from the head, as a symbol of the celestial homeland to which his soul yearned to be retransplanted.

Before exploring the enormous influence that those concepts had on classical times, we have to review the other major event that, almost in consonance with the beginning of philosophy, gave new relevance to the Greek way of thinking: the war against the Persians.

THE MYTH OF THE RATIONAL WEST
VERSUS THE IRRATIONAL EAST

As the Greeks became increasingly aware of the uniqueness of their culture, they also started to call "barbarous," meaning "those who stutter" (because they seemed to go "bar-bar-bar" when they spoke), all the people who didn't share their Logos, meaning language and reason.

By the middle of the sixth century B.C., the greatest threat to the freedom of the Greek poleis came from the Persians, who, under the guidance of Cyrus the Great, had initiated a vertiginous expansion, taking over the kingdom of Media (northern Iran and part of southern Turkey), Lydia (Anatolia), Ionia (western Turkey), and the Babylonian Empire. After Cyrus's death, his son Cambyses II added to the empire the prestigious land of the once-powerful pharaohs, Egypt. With Darius I, who succeeded Cambyses, the vast and multiethnic Persian kingdom was further expanded, reaching as far as eastern Asia and northern India. Even if it lasted only two hundred years, the Persian Empire, with its amazing mix of ethnicities, languages, and traditions, was the greatest political organization that the world, until that moment in time, had ever witnessed.

The people who, next to the king, benefited most from the wealth and prestige of the empire were the privileged aristocrats who, as vassals of the regent, governed the local satrapies from fanciful palaces, surrounded by magnificent hunting parks called *paradises* (a word eventually adopted by Christianity to describe the kingdom of the blessed), served by eunuchs and people called "adorners" because of their knowledge of cosmetics and perfumes.

The clash between the Persians and the Greeks started when the Ionian city of Miletus, which had fallen under the Persian encroachment, revolted against its occupants in 499 B.C. Fearful that the Persians would continue to push their unstoppable thrust farther west,

Athens, with some other minor Greek cities, decided to mount a counteroffensive by sending military help to the Ionian rebels.

Even if the massive Persian army had no problem in subduing the rebellious Ionians and their allies, Darius, who was known for his intolerance toward all those who dared to defy his authority, promised harsh retaliation against the rebellious Greeks. In response to that threat, the city-states decided to put aside their old rivalries, pledging mutual collaboration against the common enemy.

Most of what we know about the Persian wars comes from the *Histories* written by the fifth-century Herodotus, who was born in Halicarnassus, in the region of Ionia, which today is part of Turkey. Because he was the first writer to consult oral and written testimonies to record, in prose, the events of history, Cicero called Herodotus the "father of history." Cicero's appellation is only partially appropriate: despite his valuable contribution, Herodotus could hardly be considered historically impartial, given his biased habit of exalting the superiority of the Greeks over the "barbarian" Persians, whom Herodotus recurrently describes as decadent and morally deficient people— a cliché that Greek propaganda actively promoted, with little concern for accuracy or objectivity.

In 492 B.C., Darius tried to attack Greece, descending from the north, but he was stopped by a violent storm that destroyed a large part of his fleet. Herodotus reported that Darius, furious over what had happened, ordered his soldiers to punish the sea by slashing its waves with a whip.

In 490 B.C., a Persian flotilla composed of six hundred ships finally sailed across the Aegean and landed near the plain of Marathon, where they were confronted by the Athenian army. Herodotus, with his usual flair for the colorful and the spectacular, wrote that if all the Persians had simultaneously shot their arrows toward the sky, the sun itself would have disappeared as if enveloped in a cloud of darkness. Besides a clear reference to the magnitude of the Persian army, the metaphor was probably meant as a warning: If the enemy had prevailed, what the Greeks believed to be the natural order of things would have been irremediably altered. As a consequence, the

line of division between the West and the East would have been for-
ever annulled, depriving the world of the light of civilization that the
Greeks had so brilliantly achieved. As the civilized world would have
lapsed back into the darkness of chaos and confusion, the Greeks,
who had never before prostrated themselves before anyone (not even
their gods), would have been forced to kneel in humiliation in front of
a king who claimed to be superior to all other human beings.

Strongly motivated by that dreadful prospect, the Athenians,
assisted by a small military division sent from the city-state of Pla-
taea, bravely confronted the Persian army. Despite being greatly out-
numbered, the citizens of Athens and Plataea were able to prevail
even before the arrival of the Spartan contingent. As is well known,
when the Battle of Marathon was over, a messenger raced to Athens
to bring the news of the victory back home, only to die of exhaus-
tion as soon as his task was completed. In memory of that moment,
a "marathon race" is still performed today to honor the spirit of the
Olympic Games.

Stunned by the defeat, the Persians retreated from Greece for the
next ten years. But hostilities were resumed when Xerxes, having
succeeded his father, Darius, decided to restore Persian pride by orga-
nizing a punitive mission against the turbulent Greeks. The military
force that Xerxes amassed was enormous. To give a sense of its mag-
nitude, Herodotus wrote that it took seven days and seven nights for
the entire army to cross the immense bridge of ships that the Persian
engineers, directed by Xerxes, had built to connect the two shores of
the Hellespont.

Xerxes was convinced that upon learning the size of his military
might, the Greeks would immediately be cowed into submission. To
show how little Xerxes knew of the brave spirit of his adversaries,
Herodotus reported a dialogue that allegedly occurred on the eve
of the battle between an exiled Spartan named Demaratus and the
Persian ruler. Boasting his military superiority, Xerxes arrogantly
affirmed that an army deprived of a master inflicting "lashes" on those
who lacked courage in battle was certainly condemned to failure. In
response, the Spartan general replied, "No sir, the Law is the master

whom they [the Greeks] own; and that master they fear more than the subjects fear you. Whatever this master commands, they do; and his command is always the same: it forbids them to flee battle before any multitude of men but stand firm to their post and either conquer or die."

The words stressed the unwavering reverence that the Greeks nurtured toward the Law: a "master" that they obeyed because, in contrast with the arbitrary power of a single man (as in the Persian monarchical system), the Law assured a justice that was good and trustworthy because impersonal, objective, and universally valid for all.

It's doubtful that Xerxes could have fully appreciated the true meaning of that statement. Like all other Eastern despots, Xerxes believed that the inhabitants of his kingdom were inferior beings, unable to govern themselves. In his mind, wisdom was a prerogative that only belonged to the king, and no one had the right to contest the sanctity of his judgment and rule.

When the Persians were finally ready to launch their attack, they divided their army in two: while the fleet went along the coast, the infantry and cavalry advanced overland. Knowing that the Greeks considered warfare sacrilegious during the Olympic Games, Xerxes chose precisely those dates for the landing of his army. Despite the veto imposed by the Olympic tradition, the Spartans sent three hundred of their best soldiers to the narrow passage of the Thermopylae, or "the Hot Gates," seventy miles northwest of Athens, in a desperate attempt to delay the progress of the enemy.

The valiant death of all of the Spartan soldiers is still remembered today as one of the most heroic but also tragic acts of resistance that history has ever recorded. Upon receiving the news of the Spartans' slaughter, almost all Athenians fled the city, taking refuge on the nearby island of Salamis. When Xerxes and his troops reached Athens, they found the city semideserted. Exploiting that unexpected situation, the king did not hesitate to instruct his soldiers to inflict as much damage as possible on the city, including the burning of the main temple that stood on the hill of the Acropolis.

What Xerxes didn't know was that the Athenians, encouraged

by the brilliant general Themistocles, had used the wealth that the city had derived from the newly discovered deposits of silver from the nearby Mount Laurium to build a fleet of powerful and agile triremes (boats made of three decks of oars). When, in 480 B.C., the bulky Persian flotilla was lured into the treacherous configuration of the strait of Salamis in pursuit of the Athenians, they found themselves completely constrained in movement, hardly capable of reacting to the furious attack of the fast and highly maneuverable Greek triremes. It was reported that Xerxes, who was watching the battle from afar, sitting on a throne placed on a nearby promontory, witnessed from beginning to end the dramatic destruction of his fleet. After the Battle of Plataea, which was later won by the Spartans, the defeat of the giant Persian army was finally sealed in 479 B.C.

The victory, which assumed legendary proportions, remained a moment of great inspiration for centuries to come. Even the American Founding Fathers compared their fight against the powerful British Empire to the war between the small Greek republics and the enormous Persian Empire and, like the Greeks, claimed that the successful outcome of the war was proof that no threat could be a match to the strength instilled by patriotism and love of freedom.

What had assured that extraordinary victory? Strategic planning for sure, but also the tightly knit collaboration among Greek soldiers, as exemplified by the team-organized division called the hoplite phalanx: a shoulder-to-shoulder infantry formation advancing as a single war machine made impenetrable to the enemy's arrows by the defensive wall of metal shields behind which rose the sharp-cutting blades of long-thrusting spears. The crucial factor, of course, was the psychological strength that came from strong ideals and convictions, as Herodotus indicated when he wrote that "free men fight better than slaves." What the victory proved was that despite its vast size, the Persian army—formed of forced conscripts recruited from different tribal, ethnic, cultural, and linguistic groups, whose loyalty to their ruler was highly questionable—was ultimately no match for a militia composed of citizen-soldiers united by language and tradition, and similarly inspired by an uncompromising love of freedom and independence.

To stress the difference between the virtuous Greeks and their antagonists, Herodotus used many anecdotes. One of them recalled the incursion of a group of Athenian soldiers into the abandoned camp that a fleeing Persian division had left behind. Because it was customary for the Persian king and his entourage of noblemen to enjoy in war the same extravagant lifestyle they had at home, the military camp was full of precious ornaments and comfortable commodities such as soft carpets, silky pillows, and decorated beds. On dead soldiers, necklaces and bracelets were found and also armor and swords made of silver or gold. Even the mangers used to feed the cavalry horses were made of solid bronze. For the austere and unpretentious Greeks, such extravagant and ostentatious displays of wealth were repugnant signs of a decadent and immoral society.

A few years after the end of the war, the famous tragedian Aeschylus, who as a member of the infantry had participated in the Battle of Marathon, stressed, one more time, the contrast between the East and the West, when, in his drama *The Persians,* he attributed to Xerxes's excessive and boastful pride the defeat that he and his army suffered.

> Let no man,
> Scorning the fortune that he has, in greed for more
> Pour out his wealth in utter waste. Zeus, throned on high,
> Sternly chastises arrogant and boastful men.

The warning was also used by Aeschylus to implicitly urge his fellow Athenians to never forget "that man is mortal, and must learn to curb his pride. / For pride will blossom; soon its ripening kernel is / Infatuation; and its bitter harvest tears." As we will see, portraying the Persians as arrogant people driven by an excessive amount of pride and an effeminate taste for luxury had long-lasting cultural and also artistic consequences: for the Persians, who continued to be described as superficial and morally deficient individuals, and also for the Greeks, who from then on started to define themselves in contrast to a barbaric Other, who threatened to pollute with its effeminacy the virile integrity of the Hellenic ethos.

SPLENDOR AND CONTRADICTION
OF THE CLASSICAL AGE

The defeat of the Persian Empire, which was the most powerful entity of the time, strengthened the Greeks' impression that their civilization was vastly superior to any other people in the world. The wave of optimism struck with particular intensity the proud Athenians, whose brilliant military ability had proven so essential in defeating the enemy. Within that triumphal atmosphere, the humanistic attitude that had made possible the newly established democracy was forcefully reaffirmed.

With the establishment of democracy, every eighteen-year-old male citizen who had served two years in the military gained direct access to Athens's political life. No one was excluded, "whatever the obscurity of his condition," as Pericles declared in his famous Funeral Oration. To establish the new system, Cleisthenes, its founder, imposed a new division among the major tribes, increasing their number from four to ten. Each tribe contained subgroups called demes. The purpose of this major reshuffling was to break the blood bond that had characterized the old clan allegiances in order to boost unity and cooperation among all Athenians and redirect people's loyalty toward the greater common good. Aristotle addressed the point with these words: "If you want to set up a democracy, do as Cleisthenes did: establish new tribes, substitute religious ceremonies open to all, confuse as much as possible the relations of men with one another, and take care to abolish all previous associations."

Athens's democracy comprised three main bodies of government: the popular courts, where citizens discussed cases in front of a group of lottery-selected jurors; the Council of Five Hundred, called *Boule;* and the Assembly, *Ekklesia.* The *Boule,* whose members were selected in equal number from all ten Athenian tribes, was essentially an advisory council that chose the matters to be submitted to the scrutiny of the legislative Assembly, the *Ekklesia.* Every citizen had the right to

address the Assembly and publicly discuss the pros and cons of laws and policies concerning foreign affairs, taxation, civic regulations, the election of officials (including the *strategoi,* or military generals), and so on. Those who were present when the Assembly met were considered representatives of the entire body of citizens. If a war proposed by the *Boule* gained by majority vote the approval of the *Ekklesia,* each citizen was compelled to immediately put aside his previous business to join the army, leaving to slaves the management of his private affairs.

What sustained the democratic system was a fundamental trust in human reason: the belief that by receiving an equal footing in the life of the community, each citizen would rise to meet, with a selfless and patriotic devotion, the civic and moral responsibility that the task of governing demanded. Those accused of placing self-serving pursuits before the larger interest of the city were subject to ostracism. The term "ostracism" came from *ostrakon:* the broken piece of pottery on which the citizens placed the name of the person whom they wished to exile from the city. To what extent the practice remained fair is uncertain. What we know for sure is that ostracism was frequently deployed, even against Athens's most prestigious citizens. Miltiades, for example, who had famously contributed to the Athenian victory on the plain of Marathon, was accused of overstepping his role when, immediately after that historic battle, he decided to impose a monetary fine on the marble-producing island of Paros, in the Cyclades, for having surrendered too quickly to the Persians. Miltiades's decision to act alone, without the approval of the Athenian Assembly, prompted the anger and distrust of his fellow citizens, who decided to send him into exile. Even Themistocles, who persuaded the Athenians to build the two hundred triremes that assured the naval victory in Salamis, became the target of ostracism. The charge was corruption and an alleged implication in a treasonous plot. Given the rampant paranoia toward any possible display of hubris, the imperial attitude that Athens adopted a few years after the end of the Persian war appears quite surprising. How and why did it happen? To answer the question, we

have to focus on the political approach that Athens adopted, espe-
cially under the influence of Pericles, the brilliant general, or *strategos,*
whose charismatic personality gained him a de facto leadership role
within the city from 443 to 429 B.C.

Pericles, who belonged to an aristocratic Athenian family, was a
man of culture who could list many artists and philosophers among
his closest friends. People admired him as the best example of what a
dedicated and also cultivated citizen was supposed to be. It was in his
mold that the classical ideal of a well-rounded and multifaceted per-
sonality gained much of its glamour and appeal. Pericles's fame was
also linked to the stirring rhetoric with which he prodded the patri-
otic pride of his fellow citizens. In regard to Athens, Pericles's main
preoccupation was to give Athens, which after the war still looked
like a shabby town crossed by narrow and dusty streets, the appear-
ance it deserved as the most brilliant and successful of all Greek cities.

To make his dream possible, Pericles turned to a common fund
that, besides ships and armaments, included monetary contribution
that all city-states had gathered as a preventive measure in case of
future foreign attacks. After a brief period in Delos, where it origi-
nated, the Delian League (as the alliance was called) was transferred
to Athens. The hope that all the city-states expressed with that choice
was that the wise leadership that Athens had proven to possess dur-
ing the war would continue in its aftermath. Unfortunately, Pericles's
claim that Athens was to be recognized as the most deserving benefi-
ciary of the league soon defeated that expectation. Undeterred by crit-
icism, Pericles went on to divert a great amount of money, belonging
to the league, toward a general remodeling of Athens, which included
the ambitious reconstruction of the Acropolis, which had been greatly
damaged in the Persian attack of 480 B.C. When the construction
of the Parthenon was finally completed, in 432 B.C., the structure,
with its fifty-eight columns and more than five hundred sculptured
figures, became overnight the most impressive and mature example
of Greek classical art and architecture.

The Parthenon, which was designed by the architects Ictinus and

Callicrates and was built between 447 and 433 B.C., consists of a rectangular structure surrounded by columns topped by Doric capitals. Instead of the simple limestone that was previously used for the construction of temples, an elegant marble extracted from the nearby Mount Pentelicus was chosen, due to its bright white color marked by thin veins of iron grains—a combination that, once weathered, would suffuse that majestic structure with a golden glow.

Because, unlike those of Judaism and Christianity, the rituals and sacrifices of the pagan religion always took place outside the temple, the Parthenon only had two small rooms in its inside space: the *naos,* which housed the statue of the patron-goddess Athena, and the treasury, which was used to store many of the precious objects that the soldiers had retrieved during the war, including Xerxes's famous traveling throne. The Parthenon, which was conceived as a relatively small temple, at least in relation to the exorbitant scale of Egyptian architecture, was built to evoke the same principles of measure, balance, harmony, proportion, and symmetry that Pythagoras had posited as the blueprint of the entire universe. To project such paramount qualities, intricate solutions were used in order to counteract some of the optical distortions that the overall structure of the temple con-

The Parthenon, classical Greek architecture at its pinnacle

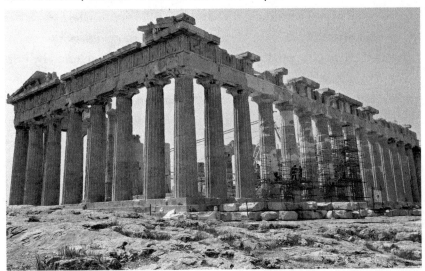

veyed. Among the many examples: the stepped platform (called sty-
lobate) upon which the massive structure rests, which was made to
slightly buckle in the center to avoid an optical sagging effect; and
the tapering of the fluted columns, which bulge in the middle while
slightly tilting inward as they rise to preserve the grace of their elon-
gated form extending under the imposing mass of the bulky roof.

As we have seen, according to Pythagoras the harmonic patterns
that music expressed had a cathartic influence on the human spirit
because they reawakened the yearning for the superior Beauty that
had organized the cosmos like a symphony. Extending to architecture
the same qualities attributed to music (the German writer Goethe
would centuries later declare that "architecture is frozen music") it is
easy to deduce the lesson that the sophisticated architects who con-
ceived the Parthenon were trying to convey: in admiring the propor-
tions that had given a beautiful shape to the formless consistency of
matter, the viewer would have been seized with a sense of awe, lifting
his mind toward the majestic truth of the all-pervading Reason. The
symbolic message was to be extended to the ethos of the city. Just as
the Parthenon derived its splendor from the measure and balance of
each of its parts (the term *symmetria* indicated the correct proportion
that each part maintained in relation to the whole), the polis would
have continued to thrive only if its organization remained consonant
with the choral structure of the cosmos: in other words, only if its
citizens continued to preserve the same spirit of collaboration and
concordance that the divine Reason had imposed on all aspects and
functions of nature.

To supervise the sculptural program that was to decorate the
magnificent edifice, Pericles hired his friend Phidias (490–430 B.C.),
who had achieved prominence for an awesome forty-two-foot-high
statue of Zeus, made of ivory and gold, for the main temple in Olym-
pia. Commissioned by Pericles, Phidias was also asked to produce two
statues of Athena, the patron-goddess who, as a deification of reason,
symbolically represented the qualities that most distinguished the
city: wisdom, law, and civilization. Of the two images of Athena (one
for the outside, one for the inside of the temple), the most imposing

was the thirty-three-foot-high statue placed in the *naos* of the Parthenon. The abundance of gold that covered the goddess's tunic, shield, helmet, and spear stood in contrast with the milky-white brightness of the ivory, which was chosen for her naked arms and for her face, which was illuminated by the sparkling beauty of her eyes made of colorful stones. (Unfortunately the two statues of Athena produced by Phidias have not survived the destruction of time.) The image provided below is a reconstruction of the statue of Athena as it appeared in the inner chamber of the Parthenon.

In Homer, the gods were portrayed as boastful and competitive beings absorbed in selfish and petty concerns. Nothing similar was to be detected in the stately image of Athena, the goddess of reason and civilization who embodied the incomparable excellence and rectitude of all Athenian people.

In the Parthenon, the point was eloquently expressed in the metopes: the sculptural high reliefs (in antiquity decorated with bright and vivid colors) that appeared on the exterior part of the temple above the columns that symbolized the victory of the Greeks over the Persians. The myths chosen to commemorate the event were the *Gigantomachy,* a legendary battle between the Olympian gods and the giants; the *Amazonomachy,* a clash between the women warriors (called Amazons) and the Athenians; and the *Centauromachy,* a war entertained by the Lapiths against the half-man and half-horse centaurs. The irreverent link that, in a metaphorical way, connected the Persians to prim-

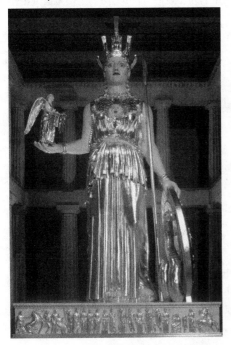

The goddess Athena as she would have been represented in the inner Parthenon

itive, monstrous, and rebellious creatures like the giants, the feminine Amazons, and the centaurs, clearly hid a propaganda purpose: if the Persian Empire had represented a disruptive force, the images suggested, it was because of the decadent qualities that, in sharp contrast with the Athenians, defined all the "barbarous" people of the East.*

To stress the vanity that characterized the Persians, the Greek artists (sculptors and painters alike) always made sure to depict in great detail the colorful trousers, whimsical hats, and pointed slippers worn by the Eastern soldiers—a laughable choice, especially when compared with the manly nudity of the noble and austere Greek warriors.

The fact that a mythological approach was chosen to describe the clash with the Persians and that not even a single realistic portrait of a Greek general or soldier appeared on the Parthenon frieze is indicative, once again, of the ethical rigor that characterized the Greek mentality. Using a recognizable image to elevate the worth of a specific individual and celebrate his singularity over others would have been considered a repugnant threat to the moral integrity that had allowed the egalitarian spirit of the polis.

A similar message was ingrained on the inner frieze of the Parthenon (now in the British Museum in London), where a majestic procession of equally young and beautiful horsemen is depicted. The image, with its technically sophisticated use of foreshortening, was used to evoke the festival, held every four years, during which the entire citizenry of Athens marched to the Parthenon to offer to the patron-goddess a new peplos (a cloak woven anew every four years by a select group of Athenian maidens) in grateful recognition of her powerful protection.

But, one may ask, why are so many horsemen paraded if, in reality, the Greek cavalry had played no role in assuring the victory against

* Eva Cantarella, in her book *Pandora's Daughters,* writes that the representation of the Amazons was not a praise of matriarchal power but a way to exorcise what was considered the abominable prospect of an army or a state led by women.

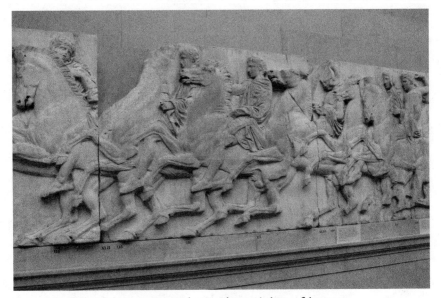

A parade of Greek horsemen on the Parthenon's inner frieze

the Persians? While reminding us of the distinguished status that a man on a horse had always indicated, Andrew Stewart in *Classical Greece and the Birth of Western Art* argues that the choice was intended to suggest, "somehow optimistically," that all Athenians had now gained the same noble dignity once associated with the old concept of *aristoi*. By celebrating all Athenians as noble (and horse-mounted) examples of excellence, the Parthenon's engravings fixed in stone what Pericles had promised to his fellow citizens: "So far as it is within my power, you will live forever and be immortal."

A similar intent spurred the creation of the many freestanding statues that started to fill the urban space: the purpose of art was the cultivation of a beauty that, much more than simply aesthetic, was meant to educate and inspire those to whom that visual message was addressed. The fifth-century artist Polycleitus in his famous *Canon* elaborated the point when he said that by employing Pythagoras's mathematical principles, the artist would be able to express the timeless quality of beauty. Kenneth Clark, in *The Nude: A Study in Ideal Form,* describes as follows Polycleitus's work: "His general aim was clarity, balance, and completeness; his sole medium of communica-

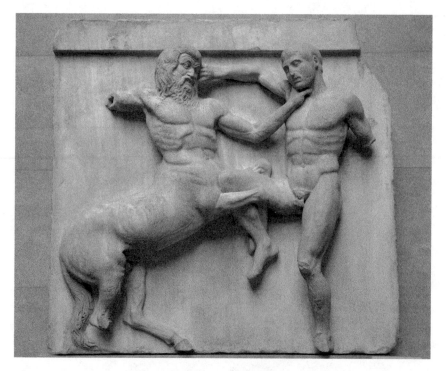

The *Centauromachy,* a subtle dig at Persian decadence

Note the extravagant garb of this Persian horseman.

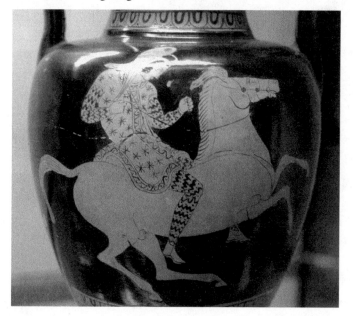

tion the naked body of an athlete, standing poised between movement and repose."

To represent the canonical beauty of man, a statue was to reflect the universal laws of proportion and symmetry: how each part of the body connected to the other and how each part contributed to the perfection of the whole. "Perfection," Polycleitus stated, "depends on numerical relationships and even the smallest variation holds an extremely important role." The fundamental idea of the *Canon* was that man (whose proportions were to be used as the basis of architecture) contained, albeit in a reduced scale, the same proportion belonging to the divinely infused order of nature. Polycleitus, who visually expressed that ideal in the famous bronze statue called the *Doryphorus,* believed that the parameters provided in his *Canon* were not relative but universal rules, in the sense that they were not an invention but a discovery. The logical outcome of that assumption was that the aesthetic function of art had, ultimately, an inspirational purpose, which consisted in producing an awe-inspired feeling of consonance and correspondence between man's reality (the microcosm) and the rest of the universe (the

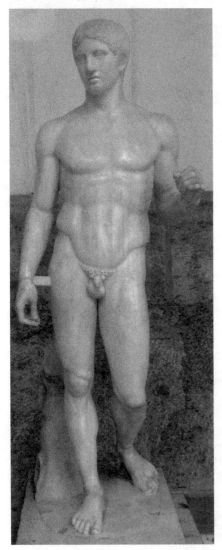

A Roman copy of Polycleitus's *Doryphorus* (Spear Bearer, ca. 450–440 B.C.)

macrocosm). The aim of art was not to replicate reality but to evoke the divine laws that, like guiding stars, gave a higher direction and meaning to the journey of man's existence.

Today beauty tends to be defined in personal terms: beauty, we say, is what one likes. To understand how incongruent with the ancient mentality that statement is, just consider the link between the words *kaleo* ("to call" in Greek) and *kallos* ("beauty"): beauty was believed to possess a magnetic quality that irresistibly called the mind back to the universal wisdom from which the human soul had originated.

Thucydides (460–395 B.C.), who has been called the "father of scientific history" because his *History of the Peloponnesian War* maintained standards of accuracy that were much higher than those of Herodotus, reported that Pericles, in the famous eulogy delivered in honor of Athens's fallen soldiers, boasted that the excellence that characterized his fellow citizens had justly earned their city the title "school of Hellas." Pericles also added that in Athens "we [citizens] cultivate refinement without extravagance and knowledge without effeminacy; wealth we employ more for use than for show." Pericles's uplifting portrayal of the Athenians hardly matched the views held by other city-states, as Thucydides, who was very critical of Athens's democratic system, points out when he writes that, according to the other members of the Delian League, Athens's "precious stones, statues, and temples costing a thousand talents" were like the jewels and cosmetics that embellished a "harlot." The bitterness that exudes from these words shows that, rather than admiration, the sentiments that the other competing poleis harbored against Athens were suspicion, scorn, and resentment.

The skepticism was not unfounded. While the artists were decorating the Parthenon with images meant to praise the upright virtues of the citizens, the austere and disciplined way of life that the city had maintained in its early years was slowly giving way to attitudes that the early generations would have considered selfish and unprincipled. The scholar Robin Lane Fox, in his book *The Classical World,* describes with these words the new taste for luxury that began to spread among the Athenians shortly after the end of the war: "Despite the hostile comments on Persian 'softness' and excessive splendour, well-off Athe-

nians responded to the styles of dress and metalwork, fine textiles and precious armour which they saw in the prizes taken from the Persian invaders. Soft, comfortable shoes even became known at Athens as 'Persian' slippers. . . . Other new sources of luxury were imports by sea. . . . Carpets and cushions came in from Carthage, fish from the Hellespont and excellent figs from Rhodes; all sorts of delicacies arrived for sale, including quantities of slaves for use down the Attic silver-mines, in the citizens' households and even on the smaller farms."

Athens's patronizing attitude and the severity with which it punished those who failed to fulfill their financial commitment to the Delian League only worsened the tension that was brewing among many city-states. The contention was that Athens's hegemonic claim represented a betrayal of the moral integrity that had once made possible the city's admirable ascent.

As a rebuttal, Pericles insisted that the money taken from the league was an appropriate token of recognition toward a city that had saved Greece from foreign encroachment. As long as Athens continued to provide that vital shield of protection, no other city-state had the right to judge its choices and actions.

In spite of Pericles's words, the imperious attitude that the city adopted toward its allies and the belligerent way with which it threatened the cities that tried to withdraw from the league seemed to prove, to many, that the city had succumbed to the most loathsome of all vices—hubris.

Anger and discontent spread like dismal winds before a storm. The tense atmosphere was worsened by the many internal fights that took place in Athens. The pettiness that often drove those contrasts seems to reveal that the Athenians, rather than being the indomitably rational, calm, and self-possessed individuals that their statues suggested, were a litigious, competitive, and impulsive people easily moved by passion and ignorance. Pericles in his famous eulogy had said that the Athenians' respect of each other's freedom was so high that no one ever felt the need to keep track of his neighbors' private affairs. The many victims that suspicion and jealousy produced

seemed to contrast that assessment. Among them were the scientist and philosopher Anaxagoras, a friend of Pericles's, who was ostracized for affirming that the sun was not a god (Helios) but "an incandescent stone larger than the Peloponnese," and the sculptor Phidias, who was ostracized shortly after finishing his work for the Parthenon. The reason adduced was that the artist had stolen some of the gold used for the statue of Athena. In addition, Phidias's detractors said that the artist had violated all norms of decency when he dared to place his own effigy on the shield of Athena. Were the accusations against Anaxagoras and Phidias real or only excuses manufactured by Pericles's enemies? The lack of any clear answer doesn't alter the fact that, notwithstanding the message so beautifully conveyed in the Parthenon, harmony, in Athens, was more a utopian ideal than an actual reality. The first clash between Sparta and Athens erupted in 450 B.C. For the following twenty years, a frail peace was maintained, but it didn't last. Eventually, Thucydides wrote, "the growth of Athens's power, and the alarm that this inspired in Sparta, made war inevitable." Sparta's decision to go to war was prompted by Athens's decision to trounce the independence of other members of the league with the purpose of turning the union into an actual empire. Led by Sparta, the Peloponnesian War exploded in 431 to end in 404 with the humiliating defeat of Athens. Along with the political factors, what contributed to the progressive weakening of Athens was a devastating plague (that took the life of Pericles, among others, in the second year of the Peloponnesian War) that many saw as divine retribution for the amoral attitude that the city had adopted.

THE ACHIEVEMENTS OF THEATER, RHETORIC, AND PHILOSOPHY

Despite such a tumultuous atmosphere, the last years of Athens's independence as a city-state were, at a cultural level, extremely dynamic

and productive. The reason may have had to do with the increased exposure to other populations and cultures that, even when rejected as barbarians, led the Athenians to confront with a greater amount of critical thinking their own traditions, habits, and ideas.

The development of drama and theater (another great Athenian invention) held a special place among the city's great achievements. The origin of theater is vague. The only thing we know for sure is that, since its earliest years, Athens held an annual festival to celebrate Dionysus. The event consisted of music, dance, and choral recitals, called dithyrambs, in honor of the god. The term "tragedy," which derives from the Greek *tragos* ("ram") and *ode* ("song"), indicates that the festivals were considered religious celebrations that included the sacrifice of animals. Competitions between authors who presented their tragedies at religious festivals remained a popular practice in the city until the fourth century.

According to tradition, Thespis had been the first actor to place himself outside the chorus and act and speak as an independent character. Later, the tragedian Aeschylus introduced a second actor and Sophocles a third one. The change made possible the face-to-face use of dialogues, which proved essential for the development of drama. The vast, open-air auditoriums where the performances took place were engineering wonders (also from an acoustic standpoint) carved in a semicircular fashion along naturally inclined hillsides. Apparently, a Greek theater could accommodate as many as fifteen thousand spectators. Maybe to compensate for the size of the theater that, as Michael Kellogg writes, "precluded any reliance on facial expression or subtle gestures," the actors always wore masks that bore exaggerated facial features and expressions that made emotional characteristics easily recognizable to the spectators. From the fifth century on, painted backdrops started to be part of the stage and also devices, such as the deus ex machina that, when needed, lifted an actor into the air to promptly whisk him away out of the scene.

Except for some plays that focused on contemporary events (like Aeschylus's drama *The Persians*), most theatrical productions were

based on ancient myths to which authors freely added personal varia-
tions. The nonchalant attitude with which the authors treated the old
myths proves that those ancient tales were considered lively sources of
inspiration rather than dogmatic repositories of untouchable truths.

The subjects explored by the three major authors of classical
Greece—Aeschylus, Sophocles, and Euripides—had to do with a
variety of existential questions: Who was man, and what was the
meaning of his life? What purpose did mythology serve, and how
did that heritage measure up in light of the progress that society had
achieved? How could justice be defined? How could man affirm his
rational dignity amid the blind unpredictability of destiny?

Aeschylus, who, as we have seen, in his *Prometheus Bound* provided
a symbolic description of the titanic drive that pushed man toward
progress, is also the author of the trilogy known as the *Oresteia*. The
cycle started with the death of Agamemnon (brother of Menelaus,
Helen's legitimate husband), who, upon his return from the Trojan
War, was murdered by his wife, Clytemnestra, and her lover Aegis-
thus. Clytemnestra was the mother of Iphigenia, whom Agamemnon
had sacrificed to appease the goddess Artemis before the Greek fleet
departed for Troy. She was also the mother of Electra and Orestes. To
avenge the death of his father, Orestes killed his mother and her lover.
Orestes was then pursued by the Furies, who wanted to punish him
for his murderous act. The Furies were finally stopped by the goddess
Athena, who proclaimed that Orestes had the right to receive a just
and lawful trial. In the *Oresteia,* the gloomy and violent belief that
past sins were to be avenged by an equal amount of blood and tears
paid by many generations was finally reversed by Athena's decision
to replace the obsolete world of myth with a new order based on the
rational rules of the polis.

Very different is the tone we find in Sophocles's *Oedipus Rex.* Oedi-
pus is a happy man until he discovers that he unknowingly com-
mitted parricide and incest by killing his father and marrying his
mother. Oppressed by shame and guilt, Oedipus blinds himself. That
Oedipus has to pay such a terrible price for actions for which he bears

no direct responsibility doesn't seem to be a matter of concern within the old mythological context, where the brutal ways of destiny are to be simply accepted as facts that man has no power to change.

Does *Oedipus Rex* prove that Sophocles was more old-fashioned than Aeschylus? The answer is not as obvious as one might think. The problem is that none of the classical authors can be precisely labeled because of the complex and oftentimes contradictory nature of their work. For example, even if, in *Oedipus Rex,* Sophocles may appear in line with the old tradition, the same thing could not be said about his drama *Antigone,* in which the author chooses a female character as the protagonist of the story. After the death of Oedipus, Sophocles narrates, the leadership of Thebes is assumed by his sons, Eteocles and Polynices. However, because Eteocles wants to prevail over Polynices, civil war erupts, ultimately causing the deaths of the two brothers. The decision of their uncle Creon to pay funerary tribute to Eteocles while denying a similar treatment to Polynices, whose body is left rotting outside the city, is challenged by his sister Antigone, who decides to honor her dead brother with an appropriate burial undeterred by the harsh punishment that she will inevitably suffer. Sophocles's use of a female character to weigh the value of public authority versus the freedom of personal morality reveals the author's willingness to push his psychological and existential quest toward territories that, until that moment, had largely been left uncharted and unexplored.

While Aeschylus and Sophocles stressed the random course of destiny to highlight the courage of the human creature and his or her noble capacity to turn suffering into empathy and moral growth, Euripides lingered on the brutal nature of the ancient gods and the unsettling contradictions that inhabit the human spirit. *The Bacchae* tells the story of Pentheus, king of Thebes, who, fearful that the presence of his cousin Dionysus (Dionysus was the son of Zeus and Semele, whose sister was Pentheus's mother) could disrupt the civilized order of his polis, tries to prevent Dionysus from entering the city. But Pentheus's purpose has no chance of succeeding because Dionysus is a powerful god, as the audience soon realizes when Pentheus, having been lured in the solitary wilderness of a mountaintop to witness one

of Dionysus's gatherings, gets dismembered by a group of frenzied maenads. Pentheus, who tried to keep away from the city the wild effects of irrationality, of which Dionysus was the embodiment, is killed by the very force he has so stubbornly opposed.

What prompted Euripides to write a drama like *The Bacchae?* Did his work express the doubt that the ideal city of man could build walls of rationality high enough to hold out the dark and irrational forces that, despite all efforts, never seemed to lose their grip on human nature? We cannot be sure. All we know is that during the time in which Euripides lived, the Greek mind reached an unprecedented maturity. Even though that didn't bring more answers, it certainly produced a more acute and more challenging exploration of the mysterious conflicts inherent in life and in the human personality.

In addition to drama, comedy also found expression in Athens. The daring mockery of the comedies of Aristophanes (447–386 B.C.) shows that in Greece, criticism, often peppered with considerable sarcasm, had become very popular, especially when it targeted politicians and philosophers. One of Aristophanes's most famous plays, *The Clouds,* offered a crude caricature of Socrates. To understand why Aristophanes had a negative view of Socrates, we have to first briefly discuss the Sophists and the basic views of the famous Athenian philosopher.

The Sophists were a group of itinerant intellectuals who, in exchange for money, taught different subjects, including rhetoric, a discipline advertised as extremely useful for those who sought an active role within the political life of the polis. The thesis of the Sophists was that, if crafted correctly, any argument had the potential to be turned in one's favor. To prove their point, the Sophists indulged in virtuoso displays of rhetoric supporting one side of an argument; when the audience was convinced, they argued the other side until, once again, general consensus was reached.

The Sophists' theory was that the universal truths that poets and philosophers had advocated were nothing but illusions. To defend that position the sophist Protagoras wrote: "Concerning the gods I am unable to discover whether they exist or not, or what they are like

in form; for there are many hindrances to knowledge, the obscurity of subject and the brevity of human life."

Pushing to the extreme this relativistic approach, the Sophists went as far as asserting that because absolute truths could not be assessed, the only thing that man was left to do was to elect himself the sole judge of his existence and selfishly pursue what best served his interest, as Protagoras's famous motto summarized: "Man is the measure of all things." The danger of dismissing universal truths to favor singular opinions and preferences left room for a risky sense of permissiveness that justified as fair game anything that assured victory, even when, to reach that purpose, a persuasive but truth-trashing rhetoric full of lies and exaggerations was employed. For a society in which collaboration among citizens had been considered the highest virtue, such cynical and selfish attitudes must have appeared as a very disruptive and dangerous proposition.

Socrates (470/469–399 B.C.), who was the son of a mason and a midwife, sternly denounced the treacherous practice of the Sophists, who, he claimed, had improperly turned education into a remunerative business, unconcerned about the negative ethical consequences of their teachings. For Socrates, who like Pythagoras had been greatly influenced by the Orphic Mysteries, the Sophists' relativism represented an extremely dangerous prospect. How, Socrates thought, could a just and ethical society be built if absolute truths such as Justice, Order, Honesty, and Morality were presented as empty words devoid of any substance?

To refute the Sophists' point of view, Socrates declared that knowledge was not a commodity transferable through monetary exchanges but a superior gift to be pursued through a rigorous exploration of the self. For that to happen, moral integrity was axiomatic. Knowing virtue, Socrates affirmed, was insufficient without the actual commitment to a life of virtue. That, he added, was also true in connection with the art of rhetoric that the immoral Sophists had badly mangled and abused, especially when they used their verbal acrobatics to desecrate with lies and fallacies the legitimacy of logic and reason.

Contrary to the Sophists, Socrates never accepted money for the

one-on-one discussions he so often entertained with his fellow citizens while strolling in the streets of Athens and in the agora. Rhetoric, for him, was not a pastime or a business but a serious commitment to a Logos that, next to clarity, demanded honest thinking and honest talking. For that to succeed, a virtuous disposition was imperative, as the word "philosopher" (*philo*, "lover," of *sophia*, "wisdom") implied. The value of philosophy consisted not simply of more knowledge but of better knowledge, meaning the qualitative improvement that empowered the mind to rise toward the higher planes of divine wisdom.

For that reason, the only thing that mattered to Socrates was to spend his days prodding people's general assumptions and beliefs with lists of questions designed to guide, with ever-increasing accuracy, the answers he received. Socrates, whose primary interests were ethical and moral, affirmed that because *he knew that he knew nothing,* his passion for dialogue implied not the dogmatic finality of answers but only the lively dynamic of questions aimed at prompting higher and higher forms of thinking and understanding, "for a life un-scrutinized is unworthy of a man." The goal of Socrates's use of dialogue was to gradually lead forth, just like a baby out of the womb (Socrates often compared himself to a midwife of the soul), the wisdom that man already possessed within. The redemptive quality that Socrates attributed to philosophy recalled Pythagoras's theory: because the soul had once been united with God, true knowledge was equivalent to a form of remembrance.

To foster a better understanding of virtue, Socrates used concrete examples: like a carpenter who crafts a table by following an ideal model, man, before acting, was to strive to get as close as possible to the prototypical model of Good and Beauty that the superior Ideas represented. Despite such emphasis on intellectual awareness, Socrates made sure to specify that as long as the soul was imprisoned within the body, the knowledge that philosophy provided remained approximate and incomplete. The point did not diminish the importance of virtue: even if the absolute Truth, in its ultimate magnitude, was bound to remain a mystery, its pursuit was enough to endow man with a power that was simultaneously moral and existential.

As we know, Socrates was put to death for his teachings in 399 B.C. How did a city that chose to reserve its central space, the agora, for the free exchange of words and ideas come to condemn so harshly a man like Socrates? The judges who delivered the sentence accused Socrates of "impiety." The claim was that Socrates's subversive views were endangering the integrity of the Athenian youth. How could the ironic and self-effacing Socrates raise such alarm, if the only thing that he claimed to know was that he knew nothing?

As we have seen, the political tension, which was heightened by the humiliation that Athens suffered with its defeat in the Peloponnesian War in 404 (only five years before the philosopher's death), certainly played a part in the decision of the judges, who affirmed that Socrates was subverting the traditions upon which Athenian society was founded. The truth is that Socrates never failed to pay the deepest respect to the polis. When he was sentenced, he was given the choice between exile and death. Socrates did not hesitate to choose the second option because, he affirmed, living away from the polis would have stripped him of his identity and, as such, would have been worse than death itself.

As I mention above, the comedic writer Aristophanes made Socrates the target of his satirical humor. The title of his play *The Clouds* indicates that, for Aristophanes, Socrates's abstract disquisitions appeared dangerously close to the Sophists' argumentations that clouded the intellect with fluffy and empty words. The interesting thing is that Aristophanes was a moralist who, just like Socrates, attributed a tremendous value to the civic commitment that every single individual was supposed to have toward the greater whole of society. Despite that common belief, the views that the two men held about the essence of the universe were profoundly divergent: while Socrates believed in a divine-regulated cosmos, Aristophanes, who was an admirer and follower of Democritus, saw the world in terms that were purely secular and material. For Aristophanes, the danger of Socrates's position consisted in linking rationality to the abstractions of metaphysical pronouncements that could not be proven instead of using reason for logical and pragmatic assessments and conclusions.

FROM PLATO TO ARISTOTLE:
THE EMPOWERING WISDOM OF PHILOSOPHY

The man who, more than any other, elected Socrates as his guide and teacher was Plato. Because Socrates left no writings, Plato used him as a fictional character to express the essence of his philosophy through the use of dialogues. Born into an aristocratic family in 427 B.C., the fifth year of the Peloponnesian War, Plato was only twenty-eight when he witnessed the devastating death of his beloved teacher Socrates. Probably fearing further retaliation against the master's disciples, Plato left Athens for more than ten years. Among the places he visited during that long, self-inflicted exile were Egypt, Lydia, and Magna Graecia in southern Italy. Upon his return to Athens, Plato, in 380, founded his famous Academy among a field of olive trees on the outskirts of the city. At the entrance of the Academy, a sign read, "Let no one ignorant in geometry enter this place."

Plato based his philosophy on the assumption that the true essence of reality was contained in superior and eternal archetypes he called Ideas. Rather than the subjective and psychological qualities we attribute to the word today, Plato's Ideas were intangible, nonmaterial prototypes of earthly things existing in a numinous state of perfection suspended far above the imperfect dimension of the material world.

Because they represented a higher reality, the Ideas Plato affirmed in agreement with Parmenides were only reachable by the mind with no support from the sensory experience. Like Pythagoras, whose teachings he had been directly exposed to during his sojourn in Magna Graecia, Plato also claimed that the soul, which represented the highest expression of human intelligence, had once inhabited the crystalline kingdom of the divine Ideas. But the memory of that original state of grace was lost as soon as the soul came to occupy the confining prison of the body. In the *Republic*, Plato used the myth of the cavern to describe the limits of man's earthly condition. Imagine, he wrote, a group of humans kept prisoners in a dark cave who are forced to stare

at the stone wall in front of them due to the ties that constrict their legs and necks. Behind them, a fire is blazing. Between that fire and the prisoners someone passes carrying different images, like statues and figures of animals made of wood, stone, and various materials.

What do the prisoners see? The answer is that the only things that the prisoners are able to see are the shadows of the objects projected onto the cave wall in front of them. The meaning of the metaphor is as follows: like those shackled prisoners, man's sensory perception is an imperfect tool existing within a world that is only a vague reflection of the perfect and eternal Ideas.

What had caused humans to suffer such a demeaning condition? In typical Greek fashion, Plato never explored the point: even if he recognized the fallacies of human nature, he never associated the concept of sin with those limitations, nor the idea that an offended divinity had punished humanity for its transgression.

All that Plato cared to ask was this: How could the soul rise again toward the light of the divine wisdom? For Plato, the only possible way forward was to leave behind the dark ignorance of the sensory experience to rely solely on an intellect fully decontaminated of all material influence. To gain true knowledge, Plato continued, man had to undergo a drastic conversion of vision: from the external eyes of the flesh (that, for Plato, were the illusory appearance of things, as reflected on the metaphorical walls of the cavern) to the internal eyes of the spirit that, beyond the deceiving surface of earthly reality, allowed the perception of the deep-seated glow that was at the origin of all things.

The symbolic value that for so long was attributed to beauty was specifically selected by Plato to further explain how the soul reawakened to a superior form of vision and understanding. When a person, attracted by beauty, fell in love, Plato explained, two opposite dynamics were put in motion: if the soul followed sensual appetites, it was dragged downward toward the dark finitude of the physical world; but if the soul followed the guide of reason, it would rise toward the luminous splendor of its native, celestial origin.

In the *Symposium,* whose title refers to the time of conversation

that traditionally followed a Greek banquet, Socrates and his friends are portrayed discussing the powerful effects that love can have on the lover, particularly in the homosexual relationships that the Greeks openly cultivated (of particular importance was the physical and mental relationship that took place between a young male and his older mentor). According to Socrates and his friends, the love inspired by women belonged to the vulgar dimension of the lower, physical passions; conversely, the homosexual Eros, which was attributed a much higher degree of value, had all the attributes necessary to ignite the yearning toward a greater and nobler form of understanding. Intellectual illumination occurred when the lover, looking into the eyes of the beloved, recognized, as in a mirror, the reflection of the superior Beauty and Truth that had once belonged to his own superior, original self. Just like beauty, Eros, for Plato, was a powerful call that irresistibly reawakened in man the nostalgic desire to be reunited with his heavenly origin.

The fact that Socrates was often described as a strong and resilient man who nonetheless had none of the handsome characteristics associated with the ideal of the warrior-soldier—he was said to have puffy eyes, thick lips, and a stub nose that made him resemble a satyr more than an Adonis—was conveniently used by Plato to demonstrate that, rather than the outer beauty of the body, it was the inner beauty of the spirit that mattered most for the fulfillment of knowledge and virtue. Socrates's beauty, which was an expression of his wisdom, also corresponded to his philosophical talent to stimulate in others the same love for Good and Beauty that radiated from the transcendental perfection of the superior Ideas.

Because he affirmed that true knowledge was, ultimately, a logically unverifiable and incommunicable experience, Plato ended up surrounding his argument with mystical tones that, far from the pure rationalism he advocated, seemed to push philosophy closer and closer toward the realm of revelation and mysticism. To follow that upward ascent and turn his words into lively vessels of spiritual growth, Plato chose to present his philosophical ideas through dialogues. The choice was dictated by the belief that the forward mental motion produced

by dialogue was the only way to enliven the verbal message, above the tomb-like rigidity of the dead written word—the *sema,* or tomb of the word, which we've discussed before. (We will return to the problem posed by the written language in a later part of the book.)

When it came to the concept of the divine, it is interesting to note how little interest Plato, in agreement with the Greek tradition, placed on the idea of a genesis: for him, God was not a Creator, like the God of Judaism and Christianity, but a Demiurge, meaning a Master Craftsman who, with the mathematical precision of a Geometer, had tamed the chaotic, primordial magma to make possible the beautiful order of the cosmos. Because the work of the Demiurge was so perfect, Plato concluded that Beauty, Justice, and Good were the three principal attributes of the divine. Those qualities, which assured that nature always produced positive outcomes, were also expected to guide man's efforts to create a beautiful, just, and good society.

For Plato, education, or *paideia,* was essential in that endeavor: a good state was a state that prepared men to be good and productive members of the community. Such a community, for Plato, involved not a democratic and egalitarian system but rather a hierarchical structure where all citizens contributed to the polis but with duties that varied according to talent, ability, and preparation. In the *Republic* and in the *Laws,* Plato wrote that the summit of that chain of responsibility was to be occupied by the philosophers, who, being the only ones capable of grasping the highest form of wisdom, were also the only people who could rule society in accordance with the Justice and Order established by the divine Ideas.

Plato's rejection of Athens's egalitarian system had been shaped by the events of history: the city that had unjustly condemned Socrates to death was, for the philosopher, also the city that, in instituting democracy, had unwisely bestowed political power upon a litigious, emotional, and ignorant mob of vulgar and uncultivated people completely unfit to assume control of the polis. For Plato, politics was a demanding activity that only the philosophers, as the most intellectually mature and morally sophisticated members of society, had the talent and capacity to undertake. To ensure that the ruler-philosophers

maintained a selfless and civic-spirited disposition, Plato suggested that the state provide them with free housing and free sustenance so that no private interest, either material or emotional, could compromise the moral integrity of those superior people. (Also, having a family was considered an inappropriate form of distraction for a true philosopher.) Plato, probably influenced by the aristocratic mentality to which he belonged by birth, also affirmed that because leisure and free time were essential for the cultivation of the mind, common people could never become ruler-philosophers, because they needed to work to earn their living.

Those whom Plato distrusted most were poets and artists, whose misguided activities were to be forbidden within the perimeter of the polis. The argument that Plato used to justify such an extreme attitude was twofold: (1) art had to be rejected because, as a fictional mimesis, meaning "copy," of reality, it was a copy of a copy, twice removed from the Truth of the divine Ideas; and (2) art was to be considered dangerous because, in appealing to emotion, it interfered with the linear path of reason, diverting toward earthly illusions and irrational passions the metaphysical journey that the mind was meant to undertake.

Plato talked in glowing terms about the peace and stability that his ideal society guaranteed, but the lack of freedom that the strict division of roles demanded (with workers at the bottom of society, warriors in the middle, and philosophers on top) made that immobile, hierarchical structure look more like a beehive or an ant colony than a functioning collection of human beings.

Around 367 B.C., a seventeen-year-old young man by the name of Aristotle came to join Plato's Academy in Athens. He was born at Stagira in 384 B.C., in the northern part of Greece. History reports that his father had served as a court physician in Macedonia, the place where Aristotle returned when, in his later years, he was summoned by King Philip to tutor his young son Alexander.

Even though Aristotle showed a great respect for Plato, he was unable to share his master's contempt for the physical world. In contrast with Plato's view, Aristotle, who founded his own Lyceum around 335 or 334 B.C., fully restored the importance of empirical

reality, claiming that reason could not operate without the support of the senses and that experience was essential to understand the laws of the universe. Having reestablished the physical dimension as a proper object of investigation, Aristotle became an indefatigable observer of the world. His wide range of interests and his detailed classifications of animals and plants made him a precursor of disciplines such as biology, botany, and zoology. Besides important treatises on physics and astronomy, Aristotle greatly contributed to politics and ethics and is considered the inventor of formal logic, which essentially is the art of clear and systematic thinking.

For Aristotle, the world was a hierarchically structured system governed by a wholly immaterial and abstract entity that he called the First Cause or the Unmoved Mover. For the philosopher of Stagira, the Unmoved Mover was the source that had put in motion the exuberant process of *becoming* that constituted the life of the universe. All things that existed—plants, animals, and human beings—contributed to that awesome dynamic by responding to the inner urge of bringing to fruition the purpose, or telos, that their natures contained within. For man, the only creature endowed with reason and language, the realization of what lay within corresponded to the realization of his social nature. The idea was that the individual was determined not by what he was born *as* but by what he was born *for.* As a consequence, happiness, or *eudaimonia,* only occurred when, by dedicating himself to the communal good, man fulfilled the purpose that his specific nature envisioned. Becoming a good member of society was the ultimate goal and meaning of human existence.

Unlike Plato, who ambitiously spelled out the rules that, in his view, would have assured the creation of a perfect society, Aristotle focused his political analysis on three main forms of government: monarchy (rule of one), oligarchy (rule of few), and democracy (rule of many). For Aristotle, as for Plato, the reason why democracy was condemnable consisted of the erroneous belief that justice was to be equated with perfect equality among all citizens. Contrary to that view, Aristotle claimed that the polis was to be conceived as a hierarchical structure, just like every other expression of nature. In his

Politics, Aristotle compared the different roles assigned to citizens to the various functions that, according to talent and capacity, sailors assume to assure the safety of navigation. A similar logic was used by Aristotle to accept not only as "natural" but also as "beneficial" the superiority that "rational beings"—that is, men—held versus slaves and women. That did not mean that Aristotle preferred the two other systems. On the contrary, even though he recognized that some men were superior to others, Aristotle never advocated the rule of one (as in a monarchy) nor that of a single privileged elite (as in an oligarchy). In later times, these considerations led political thinkers, such as Polybius and Cicero, to conclude that the best form of government was to be a mixed constitution—part monarchy, part oligarchy, part democracy—as in the case of the Roman Republic. The point will be further explored later on in this book.

In contrast with Plato, who feared the passion-inducing power of art, Aristotle affirmed that if used correctly, the catharsis, or powerful emotional release provided by art, could produce positive and useful effects. With a similar practical approach, he also reversed Plato's negative argument against rhetoric. Like dialectic, rhetoric, Aristotle contended, was extremely important because of its capacity to persuade. Well aware of the power that rhetoric possessed, Aristotle made sure to add that those who used that compelling tool had to do so with caution, respect, and most of all virtuous intent—a prescription that the Sophists had recklessly and amorally ignored. In opposition to the Sophists' deceiving practice, Aristotle affirmed that the only rhetoric that had value was the one that solidly joined the pathos of emotional persuasion with the ethos of ethics, integrity, and rationality.

✳

THE HELLENISTIC ERA

While Aristotle was pondering the kind of government that could better serve the interest of the polis, the old Greek world was inexora-

bly coming to an end. Sixteen years before Aristotle's death, Philip II, the brilliant king of Macedonia, transformed his army into a perfectly organized unit of professionally trained soldiers. Philip's plan, which was to expand his kingdom southward, was vehemently opposed by the Athenian Demosthenes (384–322 B.C.), who used his powerful rhetorical invectives to encourage the resistance of his fellow citizens. Demosthenes, who joined the army, experienced firsthand the power of the Macedonians when Philip defeated the Greek alliance, led by Athens and Thebes, in the historic Battle of Chaeronea in 338 B.C. After Philip's death, his son Alexander, in only ten years of foreign campaigns, was able to extend the Macedonian possessions to include not just all of Greece but also Thrace, Asia Minor, Syria, Egypt, Babylonia, Bactria, and Punjab. The conquest of the immense Persian Empire, which Alexander swept away in just three battles, was crowned with the destruction of the Persian capital, Persepolis, as an act of retribution for the barbaric actions that Xerxes and his troops, 150 years earlier, had inflicted on the great city of Athens. When, having arrived on the Indian subcontinent, Alexander's exhausted troops refused to go any farther, the young general was forced to promise a swift return home. The journey back came to a halt in Babylon, where Alexander suddenly fell ill and died of malaria a few days later. He was only thirty-three years old.

Alexander always expressed enormous respect toward Greek cultural values—so much so that he apparently kept a copy of the *Iliad* under his pillow for the entire Asian campaigns. Yet he violated the foundational principle of the Hellenic ethos when, in order to acquire an uncontested authority over the diverse populations that inhabited his immense empire, he attributed to himself a divine nature, just like an Egyptian pharaoh or a Persian king. The choice seems to denote an old-fashioned mentality. Surprisingly, though, that impression is challenged when one compares Alexander's vision of a universal empire with the xenophobic strain that had previously characterized the Greek mentality, as expressed by Aristotle, who said that only the Greeks deserved to live as free citizens, whereas the barbarians, being inferior people, were destined by nature to be ruled by despots.

Ignoring the view of his tutor, Alexander went on to unite East and West with the intention of reconciling the two opposite spheres of the world within a single empire. The fact that he had three wives of Eastern origin (the first one was from Bactria, a region between modern Afghanistan and Uzbekistan, while the following two were princesses from Persia) is a sign of his open-minded disposition. Recognizing the positive impact that Alexander's multicultural empire had achieved, the author Plutarch wrote that Alexander was "one sent by the gods to be the conciliator and arbitrator of the Universe." Was Alexander a conscious agent of that change? No one is sure. Anthony Pagden, in *Peoples and Empires,* observes that ultimately that's not that important; history is made of facts as much as myths: "Alexander's greatness lies less in what he intended to achieve than in what he was believed to have achieved."

Pagden's words convey a profound truth: Alexander's extraordinary life had come and gone in a flash, sudden and short as the flare of a shooting star. But the admiration that his deeds produced continued to live on to eventually grow into legend and myth. Within that transformation, Alexander simultaneously became a brilliant conqueror and an insatiably curious explorer. Legends told that Alexander reached the depth of the sea in a diving bell and flew up to the sky in a basket pulled by two griffins (mythological beasts with a lion's winged body and a bird's head).

Among Alexander's many deeds were the founding of seventy cities (among which was Alexandria, the city that eventually replaced Athens as a major center of culture) and the creation of an enormous network of trading routes that, besides a rich and flourishing market, allowed the fertile encounter of peoples and cultures that, until that moment, had known very little about one another. Within that vast melting pot, Greek language and culture were exported as far as Southwest Asia, while the heritage of the East renewed and replenished with new perspectives and ideas the cultural reservoir of the West.

Particularly important, for the West, was the encounter with the Jewish religion and also Buddhism, Hinduism, Zoroastrianism, and

mystical cults such as the Persian cult of Mithras and the Egyptian cult of Isis that celebrated nature and its recurrent cycles of death and resurrection.

Shortly after Alexander's death, the empire was divided among three of his most trusted generals, Seleucus, Ptolemy, and Antigonus. The dynasties that derived from those three generals were the Seleucids that ruled in Central Asia, the Antigonids in Macedonia, and the Ptolemeis in Egypt. (It was thanks to the Ptolemaic dynasty that Alexandria became a major center of trade and culture with an institution called Musaeum, from the Muses, where many thinkers of the ancient world gathered to study. The famous library of Alexandria, which was part of the Musaeum, contained at its height almost 400,000 scrolls.)

In contrast with the austerity so cherished in classical times, the Hellenistic period was characterized by monarchs who, modeling their behavior after Alexander, indulged in ostentatious displays of luxury and wealth. It was during this time that the Hellenistic kings, as well as many rich aristocrats, became major patrons of the arts. Because the taste that now prevailed sought an aesthetic and ornamental originality that was devoid of any particular didactic or ideological intention, style, rather than content, became the primary preoccupation of the Hellenistic artists. What was admired, especially in sculpture, was the mastery of ever more sophisticated techniques that allowed a perfectly faithful reproduction of reality. The statue of Laocoön and his children, crafted by an anonymous sculptor who lived around 200 B.C., is a good example of this new approach. The scene describes the death of Laocoön, who had tried to prevent the Trojans from taking the wooden horse inside the city. As a punishment, the gods who sided with the Greeks had Laocoön and his children attacked and killed by snakes emerging from the sea. The melodramatic expression of anguish and pain that Laocoön displays in the dynamic contortion of his body, masterly described in all its anatomical details, shows how far the pathos of Hellenistic art had come from the lesson of calm composure and restraint that the

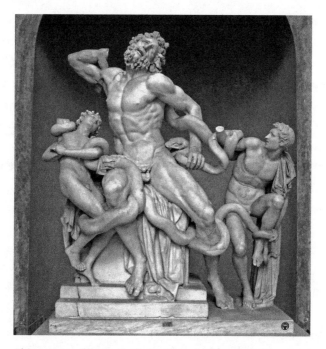

This statue of Laocoön being attacked by snakes
(ca. 200 B.C.) epitomizes the qualities of Hellenistic art.

classical era, for ethical and ideological purposes, had so consistently pursued.

At this time, female nudes also made their first appearance in art. The first artist to do so, defying the prohibition that earlier ethical concerns had imposed, was Praxiteles, who in the fourth century sculpted an unclothed image of the goddess of love, Aphrodite.

The disciplines that most benefited from the exchange of ideas and knowledge that the Hellenistic expansion of the world's boundaries allowed were the natural sciences, as attested to by the work of people like Ptolemy, whose contribution to astronomy was based on Babylonian knowledge spanning back more than eight hundred years. Euclid and Archimedes in mathematics, Strabo in geography, and Galen in medicine are other noted figures who bear mentioning.

Despite the well-being and relative stability that the Hellenistic monarchies were able to assure, the sense of loss and bewilderment

that many felt within a political reality that had become much too big and unpredictable to be controlled, and too various and dispersed for the cultivation of the kinship that the smaller reality of the polis had allowed, produced a dramatic shift in thoughts and attitudes. The prevailing theme of the major philosophical schools that developed in the Hellenistic era—the Skeptics, the Epicureans, and the Stoics— was a sense of isolation and resignation in the face of the increasingly confusing challenges that life presented. The contrast with the old mentality was made evident by the Skeptics, who claimed that society was a pure convention and not, as Aristotle had said, a natural outcome of man's rational self; and by the Epicureans, who contended that because life was the result of pure chance rather than a preordained order, man needed to pursue private forms of simple contentment away from the public engagements of political affairs. Far from the pursuit of boundless pleasure, as the word "epicurean" seems to imply today, Epicurus and his followers (which, as we have said, in later times included the Latin writer Lucretius) never betrayed the principle of moderation that had always held such importance in Greek mentality. The word *ataraxia,* which Epicurus used to define pleasure, meant lack of emotional disturbance and absence of pain within a life free from the fear and superstition likened to the false beliefs propagated by religion.

The emphasis toward a more personal and introspective approach was also stressed by the Stoics. Unlike the Epicureans, with their materialism, the Stoics believed that the world was an animated and divinely infused reality where nothing occurred by chance because everything had been preestablished by a superior, providential wisdom. That view, today, is echoed in expressions such as "everything happens for a reason," which implies that things must have a meaning even when they appear incongruous with and incomprehensible to our human logic. With a similar attitude, the Stoics claimed that happiness occurred when man learned to accept, with fatalistic resignation, all the puzzling twists and turns that life presented. The Stoics' belief that everything was part of the same great body of nature and that, as Richard Tarnas writes, "all human beings shared in the

divine Logos" led them to the conclusion that all men were "members of a universal human community, a brotherhood of mankind." As we will see, that claim had an enormous resonance in Western culture, including views that in later times found expression in Christianity.

The Hellenistic period lasted almost three hundred years: from Alexander's death in 323 B.C. to the Battle of Actium, on the western coast of Greece, in 31 B.C., when Octavian (the future emperor Augustus), having defeated Antony and his lover, Cleopatra, brought to an end the Roman Republic to establish the empire.

PART TWO

ANCIENT ROME

The Battle of Actium, in 31 B.C., in which Antony and his lover, Cleopatra, ruler of Egypt, were defeated, marked a seminal moment in the life of the victorious Octavian (63 B.C.–A.D. 14), Julius Caesar's grandnephew, who, having avenged the assassination of his great-uncle, became the most powerful man in Rome with the consent of the Senate, which bestowed upon him the honorific title of Augustus, an adjective transformed into a noun meaning "the most venerable one." This event, which coincided with Rome's rise to world superpower, also marked the end of the republic (established around 509 B.C.) and the beginning of the empire. The peace and stability that Rome experienced under Augustus's imperial rule ushered in a long period of peace and prosperity, known as the Pax Romana, that lasted almost two hundred years.

The image of the empire orbiting like an awesome solar system around the brilliant accomplishments of Rome has always maintained a very special place within the mythical realm of Western culture. That luster, however, becomes much more problematic when one considers the critical voices that, wary of the empire, nostalgically mourned the passing of the virtuous republican ethos that had governed the city for nearly five hundred years.

One of the most notable supporters of the Roman Republic was Marcus Tullius Cicero (106–43 B.C.), the moral philosopher, lawyer, and brilliant orator whose blistering words of admonition left a long shadow of prophetic doubt over the glittering glamour of the newly established empire. Cicero was born in Arpinum, a small town south of Rome, into a well-to-do family. It is believed that his ancestors

became wealthy by cultivating chickpeas—*cicer*, in Latin, from which his cognomen, or last name, might have originated. Cicero was an ambitious man who tirelessly worked at gaining political prominence in Rome. His marriage to Tullia, who was a very wealthy woman, was apparently dictated by the opportunistic realization that her wealth could be an asset in advancing his political career. Cicero's true love was his daughter Tullia. When she died at a very young age, Cicero became inconsolable. To try to cope with his sorrow, he turned to the writing of Greek philosophers, but he was forced to admit that "grief defeats all consolation."

Throughout his life, which was punctuated by years of civil unrest in Rome, Cicero never relinquished his faith in the republican system and therefore never accepted the ascent to power of Julius Caesar, the general who, after challenging the authority of the Senate, defeated his rival Pompey and went on to become dictator. In Caesar's arrogance and ambition, the moral philosopher perceived the insidious threats to society against which he had long warned his compatriots. The target of Cicero's severe indictment was Caesar's ruthless dismissal of the selfless commitment of those who, during the republican years, had served the city's grand destiny without any demand for personal power and recognition.

As with most educated men of his times, Cicero learned Greek at a very young age. After being exposed to the vast well of Greek knowledge (which, as we will discuss in depth later, Rome acquired when it conquered the Hellenistic kingdoms), he became particularly taken by the teachings of the Stoics, whose wisdom he weaved into and adapted to his own political thinking. The point deserves to be stressed: Cicero's Stoicism was a distinct, Romanized version of the Hellenistic philosophical school founded by Zeno of Citium (not to be confused with Zeno of Elea) in the early part of the third century B.C. As we have seen, according to the Stoics the universe was an animated entity organized by a divine Intelligence. Because man was endowed with reason, he had the capacity to recognize the superior order that sustained the perfect organization of the cosmos. To live in agreement with that intrinsic harmony, man had to emancipate himself from

the disorderly interference of passions (such as ambition, greed, envy, and fear) to reach a calm and detached state of mind called *apatheia,* meaning "without pathos." Contrary to our modern interpretation of the word "apathy," *apatheia* for the Stoics indicated the steady and calm attitude of those who succeeded in purifying the mind of the enslaving and misguided effects of passion. The belief that beyond the apparent confusion and contradictions of the world a divine Reason had preordained the destiny of all living things armed the Stoics with a great amount of patience and resilience. Even the death of a loved one did not upset a true Stoic, for whom the adjective "tragic" was applicable only to the failure to accept, with virtuous fortitude, whatever the divine wisdom had established, no matter how incongruous with man's reason the divine motifs might have appeared.

Zeno's inward attitude and his excessive tendency toward acceptance and resignation were profoundly revised by Cicero, who gave Stoicism a much more pronounced and engaging public and political spin. Cicero's main concern was the defense of the Roman Republic. With that purpose in mind, Cicero used the Stoics' emphasis on courage, endurance, and self-discipline to affirm that virtue occurred when man, in agreement with the orderly laws of the universe, chose reason as the driving force of life and society. In his *Laws,* Cicero wrote, "Since, then, there is nothing better than reason, and reason is present in both man and God, there is a primordial partnership in reason between man and God." As a divine-instilled talent, the development of reason represented man's greatest accomplishment and the highest form of virtue: "Moral excellence is reason fully developed."

As we have seen, Aristotle had optimistically believed that nature had organized everything for the best. That truth, he argued, was apparent in the gift of reason that had given man an instinctive urge to live with others. In agreement with Aristotle, Cicero, in his book *On Duties,* maintained that true humanness occurred when man developed to his utmost the social talents for which he was created. "We are not born for ourselves alone, . . . but our country claims for itself one part of our birth."

Because reason was man's most ennobling characteristic, creating

a good and orderly society was the best way to conform to the ethical principles that the divine intelligence had encoded in the harmonic workings of nature. The idea fostered the long-lasting belief in a fixed, eternal, and self-evident natural law universally valid for all people in the world. As Cicero stated in his *Republic,* "Law in the proper sense is right reason in harmony with nature. It is spread through the whole human community, unchanging and eternal. . . . This law cannot be countermanded, nor can it be in any way amended, nor can it be totally rescinded. We cannot be exempted from this law by any decree of the Senate or of the people; nor do we need anyone else to expound or explain it. There will not be such law in Rome and another in Athens, one now and another one in the future, but all the peoples at all times will be embraced by a single and eternal and unchangeable law. . . . Whoever refuses to obey it will be turning his back on himself."

Because for Cicero the political collaboration that had animated Rome's *res publica* ("public affairs," from which derives the word "republic") had best represented the wisdom of a fully developed reason, he was fond of saying that Rome had been "the most religious of all nations." As used by Cicero, the term "religion" involved not a spiritual and metaphysical detachment from reality but rather the bond of trust, discipline, and responsibility that had denoted the patriotic spirit of the early citizens of Rome. If the Roman Republic had been an example of religiosity, Cicero held, it was because the lawful concordance that had animated its civic spirit had faithfully mirrored the harmonious concordance that ruled, at a universal level, all other aspects of nature.

Even though the republic, as conceived by Cicero, did not survive the test of time, his ideas remained a powerful point of reference for Western culture for many centuries to come. On the subject, Neal Wood in *Cicero's Social and Political Thought* writes, "American constitutionalists, no less than French revolutionaries a decade later, thought of themselves as heirs to the Roman republicans and most appropriately looked to their greatest political thinker [Cicero], the cultural statesman and *pater patriae,* for tutelage in the colossal task

of founding a new order." To better understand these ideas, we must briefly review the history of Rome.

Rome was founded on the banks of the river Tiber in 753 B.C. Initially, the city was ruled by Etruscan kings, but that dominion came to an end in the sixth century B.C. with a rebellion of a group of Latin tribes who defeated the Etruscan kings and replaced them with a republic led by two consuls, appointed for one year, and a senate whose members served for life.

The distribution of power that the system assured was aimed at minimizing the risk that a monarchical rule of one would ever return—a prospect that the Romans vehemently opposed, just as the Greeks of classical times had done before Alexander the Great brought to an end the era of the polis.

Even though being an aristocrat (meaning a member of one of the old families that could link their origin to the very beginning of the city) was a basic requirement to enter politics, having an illustrious name was not sufficient to gain political office. Merit was equally important, as indicated by the long list of offices, called the *cursus honorum,* that one had to perform before being eligible for the prestigious position of consul, which included executive and military powers. The *cursus honorum* comprised ten years of military service, plus an ascending series of posts: quaestor (an administrative job), aedile (appointed to review and control public works and the organization of games and festivals), censor (assigned to monitor the honorable behavior of the citizens, including their duty to pay taxes and serve in the military), praetor (which involved a judicial post), and finally consul.

To forestall any excessive accumulation of power, each consul, besides having a term limit of one year, could enforce a veto with which, if needed, he could block or overturn the decision of the other. That rule was modifiable only in moments of particular danger when, with the approval of the Senate, extraordinary military powers were granted to a single individual (a temporary yet absolute dictatorial authority called imperium) that were to be revoked immediately after the crisis ended.

The Senate, which initially included three hundred members, directly evolved from the council of elders that had once advised the king, as explicitly indicated by the word "senator," which originated from *senior,* meaning "elder." Eventually, the Senate became the most important organ of government: it was the Senate that controlled the election of the magistrates, monitored the finances of the state, set the course of foreign policy, and had the last word in the passing of laws.

The high esteem that senators enjoyed was based on the assumption that only noble, rich, and therefore educated and vastly experienced people possessed the necessary wisdom to deal with public and political matters in a way unmarred by the petty trappings of personal and private ambitions. For that reason, all senators were expected to maintain exemplary conduct, respectful of the ideals of honesty, loyalty, frugality, and modesty that constituted the ethos of the republic.

The superior role that the patricians, as representatives of the oldest landed families, maintained over the lower classes, the plebeians, exemplified the patriarchal structure of Roman society. The patricians were respected because they were seen as father figures of the nation (the word "patrician" derives from *pater,* meaning "father"): wise and learned individuals committed like no one else to the success and prosperity of the nation. Once again, at the center of that mentality rested the old faith in reason: the aristocrats could exercise greater political power because they were considered more rational than those who, lacking status and education, were more likely to fall prey to irrational impulses and passions.

The fact that political positions were not compensated further assured that only the rich patricians, who benefited from the wealth produced by their vast estates, had the time and financial means necessary to compete for governmental offices. The aristocrats' monopoly over religious and priestly functions further implied that their authority enjoyed the approval and blessings of the gods. The highest religious office was that of the *pontifex maximus,* who made sure that the gods were respected and that they were kept content through propitiatory rituals performed on behalf of the state. To interpret

the moods and wishes of the heavenly regents, the *pontifex maximus* studied revelatory signs, such as the flight of birds or the entrails of a sacrificed animal. The vestal virgins, who were under the control of the *pontifex maximus,* were young, unmarried priestesses assigned to different rituals, among which was the tending of the perennial fire that symbolized the very survival of the state. If a vestal virgin betrayed the oath of chastity, she was condemned to die by being buried alive.

The respect that surrounded the patricians was symbolized by the outfit of the senators, consisting of a white toga decorated with a single purple band meant to express the moral purity that those individuals were believed to embody—a concept that is still traceable today in the word "candidate" (from *candidus,* meaning "candid"), which evokes the stain-free honesty and integrity that, allegedly, characterizes all those who hold public and political positions. Until the nineteenth century, statesmen and politicians, both in Europe and in America, were very often depicted, in sculptures and paintings, wearing Roman togas, as a symbol of the gravitas and moral excellence that distinguished them.

To illustrate the noble civility that had pervaded the early republican years, many exemplary stories were invoked. One of the most memorable involved the patrician Cincinnatus (519–430 B.C.), who promptly responded to the request of the Roman Senate to put aside the plow with which he was working his land to assume the imperium—the absolute military authority he was granted to combat the incoming threat of a neighboring population. As soon as victory was achieved, Cincinnatus, a model of integrity and modesty, didn't hesitate to renounce the power with which he had been invested to return to the simple anonymity of his previous existence. Cincinnatus's refusal to take advantage of his position and his willingness to relinquish fame and adulation in favor of the humble yet authentic dignity that tradition assigned to the cultivation of one's ancestral lot catapulted his legacy into the firmament of the republic's most admired and beloved heroes. A statue of Cincinnatus, in the Ohio city

ABOVE LEFT: A statue of Cincinnatus, who epitomized the selfless virtues of the early Roman Republic, in his namesake city of Cincinnati, Ohio. ABOVE RIGHT: Americans, steeped in Roman history and mythos, applied the example of Cincinnatus to the "father of our country," George Washington.

of Cincinnati that bears his name, shows the Roman leader returning the fasces to the Senate (the fasces being the bundle of rods that had initially symbolized the power of the king and then represented the briefly held dictatorship of the imperium), while the other hand holds the plow with which he is about to resume his old work. In that simple gesture, the essence of the republican spirit was strongly conveyed: without the exemplary patriotism of people like Cincinnatus, willing to place the interest of the community above self, Rome would never have become the ruler of the world and, most important, the greatest example of human civilization.

The story of Cincinnatus gained popularity with the American Revolution, when George Washington, like the Roman hero, having fulfilled his duty on behalf of the country, humbly returned to the cultivation of his land in Virginia. The parallel between Washington

and Cincinnatus was also stressed to praise the virtuous simplicity of the Americans in contrast with the pretentiousness of the British oppressors.

Ennobling stories like that of Cincinnatus represented, for the Romans, the embodiment of what they called the *mos maiorum:* the "old ways" through which the forefathers had expressed their unconditional devotion to family and state. For the Romans, who did not possess a written constitution, the *mos maiorum* represented a fundamental point of reference: an unwritten code of conduct upon which were based the civic and moral norms that animated the republican system. The connection between *mos* and "morality" still evokes the moral value that the past associated with tradition.

In time, the aristocrats' greatest challenge came from the entrepreneurial class, called the *equites* (the name *equites* had originally indicated those who could afford a horse to go to war). This class had amassed substantial wealth through trade, an activity that the senators were forbidden, by law, to engage in, because commerce was believed to be a breeding ground for vulgar and selfish pursuits incompatible with the high moral standards that the nobility was expected to possess. The prejudice ended up hurting the aristocracy in unforeseen ways. When the pressure from the ever more rich *equites* could no longer be ignored, the blue-blooded elite were forced to accept those nouveaux riches as political equals within the government of the city. The term *optimates* included all those who belonged to that new and extended definition of the upper class.

More problematic was the situation of the commoners, or plebeians, who were denied access to relevant political positions. The problem was exacerbated by Rome's military organization, which was based on the physical and financial contribution of all the citizens of Rome. The system's inequity was evident: the aristocrats who could afford the best weapons and armor assumed commanding posts, while the small farmers and artisans filled the less prestigious ranks of foot soldiers. The heavy demand placed on the lower ranks, coupled with the risk of being reduced to a serf's condition if one incurred a debt that could not be repaid (which was often the case, especially when,

to serve the country at war, a farmer was forced to leave his land unattended for many months at a time), pushed the situation to an inevitable rupture point. In 494 B.C., the plebeian population, exasperated by the abuses of the upper class, seceded by withdrawing to a hill near Rome. The threat of having the army depleted of its soldiers forced the nobles to grant two important concessions: the institution of two tribunes of the plebs to protect the interests of ordinary citizens and the issuing of the Twelve Tables that represented the first written code of Roman law concerning basic legal rights.

Although the exact content of the Twelve Tables is unknown because only a few fragments have survived, scholars agree that the document represented an important first step toward Rome's most important contributions—the development of law and the establishment of civil rights. Those rights, which along with familial regulations and juridical issues were essentially aimed at the protection of private property, should not be confused with our modern concept of universal rights based on the moral recognition that there is no difference of worth between human beings. This egalitarian concept took two more millennia to be formulated.

As we have seen, finding an ideal form of government had been an issue of central importance for the Greeks. But all the political systems they had conceived had proven problematic, Athens's democracy included. Reflecting on the issue, Cicero claimed that the only ones who had come up with a truly durable solution were the early Romans, whose republican system, being a mix of different forms of government, had been able to balance, in harmonic equilibrium, the interests of the various social classes. Cicero's view derived from the Greek historian Polybius (203–121 B.C.), who had described the Roman Republic as an ideal constitution formed by the perfect blend of three forms of government: monarchy (as represented by the consuls), aristocracy (senate), and democracy (popular assemblies).

For thinkers like Polybius and Cicero, the most important aspect of Rome's mixed constitution consisted of its capacity to prevent the monarchical tyranny of one, the oligarchic tyranny of few (essentially formed by the wealthy elite), and the tyranny of many, which, in their

view, democracy, as the rule of an uneducated, excitable, and often irrational mob, represented.*

Despite the praise it received, the *concordia ordinum,* meaning the peaceful collaboration between the different social strata that Cicero attributed to the republic, appears more an ideal than a reality, particularly when we consider the dissatisfaction of the lower classes, whose repeated attempts to gain greater rights were regularly thwarted by the maneuvering of the rich, who always managed to keep the system slanted in their favor.

This endemic disparity among citizens gives the Roman Republic a connotation that, ultimately, is very different from our contemporary understanding. Today the terms "republic" and "democracy" are nearly interchangeable. The same thing cannot be said about the Roman Republic: a system that was based not on the absolute equality of all people but on the different privileges that wealth and gender conferred. (Even if women were called citizens, they were considered inferior to men and denied an equal status within society.) A radical disparity also existed among men: even if liberty was assured to all citizens, having a share in the government of the city was not the same for all, in that political participation varied according to the class to which, by birth, each individual belonged.

The underlining assumption, which Cicero shared with Aristotle, was that natural justice meant not universal equality but a *proportionate* equality. "Proportionate equality," writes Neal Wood in *Cicero's Social and Political Thought,* "occurs in a state where citizens are divided by worth (dignitas) from the lowest to the highest into a hierarchy of legal orders. Each citizen belongs to a distinct station or rank (status) in the hierarchy." Institutionalized within the mixed constitution of the Roman Republic, that difference of status was consistently used

* With its division of powers and its mechanism of checks and balances, the Republic conceived by the American Founding Fathers was based on an articulation of the Roman model, conceived as a mixed constitution, combining the power of one (the president); the few (the Senate); and the many (the House of Representatives).

to favor "the privileged few to the detriment of the underprivileged majority." Birth and wealth gave greater worth to the individual by making him naturally superior to those who, lacking money or property, could only contribute to society by breeding children, as the meaning of the word *proletarius* suggests (*proles* means "offspring" in Latin).

In that sense, contrary to what the symbol SPQR, meaning *Senatus Populusque Romanus,* or "the Senate and the people of Rome," seems to suggest, the people who truly mattered within the Roman Republic were a restricted oligarchy of men belonging to the old nobility and the rich *equites.* Within that context, a less affluent plebeian would seldom have reached the top of the political ladder. A plebeian who managed to succeed was given the title of *novus homo,* meaning "new man" (Cicero, who after being quaestor, aedile, and praetor was granted consulship for the year 63 B.C., was called a *novus homo,* which meant that none of his ancestors had ever held any political office before).

From its beginning, Rome distinguished itself by the strength of its military. Except for the setback it received from the northern Gauls, who attacked the city in 390 B.C., Rome from the fourth century B.C. on enjoyed a long series of victories that assured its quick expansion throughout the Italian peninsula. A new phase occurred when the city turned its predatory interest toward the rich and powerful North African city of Carthage that had dominated the Mediterranean basin since the eighth century B.C. The term "Punic Wars," referring to the one hundred years of military engagement between Rome and Carthage, evokes the Phoenician origin of the African city (*punicus* was the Latin word for "Phoenician"). The first war against Carthage, which lasted twenty years, gave Rome control over Sicily, to which was later added Sardinia and Corsica (all territories previously belonging to the African city). Less favorable was the Second Punic War, in which Rome suffered a devastating defeat in Cannae, in southern Italy (216 B.C.). The Carthaginian general who inflicted such a humiliating blow to the Roman legions was Hannibal, who famously entered Italy by crossing the Alps with fifty thousand troops and forty elephants. It took the brilliant leadership of the Roman

general Scipio Africanus to avenge the humiliating defeat of Cannae with the decisive victory of Zama in 202 B.C. Rome's supremacy over the Mediterranean was completed in 146 B.C., when it finally crushed and razed to the ground its legendary enemy. The Roman ritual that followed, which consisted in sowing salt in the enemy's land, symbolically denied any future growth to the city that the Romans had condemned to death. The vehement demand delivered by one of Rome's most stern statesmen, Cato the Elder (234–149 B.C.), *"delenda est Carthago"* (Carthage must be destroyed), has remained emblematic of the ruthless attitude that Rome maintained toward its fierce adversary.

With the threat of Carthage removed, Rome's centrifugal power became literally unstoppable. Within a few years, its orbit of influence grew to include, next to the parts of the Iberian Peninsula that had previously belonged to Carthage, all of North Africa. Subsequently, Rome conquered Macedonia in 148 B.C. and, by 133 B.C., all the rest of the Greek territories. The many other countries that one by one were taken over by Rome included Anatolia, Mesopotamia, Persia, and part of what is today Pakistan, as well as the Levantine countries of modern Lebanon, Syria, Israel, and Palestine.

Military power created the Roman Empire, but that power would not have survived without the extraordinary political and administrative skills with which the Romans organized the gigantic expanse of their dominion. Governors and military officials, who were deployed in the various provinces, assured peace as well as the political and administrative cohesion of the empire, while tax collectors gathered the money needed to sustain that complex organization.

Rome's ascent to power had indeed been spectacular, but that success didn't come without challenges and complications. The most dramatic came from the impoverished small farmers who, after shouldering the military burden, ended up outnumbered by the legions of slaves, captured in war, whose work was now exploited in the immense stretches of land (the latifundia) controlled by the ever-richer upper class. As a consequence, Roman society became increasingly polarized, with the rich shamelessly exploiting their position of power while the disenfranchised farmers, unable to overcome the

competition of the latifundia, sold or abandoned their lots to join the ranks of the dispossessed (to which also many immigrants from the conquered lands belonged) who had begun to occupy the urban environment. The situation gave way to a populist movement led by the Gracchus brothers, Tiberius and Gaius, who, on behalf of the *populares,* demanded a general redistribution of the land to alleviate the desperate condition into which so many had fallen.

Galvanized by the violent deaths of the two Gracchus brothers, the populist movement gained a major victory in 107 B.C., when a general named Marius introduced a new method of military recruitment. Because small farmers had become so scarce, Marius enticed landless people to fill the ranks of the army by joining as volunteers. Besides being provided with training and weapons, these volunteer soldiers were given the assurance of a bonus of land to be received at the end of their deployment. The appeal of Marius's reform was enormous, but so were the unexpected consequences that occurred when the troops, having become more loyal to their generals than to the nation, allowed their leaders to prolong their imperium in open defiance of the authority of the Senate.

The situation degenerated when a number of generals, who had amassed wealth through war plunder and looting, started to compete with one another, showering with gifts and favors their soldiers and supporters with the intention of increasing their influence in Rome's political world.

The enormous enthusiasm that surrounded a winning general was displayed in the triumphs: the boisterous processions that took place at the end of a victorious campaign, which were architecturally commemorated with triumphal arches placed at different points of entrance to the city. With the consent of the Senate, a general who had killed at least five thousand enemies could request the privilege of parading his troops beyond the sacred limit, or *pomerium,* of the city (a general who could not claim the same amount of enemy deaths only received an ovation, meaning a smaller celebration in which only *ovis,* or "sheep," were sacrificed). While the proud soldiers displayed the war booty and the prisoners of war to the cheering crowds, the

general, crowned with a laurel wreath, stood on a chariot pompously accepting the adulation of the public, whom he made sure to please with the dispensation of generous gifts meant to show the largesse of his noble spirit. The twelve lictors, who preceded the triumph, carried the bundle of rods called fasces (from which Mussolini derived the term "fascism") that symbolized the general's power to dispense life and death.

The red paint that covered the general's face was meant to evoke the vitality of Jupiter, the most powerful of the gods. The detail is important because, just as with the classical Greek heroes, the aura surrounding the winner elevated him to godlike status. But that display of pride was not allowed to go on forever: when the procession reached the temple of Jupiter, the general removed his laurel crown and placed it at the feet of the god's statue. That act of submission was reinforced by the presence of a slave who, throughout the ceremony, kept whispering in the general's ear, "Remember that you are only a mortal man." The warning was meant to curtail any possible burst of hubris: though praised as a god, the general had to remember that his triumph would last only one day.

One of the most memorable triumphs took place when the general Lucius Aemilius Paullus returned home from the victorious campaign in Macedonia (168 B.C.), which marked the end of the hegemonic power of the Greeks in the eastern part of the Mediterranean. The biographer Plutarch, in his *Life of Aemilius Paullus,* describes the great crowd who came to witness the event. To welcome the returning troops, all temples were open; garlands of flowers filled the air with colors and perfume, while trumpeters accompanied 250 wagons full of looted statues and paintings. Right behind them came more wagons filled with armor, helmets, shields, swords—all the gold, silver, and bronze that belonged to the defeated warriors. Among the many captives led in shackles through the Roman crowds was the humiliated king of Macedon. To describe the shocked expression of the Macedonian king, Plutarch wrote that he appeared "deprived of reason" because of "the greatness of his misfortunes."

The snobbish disdain that the Romans expressed vis-à-vis the

Greeks appears much less convincing when one considers the extraordinary gift of culture that the captives provided to the winners. When they initially made their appearance on the stage of history, the Romans proved to possess courage, endurance, and discipline—qualities characteristic of strong yet rugged soldiers who had neither the talent nor the inclination for higher intellectual pursuits. Things drastically changed when, having conquered the Hellenistic world, the predatory instinct of Rome was unexpectedly transformed by the cultural richness of its prey. As the poet Horace (65–8 B.C.) famously stated, *"Graecia capta ferum victorem cepit,"* which means "when Greece was taken she enslaved her rough conqueror."

Greek influence had initially filtered into Rome through the neighboring Etruscans, who had come in contact with the colonies established by the Greeks in the southern part of the peninsula and on the island of Sicily. But that initial rivulet was transformed into a full inundation when the Hellenistic world, in the second century B.C., fell under Roman domination. "For it was no tiny stream that flowed into this city from Greece, but rather a rich flood of moral and artistic teaching," as Cicero stated in his *Republic.*

Cicero was right: whatever Rome produced from 200 B.C. onward contained, at its deepest core, a fertile fragment of Greek genius and creativity. In that vast process of assimilation, religion also became a mix of Greek and Roman gods: Zeus came to be identified with Jupiter, Athena with Minerva, Aphrodite with Venus, Dionysus with Bacchus, and so on.

Besides religion, the Romans drew heavily from Greek philosophy, which, through their pragmatic approach, became an exploration of how to translate abstract notions, like the Platonic ideals of Justice, Beauty, and Good, into actual rules and laws. Commenting on the difference between the Greeks and the Romans, Edith Hamilton, in her book *The Roman Way,* correctly concludes, "The Greeks theorized; the Romans translated their theories into action."

But the Greek cultural input was not appreciated by all. Cato the Elder, the famous senator, consul, and censor whom Cicero called "the prince of all virtues," relentlessly scorned the Greeks, whom he

considered a wretched, frivolous, and ostentatious people, in love with nudity as well as abstract and useless mental exercises. By sinking too deep in the quicksand of those decadent characteristics, Cato maintained, Rome's discipline and virtue would dissolve with devastating consequences for the future of the city.

In a letter addressed to his son, Cato wrote, "In due course, my son Marcus, I shall explain what I found out in Athens about these Greeks, and demonstrate what advantage there may be in looking into their writings (while not taking them too seriously). They are a worthless and unruly tribe. Take this as a prophecy: when those folk give us their writings they will corrupt everything."

More than anything else, Cato's burning indignation was aimed at the feminine qualities that, in his view, characterized the Greeks, who were known for their love of beauty and their sexual freedom. What Cato was trying to insinuate was that an excessive exposure to Greek taste and mentality would have potentially sapped what had been the Romans' most precious characteristic—their legendary manliness.

Those negative views were mostly influenced by the changes that Greek culture underwent once Alexander's conquest gave way to the Hellenistic experience. Alexander, as we have seen, was a great admirer of Greek tradition and values. He venerated Homer and liked to think of himself as a new Achilles. But as his military successes grew, his young mind failed to retain the lesson of humility imparted by his beloved Homer. As a consequence, Alexander, violating the rule of moderation that the Greeks respected more than anything else, assumed absolute power, claiming that he possessed a divine nature.

Emulating Alexander's indulgence in pompousness and grandeur, all the Hellenistic monarchs who followed him openly betrayed the old classical ethos of measure and restraint to engage in rich and ostentatious habits. It was mainly from the example set by Ptolemy, Alexander's general who was given control of Egypt and who established a pharaoh-like cult of himself, that the Romans derived their view of the Greeks as irrational, decadent, and "effeminate" lovers of all sorts of extravagant excesses. As we will see, the prejudice substantially grew when the Egyptian queen Cleopatra appeared on the stage

of Roman history as the lover of two famous Roman generals, Julius
Caesar and Marc Antony.

For the austere, Spartan-like mentality that had characterized the
early Romans, nothing could be worse: if man's mental and physical
hardiness was to be sapped by decadence and luxury, mighty Rome
would certainly crumble and fade away.

Despite the alarm of moralists like Cato, the fascination that Greek
culture, style, and taste exercised on the Roman mind appeared as
magnetic and irresistible as a lunar tide upon the ocean. The cultural
fusion that ensued was facilitated by the presence of many Greeks
brought to Rome as slaves. Some were used for humble works, but
many, especially those who possessed cultural and/or creative talents,
were placed in very respectful positions, such as tutors hired by the
rich to educate their children.

It is in this period that many Romans, enriched by the wealth
that poured into the city from all the corners of its sprawling empire,
started to violate the traditional norms of acceptable behavior, taking
time away from public life to pursue personal and private affairs. The
most glaring symbols of that new trend were the grand villas that the
members of the upper classes built in the countryside outside what had
once been the inviolable boundary of the city. The relation between
the life of leisure enjoyed in the villa and the life of duty carried on
in the city was epitomized in the concepts of *otium* and *negotium*. The
villa was the place where the individual, through his *otium,* or "time
of leisure," could express his private and individual interest apart from
the *negotium,* or "time of duty," that the city demanded. The contrast
with the past was dramatic: the individual, who had once perceived
his identity as indivisible from the state, was now emerging as a pri-
vate entity interested in personal and private matters that were often
completely at odds with the larger concerns of society.

The pursuit of luxury that the early generations had so vehe-
mently condemned soon became the most tangible proof of that
change in mentality, as shown in the large and elegant villas that
began to mushroom throughout the Italian territory. Everything in
those opulent and fancy mansions exuded the flavor of Greek style

and fashion: from the central, open courtyard called the atrium, to the
porticoes and loggias decorated with long rows of beautiful marble
pillars, to the interiors filled with a great amount of costly objects
and furniture inlaid with gold, silver, and ivory. To be recognized
as someone of stature within society, a person would dispense a tre-
mendous quantity of money. The demand for silks, linens, jewels,
perfumes, and cosmetics soared among rich women, while their men
offered elegant dinner parties put together by chefs hired from differ-
ent parts of the empire. Among the most extravagant culinary delica-
cies were boars' heads, sows' udders, peacock roasts, donkey stew, and
a great variety of songbirds.

Because everything Greek was considered elegant and refined and
because the wealthy were eager to show the sophistication of their
taste, a dramatic increase in the import of art occurred. When the
spoils of war became insufficient to match the vast demand, legions
of talented Greek slaves were brought to Rome to adorn the showy
abodes of the rich. Thousands of Greek-looking sculptures were
manufactured (which, in many cases, were copies of famous classical
or Hellenistic models), as well as frescoes made with a great variety
of vivid pigments. The themes of those frescoes were various: some
consisted of mythical and allegorical decorations evocative of Greek
practices and beliefs; others depicted idyllic landscapes in which the
boundary of the ordinary dissolved in fantastic visions full of dreamy
and fairy-tale magic.

Sensual and even erotic overtones were frequent, especially in
the matrimonial room where the procreative power belonging to the
genius of the paterfamilias was believed to reside. The word *domus,*
which in Latin means "house," also evoked the uncontested *domi-
nium* of the paterfamilias, whose rule, as in the Greek tradition, was
deemed absolute within the family.

The names given to the rooms of the villas stressed the admira-
tion accorded to everything Greek: the *lyceum* was the place where
books were collected adjacent to busts of poets, philosophers, and ora-
tors; the *pinacotheca* was the area dedicated to the family art collection;
the *triclinium* indicated the dining space, which was often guarded

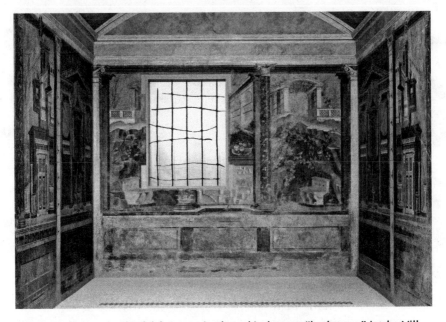

The elaborate and colorful frescoes in the *cubiculum,* or "bedroom," in the Villa of P. Fannius Synistor at Boscoreale, displayed at the Metropolitan Museum of Art in New York

by a statue of Dionysus; the *lararium* was the space dedicated to the household gods.

To prove their worth, many rich magnates got into the habit of ordering sculptural portraits of themselves: some of these effigies were displayed in private homes; others were reserved for the grand funerary mausoleums that every respectable family possessed. The famous realism of Roman art owes a lot to the vanity of those rich, pretentious people. Young, old, fat, thin, beautiful, ugly, toothless, wrinkly, bald: besides a dignified air of Roman gravitas, what those rich Romans demanded from the artists were effigies that could be immediately recognized by the circle of friends whom they were trying so hard to impress.

Initially, the art of portraiture had been limited only to the cult of the ancestors whose wax masks were kept at the entrance of private homes. The right to possess such masks only belonged to those who had attained at least one position of relevance within the Roman state.

The funeral procession of a notable individual was accompanied by actors wearing the masks of his ancestors, of whom they repeated the most famous sayings.

Within the ever more frivolous atmosphere that began to dominate the later years of the republic, busts and portraits of the rich became a commonplace even among the living. Some wealthy sponsors, overcoming the initial adversity toward Greek nudity, went as far as ordering unclothed representations of themselves. The muscular nakedness of lawyers and officials boasting a perfectly idealized body was meant to be reminiscent of the heroic ideal of Greek classical times.

Politics was not spared this new kind of open and blunt ambition. Because acquiring prestigious political position had become an obsession among the rich families, bribery, corruption, and intrigue became the rule of the day in the capital of the empire. Commenting on the poisonous effect that money had on his fellow countrymen, Cicero sadly concluded that in Rome everything was "for sale."

When Rome was still a relatively small city-state, the authority of the senate had been sufficient to assure the functioning of government. However, as the city grew to become the head of a huge and

Roman sculptural effigies tended far more toward realism than idealism.

rich empire, the senate lost much of its capacity to maintain unity within a much larger society, increasingly vexed by the contrasting interests of different classes and competing political factions. Instability allowed the rise of several strongmen who shrewdly exploited the chaos to gain political influence. After Sulla, who appointed himself dictator, and Catiline, who tried to overthrow the republic, came the alliance of three prominent military commanders known as the First Triumvirate (60 B.C.).

The men who formed the First

The hairstyle of Pompey in this bust consciously matches that of Alexander the Great—a mark of destiny.

Triumvirate were the vastly ambitious Julius Caesar, the immensely rich Crassus (who died prematurely fighting the Parthians), and the powerful Pompey, who had acquired great prestige during his campaigns in Spain, Syria, and Palestine, as well as in the Mediterranean, where he freed the sea from the raids of marauding pirates. Initially, the starring role was held by Pompey, who, after his conquests in Africa, was awarded the title of *Magnus,* just like Alexander the Great. To suggest that Pompey was a Roman version of Alexander, his sculptural portraits were given the same leonine hairstyle that Alexander had sported (as in the marble busts produced in the fourth century by the sculptor Lysippus shown above). The enormous prestige that the detail conferred is almost impossible for us to comprehend: those curls parted in the middle to frame the face like the mane of a lion represented not just a style but the mark of destiny of a man whom many considered the deserving successor of Alexander the Great.

Among the many acts that had turned Pompey into a darling of the Roman people was the gift of an enormous theater—the first built in stone rather than wood. To make sure that the Romans would never forget his legacy and generosity, Pompey placed an imposing statue of himself at the entrance of the theater, surrounded by other statues that personified the various nations that he had subdued for the benefit of Rome.

Although great, Pompey's reputation was soon overshadowed by that of Caesar, who, having become governor of northern Italy and

southern France, led his troops into Gaul (modern France) to con-
quer, on behalf of Rome, a territory that was two times the size of
Italy. The conquest, which pushed the Roman boundaries up to the
English Channel, marked a historical turning point: not only for the
stunning victory over the fierce Gallic tribes, but also because, from
then on, the center of gravity of the empire was forever switched from
the Mediterranean to continental Europe. (Britain, which Caesar was
the first to invade, was annexed to the empire only one hundred years
later during the reign of the emperor Claudius.)

During the Gallic campaigns, Caesar had consistently maintained
that the only thing that truly mattered for him was the success of
Rome, but the senate remained suspicious about his true intentions.
The mistrust was well placed: as a response to the senate that had
ordered him to disband his troops before reaching Rome, Caesar in
49 B.C. defiantly crossed the Rubicon, the small stream that marked
the southern border of his provincial command. A state of emergency
was immediately declared. Pompey, asked by the senate to mount a
counterattack, went to Greece to gather more manpower. The clash
between Pompey and Caesar—the two enormously successful and
egotistical generals who had long aspired to become the sole masters
of Rome—culminated in Pharsalus in 48 B.C. with the victory of
Caesar. Pompey, who was able to flee, sought refuge in Alexandria,
where the young pharaoh Ptolemy XIII, who was only thirteen years
old, reigned with his sister-wife Cleopatra (marriage between siblings
was customary among Egyptian rulers).

The pharaoh's promise to protect Pompey was suddenly bro-
ken when, to please Caesar so that Rome, in return, could recognize
Egypt as an ally, Ptolemy had Pompey killed and beheaded. To the
pharaoh's great surprise, Caesar's reaction ran exactly contrary to his
expectation: furious that a foreign leader had dared to kill a Roman
general, Caesar immediately seized control of Egypt. Cleopatra, who
aspired to get rid of her younger brother, turned the situation to her
favor when she became Caesar's mistress and eventually gave him
a child by the name of Caesarion. After Ptolemy died by drowning

in the Battle of the Nile, Cleopatra became the sole leader of her country.*

When he returned to Rome, Caesar, emboldened by his amazing victories, violated the fundamental rule of the republic by electing himself supreme commander of the army and dictator for life. The triumph he sponsored to celebrate his campaign was a powerful pro-pagandistic tool: the civil disorder that for so long had divided Rome would come to an end, Caesar's triumphal festivities implied, only if a strong leader took control of the nation.

The ability with which Caesar trampled down the opposition and the mischievous machinations he used to gain the respect of the public speak volumes about his charisma and his political cunning. Pondering the amazing ability of a man who could sway legions to his side as easily as he tamed his curls back to hide his receding hairline, Plutarch, evoking Cicero's thoughts, wrote, "When I see his hair so carefully arranged and observe him adjusting it with one finger, I cannot imagine it should enter such a man's thoughts to subvert the Roman state."

As soon as he assumed control of Rome, Caesar started a program of social and political reforms, which also included the creation of the Julian calendar—a solar calendar made of 365 days that replaced the old lunar calendar. (The Julian calendar was replaced in 1582 by the Gregorian calendar, from Pope Gregory XIII, which is still in use today.) The month of July was named after Julius Caesar, who was born in that month. Later, the month of August took its name from Augustus.

The first thing that Caesar did to solidify his position was to envelop his authority with the same mythical aura typical of East-ern leaders. With that purpose in mind, Caesar, in a way that was

* Around this time, the famous Library of Alexandria was destroyed—a loss mourned by historians and scholars to this day. The ancient historians Plutarch and Ammianus Marcellinus wrote that Caesar's troops accidentally burned down the library. The account, which has remained controversial, doesn't change the fact that the fire caused the loss of thousands of irreplaceable scrolls and books.

evocative of Alexander's style, started to insinuate that his leadership directly derived from the gods, who had chosen in him a leader worthy of Rome's legendary destiny. From then on, his image began to appear on coins—an honor that, previously, had been assigned only to the gods.

One of the most symbolic acts with which Caesar sanctioned his newly acquired power was the construction of a new forum, placed right next to the one that since the beginning of Rome had been the only commercial, administrative, or religious center of the city. The main temple that Caesar built in his Forum was the one dedicated to Venus, the goddess from whom he claimed to directly descend. It was reported that, shortly before his assassination, Caesar asked the Senate to meet him in front of the temple of Venus Genetrix (Venus Mother). When the venerable assembly approached him, Caesar, with insolent truculence, remained seated, refusing to stand up as tradition prescribed—an incredible act of defiance toward the sanctity of a political entity that for centuries had enjoyed an undisputed respect among all the citizens of Rome.

It all ended in 44 B.C. when a group of conspirators, led by Brutus and Cassius, killed Caesar in the name of the *libertas* that the city had lost when his dictatorship brought to an end the republic. Despite their intentions, the conspirators' action did not provoke its intended consequences. Describing the funerary pyre that consumed Caesar's mortal body, the art historian Georgina Masson observes, "In that fire the Republic perished and Caesar emerged from it as something more than human. A column was erected on the spot, the first monument to a mortal man to be built within the sacred precincts of the Forum; during Augustus's reign Caesar's altar and temple replaced the column and he was officially deified."

During the games held as funerary tributes to Julius Caesar, a comet appeared in the sky for seven days. The comet was interpreted as a prodigious proof that Caesar had reached the heavens, where he was now residing among the immortal gods. From then on, the iconography concerning Caesar almost always included the star (the *Sidus Iulium*) that had announced his deification.

AUGUSTUS AND THE EMPIRE:
THE THEATER OF POLITICS AND POWER

The next thirteen years witnessed the conflict between Marc Antony, who had once been Caesar's friend and protégé, and the young Octavian, Caesar's grandnephew, both wrestling to be recognized as the legitimate heir of the murdered dictator. Initially, the two men had established a triumvirate that also included Lepidus. The first act of this Second Triumvirate was to go after the conspirators who had murdered Caesar. That mission was accomplished when Brutus and Cassius, defeated in the Battle of Philippi in 42 B.C., committed suicide. With the excuse of avenging Caesar, a vast campaign of repression was begun. In the bloodshed, at least three hundred senators found a violent death as well as two thousand equestrians. Among the victims was Cicero, who had branded Antony an enemy of the state. As a trophy and a warning to all others who would have dared to oppose him, Antony ordered his men to expose in the Forum the decapitated head and cutoff hands of Cicero—a brutal end to the most eloquent voice speaking in defense of the republic.

In the following years, the two main members of the Second Triumvirate (Lepidus having been pushed aside) divided the empire between themselves: Octavian took control of the West, Marc Antony of the East. Plutarch describes the festivities that Marc Antony received upon his arrival in Ephesus (in today's modern Turkey), when he was honored as Dionysus. Women welcomed him dressed as bacchantes, while men and boys dressed as satyrs and fauns danced to the music of harps and flutes. The pompous way in which Eastern leaders were worshipped immediately seduced Marc Antony. The coup de grâce occurred when he met the Egyptian queen Cleopatra. The theatrical way with which Cleopatra staged her arrival, when she officially came to meet Marc Antony, is described with these words by Plutarch: "She came sailing the river Cydnus, in a barge with gilded stern and outspread sails of purple, while oars of silver beat time to the music of

flutes and fifes and harps. She herself lay all along, under a canopy of cloth of gold, dressed as Venus in a picture, and beautiful young boys, like painted Cupids, stood on each side to fan her. Her maids were dressed like Sea Nymphs. . . . The perfumes diffused themselves from the vessel to the shore."

Captivated by that mesmerizing sight, Marc Antony immediately fell in love with Cleopatra. As soon as the news of the love affair reached Rome, Octavian began to rally the people against him. Marc Antony, Octavian said, not only had abandoned his Roman wife, Fulvia, for the sensual Egyptian queen but also was now flamboyantly equating himself with Dionysus while his mistress acted like the personification of Isis. The thought of a Roman general corrupted and rendered "effeminate" by the witchlike powers of a promiscuous Eastern queen left the Romans dumbfounded and horrified. Disbelief was replaced by outright anger when alarming rumors spread the news that Marc Antony was planning to hand Rome to Cleopatra and move the Roman government to Alexandria. The fear that the two lovers were plotting a coup d'état sparked a conflict. Octavian, who was put in charge of the mission, swiftly confronted and defeated the two lovers and their army at Actium in 31 B.C. Both Marc Antony and Cleopatra avoided the humiliation of being dragged along the streets of Rome as traitors and prisoners by committing suicide.

The grandiose triumph that followed Octavian/Augustus's victorious campaigns lasted for three uninterrupted days—a record never enjoyed by any other general before. The excitement produced by the lavish festivities electrified the crowds, who were treated with lots of free food and wine and a great variety of athletic events. The most cherished ones were chariot races and animal hunts, which were made particularly thrilling by the presence of many exotic species brought to Rome from different parts of the empire, such as tigers, lions, rhinoceroses, and hippopotamuses that were carelessly slaughtered to please the bloodthirsty frenzy of the Roman people. To further enhance his public image, Augustus also awarded land to his soldiers and generously distributed gifts and money to the citizens of Rome.

To avoid the accusation of impropriety, Augustus also made sure

to promptly disband his troops before entering the city. His subtle calculation was to act as if, after valiantly defending the reputation of Rome, he was now going to surrender all powers and, like a humble Cincinnatus, retire to private life. Augustus, of course, knew perfectly well that an act of abdication on his part was never going to be accepted. He was right: because everybody feared that without a strongman the city would immediately relapse into civic unrest, the Senate begged Augustus to renew his consulship. With his usual flair for showmanship, Augustus initially displayed hesitation and reluctance but then graciously accepted the Senate's offer as if to prove that nothing, not even the prospect of a peaceful retirement, mattered more to him than the safety and well-being of the state. The extension that the Senate offered each time the appointment elapsed allowed the gradual yet inevitable rise of Octavian/Augustus to the pinnacle of power.

Even though he was directly responsible for his dictatorial consolidation of power, Augustus, with strategic acumen, always managed to appear in keeping with the rules of the republic. Unlike his brusque, impatient, and less politically astute great-uncle, he prudently morphed into a dictator without ruffling any feathers: in other words, without ever losing the mark of legitimacy, despite the illegitimate quality of his acts. Augustus's brilliance was to understand that even though the Senate had become practically insignificant, the too-obvious gathering of power in the hands of a single man would have rubbed the wrong way the antimonarchical feelings that the Romans had fiercely cultivated since the beginning of their history. For that reason, Augustus chose to disguise his real intentions behind the benign mask of savior and protector, instead of usurper, of the old republic, whose power, he proclaimed, he was determined to restore and revive.

The complacency with which people went along can easily be understood: as the exhausted citizens of Rome, tired of so many years of external and internal conflicts, chose to transfer onto the emperor the responsibility of the now-immense empire, the grateful emperor returned the favor by assuaging the bad consciences of his fellow cit-

izens by using the unthreatening term of *principate* to describe his imperial rule (the full title was *princeps senatus,* "first among senators"). By pretending that he was not an absolute monarch but just the leader of the Senate, the emperor gave his fellow citizens the excuse they needed to convince themselves that they were still free agents of a free and self-determined society. Within that fictional narrative, Augustus's role became that of an illuminated leader: a *princeps* who, by governing in collaboration with the institutions of the state, led a government that was a further elaboration rather than a subversion of the old republican system. The complaisant senators continued to debate, the magistrates to deliberate, but behind the artifice the unspoken truth remained: in all political matters, the only voice that counted was that of Augustus. The rest was only fiction and travesty: the subtle web of psychological persuasion brilliantly weaved by an ambitious and astute man fully conscious of the power of his political propaganda.

When the grateful Senate attributed to Octavian the title of *Augustus,* he was shrewd enough to accept it but with a certain amount of reservation, as if to imply that given his humble disposition he would have preferred the title of "first citizen" or, more poignantly, that of *pater patriae,* meaning "father of the nation."

Notwithstanding that unassuming attitude, Augustus never missed the opportunity to stress the Olympian origin of his family— an origin that made him, just like Caesar, a direct descendant of Venus. To promote the cult of his persona, Augustus often made references to the deification that Caesar had received after death, which, consequently, made him a direct "son of the divine Julius."

But that lofty title was also carefully leveled by a populist attitude that favored all the citizens of Rome, independently from the class to which they belonged. In years of food shortages, Augustus provided free grain to the poor while building bridges and an awesome network of roads to facilitate trade and commerce for the benefit of an ever-growing middle class. To mitigate the fear that a shift in favor of the middle class would have erased the last semblance of the old elitist regime, Augustus continued to stage an attitude of defer-

ence toward the snobbish aristocrats, knowing full well that the most powerful way to draw them to his side was to continue to shower them with the most irresistible of all trappings: flattery and adulation.

Building on this firm coalition of consent, Augustus introduced many reforms, among them the creation of an imperial army that for the first time was composed of professional soldiers paid in money rather than land. To strengthen the state, Augustus also convinced his followers that to repair the social fabric, a moral reform was imperative. What was needed in order to achieve that goal, Augustus believed, in agreement with authors such as Sallust (86–ca. 35 B.C.), Livy (59 B.C.–A.D. 17), and Cicero, was a revival of the old *mos maiorum:* the decorum, modesty, gravity, and above all loyalty to civic duty of the old republican years that wealth and competition had so dangerously undermined. To reverse that dangerous trend, Augustus encouraged the Senate to pass laws directed at revamping decency and modesty among the rich and unruly *optimates,* who were now threatened to be sanctioned for any vulgar and excessive display of wealth. To assure a dignified level of decorum, he imposed the wearing of the toga on all those admitted to the Forum. Augustus also used his power to revive and protect the sanctity of the Roman family, which he tried to turn again into the bastion of discipline it had represented in the early years of the republic. The Julian laws, which he passed in A.D. 17–18, included all sorts of legal consequences for people who failed to get married and have children and also for those who divorced or indulged in adultery, prostitution, and fornication. It must have been a shock and a great embarrassment for Augustus to have to ban from the city his own daughter and granddaughter, both named Julia, and punish them because of their obscene and adulterous sexual practices. It seems that even Ovid (43 B.C.–ca. A.D. 17 or 18), the famous author of the *Metamorphoses,* was forced into exile for writing the *Ars amatoria:* a book considered morally inappropriate because it was about the pleasures of love.

To revitalize patriotism, Augustus also decided to invest a lot of money in the aesthetic appearance of the city. To that aim, he invested a great amount of his personal fortune, next to public funds that the

city easily drew from the wealth accumulated through commerce and trade—activities that had become particularly vigorous thanks to the immense web of roads that were increasingly linking the lands of the empire.

The reason Augustus worked so hard at improving the appearance of the city derived from his belief that what the citizens needed most was a highly charged visual narrative—a narrative that, in glamorizing the role of Rome as capital of the world, would reignite people's love for their nation and with it the desire to redirect toward civic purposes their interest, passion, and monetary contributions. Many centuries later, the same concept was spelled out by another famous dictator who greatly admired Augustus, Napoleon, who said, "When you want to arouse enthusiasm in the masses, you must appeal to their eyes." In other words, dazzle the eyes in order to influence the mind.

The Egyptians, with their imposing architecture and arresting sculptures, had understood that truth very early, as did Pericles, in the fifth century B.C., when he skillfully used art as an essential tool of political propaganda—a choice that ushered in Athens's Golden Age that Rome, in a similar way, was now reproducing in Augustus's Golden Age. The historian Suetonius (ca. A.D. 69–after 130), the author of *The Lives of the Caesars,* reported that before dying, Augustus uttered these words: "I found Rome built in bricks; I leave it clothed in marble."

When Julius Caesar died, Rome was already a relatively developed urban center. But the toll inflicted by the long years of civil unrest, combined with an overall lack of urban planning and the squalid quarters in which many poor plebeians lived, kept the living conditions of Rome far below the standards that characterized many Eastern cities. To address the problem and give Rome the appearance it deserved, Augustus took many important steps. The first one was to pour a lot of money into upgrading and repairing the basic infrastructure of the city, like roads, canals, bridges, and sewers. He placed armed policemen in bandit-ridden areas and even instituted the first rudimentary fire brigades that serviced the city during the

night hours. In addition, Augustus greatly upgraded Rome's water supply through the repair or building of new aqueducts. The project favored the rich, who could now afford fancy heated bathhouses in their private homes, but also the greater population, who, for the first time, could enjoy the amenities offered by the solace of the many refreshing fountains that began to dot the city and also the pleasure of public baths, or *thermae*—the imposing structures decorated with a great amount of statues, marble-covered walls, and mosaic floors that contained pools and also massage rooms and sweating rooms.

Claiming that the gods had taken offense at the scandalous deterioration that so many shrines suffered, Augustus also promoted the restoration of a great amount of temples. His aim was to rekindle the religious devotion of the citizens in view of an increased respect for the state. For that reason, just as Julius Caesar had done before, Augustus assumed the title of *pontifex maximus* (A.D. 12), who, just like the father within the microcosm of the household, was assigned to perform the rituals that assured the peaceful concordance between the patron divinities and the state. Exploiting the lofty prestige that the position of *pontifex maximus* embodied, Augustus was able to convince his fellow citizens that his leadership had been directly chosen by the gods, who, like a father within the family, had assigned to him the guardianship of the city.

To bestow upon Rome a mantle of munificence, Augustus's architects closely followed the guidelines developed in Greek classical times: from the use of columns (with Corinthian, Ionian, or Doric capitals, to which the Romans added a hybrid form known as Composite), to the design of elegant temples and basilicas—the elongated halls framed by side colonnades that were used as law and business courts.

To add color to that great scenario, a polychrome variety of stones and marbles (which were also used as a reminder of the amazing geographic expansion of the empire) was deployed: yellow and ocher marble from Numidia, deep-red porphyry from Egypt, translucent alabaster from the Near East, pure-white marble from the island of

Poros in Greece or the Luna quarries in Italy, besides all the hues of
pink, gray, or red derived from different kinds of granite.

To further bolster the reputation of Rome, Augustus's propa-
ganda used the city as a showcase for the most prestigious trophies of
war—like those pillaged from Egypt, a country that always fired up
the Roman imagination with the mysterious beauty of its old and leg-
endary civilization. Among the most striking spoils was the magnifi-
cent obelisk from Heliopolis, a huge phallic symbol that represented
the god of light and fertility, Osiris. Once in Rome, the obelisk was
rededicated to Apollo and placed on the central *spina* of the old arena,
called Circus Maximus, which was used for popular sports, especially
chariot races.

Making Apollo the patron of the circus was a fitting choice
because, in the myth, the sun god daily drove his four-horse chariot
across the sky. The celebration of Apollo was also an indirect way to
praise the leader of the empire, who had elected Apollo as his patron-
god. Significantly, the imperial image that was placed on Augustus's
triumphal arch (and on his enormous mausoleum) was that of the sun
god Apollo proudly riding his golden chariot. The connection with
the god was also used to reinforce a popular rumor that claimed that
Augustus's mother had been impregnated by Apollo, who appeared as
a snake while she was asleep in his temple. Augustus never addressed
the story, but the simple fact that he never openly denied it seemed an
indirect acknowledgment of the veracity of the rumor. Mystery and
magic did the rest: the emperor was soon revered as a mythical figure
by the highly impressionable people of Rome.

Although full of Greek references, the architectural style that pre-
vailed during Augustus's age followed the Roman preference for the
massive and the imposing in contrast with the more restrained sense
of balance and measure that had characterized the simple elegance of
Greek classical times—a tendency that was further elaborated by the
brilliance of Roman engineers who also perfected the use of the arch
and the vault.

Even if larger and somehow more grand and showy, the austere

solidity that Rome's architecture radiated expressed the same ten-
dency toward clarity, proportion, and rationality made popular by the
Greeks. Vitruvius (ca. 80/70–ca. 15 B.C.), the famous architect and
engineer who lived during Augustus's time, wrote in his treatise *On
Architecture* that an architect was to be an educated man with knowl-
edge of arithmetic, geometry, philosophy, history, law, astronomy,
and music. Vitruvius's stress on a well-rounded personality shows the
affinity with the Greek concept of *paideia,* according to which edu-
cation, more than a simple accumulation of knowledge, involved an
overall process of mental and spiritual growth and maturation.

If the architect, Vitruvius stated, wanted to express beauty, he
had to first understand the timeless quality of beauty as it trans-
pired in the symmetry and proportion that, for the Romans as for
the Greeks, pervaded all natural things. Following a well-established
philosophical tradition, Vitruvius attributed an ethical and pedagogi-
cal intention to the beauty of art—a beauty that, just like the verbal
refinement of rhetoric, was expected to inflame the heart and mind
of the viewers toward greater and nobler thoughts and ideals. (Rome's
urban plan became a model for all other cities of the empire, which,
besides a central forum, had theaters, temples, and baths.)

Among the architectural initiatives that Augustus undertook,
none was more important than the new Forum bearing his name,
which was built in the center of the city, adjacent to the Forum of Cae-
sar. The Forum was a square flanked by two long lines of colonnades.

In the many niches that appeared between the columns stood the
statues of the most famous republican personalities—all the heroic
and larger-than-life characters (like Cincinnatus) whose stoic and self-
less devotion had sprinkled with the golden dust of eternal glory the
history of the early republic. Naturally, the model of perfection that
stood at the top of that mighty pyramid of virtues was embodied by
the father of the nation: Augustus, whose forty-six-foot-high mar-
ble image was kept in an ornate cell at the end of one of the colon-
nades. The association with the founding fathers of the republic was
an implicit way to affirm that the history of Rome had reached its
pinnacle with Augustus, the ultimate champion of Roman greatness.

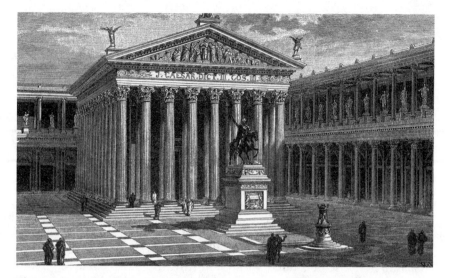

The new Forum built by Augustus associated the emperor in every way with the virtuous and heroic old republic.

Within the Forum was also the temple of Mars Ultor (Mars the Avenger) that Augustus built to celebrate the famous great-uncle whom he had promised to avenge. Paul Zanker, the author of an important book about Augustus's use of images, explains that the choice was also meant to recall the mythical origin of Rome. According to legend, the god Mars, in one of his many escapades into the world, had managed to impregnate the vestal virgin Rea Silvia, daughter of Numitor, king of Alba Longa, who had been displaced by his brother Amulius. When Rea Silvia gave birth to the twin brothers Romulus and Remus, Amulius, to eliminate the possibility that one day the boys might threaten his rule, tried to kill them by throwing them in the river Tiber. But the babies survived, saved by a she-wolf that nursed them with her milk and then by a shepherd who took care of them as if they were his own children. When they grew, the twin brothers decided to found a new city near the banks of the Tiber. While they were choosing the exact location for the future city, a dispute arose between the two brothers. Following an old tradition, Romulus plowed a furrow to mark the perimeter of the future city. When Remus dared to jump over that limit, Romulus killed

him, thus marking with brotherly blood the beginning of Rome. The bottom line of that complex use of mythology was that while Mars seeded the martial virility of Rome, Venus (from whom the Julian family derived) was the guarantor of its formidable prosperity.

To celebrate the inauguration of the Forum, the emperor financed many popular events: athletic contests, acrobatic shows, chariot races, plus a great amount of animal hunts. (It seems that *just* for the inauguration of the Forum, 260 lions were slaughtered to amuse the people of Rome.)

To avoid any undesired comparisons with the grandiose pretentiousness pursued by the Hellenistic monarchs, Augustus made sure to always maintain a very low-key demeanor in his daily life. He lived in a simple house decorated with plain furniture, ate coarse food, and wore a homespun woolen tunic that was said to have been woven by his wife and his niece instead of by a slave. Skillfully performed, that humble conduct was designed to portray the emperor as an unflappable leader who had gained authority by moral prestige rather than by ambition, cunning, and intrigue. The fact that his house stood right next to the temple of Apollo had an important symbolic meaning: in contrast with Marc Antony, who, driven by moral flabbiness, had compared himself to Dionysus, Augustus always presented himself as a faithful follower of Apollo—the god of rationality, measure, balance, and restraint.

The most important sculptural image of the emperor is known as Augustus of Prima Porta. In a way that is strikingly reminiscent of Polycleitus's *Doryphorus,* the greatness of the emperor is expressed through a godlike beauty that is at the same time physical and mental, as indicated by Augustus's firm yet calm and confident demeanor—a demeanor to which a special touch has been added: the raised arm typical of an orator. Why is the detail so important? To answer, we have to turn again to the Greeks, who, since the time of Homer, had always deemed oratory a political necessity, especially among military leaders, who, in order to encourage their soldiers to face death with dignity, had to remind them of the eternal glory that their sacrifice would earn them. Later, as we have seen, the art of oratory was given a

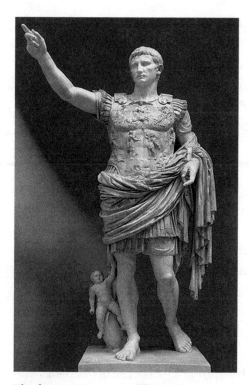

The famous Augustus of Prima Porta—every inch a confident leader and close to a god

dangerous twist by the Sophists, who argued that a beautifully crafted speech was an ideal tool to gain influence on the political stage. The Sophists' position was vehemently opposed by Socrates and Plato as well as by Aristotle, who, in his *Rhetoric,* claimed that to maintain words free from the malevolent spin of demagogy, the orator was to firmly weld the Logos of eloquence with the Logos of reason and morality. The immense resonance that Aristotle's lesson produced informed the solemnity attributed to the propagandistic image of Augustus—the man whose just actions and just words were equally trustworthy for their honesty and integrity. To support that claim, Augustus always applied to his words the same simplicity he kept in his personal demeanor. Suetonius said that the emperor willingly avoided any forced and affected verbal embellishments, which he called "the stink of far-fetched phrases." His ambition was not to impress the audience with a sonorous speech but to gain the trust of the people through the clarity and transparency of a few direct and honest words. (Americans will ascribe a similar verbal ability to the greatest of presidents, Abraham Lincoln.)

The clear conviction that the calm composure of Augustus's statue conveyed was also a way to address the emperor's role as pacifier interested in bringing law, peace, and unity to the great racial, cultural, and religious diversity that constituted the Roman commonwealth. Those who had resisted Roman power were described as treacherous people,

like the uncivilized Parthians depicted on the cuirass, or breastplate, of the statue. The event evoked the recovery of the military standards that the foe Parthians had snatched away from the Romans during a battle along the eastern frontiers of the empire. (The Parthians, who occupied a region that more or less coincides with today's Iran, were the most formidable enemies that Rome had in the East.) The episode was chosen to show how the uncivilized easterners had been put to shame by the superior nobility of the Roman race.

What is interesting to notice is that to increase the mythical aura that surrounded Augustus, his image, in contrast with the crude realism so congenial to the Romans, always bore the idealized traits of a handsome, strong, and eternally young man. Indeed it was a very flattering portrait for a man who, in reality, seems to have been quite frail (Suetonius tells us that he often suffered from colds, diarrhea, bladder problems, and rheumatism) and unattractive (to conceal his modest height, Augustus would wear shoes designed to elevate him a few inches). The fact that time transformed the appearance of everyone, except that of the eternally young and beautiful emperor, was a way to elevate him to a super-mundane status—a reference underlined by a small Cupid riding a dolphin that was used as a reminder of his divine lineage as a descendant of Venus (Cupid was Venus's son). The detail was also meant to confirm that Augustus's ascent to power had not occurred by chance but been directly foreordained by the gods.

As an example of *pietas* (intended as devotion to family and state), the emperor was also portrayed as *pontifex maximus*. In Augustus's idealized image, all virtues converged: fortitude, courage, military distinction, and the integrity of moral wisdom. In a way strongly reminiscent of Plato's theory of a state led by philosopher-kings, Augustus was presented as the embodiment of reason—the cornerstone upon which rested the solid ideal of an empire brimming with justice, virtue, and law.

Reproduced thousands of times, on statues and on coins, those standardized and idealized portraits of the emperor were made ubiquitous throughout the empire. The omnipresence and omnipotence

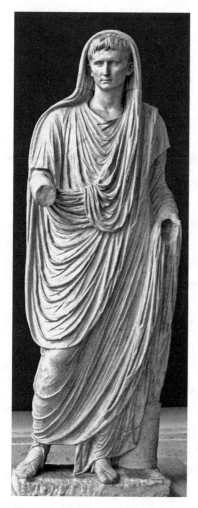

Augustus as the *pontifex maximus*

of the emperor was to be a reminder that the imperial cult also represented the cult of the ancestral tradition. As a superior example of virtue, the emperor was to be honored and emulated as the greatest expression of *romanitas*.

That carefully nurtured cult of the emperor also included the glorification of the members of his family, whose marble statues were placed in the Forum next to the vast crowd of effigies that depicted the most notable protagonists of Roman history. To assure a recognizable status to his dynastic lineage, Augustus dedicated to his relatives a number of famous architectural enterprises, like the Portico of Livia, built in honor of his wife, and the Portico of Octavia, which was conceived as a tribute to his sister. Other architectural landmarks were dedicated to the four young men—the nephew Marcello, the stepson Druso, the grandsons Gaius and Lucius—whom Augustus had chosen as his successors, although destiny repeatedly interrupted his plan by ending their lives at a very young age. The strong resemblance to the emperor that the marble portraits attributed to these youngsters shows the conscious choice of presenting them as clones of Augustus. It was reported that to push as far as possible that stage-managed resemblance, Augustus tried to teach them to imitate his own handwriting.

Augustus's desire to assure continuity to his legacy was a way to keep alive the myth he had crafted not just for himself but also for the

Roman people on whom his stewardship had bestowed the dignity of a highly romanticized identity. The early Romans had been rough people driven to conquest by the desire to enrich themselves through looting and pillage. The brilliance of Augustus was to understand that in order to establish political consensus and turn those coarse conquerors into disciplined subjects, a grandiose narrative capable of providing an inspiring meaning to history needed to be created. In pursuit of that purpose, Augustus's propaganda suggested that the Romans had been successful conquerors not just because of their strength but because, as paragons of virtue, they had been selected by the gods as their chosen people. With a similar intent, those who had been conquered were led to believe that being corralled within the folds of the Roman Empire was not a defeat but rather a lucky opportunity to become part of the outstanding civilization made by men whose superior character had been forged by reason, law, and ethical principles.

To enhance that awesome narrative, Augustus's propaganda used not only the visual arts but also the work of writers and poets, who endlessly harped on the glowing qualities of early Roman times. Among them was Livy, the author of the famous book *Ab urbe condita* (From the foundation of the city), which was a collection of stories about the most distinguished figures of early republican times, people whom the Romans were urged to emulate in order to preserve the good fortunes of the city. Among the stories meant to assign a missionary role to Rome, Livy recalled the event that took place when Romulus, the founder of Rome, suddenly disappeared while reviewing his troops, lifted toward the sky by an impetuous vortex of wind.

Shortly after, the people who had gathered to mourn the disappearance of their leader heard his voice thundering from the heavens: "Go, and tell the Romans that it is the will of Heaven that my city of Rome should become the capital of the world. Let them attend the arts of war; and let them know—and pass the knowledge on to their descendants—that no human force will ever be able to resist the Roman arms."

Those prophetic words convinced the Romans that the cause of

Romulus's disappearance had been a divinely guided apotheosis: the founder of Rome had been raised, alive, to the heavens to reside among the gods of Olympus. Certainly a well-deserved destiny for the man who had founded the city destined to spread the ennobling quality of civilization over the entire world. The famous Pantheon that Agrippa, a close collaborator of Augustus's, commissioned was erected in the place where Romulus, according to legend, had disappeared. The opening, called an oculus, or "eye," on top of the enormous cupola was originally intended as a reminder of Romulus's ascent to the heavens.[*]

With Horace and Virgil, the prophetic tone of Livy's prose was morphed into a poetic encomium of the Golden Age of peace and prosperity that Augustus had initiated. Particularly famous, in that sense, was the prophecy that appeared in book 4 of Virgil's *Eclogues* (a poem written in praise of the farmer's life), where the author, celebrating the advent of the new Golden Age, wrote,

> Ours is the crowning era foretold in prophecy:
> Born of Time, a great new cycle of centuries
> Begins. Justice returns to earth, the Golden Age
> Returns, and its first-born comes down from heaven above.

Who was the mysterious child who was going to descend from heaven to save the world? Some scholars say that the poet might have hinted at a possible future child born from Augustus. More likely, the reference was simply a way to announce the rejuvenation of the world that Augustus, as a mythical *alter conditor* (second founder of Rome), had made possible. As we will see, those words were given a whole new meaning during the Christian Middle Ages, when Virgil's

[*] Many centuries later, when the Pantheon became Christianized, Romulus's ascension was replaced by the ascension of the Virgin Mary. In the seventeenth and eighteenth centuries, the ascension of Mary was commemorated, every May, with a theatrical reenactment that consisted of pulling through the oculus a puppetlike figure of the Mother of Christ flying off toward the sky amid a shower of colorful flowers.

mysterious child came to be identified with Jesus. The reason Virgil was recruited by Dante as a guide in the *Divine Comedy* derived from the Christian belief that the Latin poet, illuminated by the word of God, had been granted the gift of true prophecy, even though he was a pagan.

Since the times of Hesiod, the Greeks had pessimistically believed that history was inevitably destined to follow a declining course and used the terms "Golden, Silver, and Bronze Age" to describe, in descending order, different periods. The traditional belief that goodness and happiness had existed only in a distant, primeval era was overturned by the Augustan poets who claimed that the times they were living in represented the beginning of a new era that, unlike previous times, was going to build a present and a future so brilliant as to be impermeable to decay and corruption.

Of all the mythmakers of Augustus's time, the greatest of all was Virgil, whose *Aeneid* shrewdly linked the Augustan age to the most legendary of all beginnings—the war of Troy, sung by Homer—that gave Rome the noble past from which would develop its glorious future. The connection between Rome and Troy was also astutely constructed as a way to emancipate the Romans from the sense of inferiority they felt vis-à-vis the much-admired but also much-envied and much-resented Greeks.

The protagonist of Virgil's epic is Aeneas, the son of the Trojan nobleman Anchises and the goddess Venus. The first prophecy that appears in the *Aeneid* is that of Jupiter, who tells Venus that her son Aeneas is destined to initiate the history of a city to which the gods had bestowed the unique gift of unlimited glory: "To the people of Romulus I set no fixed goal to achieve. . . . I have given them authority without limit."

The reason why Aeneas is selected as precursor of such an amazing future is made immediately evident by the virtuous obedience with which the levelheaded hero takes on the responsibility that the god had assigned. At the beginning of the story, Aeneas and his men, who have escaped the destruction of Troy, are caught in a terrible tem-

pest at sea. Forced to reach land, they find themselves in the northern African kingdom of Carthage, where they are warmly welcomed to the palace by the queen Dido. At her court, Aeneas narrates to Dido some of the most dramatic events that accompanied the fall of his native Troy: from the wooden horse that doomed the Trojans' fate to his escape from the burning city with his young son Ascanius and his old father, Anchises (who died before their landing in Carthage).

The love story that soon blooms between Dido and Aeneas keeps the hero in Carthage for a full winter. But when spring comes, Aeneas resolves to obey the call of destiny, leaving behind the leisurely life he has enjoyed next to his lover Dido. Dido's tremendous sorrow, which eventually results in her suicide, cannot dissuade the hero, who sails away while Dido's funeral pyre shines on the ever-distant shore.

For a Roman of those times, the implicit comparison between Aeneas, who evoked Augustus, and Marc Antony must have been very clear. Marc Antony, who had repudiated his Roman wife for an illicit love affair with an Eastern queen, had proven to be vastly undeserving of the legacy of Aeneas: the pious, dutiful, and strong-willed precursor of Rome who, just like Augustus, never hesitated to put off his own interests to bravely fulfill the destiny that the gods had assigned.

When he finally arrives on the shores of Italy, Aeneas lands in the proximity of Cumae. The famous Cumaean Sybil allows Aeneas to descend to the underworld to visit the ghost of his father, Anchises. During his journey in the afterworld, Aeneas encounters many people he knew when they were alive, Dido included. When he is finally reunited with Anchises, Aeneas learns about the "illustrious souls" that, one day, will inherit their "Trojan name" (6.759). The universal, redemptive, and providential destiny assigned by the gods to Rome is presented with these words by Anchises:

> Others (I can well believe) will hammer out bronze that breathes
> with more delicacy than us, draw out living features
> from the marble: plead their causes better, trace with instruments

the movement of the skies, and tell the rising of the constellations:
remember, Roman, it is for you to rule the nations with your
 power,
(that will be your skill) to crown peace with law,
to spare the conquered, and subdue the proud.

<div style="text-align: right">(AENEID 6.847–53)</div>

The others, to whom Anchises's words assign great ability in art, music, rhetoric, and astronomy, are the Greeks—brilliant people, Anchises intimates, but not as brilliant as the Romans, whom the gods had ultimately chosen to assure justice, law, and peace over the entire world.

The goal of the *Aeneid* was to instill in the Roman mind the conviction that the empire, rather than being solely the result of ruthless violence, represented the gods' recognition that no other people were as laudable as the virtuous and courageous Romans.

With Augustus, the role of Rome was elevated to become, as Lidia Storoni Mazzolani writes in *The Idea of the City in Roman Thought,* "the City of Mankind, the lighthouse of civilisation, the mother of the nations—the greatest, proudest, most eternal, unconquered, protective, divine of all cities."

Of course, the greatness that such myth inplies should not blind us to some ugly historical facts. As the historian J. M. Roberts writes, "In many provinces revolt was endemic, always likely to be provoked by a particular burst of harsh or bad government." The other endemic problem was the poverty that oppressed many members of the lower classes who filled the urban environment and also the countryside. (In spite of the emphasis on urbanization, in fact Roman society remained essentially agricultural and rural.)

The myth cultivated by Augustus's propaganda was given a visual rendering in the famous *Ara Pacis* (Altar of Peace). The decorative reliefs depicted in the marble panels that run around the external part of the *Ara Pacis* celebrate the achievements of Augustus, who is seen giving offerings to the gods next to the legendary Aeneas. The rapprochement between Aeneas and Augustus was meant to stress the

common lineage of the two men (both being descendants of Venus) as well as their common role as fathers of the nation.

The majestic procession that unfolds on the longer sides of the *Ara Pacis* represents Augustus and the members of his family, including his direct and adopted grandchildren, heading toward the altar of the Goddess of Peace.

At the entrance of the altar, the image of the motherly matron surrounded by children, animals, and the richness of nature allegorically indicated the peaceful fruitfulness of that blessed new age.

In his *Fasti,* Ovid, the other famous poet of the Augustan era, celebrated with these words the great peace that the Romans had established:

> Let the soldier carry arms only to repress arms.
> Let the trumpet sound only for ceremony.
> Let the ends of the earth stand in awe of the men of Rome:
> If not fear, let there be love.
> Priests, add incense to the flames of Peace,
> Strike down the white victim.
> May the house which guarantees peace, in peace last for ever—
> Be that your prayer to the gods who love pity.
>
> (*FASTI* 1.709–22)

After the war that for so many centuries men of great character had conducted, peace was finally going to triumph in a world made one under the wise leadership of Rome.

The intention of Augustus's political propaganda was to smooth the sharp edges of Rome's imperialism and define its control over other nations as, to use the words of Lidia Storoni Mazzolani, a benevolent "protectorate" rather than a harsh "dominion." Despite that apparent inclusivity, however, Augustus never relinquished his view of the Romans as a master race. The point is expressed by Suetonius, who wrote that Augustus wanted to keep the Romans uncontaminated by foreign blood: "Augustus thought most important not to let the native stock be tainted with foreign or servile blood, and was

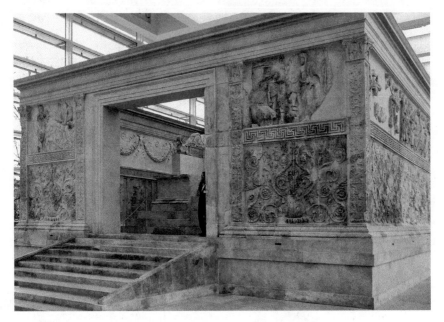

The *Ara Pacis,* or Altar of Peace, whose relief panels served Augustus's propaganda purposes

Aeneas and Augustus, two fathers of the Roman nation

The Augustan family, in majestic procession

An allegorical rendering of the peace and prosperity of the Augustan age

therefore unwilling to create new Roman citizens." Following Augustus's policy, citizenship remained a privilege sparingly granted to non-Roman people living beyond the Italian territories. Only with the emperor Caracalla, in A.D. 212, were all freemen in the empire finally given full citizenship.

It was reported that Pericles, on his deathbed, said that he wanted to be remembered for never having used power for a selfish purpose. Suetonius writes that just before dying, Augustus said, "Have I played my part in the farce of life creditably enough?" And then he added, "If I pleased you, kindly signify your appreciation with a warm good-bye." The image, which recalls an actor accepting the applause of the public before exiting the scene, appears well fitted to an emperor so apt at mixing fiction and reality within the theater of politics.

<center>❋</center>

AUGUSTUS'S SUCCESSORS

When Augustus died in A.D. 14, after more than forty-four years in power, the danger of a political system hinging on the arbitrary whims of a single man acting without the assistance of the collective wisdom represented by the Senate soon became evident. Augustus had been a man of immense ambition, but his desire to improve the life of his fellow citizens cannot be doubted. The simple fact that to avoid an increase in taxes, he often used his own fortune to cover governmental expenses proves his dedication to the well-being of the city. A similar kind of benign despotism would not be found in later members of the Julio-Claudian dynasty. The gloomy Tiberius and the physically challenged Claudius were relatively competent rulers, but Caligula and Nero were definitely two degenerates who saw power as a private privilege to be used and abused at will.

Caligula, who ruled between A.D. 37 and 41, was an egomaniac who used to compare himself to a pharaoh and asked from his subjects the same kind of devotion due to a god. Suetonius writes that Cal-

igula often appeared in public wearing jewels and a cloak encrusted with precious stones. Occasionally, he carried a trident to be associated with Neptune or a caduceus to resemble Mercury. At times, he even dressed up like Venus. His favorite divinity was Jupiter, of whom he claimed to be the embodiment. Because of that, Caligula had many statues of the god decapitated and their heads replaced with new ones bearing his own features. He committed incest with three of his sisters and enjoyed the spectacle of human agony and torture. The method of killing he ordered his soldiers to use consisted of blows that would leave the victim covered with wounds but spare vital organs. The pleasure he felt witnessing the slow death of a human being was captured in his favorite motto, "Make him feel that he is dying." Despite such unblinking ruthlessness, he was a very fearful man: Suetonius says that at the first sound of distant thunder, he would run to bed and hide his head under the sheets. Caligula was famous for indulging in all sorts of decadent habits, like bathing in hot and cold perfumes, drinking pearls dissolved in vinegar, and spending time and money on all sorts of extravagant projects, including building grandiose galleys with jeweled decks, multicolored sails, colonnades, and banqueting halls for his one-day cruises, or a stable made of marble and ivory for his favorite horse, whom he planned to elevate to the position of consul. When in need of more funds to finance his lavish amusements, Caligula did not hesitate to impose higher taxes on his subjects.

With such venal and unprincipled leadership, the moral integrity that Augustus had tried to enforce within society soon degenerated. As vice and corruption spread, many people sought consolation in religion, especially in the Mystery cults, coming from the East, that promised salvation after death, like the cult of Isis, imported from Egypt, and that of Mithras from Persia. The sun god Mithras, who was believed to lead the war between good and evil that had permeated the Persian mind since the time of Zoroaster, is represented in an important fresco in Rome known as the *Barberini Mithraeum*. In the fresco, Mithras, wearing a cloak decorated with seven stars representing the seven planets, is seen slaying the cosmic bull. It was believed

that from the blood of the animal the rotating motion of the sky had begun and with it the rhythmical dance of the zodiac signs that determined the seasons and, to a great extent, the destiny of every human life.

Also Christianity, which derived from Judaism—Christ, who was born toward the end of Augustus's reign, preached and died in Palestine during the time of Tiberius—must initially have been considered a mystery religion because of the secret ritual of initiation—that is, baptism—that its followers undertook.

In general, Rome had always been very tolerant toward the gods of the people it conquered and had no problem in adapting and assimilating foreign divinities to its already crowded Olympus. The reason for that relaxed attitude was that the only religion that truly mattered for Rome was the one that involved the divinities that had assisted the ascending parable of its sterling history. As such, the only thing that Rome asked back from its subjects—who were otherwise free to choose whatever religion they wanted—was a total devotion toward the generous gods that had engineered the good fortunes of the city. As many scholars have pointed out, the benevolence with which Rome handled the cults and religions of the people it conquered helped enhance, with positive results, the general cohesion of the empire.

But things were not as easy when Christians were involved: because they steadfastly refused to pay tribute to the emperor and to Rome's tutelary divinities in the belief that only their God was worthy of devotion, Christians soon became targets of suspicion on the part of the political apparatus. Among the many fallacious rumors spread against the Christians were the ones that accused them of immoral conduct and sexual promiscuity (because they called themselves "brothers" and "sisters") and even cannibalistic practices—an evident misunderstanding of the Eucharistic ritual, in which Christians were said to eat and drink the flesh and blood of their Savior.

During Nero's reign (A.D. 54–68), the first terrible wave of state-sponsored persecutions occurred. Many scholars have inferred that the cruelty Nero displayed against the Christians was a sign of a growing pathology threatening his unstable mind. His actions seemed to con-

firm that suspicion: he brutally killed his mother and his wife, and, like Caligula, he didn't hesitate to exhaust the state treasury to satisfy his capricious taste in all sorts of exuberant excesses. Although he had received an excellent education from the Stoic philosopher Seneca (4 B.C.–A.D. 65), virtue was definitely not a trait of his personality. He loved music, poetry, and theater and surrounded himself with writers and artists. Because he was an exhibitionist who craved flattery and attention, he often staged grand public performances in which he acted, sang, played the lyre, and recited poetic verses that in many cases he had personally composed. His performances, accompanied by the exaggerated applause of a servile audience, went on for hours. No one was allowed to show signs of boredom or indifference, and no one was allowed to leave. People often fainted, or pretended to faint, just to put an end to those interminable displays of ego-stroking vanity. Portraying himself as a great patron of culture, Nero instituted new games, called *Neronia,* dedicated to Greek arts and traditions. He shocked many members of his court when, during these festivals, he mocked the gravitas of many senators by forcing them to compete as actors, dancers, musicians, and athletes.

When a devastating fire broke out in Rome, the emperor readily accused the Christians of the crime, condemning them en masse to death. Suetonius, who suspected that Nero had been responsible for igniting the fire, claimed, probably with some exaggeration, that he played the lyre and sang the "sack of Ilium" (meaning "sack of Troy") while the city was enveloped in flames. The historian Tacitus (ca. A.D. 56–ca. 117), who described Nero's persecution of the Christians, wrote in his *Annals* that some of the victims were "covered with the skins of wild beasts" and then left "to be devoured by dogs," while others were dipped in oil and nailed to crosses to then be set on fire "to serve as torches, during the night."

Notwithstanding such a great amount of agony and humiliation, Christians remained incredibly strong and brave. Death did not scare them. On the contrary, to receive martyrdom in the name of God was considered a great privilege and also a sure way to get a pass to eternal salvation. Justin Martyr (A.D. 100–165) put it this way: "Since

our thoughts are not fixed on the present, we are not concerned when men put us to death. Death is a debt we must pay anyway."

How could the state successfully pursue a campaign of repression against people who welcomed death with such serenity? Rome had never experienced anything like that. Disarming as they were, the Christians were among the toughest adversaries that Rome had ever confronted.

Many Romans, who believed that Nero had caused the fire, said that his real purpose was to clear the land for the construction of his new, luxurious residence called the Domus Aurea. The Domus Aurea was conceived as a mini-replica of the world: a grand playhouse built to satisfy the childlike mind of an emperor who liked to claim ownership of the universe as if he were a god.

When Nero inaugurated the enormous palace, Suetonius tells us, he allegedly sighed and said, "At last, I can begin to live like a human being!" The colossal statue that, according to Suetonius, was placed at the entrance of the Domus Aurea represented a naked sun god with rays of light jutting out of his head, but with facial features that clearly belonged to Nero.

To appease the people and distract them from his capricious habits, Nero sponsored many bloody games and also built a new, gigantic amphitheater where, allegedly, Saint Peter was crucified—in an upside-down position, as Peter personally requested, because he did not feel worthy of the same sacrifice that Christ had endured.

The toxic atmosphere that Nero's aberrant behavior produced led many to believe that an irreversible decline had seized the Roman world. Tacitus, the historian who in his *Annals* and *Histories* described the reigns of Tiberius, Claudius, and Nero, wrote about the corrupting effects of absolute power and the negligent complicity that had infected all levels of society: from the upper class, who maintained a hypocritical deference toward the emperor just to protect its own interests, to the ignorant and mindless plebeians, who were easily kept content with free food and free access to the orgies of blood that took place in the circuses—a decadent depravity that the poet Juvenal (ca. A.D. 60–ca. 130) sanctioned with these famous words: "The

people that once bestowed . . . consulship, legions and all else, now meddles no more and eagerly longs for just two things, bread and circuses [*panem et circenses*]."

Vice had proved stronger than virtue and evil more pervasive than good. Like other moralists who idealized the republican past, Tacitus was critical of imperial power and had a negative view of Greek culture, which, in his view, had profoundly softened the Roman character. He was revolted by Nero's theatrical poses and condemned as laxity his infatuation with poetry and music. He called those who had been influenced by Greek taste and fashion by the worst names he could think of, such as actors, prostitutes, eunuchs, ballet dancers, singers, astrologers, and homosexuals. His abrasive words of condemnation included Jews and Christians who, by refusing to pay tribute to the traditional gods, had caused the pernicious consequences that had doomed his times.

The critic Ronald Mellor writes that Virgil and Tacitus were the creators of two opposite myths: while Virgil sang of Augustus's time as a miraculous beginning of a happy era of peace and prosperity, Tacitus mourned the setting splendor of a city that, in his view, had been permanently tarnished by vice and corruption. Augustus's propaganda had attempted to disguise under a benign mask the imperialistic system that now governed Rome. Tacitus ripped off that false facade, claiming that what Rome called civilization was, in reality, only oppression, exploitation, and abuse. Tragically aware of that truth, he gave voice to a fictional barbarian (in his book *Agricola*) to deliver this scathing indictment of Rome: "They ravage, they slaughter, they seize by false pretenses and all of this they hail as the construction of an empire. And when in their wake nothing remains but a desert they call it peace."

After Nero, whom the Senate had condemned as a public enemy, was finally assassinated, a harsh fight between aspiring successors ensued. The man who finally emerged as the next emperor was Vespasian, who belonged to the Flavians, a nonaristocratic family who had accumulated wealth through commerce and advantageous marriages and later achieved fame and honor in the ranks of the military.

Because he was aware that his family lacked the glowing aristocratic veneer that the members of the Julio-Claudian line had boasted, Vespasian put a lot of energy into sponsoring projects that could win him the approval of the populace. Symbolically, Vespasian's most important act was the destruction of Nero's Domus Aurea and the draining of the lake that had once embellished the villa's gardens. To draw a clear distinction between himself and his predecessor, Vespasian selected the ground where Nero's Domus Aurea had stood as the place where his gift to Rome would be built—the new, grandiose amphitheater, later known as the Colosseum.

The name Colosseum derived from the colossal bronze statue that, as mentioned above, initially stood next to the Domus Aurea. That statue, which after Nero's death was given a new head with the feature of the sun god, was placed near the Flavian arena. From that colossal presence the Colosseum got its name. Before vanishing in the eighth century A.D., that imposing statue was used as a symbol of the state in front of which every citizen had to profess his or her allegiance with offerings and prayers.

It is disturbing to think that to build the Colosseum, Vespasian

The plundering of the Temple of Jerusalem, rendered on the Arch of Titus

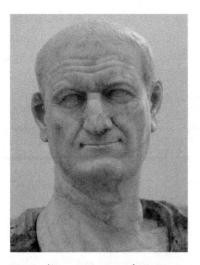

Vespasian was a more down-to-earth emperor than Augustus, yet he was still deified by his son Titus.

and his sons, Titus and Domitian, used much of the treasure accumulated when Rome, to repress a Jewish rebellion, captured Jerusalem and destroyed the Jewish Temple in A.D. 70—events commemorated by the reliefs that are still visible today on the Arch of Titus, where soldiers are seen carrying back to Rome the menorah and other precious objects plundered from the Temple in Jerusalem.

After the excesses of the previous emperors, Vespasian's capable and moderate leadership was greatly appreciated, in particular because of the stability he brought back to the empire's finances. Yet, unlike Augustus, Vespasian was never presented as an ideal of *pietas* or moral perfection. The naturalism that characterizes his rugged-looking bust is very explicit in this sense: only half a century after the death of the first emperor, society had become much too cynical to believe that its leaders were anything else than strong, skillful, and war-hardened military men. Despite that down-to-earth attitude, elevating power to mythical proportions remained a common Roman practice.

Suetonius reported that just before dying, Vespasian humorously said, "Oh dear, I think I am going to become a god." He was right: as soon as he passed away, his son Titus made sure to deify his father in a way that became customary among all emperors who had shown the slightest glimpse of decency toward the people of Rome.

Under Titus and later his brother, Domitian, the construction of the Colosseum was completed. The inauguration of the huge arena, which could accommodate more than fifty thousand spectators, lasted one hundred days. During that time, all sorts of sanguinary entertainments were staged: fights between gladiators, as well as fights

between men and such beasts as lions, tigers, and elephants. The most awe-inspiring events occurred when the arena was flooded with water and turned into an artificial lake. In the mock naval battles that took place in that diminished replica of the sea, an enormous number of men found a violent death, either by being butchered by swords or drowned. The famous Piazza Navona, in Rome, derives its name from *nave*, "boat" in Italian, because it used to be an amphitheater where similar mock battles took place.

The contemporary historian Mary Beard writes that trying to understand the Roman mentality is like balancing oneself on a tightrope. On one side are things that we can still appreciate today, like the Romans' contribution to art, architecture, engineering, and law. But as soon as we look on the other side, a shocking contrast emerges. How could people who called themselves civilized feel unfazed by the horrors of slavery and enjoy spectacles as gruesome as the ones performed in the Colosseum? The answer evokes the same prejudiced disdain that the Greeks nurtured toward all those who, by being non-Greek, were defined as barbarians. Similarly for the rough Romans who viewed all those who did not fit their cultural mold, such as foreigners, prisoners of war, slaves, condemned criminals, and Christians, as less than human and therefore unworthy of respect and compassion. The bloody games that at a subconscious level were reenactments of military battles served to keep alive the feelings of prejudice and contempt that had sustained the aggressive instincts of Rome's imperial expansion.

The last of the Flavian emperors, Domitian, was a strange mix of fanaticism, cruelty, and paranoia. Because he was convinced that his nonaristocratic lineage could be used against him, Domitian tried to elevate his prestige by trumpeting that it possessed a divine origin. His father, Vespasian, and his brother, Titus, had understood that paying some sort of respect to the Senate was important for the survival of the monarchy, even if, just as Augustus had taught, that act was purely ceremonial. Rejecting that tacit agreement, Domitian openly manifested his dislike for the Senate, whose advice he dismissed with condescending haughtiness. In promoting the cult of his personality, he demanded to be called *dominus et deus noster* (Our Lord and God).

When Domitian was murdered in a conspiracy organized by court officials, the Senate condemned his memory to oblivion through a decree, called *damnatio memoriae,* which involved the melting of all the coins and statues that bore his features and the destruction of all the buildings that had been erected in his honor.

The five emperors who followed Domitian—Nerva, Trajan, Hadrian, Antoninus Pius, and Marcus Aurelius—were famously called "the good emperors" by the widely acclaimed eighteenth-century historian Edward Gibbon, who, in his book *The Decline and Fall of the Roman Empire,* praised their times as the happiest in human history: "If a man were called to fix the period in the history of the world, during which the condition of the human race was most happy and prosperous, he would, without hesitation, name that which elapsed from the death of Domitian to the accession of Commodus."

Even if the era praised by Gibbon was marked by a sound economic policy and a steady administration, defining those times as the happiest in human history seems definitely overstated. Especially if one considers that the horror of slavery was still in full bloom, that women were still deprived of a public voice, that a tremendous amount of poverty plagued society, and that an unfathomable cruelty still corroded, like a deep-rooted cancer, Roman society.

Among the five "good emperors," the one who historically received the greatest amount of praise was the Spaniard Trajan, the first non-Italian emperor, who reigned from A.D. 98 to 117. What prompted such admiration was that Trajan was the first emperor to institute some sort of rudimentary programs aimed at providing food and shelter for orphaned children. Some historians claim that what moved Trajan's choice was not so much humanitarianism as the need to increase a population that had been decimated by diseases and epidemics. Whatever his motivation, the help he gave to the disenfranchised was enough to turn him into a legend that kept growing throughout the centuries.

In the Middle Ages, a popular legend spread the rumor that Pope Gregory I (reigned A.D. 590–604) had resurrected the "good emperor," just for the brief time necessary to baptize Trajan, who,

once converted to Christianity, dropped dead one more time. Also, in Dante's *Divine Comedy,* Trajan is given an important role. While the poet ascends the mountain of purgatory, he sees a series of vignettes sculpted in the rock. According to Dante, those vignettes, which were a product of God's divine Providence, had the didactic purpose of illustrating examples of humility to the souls that were purging their sins in purgatory. Among those examples, Dante includes Mary and the angel's annunciation, David dancing before the ark, and Trajan next to the widow who, as the legend reported, stopped him, while he was on his way to war, to demand justice for the murder of her son. Trajan's tremendous display of clemency, Dante wrote, consisted of the fact that the emperor, moved by the words of the poor widow, decided to briefly postpone his departure to satisfy her request for vengeance—which probably resulted in the killing of her son's murderers.

Why would that moment be listed as an outstanding example of humility? It's hard to make sense of it, at least from our modern perspective. The only thing that we can conclude is that the adjective "good" had a meaning that was very different from our contemporary definition. This is not meant to diminish the accomplishments of Trajan: he was certainly infinitely better than emperors like Caligula and Nero, but that does not change the fact that the mercy he was so famous for remained that of a master—a man who could use his arbitrary judgment to determine, as he wished, who lived and who died. Only in these terms can we understand why a simple gesture of consideration might have been described in such glowing tones by poor people used to remaining completely invisible in the eyes of their emperors.

The suspicion that Trajan might not have been the unassuming man his legend suggested seems confirmed when we learn that the supposedly humble emperor could not resist the temptation of building an immense new Forum in his own honor, which was inaugurated with 120 days of games in which rivers of blood (of gladiators, prisoners, and animals) were spilled for the amusement of the Roman populace.

Trajan was also responsible for building a great market area, near his Forum, and also for donating to the people of Rome a big bath complex enhanced, at the entrance, with an imposing statue of himself. One of Trajan's most famous landmarks was the awesome column (one of the few wonders of antiquity that can still be admired today) placed in the middle of his Forum, whose reliefs commemorated the campaign against Dacia (contemporary Romania). The beauty and originality of the column, made of pure-white marble from the island of Poros in Greece, consist of the magnificent sequence of sculptural images that wrap around it, bringing higher and higher toward the sky the memory and deeds of the brilliant leader and his army. When Trajan died, his ashes were placed at the bottom of the column in a golden container, while his bronze image was secured on its top to mark the apotheosis of the great leader who, by bringing glory to Rome, had earned for himself a place of honor among the immortal gods.

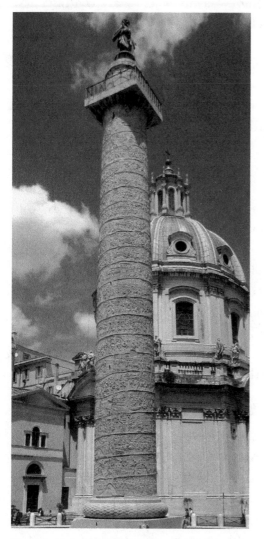

Trajan's Column, still standing in the Forum, memorialized his military achievements.

When Rome became the capital of Christianity and the seat of the papacy, many pagan monuments were Christianized. That also occurred when, in

1588, the church, in part to exorcise the pagan past, in part to celebrate its own power, decided to remove the bronze statue of the emperor, on top of Trajan's Column, to replace it with a statue of Saint Peter. The idea that for more than four hundred years Saint Peter has been looking down at the city from the top of a column covered with scenes of soldiers and war seems rather incongruous. But that whimsical overlapping of sacred and profane symbols is probably one of the most interesting aspects of Rome—a city where sharp contrasts have always managed to stand side by side in a bizarre yet also fluid and seamless coexistence.

With Trajan's conquest of Romania, the empire achieved its greatest extent. The need to strengthen the borders of the empire became a priority for Hadrian, Trajan's cousin and successor, who built a huge defensive wall along the northern frontier. Hadrian was a refined and cultivated man with an immense passion for beauty and art. In pursuit of that passion, he spent twelve of his twenty-one years in power away from Rome, touring different provinces of the empire. The villa he eventually built in Tivoli, a few miles outside Rome, was conceived like a personal museum with baths, libraries, theaters, and temples built in the many different architectural styles that Hadrian had admired during his travels around the world.

By placing his villa outside the city, Hadrian was following the pattern that had become popular since the late years of the republic, when the upper classes started to think of their country estates as places dedicated to the *otium* of pleasurable activities, away from the busy affairs, or *negotium,* of the city. Of course, the choice might also have been a way for Hadrian to keep his lavish and expensive passion for art at a safe distance from the scrutiny of fellow citizens, thus avoiding a possible backlash of criticism.

In Rome, Hadrian's name is forever linked to two very special architectural projects: the completion of the Pantheon and the grandiose construction of a mausoleum, which was built as a tomb for himself and his family. The structure, whose monumental size competed with Augustus's mausoleum, was big enough to be trans-

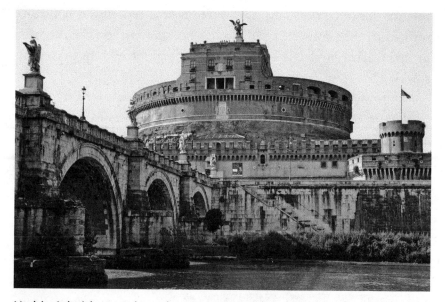

Hadrian's lavish mausoleum, later transformed into the papal fortress
Castel Sant'Angelo

formed, in later years, into a papal fortress, known, since then, as
Castel Sant'Angelo.

The good administration that had characterized Hadrian's rule
continued with his successor Marcus Aurelius, who acquired the rep-
utation of a philosopher-king for his commitment to the teachings
of Stoicism. Since the troubled times of Seneca, Stoicism, rather than
the philosophy of public engagement praised by Cicero, had returned
to being a philosophy of withdrawal and resignation. The Stoics of
these disillusioned times—to use Bertrand Russell's words—asked
not "how can men create a good State?" but rather "how can men be
virtuous in a wicked world, or happy in a world of suffering?" For
Seneca, who, as tutor of Nero, had witnessed firsthand the atrocities
of which human nature is capable, that fierce clinging to resignation
might have appeared as the only possible anchor of salvation in a
world full of violence and darkness.

When Seneca, disheartened by what he witnessed at Nero's court,
asked his master to be relieved of public duties, the emperor accepted.

But the sheltered oasis of peace where Seneca retired did not prove sufficiently safe from the cruel Nero, who, shortly thereafter, accused his old teacher of plotting against his life and forced him to commit suicide.

During his life, Seneca had often been accused of hypocrisy because of the wealth and comfort that his closeness to the emperor assured. But the dignity with which he confronted death assured his memory a glory that dissolved all previous reservations. "With all his faults," writes Will Durant with his usual wit, "[Seneca] was the greatest of Rome's philosophers. . . . Next to Cicero he was the most lovable hypocrite in history."

Following the Stoic principles that Seneca had professed, Marcus Aurelius claimed that the only way to achieve inner serenity was to

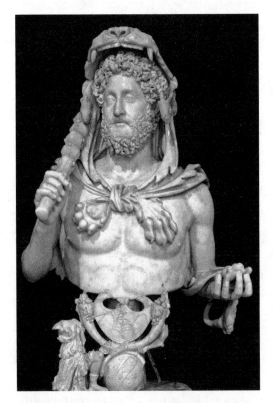

accept with dignity the incomprehensible events of life. That fatalism indicates that Marcus Aurelius was a very complex man, someone who might have wished to withdraw from the world to dedicate himself to the cultivation of the soul but as an emperor was forced to practice the exact opposite of what he was preaching. The fact that he wrote his *Meditations* during his campaign against the barbarian tribe of the Marcomanni is significant in that sense. At night, in his tent, he wrote of virtue, stoic acceptance, and purity of

The depraved Commodus, who filled Rome with images of himself as Hercules, draped in a lion's pelt

spirit, but as soon as morning came, he promptly replaced the pen with the sword to lead his troops into battle, where he urged his men to gain glory by slaughtering as many barbarians as possible.

Given that dissonance, even beautiful phrases like the following one from his *Meditations* assume a questionable meaning: "Consider frequently the connection of all things in the universe and their relation to one another. For things are somehow implicated with one another, and all in a way friendly to one another."

Even if the beauty of the quotation cannot be denied, we have to remember that in Marcus Aurelius's times the Stoic ideal of universal brotherhood was still a fiercely biased one that excluded all slaves as well as all uncivilized people like the less-than-human barbarians who lived outside the borders of Rome's vast empire.

It is strange to think that the man who succeeded the melancholic Marcus Aurelius was one of the most depraved emperors of Roman history: his son Commodus, who filled the empire with images of himself portrayed like Hercules with a lion skin covering his head. To emulate Hercules, Commodus often performed in the Colosseum. One of his favorite performances consisted in chasing, on a horse, a group of terrified ostriches let loose in the arena, which he killed by chopping off, one by one, all of their heads. When he wanted to stage a confrontation with other men, he made sure to select wounded prisoners or, even better, disabled amputees.

<div align="center">✳</div>

THE DECLINE OF THE EMPIRE
AND THE RISE OF CHRISTIANITY

With the passing of time, holding together the immense empire became an increasingly difficult task. In the third century, major calamities further exacerbated the already parlous situation; among them were a deep economic crisis, the spread of famine and epidemics, and the pressure of the many barbarian tribes that threatened to

cross the borders of the empire. To confront the latter problem, different solutions were attempted: from peace treaties with foreign tribes to enrolling friendly barbarians as mercenaries in the Roman army. To strengthen the system, Diocletian, who reigned from A.D. 284 to 305, established a despotic regime where military personnel, rather than civilians, were assigned to political offices. To assure a better defense of the frontiers, Diocletian also decided to share with a trusted general, named Maximian, the title of Augustus. Maximian was put in charge of the West while Diocletian, who always preferred his native Dalmatia to Rome, took control of the East. To assist the two Augustuses, two more co-rulers, who were each given the title of Caesar, were added. The high cost of this vast organization forced the creation of an intricate bureaucracy aimed at assuring a more efficient way to collect taxes from all the provinces of the empire.

To strengthen his authority, Diocletian declared that he was the incarnation of Jupiter and assumed the title of *Dominus,* meaning "Master" and "God." Diocletian also adopted the diadem: the jeweled head ornament that had been loathed by earlier generations as the most outlandish symbol of Eastern royalty. The historian Gibbon writes that as time went by, life in the palace was rendered increasingly "more difficult, by the institution of new forms and ceremonies. The avenues of the palace were strictly guarded by . . . domestic officers. The interior apartments were intrusted to the jealous vigilance of the eunuchs; the increase of whose numbers and influence was the most infallible symptom of the progress of despotism. When a subject was at length admitted to the Imperial presence, he was obliged, whatever might be his rank, to fall prostrate on the ground, and to adore, according to the eastern fashion, the divinity of his lord and master."

Because the Christians, whose fast-expanding religion had now reached every province of the empire, professed that the only *Dominus* that they were willing to respect was their God, Domitian unleashed against them a violent campaign of repression and persecution. By imperial order, Christians' properties were confiscated, churches destroyed, and assemblies forbidden, many Christians were tortured

and killed. It is often said that no weapon is stronger than words. Nothing proves that truth more than what Rome received from the pen of John of Patmos. The early Christians believed that it was John the Evangelist, but modern scholarship has rejected that view. John, it is now believed, was someone who fled the Roman persecutions in Palestine during the reign of Domitian and landed on the island of Patmos, near the coast of present-day Turkey, where he said he encountered an angel. The prophecy that was revealed to him by the angel was called the Apocalypse, meaning "revelation." The Apocalypse, which was written to bring consolation to the persecuted Christians, described the coming of the Messiah as an avenging warrior who, trampling the enemies under the hooves of his white horse, would bring about the triumph of Good over Evil that would crown the end of time. In his account, John condemned the Roman Empire as the ultimate evil, calling the sinful city of Rome a Babylon of depravity and a prostitute drunk with the blood of the Christian saints.

The history of Christianity suddenly changed under the emperor Constantine, who, having claimed the Western throne after the death of his father, was confronted by the Eastern rival Maxentius. On the eve of the battle, Constantine claimed to have had a dream in which a cross appeared accompanied by these prophetic words: "In this sign you will conquer." Interpreting the dream as a direct message from God, Constantine placed the Christ's insignia on all the banners of his army. The victory he obtained made the grateful emperor overturn the policy of his predecessors and declare unlawful the persecution of the Christians. With the Edict of Milan in 313, Constantine granted to all his subjects equal freedom of religion.

Besides returning to the Christians their confiscated properties, Constantine diverted major funds for the construction of Christian churches. The most important one, which was dedicated to Saint Peter, was built next to the old circus of Nero, where, allegedly, the saint had been crucified. To accommodate the vast congregations that attended the Christian ritual, Constantine's architects used the model of the old basilicas: the elongated rectangular structure ending in an apse that the Romans had used as courts of law.

In his *Oration in Praise of Constantine,* the fourth-century writer Eusebius wrote that God had directly selected Constantine as his representative and emissary on earth because of his exemplary valor and piety. "Our emperor, like the radiant sun, illuminates the most distant subjects of his empire. . . . Invested as he is with a semblance of heavenly sovereignty, he directs his gaze above, and frames his earthly government according to the pattern of that Divine original, feeling strength in its conformity to the monarchy of God."

The fact that Eusebius's words greatly exaggerated the religious qualities of the emperor is addressed by many scholars, who point out that Constantine only converted to Christianity at the very end of his life, in A.D. 337. That seems to indicate that behind Constantine's acceptance of Christianity was, more than an act of faith, a very precise political calculation: by siding with the God of Christianity, Constantine wished to be allied with a powerful divinity who would assist him in cementing his authority and also strengthen the unity among the citizens of the empire.

What Constantine probably did not realize was that the Christians were not the meek and peaceful people he might have initially thought. Constantine might have become aware of this as soon as, having allowed Christianity, he was confronted with different groups ferociously fighting one another to impose their own version of the religion. The most vociferous among these groups was the one led by Arius, who challenged the dogma of the Trinity by refusing to accept that Christ's divinity was identical to that of God, the Father. To put an end to the raging controversy that the Arians had unleashed, Constantine, asserting his power as political and also religious leader of the empire, held a council in the city of Nicaea, in modern Turkey, in A.D. 325. Following the council's resolution, the Son was definitely declared identical to the Father and Arius's movement condemned as heretical.

In contrast with the ideals of poverty and humility that the religion he had legalized so strongly preached, Constantine continued to indulge in the same life of splendor and luxury that so many other emperors before him had adopted. In pagan-like fashion, Constantine

also never repudiated his simultaneous allegiance to different divinities, such as Hercules, Apollo, and especially the popular *Sol Invictus,* the "Unconquered Sun God." The choice of Sunday as the Christian sacred day, instead of Saturday, the Jewish Sabbath, and the designation of December 25 (the main festival of the *Sol Invictus*) as the day of the Nativity show that the emperor, in agreement with the Roman habit of fusing different faiths, thought it perfectly legitimate to associate Christian traditions with commemorations and festivals drawn from his favorite pagan cults.

Because the pressure of the barbarians coming from the East required a defensive geographic position that was more strategic than Rome, Constantine in A.D. 330 founded a new capital on the Bosporus (present-day Istanbul). Even though it was called New Rome, the city from the beginning was known as Constantinople, after the name of its founder. The legions of architects, engineers, and workmen whom Constantine enrolled to enhance the appearance and functionality of the city turned Constantinople into one of the most impressive capitals of antiquity. With its enormous defensive walls, its grand palaces, its paved streets, its colonnaded porticoes, its open squares, and its famous hippodrome dedicated exclusively to horse races, after Constantine banned the gladiatorial games, Constantinople maintained that awesome reputation for the next twelve centuries.

In Constantinople, as in Rome before, the main theme that artists were assigned concerned the celebration of the larger-than-life emperor who wished to be seen by his people as the embodiment of the great diversity that the empire represented. Marilyn Stokstad, in her book *Medieval Art,* writes that in the bronze statue of Apollo that bore the emperor's features and stood atop a column made of porphyry, relics precious to different religions were collected: "for the Jews, an adz used by Noah to build the Ark . . . , for Christians crumbs from the loaves of bread with which Christ miraculously satisfied five thousand faithful . . . , for good Roman citizens, the standard that had been carried to Rome by its mythical founder, the Trojan prince Aeneas."

Constantine's immense ego, as well as his lack of understanding of the essential message of Christianity, was reflected in his choice to

build a church, in Constantinople, dedicated to the twelve apostles, called the *Apostoleion,* which he also proposed as his resting place, as if to suggest that he was to be remembered as the thirteenth apostle. The proposition, which must have appeared much too grandiose even for people long accustomed to the extravagance of their rulers, was eventually rejected, and Constantine's body was laid to rest in a mausoleum adjacent to the church.

With Constantine's successor Theodosius I, all pagan cults were declared illegal, while Christianity, in A.D. 379, was made the sole religion of the empire. Balancing political interest with Christian principles, however, proved to be harder than what Constantine and Theodosius might have anticipated. Theodosius was made aware of the problem when he was confronted with harsh criticism from the bishop of Milan, Saint Ambrose (ca. A.D. 340–397). To punish a riot in Thessalonica in which a Roman military commander was killed, Theodosius in retaliation approved the murder of seven thousand civilians. Outraged by the event, Ambrose harshly reprimanded the emperor and asked him to repent. Upon his refusal, Ambrose, who was a stern believer that the spiritual power of the church was superior to the temporal power of the state, excommunicated Theodosius. Worried about the price he might have to pay in the afterlife, or maybe simply fearful that the criticism of the stern bishop could produce negative political repercussions, the distraught Theodosius was forced to bend to the will of the bishop in order to have the excommunication recanted.

Another famous instance occurred when Symmachus, who was a Roman prefect, asked that the pagan Altar of Victory, which had been removed by the emperor Gratian in 382, be restored to its old position of privilege in the Senate. When he learned about this, Ambrose, the feisty bishop of Milan, promptly wrote to the emperor Valentinian II to urge him to condemn Symmachus's sacrilegious initiative. Symmachus responded, "What does it matter by which wisdom each of us arrives at the truth? It is not possible that only one road leads to so sublime a mystery." Symmachus's passionate defense of freedom of religion failed to move the stern Ambrose, who once again prevailed.

When Theodosius died, in A.D. 395, he left the leadership of the Eastern and Western Empires in the hands of his two immature sons: Arcadius, who was eighteen years old, and Honorius, who was only eleven. (Because of his young age, Honorius was helped by the adviser Stilicho.)

At the beginning of the fourth century, the Huns, a Mongol population from central Asia who had been blocked by China's protective wall, began to move westward, entering southern Russia around A.D. 350. The terror that the progression of the violent Huns provoked prompted a massive westward movement of many barbarian tribes living outside the Roman boundaries.

For the ailing empire, weakened by centuries of slow decay, the most dramatic moment of weakness occurred in August 410, when Alaric, ruler of the Visigoths, crossed the border of the empire and descended upon Italy to then attack Rome. Even if Rome had long ceased to be the center of the imperial government, the humiliation inflicted on the legendary city that had managed to remain immune to foreign attack for eight hundred years sent shock waves of horror and dismay throughout the world.

To highlight the moral decadence that pervaded the Latin kingdom, the historian Procopius told a bizarre anecdote concerning the Western emperor Honorius, who had transferred his court to Ravenna. When a messenger came to tell him that "Rome had succumbed," the emperor cried out, incredulous, "But how can it be, if just this morning it ate from my very own hand!" What Honorius was referring to was his pet: a very large chicken that he had named Rome. When the messenger, catching the misunderstanding, explained that he was referring to the city of Rome, the emperor sighed with relief and said, "Oh dear! For a moment I feared that it was my chicken that had died!"

After the sack of 410, which was followed by a later attack of the Vandals in 455, the Western Empire languished for a few more years before it finally came to an end in 476, when the last Roman emperor, Romolo Augustolo, was deposed by a barbarian chieftain by the name of Odoacer. Seven centuries after it had been founded, the glorious

city, with this Romolo Augustolo—a diminutive that mocked the past grandeur of Rome—finally died.

<div align="center">✳</div>

AUGUSTINE'S TALE OF TWO CITIES

Even though the prestige of Rome had steadily declined since the beginning of the third century A.D., the myth of the city had remained powerful throughout the world. For this reason, when Rome was attacked by the barbarians, the repercussions had enormous resonance. What had caused the fall of the city that had so brilliantly imposed its power on most of the known world? Pagan thinkers had no doubt: if Rome had fallen, it was because the Christians had disrespected the divinities that for so long had assured the greatness of the city's pagan past. The argument could have been a serious risk for Christianity if not for the powerful rebuttal provided by one of Christianity's most effective and energetic leaders, Augustine.

Aurelius Augustine was born in 354 in Tagaste, in Roman North Africa. At seventeen, he went to Carthage, which after being destroyed in the Punic War was rebuilt as a Roman city, to study rhetoric. In his *Confessions,* Augustine expresses shame toward those early years when, he says, he led a dissolute and lustful life. He had a long relationship with a mistress who also gave him an illegitimate child. Even if his behavior scandalized his fervidly Christian mother, Monica, he felt unable to change. The famous plea "Grant me chastity and continence, but not yet" belongs to this period. He began to change only when he read Cicero's dialogue *Hortensius* (now lost), which sparked his interest for philosophy. Before embracing Christianity, Augustine had been attracted to Neoplatonism and Manichaeanism, the religion founded by the Persian prophet Mani (ca. A.D. 216–ca. 276), which contained many elements of the older creed known as Zoroastrianism, which held that the universe was the stage of a perennial conflict

between good and evil. His encounter with Ambrose, the bishop of Milan, finally led him to Christianity.

The Manichaean and Neoplatonic interest that Augustine had cultivated in his early years informs his *City of God,* where he describes the existence of two opposite cities: one belonging to God, the *civitas Dei,* and the other to man, the *civitas terrena,* the "earthly city." Using Genesis to support his thesis, Augustine claimed that the fundamental mark of the *civitas terrena* was the stain of blood and violence produced by Cain's murder of his brother, Abel. With that horrible act of violence, the human city had violated, since its very beginning, what it was supposed to stand for: a brotherhood of peaceful coexistence. Stressing the fact that Rome had also been founded on a similar fraternal murder (as mentioned before, Romulus founded Rome after killing his brother, Remus), Augustine clearly wanted to demonstrate that man was a devious, cruel, and violent creature.

As Augustine wrote, "Whereas Cain, like Romulus, murdered his brother in order to rule alone and fix his love upon temporal things, Abel, in humble faith and hope, directed his love towards his Creator; whereas Cain founded a city Abel was 'a pilgrim and stranger in the world . . . predestined by grace, by grace a pilgrim below, and by grace a citizen above.'"

As the stories of Cain and Abel and Romulus and Remus had proven, man's lack of moral rectitude had doomed all possible hope to create a city of justice and brotherhood on earth: "Two loves have created two cities, two communities: the earthly city was built on self love to the detriment of God, and the celestial city on the love of God to the detriment of the self."

In pagan culture, man had been exalted as the central agent of history and the main promoter of civilization. In a completely opposite fashion, Christianity presented man as a sinful being condemned to expiate his excessive pride in an alien and unfriendly universe. Within that uprooted condition, man would have found salvation only if he learned to turn his life into a journey toward the metaphysical city of God.

"A Christian," Augustine wrote, "is a man who feels himself a stranger even in his own house, in his own city; for our fatherland is on high. There we shall not be aliens; but here below everyone feels himself a foreigner, even in his own house." With Christianity, the old devotion to family and city became irrelevant. As stated in the New Testament, to serve God, man had to abandon all previous ideals of social and familial commitment. To stress the absolute priority that the love of God was to be given, Matthew, in his Gospel, attributed the following words to Christ: "He that loveth father or mother more than me is not worthy of me: and he that loveth son or daughter more than me is not worthy of me" (10:35–37). And later, "And every one that hath forsaken houses, or brethren, or sisters, or father, or mother, or wife, or children, or lands, for my name's sake, shall receive an hundredfold, and shall inherit everlasting life" (19:29).

The true believer was like a pilgrim, ready to leave behind everything he cherished and owned in his terrestrial life. The way to salvation was a road paved with renunciation, subjection, and self-negation. While virtue for the Romans corresponded with courage and virile assertiveness, virtue, for the Christians, came to indicate meekness, obedience, humility. To further deny the importance of all human accomplishment, Augustine went as far as to affirm that everything that man had arrogantly claimed to have created on his own was doomed to dissolve in dark oblivion. The destiny of Rome had exemplified that intrinsic truth: the permanence of human achievement was nothing but an illusion. The fall of Rome was the proof that without the mercy of God and the help of His Grace, even the strongest of all empires was condemned to crumble into an insignificant pile of scattered stones, wood, and dirt: "Rome is now nothing more than a pile of stones and woods. . . . Everything that man builds is bound, one day, to die and fall."

With Augustine, a haunting sense of guilt and insufficiency took over the Christian psyche. "The time of life," Augustine said, was nothing but "a race toward death," a brief span of time granted to each individual as an opportunity to atone, with humble devotion, for

the devastating consequences that the original sin of Adam and Eve had caused.

As the scholar Richard Tarnas writes in his *Passion of the Western Mind,* "Love of God was the quintessential theme and goal of Augustine's religiosity, and love of God could thrive only if love of self and love of the flesh were successfully conquered." That also meant conquering the craving of knowledge that, as the Bible indicated, was to be directly linked to Eve's concupiscence. By viewing the soul as the seat of rationality, Plato and Aristotle had established an intrinsic unity between the soul and the mind. Because, as Socrates had preached, without the cultivation of philosophy the acquisition of a higher wisdom would have been impossible, the Greeks also fostered the belief that knowledge was equal to virtue. As we will see more in depth in the next chapter, by separating mind from soul, the Christians drastically dismissed the pagan trust in reason, affirming that, much like sensuality, the craving of the mind for knowledge was to be associated with man's excessive and sinful attachment to inappropriate and impure kinds of desire. The claim, which was a death sentence for philosophy, made theology the sole repository of the truth and the sole voice of authority in matters that Greek and Roman thinkers (like Cicero) had placed under the umbrella of philosophy, such as ethics, politics, and science.

The Christian perspective raised to new heights the importance of the church, whose guidance, as Augustine claimed, was to be considered essential for the salvation of mankind. "The kingdom of God which is represented on earth by the Church, derives from Abel, while the secular state derives from Cain: this last one, therefore, has no end in itself and should be subservient to the needs of the first."

Augustine's argument was used throughout the Middle Ages to assert that, given the moral defects of the secular world, the church was superior to the state and indispensable for the preservation of justice and peace in the world. The problem that Augustine could not have anticipated came when the church, emboldened by the accumulation of power, started to aspire to an ever-increasing political influ-

ence, claiming a theocratic preeminence that had little to do with the spiritual purity pursued at the beginning of Christianity. An important turning point occurred when Charlemagne, with the consent of the pope, became emperor of the Roman Empire (what was left of it, at least) in A.D. 800. Augustine would have been shocked by those events. The church that he had in mind was an apostolic community that had nothing to do with an organization aiming at the realization, on earth, of a secular and political empire. The misreading of Augustine's intention, which was developed by later representatives of the Christian church, is explained with these words by Vernon J. Bourke in his book *The Essential Augustine,* "From Charlemagne onward, the Holy Roman Empire was inspired by a misreading of Augustine's *City of God.* Many people felt that he [that is, Augustine] had planned the establishment of a Kingdom of God on this earth, in the form of a Christian renewal of the Empire of ancient Rome. This was not really his intent; Augustine's was an other-worldly ideal, a distinction of two kinds of men, and two societies which would never be formally institutionalized in the course of time. After the Last Judgment, they were to be separated in Heaven and Hell."

PART THREE

THE EARLY MIDDLE AGES

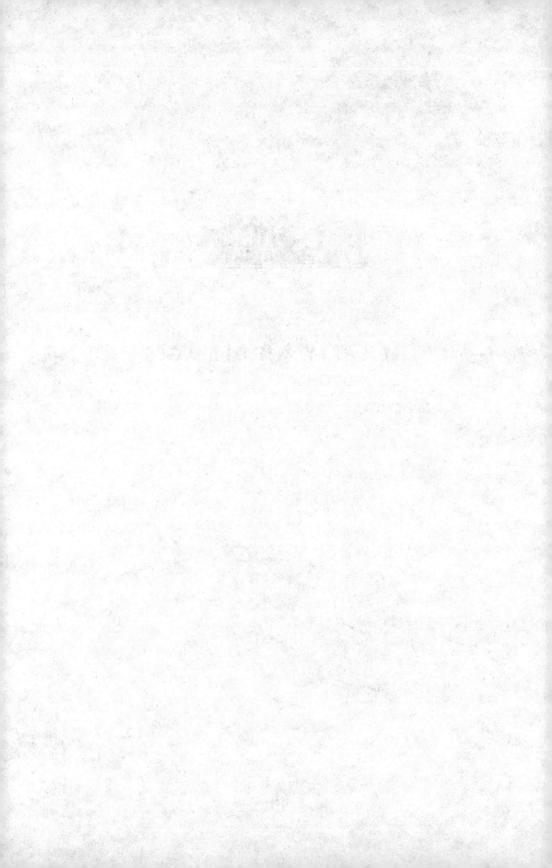

THE TRIUMPH OF CHRISTIANITY
AND THE DEMISE OF THE RATIONAL MIND

Christianity, an offshoot of Judaism, is based on the teachings of Christ, Who was born around 4 B.C. and lived in Judaea and Galilee. Because the Middle East, where Christianity developed and spread, was essentially Greek in culture and mentality, the evolution of Christianity ended up assimilating many ideas derived from the Hellenistic heritage. We should remember that next to a pure Greek influence (Pythagoras, Plato, Aristotle, the Stoics, and so on), that heritage also included many traditions and ideas that the West acquired from the East when Alexander the Great stretched the boundaries of his empire as far as India. Many Mystery cults, like Orphism, were part of that enlarged Hellenistic horizon, as well as religions like the Persian Zoroastrianism and Manichaeanism. To the various influences that Christianity received in its complex development, we should also add ceremonial traditions (like chanting, the use of candles, incense, and holy water) and the institution of the priesthood, which probably derived from Syria, Egypt, Babylon, and Persia. Of course, of the myriad tightly woven threads that spun the doctrine and ritual of Christianity, none is more important than the one that it derived from the People of the Book—the Jews.

The Christian Bible is formed by the Hebrew Bible, or Old Testament, and the New Testament. Some parts of the Old Testament were composed almost a thousand years before the New Testament. The first five books of the Old Testament (Genesis, Exodus, Leviticus, Numbers, Deuteronomy), called the Torah in Hebrew and the Law in English, relate the story of creation, the sin and fall from paradise of

Adam and Eve, the escape of the Hebrews, God's chosen people, away from the foreign bondage in Egypt, and the conquest of the promised land. The New Testament, which scholars believe was originally written in Greek, revolves around the figure of Christ (who probably spoke Aramaic, the common tongue of Judaea). The New Testament includes the Gospels, the Acts of the Apostles, the Epistles (which include the letters of Saint Paul), and the book of Revelation.

Contrary to the impersonal Demiurge that for Greek philosophers was behind the order of the cosmos, Christianity described the world as the loving expression of a Creator so invested in His creation as to honor the sanctity of every human being beyond any disparity of status, privilege, and fortune:

> Blessed *be ye* poor: for yours is the kingdom of God. Blessed *are*
> *ye* that hunger now: for ye shall be filled. Blessed *are ye* that weep
> now: for ye shall laugh.
>
> (LUKE 6:20, 21)

For the class-conscious society of pagan times, the change was revolutionary: all who had previously been rejected and forgotten (the dispossessed, the outcast, the slave, the oppressed, the prostitute) were now accepted and welcomed in the kingdom of God. The star of Bethlehem, which was said to have announced the birth of the Messiah to the mighty kings and the poor shepherds alike, was meant to mark the beginning of a universal ideal of justice unthinkable before, where all human beings were granted a similar level of importance under the common denominator of children of God, equally valued and equally respected.

The principle did not find an immediate application in reality. In fact, it took many more centuries to mitigate horrors such as slavery or the disparaging treatment of women. Nonetheless, the respect for the sacredness of human life that Christianity preached enormously influenced the cultural development of the West especially from a legal and juridical point of view.

The extraordinary value that Christianity attributed to human

life found its origin in the Jewish narration of the biblical Genesis, where God, having called the world into existence, was said to have forged out of clay a creature made in His own "image and likeness."

> Let us make man in our image, after our likeness: and let them have dominion over the fish of the sea, and over the fowl of the air, and over the cattle, and over all the earth, and over every creeping thing that creepeth upon the earth. So God created man in his *own* image, in the image of God created he him.

In man God had selected a near replica of Himself: an interlocutor meant to share His eternity to become, next to Him, the master of all creation—a position of privilege that was confirmed when God assigned to man the power to name all the animals that populated His kingdom:

> God . . . brought *them* [animals] unto Adam to see what he would call them: and whatsoever Adam called every living creature, that *was* the name thereof.

This spectacular bond with the divine raised to an unprecedented level the worth of the human creature. But everything came to a crashing end when Adam and Eve (whom God shaped out of Adam's rib) ate the forbidden fruit from the tree of knowledge that, as God had commanded, was to remain beyond their reach.

When he tempted them, the serpent had promised Adam and Eve the acquisition of God's knowledge. The falsity of that promise was revealed by the punishment that the first two humans received as soon as, plucked away from the sky, they were plunged into the earth, where their souls, stripped of their robes of light, remained buried, as in a tomb, in the corruptible tunic of flesh of the body.

With man's subjective choice, God's objective reality was lost forever: eternity was replaced by history with its unforgiving constraints of time and space. It was at that moment, the Bible says, that Adam and Eve realized they were naked. The nakedness symbolized the vulnerable poverty of their newly acquired condition: the frailty of the

body, the insufficiency of the mind, the sweeping nature of time, the brutal finality of death.

Instead of a superior form of understanding, all that Adam and Eve gained with their transgression was ignorance, pain, and confusion within a shattered world marked by the struggle of all living creatures competing for dominance and survival. Thrown into that battle, the two humans were lowered to the level of animals over which they had previously ruled. To describe man's newly acquired identity, religious writers often talked of a sort of animalization. The furry skins that in many medieval depictions cover the nudity of Adam and Eve were used to symbolize the animal-like condition that humanity had descended to after the Fall.

From that moment on, to exist became equivalent to living away from the place of one's origin: in other words, living in exile like a stranger lost in a foreign and unforgiving land. (Etymologically, "to exist" comes from the Latin *ex stare*, which means "stay outside.")

In describing the odious *hyle* of the terrestrial dimension—in Greek, *hyle* denoted the formless matter of chaos—Christian thinkers defined the world as a "region of unlikeness" or, echoing the Old

Adam and Eve, depicted in medieval imagery, being expelled from the Garden of Eden

Testament, an "Egypt of matter." The disparaging terms were used to describe the world as a place of painful captivity in contrast with the blissful harmony experienced in the lost homeland of paradise.

How could a creature so tightly enmeshed in the dull and dark consistency of matter regain the spiritual lightness necessary to soar back toward the kingdom of God?

The answer, for Christianity, resided in the compelling story of a forgiving God who, having assumed through Jesus Christ a corporeal form, made possible the restoration of man's original state despite all the deficiencies and tribulations caused by sin.

The Christian idea of a compassionate Creator derived from the Jewish tradition, where God, expressing His love for the Israelites, His chosen people, earnestly assisted their journey, from the subjugation they suffered under Egyptian domination, to the conquest of a homeland where, in harmony with God's divine will, Israel would finally rejoice in justice and freedom.

Despite so many similarities—each saw life as a journey from shackles to freedom—what distinguished Christianity from Judaism was the *who* and the *where* of the story. Whereas the Jews dreamed of a kingdom of justice on earth for the benefit of God's chosen people, the Christians focused on a spiritual rather than an earthly kingdom: a superhistorical and superterrestrial promised land universally available to all of mankind.

To return to that celestial homeland, man had to retrieve the fragment of divinity that still shone, like a precious gem, within the fractured nature of his terrestrial reality.

Neither shall they say, Lo here! or, lo there! for, behold, the kingdom of God is within you.

(LUKE 17:21)

God's glory resided in the deepest recesses of the human spirit, far removed from the bleakness of the earthly ordeal. As Paul stated in his Second Epistle to the Corinthians, "Whilst we are at home in the body, we are absent from the Lord."

Because no escape from that exile was possible without the mediatory intervention of Christ, and because no knowledge of God could have taken place without the transformative action of His Word, the message that the New Testament contained principally focused on the life and teachings of Christ. Not what He wrote—Christ, like Socrates, did not leave any written testimony—but what was reported about Him in the Gospels of Matthew, Mark, Luke, and John. Historians have established that, unlike what was believed in the past, the Gospels (meaning "good news") were not written by people who personally met Christ but by authors who composed their account toward the end of the first century A.D. The Gospels were made part of the New Testament around the second century A.D.

The word "synoptic," applied to the Gospels, refers to the similarities in narratives and themes that the texts contain, with the exception of the more complex and intellectually challenging Gospel of John, in whose mystical approach God's kingdom is described as a crystalline triumph of light in contrast with the gloomy darkness of the world. Pivotal to John's theological approach is the definition of God as Logos: a term that in Greek, as we have seen, simultaneously meant "word" and "reason," and was used in the Hellenic tradition to indicate the ordering force of a divine Rational Mind. Adapting the term to Christianity, John, at the beginning of his Gospel, used "Logos" to define the creative power of God: "In the beginning was the Word, and the Word was with God, and the Word was God."

The vein of Platonism that runs through the Gospel of John finds further echoes in the contribution of Paul (ca. A.D. 5–ca. 67): a cultivated Hellenistic Jew who took an active part in the persecution of early Christians until he underwent a sudden conversion while on his way to Damascus. In the Acts of the Apostles (9:3–6), Paul's sudden illumination is described as follows:

> And as he journeyed, he came near Damascus: and suddenly there shined round about him a light from heaven: And he fell to the earth, and heard a voice saying unto him, "Saul, Saul, why persecutest thou me?" And he said, "Who art thou, Lord?" And

the Lord said, "I am Jesus whom thou persecutest: *it is* hard for thee to kick against the pricks." And he trembling and astonished said, "Lord, what wilt thou have me to do?" And the Lord *said* unto him, "Arise, and go into the city, and it shall be told thee what thou must do."

Paul—Saul was his name before the conversion—who, from that moment on, dedicated his life to the teaching of Christ, is believed to have died in Rome, in A.D. 67 during the persecutions against the Christians unleashed by Nero. In the Epistles he wrote to the Christian communities he founded, Paul brought to a whole new level of clarity the Christian idea of salvation.

To explain the essential meaning of Christ's mission, Paul focused on the ritual of baptism:

Know ye not, that so many of us as were baptized into Jesus Christ were baptized into his death? Therefore we are buried with him by baptism into death: that like as Christ was raised up from the dead by the glory of the Father, even so we also should walk in newness of life.

(ROMANS 6:3–4)

Through the ritual of baptism, Paul preached, the initiate was encouraged to symbolically imitate Christ, who died on the cross to free the human soul from the prison of matter:

I am crucified with Christ: nevertheless I live; yet not I, but Christ liveth in me: and the life which I now live in the flesh I live by the faith of the Son of God, who loved me, and gave himself for me.

(GALATIANS 2:20)

As in the sacrifice of the cross, baptism simultaneously indicated the death of the flesh and the resurrection of the spirit: in other words, the replacement of the old Adam with the new one that Christ, as archetype of human perfection, embodied. Paul, who, more than

once, called Christ the "new Adam," wrote in the First Letter to the Corinthians, "For as in Adam all die, even so in Christ shall all be made alive."

The aim of the believer was to humbly forsake selfhood in order to gradually advance toward the greater perfection of God. The transformation that God required was not confined to the body: as Paul explained, the mission of Christ also involved a drastic indictment of the excessive value given to the human mind.

Pythagoras, Socrates, and Plato had all maintained that the soul was the seat of reason and that reason was the highest and noblest quality of human nature. For Christianity, on the other hand, reason possessed characteristics that, more than to the soul, belonged to the body with which it shared similar deficiencies and appetites. The point was addressed by Paul, who repeatedly insisted that God, Who transcended all things, also transcended human knowledge. To make his point, Paul dismissed with these words the arrogant confidence previously assigned to human reason: "The foolishness of God is wiser than men; and the weakness of God is stronger than men."

In contrast with the classical tradition, Paul rejected the importance attributed to the rational mind, affirming that it was an insufficient means toward a superior form of understanding unless assisted by the auxiliary help of Grace as represented by Christ. To stress the inadequacy of reason, Paul went as far as to compare humans to helpless, suckling babies, in need of the "milk" provided by the teachings of Christ, without which they would have been unable to absorb the food of true understanding:

> And I, brethren, could not speak unto you as unto spiritual, but
> as unto carnal, *even* as unto babes in Christ. I have fed you with
> milk, and not with meat: for hitherto ye were not able *to bear it,*
> neither yet now are ye able.
>
> (1 CORINTHIANS 3:1–2)

Christ's frequent use of parables was justified in a similar way in the Gospel of Matthew (13:13):

Therefore speak I to them in parables: because they seeing see not; and hearing they hear not, neither do they understand.

Since the Fall of Adam and Eve, the Christian doctrine claimed, mental deficiencies had imprisoned humans on the surface of reality, unable to see, hear, or understand the innermost significance of things. To overcome the limit of man's superficial and horizontal kind of perception, Christ used an enigmatic and indirect form of storytelling aimed at challenging mental habits and preconceptions, in order to spark a deeper and more refined form of understanding.

Augustine, in his *On Religious Truth,* addressed the teaching method of Christ with these words:

God did not disdain . . . to sport with our childish mentality by speaking in parables and similes and to cure with clay of this kind the interior eyes of our souls.

Because man's crippled faculties would have been overwhelmed when confronted with God's immensity, the use of an indirect idiom consisting of parables, symbols, metaphors, and similes became central in describing the message of the divine. Why? Because, Augustine asserted, just as fairy tales do when teaching moral principles to children, they reduced to an accessible level the complexity of the divine discourse.

Christ's use of parables was aimed at stimulating man's emotional and intuitive awareness through stories that encouraged new ways of thinking beyond the linear channels of logic and rationality. Accordingly, the third-century Christian apologist Clement of Alexandria (ca. A.D. 150–ca. 215) compared Christ to a pedagogue, a teacher who had come to assist the growth of man's inner potentials beyond what the Christians considered the flat, prosaic, and ultimately ineffective syntax of all rational and empirical discourse.

Following those guidelines, the novice was taught that, just like the truth that lay deep beyond the surface of the world, the words of the Bible were to be not taken literally but rather used as clues constantly pointing toward something else—something that moved the

spirit forward toward a meaning that, ultimately, could be alluded to only indirectly because it was irreducible to any earthly forms of comprehension.

To further explain the revelatory quality of the biblical message, Augustine compared the inner significance of the words to the soul within the body. The words of the Bible, Augustine wrote, were like "fleshy robes" covering the deeper meaning that waited to be unwrapped—a task that was achievable only by exploring the message of the Bible with the eyes of the spirit rather than the eyes of the flesh.

The view shows the influence of the Jewish tradition, where text and interpretation were considered not two separate entities but two connected aspects of revelation. George Steiner, in his book *Real Presences,* explains that the purpose of Jewish exegesis was to expand, as in an unending process of signification, the message contained in the book of God: "In Judaism, unending commentary and commentary upon commentary are elemental. . . . The lamps of explication must burn unquenched before the tabernacle. Hermeneutic unendingness and survival in exile are, I believe, kindred."

The dynamic by which each word and each image of the Bible was made to expand as with growing ripples of signification evoked the infinity of God's metaphysical mystery: the unmeasurable, indescribable, unreachable Logos of the Father Who had given life and form to the entire universe.

The endless decoding that the mystery of the Bible demanded is described by Northrop Frye, in his book *The Great Code,* as "a single process growing in subtlety and comprehensiveness," to express not "different senses, but different intensities or wider contexts of a continuous sense, unfolding like a plant out of a seed."

The sentence echoes Matthew 13:23, where Christ compares his words to seeds: small on the outside but full of creative energy if planted in the appropriate kind of soil.

> But he that received seed into the good ground is he that heareth
> the word, and understandeth *it.*

Just as a small seed produces an enormous tree, the humble words offered by the Bible were said to bloom into heavenly visions if placed in the nurturing terrain of a heart made appropriately fertile by the abundance of faith.

To affirm that faith was the only possible path to God, Augustine wrote, "Seek not to understand that you may believe but believe that you may understand." What Augustine meant to express with that assertion was that faith was indispensable for the achievement of true knowledge. The value of human reason, which for so many centuries had remained supreme, was now surpassed by a faith placed directly at odds with tangible certitudes, rational argumentations, and logical conclusions. More than the intelligence of the mind, what was needed to reach God was the intelligence of the heart—the faith that Christ demanded when He asked humanity to plunge with Him into a depth that, just as in the ritual of baptism, was a paradoxical unity of annihilation and fulfillment, darkness and light, blindness and vision, death and life.

The transformative quality attributed to Christ's supernatural intervention was also stressed to support a written religious tradition among a population that, being in great part of pagan descent, was accustomed to attributing the validation of its creed to a purely oral exercise. The historian Charles Freeman, in *The Closing of the Western Mind: The Rise of Faith and the Fall of Reason,* writes that it was not until A.D. 135 that the first Christians, of pagan background, finally started to accept the value of the biblical written text, acknowledging its authority over the oral tradition that for centuries had been considered the only legitimate vehicle of religious transmission.

As we have seen, the distrust toward the written word goes back to the Greeks. In the *Phaedrus,* Plato, using his alter ego Socrates, attacked the stiff and static quality of the written word, claiming that by immobilizing the dynamic of the oral exchange, it induced a dangerous state of mental atrophy. Plato's use of dialogues to develop his philosophical ideas was consciously selected with the intention of preserving the lively ebb and flow of the oral argument without which, Plato believed, the progress of knowledge would not occur.

With the passing of the centuries, the animus toward the written word subsided. But when Christianity, following Judaism, introduced itself as a religion based on the authority of a written text, old concerns about the lifeless quality of the written word inevitably resurfaced. To ward off any possible criticism, the Christians, in agreement with the Jewish lesson, evoked the power of the symbolic discourse.

The etymology of the word "symbol," as derivative of *symballo,* which in Greek meant "to gather," or "to reunite," can help us understand what's at the heart of that amazing process of signification. In Greek antiquity, when an agreement between two parties was contracted, an object was broken in two in order to guarantee, until the later reunion of the two partners, the promise of the stipulated accord. The object, which was going to return whole with the reunion of the two parties, was called "symbol." A similar interpretation was connected to the divine Word, as expressed in the Bible: a sign or symbol that, by constantly pointing past itself, solicited an engaging response on the part of a fully involved reader/believer.

In contrast with the passive acquisition induced by the dead written word that the Greeks had feared so much, the symbolic discourse of the Bible came to be seen as a living process that, by soliciting a dialogue between reader and text, led to further and further depths of understanding man's awareness of the divine. Failing to go beyond the surface of one's own immediate experience meant to remain trapped within the literal, and therefore external and superficial, meaning of things—the *letter that kills,* which, for Paul, was the secular Logos of all the non-Christians.

To exalt the superior knowledge that the Bible imparted, the Christians used the image of Christ: the Logos Who, by dying as a man and resurrecting as a god, lifted the human condition above its physical, mental, and verbal limitations. Christ was the force that freed the soul from the mortal flesh (*soma,* in Greek) and in so doing liberated the human idiom (*sema*) from constraints of its mortal tomb (*sema*). Christ, the divine Logos, represented the transit of the visible into the invisible, which meant the metamorphosis of the ordinary events of life into the extraordinary mystery of God.

The effect that the mediating intervention of Christ produced in bringing together the human and the divine dimensions corresponded to the function of the biblical symbol that restored the cosmic dialogue between God and man that sin had interrupted and that the Word of Christ, as the ultimate symbol of God's love, had come to heal and restore. Contrary to the healing action that the Word of God represented, the diabolic force of evil (in Greek, the opposite of *symbolon* was *diabolos*) indicated disunity and division: the dramatic rift that, since the sin of Adam and Eve, had come to separate humanity from God.

<p style="text-align:center">✳</p>

THE SYMBOLIC DISCOURSE OF ART

Could art, which had traditionally been concerned with the tangible appearance of things, be turned into a vehicle of higher contemplation? In other words, could art be placed at the service of the invisible reality of the spirit? The dilemma was further complicated by the suspicion that Jewish tradition had always cultivated against the sin of idolatry intrinsic in the creation of any graven image, as expressed in Exodus 20:4–6:

> Thou shalt not make unto thee any graven image, or any likeness *of any thing* that *is* in heaven above, or that *is* in the earth beneath, or that *is* in the water under the earth.

The Jewish belief that the mystery of God could not be contained within any terrestrial form also extended to the verbal domain. The rule was so strict that originally "Yahweh," the Hebrew word for "God," was written "YHVH" to make impossible, without vowels, the actual pronunciation of His name.

The ban on images had an enormous impact on early Christians, as attested by the approximately two hundred years that preceded

the hesitant beginning of religious art. What overcame that initial reluctance was the pressure of necessity: in a world in which most people were illiterate, the use of a visual narrative offered a unique opportunity to teach the message of the new religion.

The first steps toward a Christian visual language can be found in the catacombs, the underground passages used as burial places by the early Christians. The most notable aspect of those early wall paintings is the hasty and crude style that characterizes them. Some scholars warn us not to dismiss as naive those early Christian representations: if those visual testimonies appear humble and unadorned, they say, it is not because the Christian artists were incompetent and inexperienced but because they consciously chose to be simple.

Because the Christian artists wanted to address the superior reality of the spirit, they deliberately eschewed the likeness of naturalism to pursue a coded narrative meant to suggest, albeit in an oblique manner, something that was believed to remain beyond what the formal appearance of things described. The extremely simple yet highly significant images we see in the catacombs are indicative of that shift of priorities. Instead of a realistic and aesthetically pleasing depiction of characters and events that could have dangerously trapped the eyes on the external and the superficial, a rough and often clumsy use of images was strategically adopted to stimulate the creative imagination of the viewer. The more the images appeared sparse and incomplete, the more the catechumen was forced to look for a meaning that was deeper than what was immediately apparent.

To stimulate a deeper form of understanding, Christians often probed the Old Testament to find allusions to the mission of Christ. Paul addressed the point in the Epistle to the Galatians (3:23–24):

> But before faith came, we were kept under the law, shut up unto the faith which should afterwards be revealed. Wherefore the law was our schoolmaster *to bring us* unto Christ, that we might be justified by faith. But after that faith is come, we are no longer under a schoolmaster.

As explained by Paul, the Old Testament had served an important role of preparation and maturation. But that initial tutorial phase would have remained a dead letter without the life-giving message of Christ, through Whom man's journey had finally found a coherent and all-encompassing conclusion.

With these notions in mind, let's look at an image in the Catacomb of Saint Priscilla, where a minimal, sketchy number of details are used to represent a shepherd and his lambs. Asked to interpret the image, an early convert might at first have recalled passages from the Old Testament, or the animal sacrifice that accompanied most religious practices, Judaism included. Even if valid—a Christian teacher would have noted—those interpretations would have remained insufficient without the deeper meaning offered by the New Testament, where Christ was simultaneously described as a divine Shepherd (in the Gospels of Luke 15:3–7 and John 10:11–16) Who had come to guide humanity, represented by the flock of lambs, back to the

Christ the Shepherd, as drawn in the Catacomb of Saint Priscilla

green pastures of paradise, and also as the supreme Lamb sacrificed to redeem the sins of the world. As Paul wrote in Hebrews 9:12–14,

> Neither by the blood of goats and calves, but by his own blood he entered in once into the holy place, having obtained eternal redemption *for us*. For if the blood of bulls and of goats, and the ashes of an heifer sprinkling the unclean, sanctifieth to the purifying of the flesh: How much more shall the blood of Christ, who through the eternal Spirit offered himself without spot to God, purge your conscience from dead works to serve the living God?

With Christ, the Lamb of God, the old rituals of animal sacrifice had become superfluous and obsolete, as John the Baptist had also declared when he said, "Behold the Lamb of God, which taketh away the sin of the world."

To show that Christ was God's ultimate revelation, images from the Old Testament were repeatedly used as prophecies of the New. The stories most often alluded to with that intent were Isaac saved from the sacrificial knife of his father, Abraham; Jonah swallowed and then spit out by the whale; Daniel in the pit surrounded by lions that were magically tamed; and the three youngsters miraculously spared by the flames that surrounded them in the fiery furnace.

As different tributary streams empty their waters into a primary river, all those narratives were repurposed as anticipations and pre-figurations of a future culminating event: the death and miraculous resurrection of Christ, which, as a synthesis and completion of all past narratives, represented the final triumph of good over evil, spirit over matter, life over death.

The sense of awe needed to sustain such an intense kind of faith is well described by Abraham Joshua Heschel in *God in Search of Man: A Philosophy of Judaism*: "Among the many things that religious tradition holds in store for us is *a legacy of wonder*. The surest way to suppress our ability to understand the meaning of God and the importance of worship is *to take things for granted*." Loss of wonder, as well as the

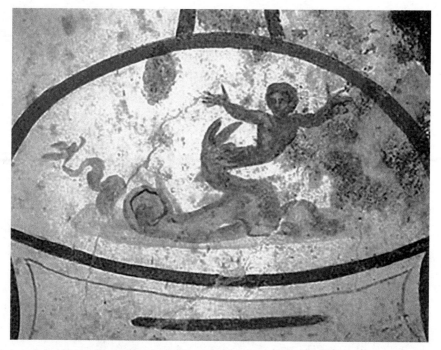

Jonah being swallowed by the whale, also in the Catacomb of Saint Priscilla

Three children being spared in the fiery furnace

belief that all mysteries could be fully explained, is considered by Heschel the biggest threat to religion.

He then continues, "Awareness of the divine begins with wonder. It is the result of what man does with his higher incomprehension. The greatest hindrance to such awareness is our adjustment to conventional notions, to mental clichés. Wonder or radical amazement, the state of maladjustment to words and notions, is therefore a prerequisite for an authentic awareness of that which is."

For a Jew or a Christian of antiquity, the galvanizing passion conveyed by these words would have strongly resonated. The reason was that training the mind to coexist with the uneasiness caused by the enigma of life was considered essential for the development of a higher form of understanding. The corollary idea was that faith was not a peaceful and passive experience but a daring and radical one. Faith required passion and determination: the audacious willingness to push forward one's quest even if the final destination remained shrouded in mystery.

Faith, for the Christians, was not an act of intellectual comprehension but a rapture and an awakening: a state of emotional fulfillment that occurred when the I, filled with love, merged with and dissolved in the infinity of the divine You.

In contrast with the trust in human reason that the pagan world had so proudly advertised, Christian salvation promised not intellectual satiation but the unquenchable passion for a God who was to remain elusive and unknowable to all earthly attempts to pinpoint in words, thoughts, or images the vastness of His mystery.

To stress that God surpassed all earthly horizons, Christian artists made sure to never describe the heavenly Father, using, in His place, only the image of Christ: the living icon through which the invisible God had chosen to reveal Himself to the world ("He that hath seen me hath seen the Father" [John 14: 9; 12:45].)

In line with that principle, the only feature of the Father that the artists of the Middle Ages ever dared to depict was a hand barely appearing from the sky. Aside from that reference, the unknowable and indescribable God was only made manifest through the mediat-

ing image of Christ, Who had come on earth to reshape humanity in God's image and likeness. What's interesting to note is that despite the enormous relevance given to the image of Christ, the gruesome depiction of the body hanging on the cross (which became common many centuries later) was consciously avoided in early religious art.

To understand the reason behind that choice, we have to remember the sharp contrast that separated the Christian Messiah from the Messiah expected by the Jews: a man who, as the prophets had announced, was going to be a strong and powerful military leader and who would have finally assured the triumph of Israel for the benefit of God's Chosen People. The difference between that Messiah and the meek and apolitical Jesus could not have been starker: far from assuring the triumph of an earthly kingdom, the land promised by the Christian Messiah was a place of spiritual freedom available to all who humbly abandoned all tangible and material claims. The radical view proposed by Christianity also transpired in the death on the cross suffered by Christ—a death that was considered the most degrading and repulsive form of execution, a punishment traditionally assigned to criminals, slaves, and, in general, people of destitute condition. How, pagans and Jews alike contended, could someone

All of God the Father that was ever allowed to be rendered in early medieval Christianity was His hand.

A Roman graffito mocking Christ as a crucified beast of burden

The Lamb of God with the cross as a banner of victory. Basilica of Cosma and Damiano, Rome, seventh century A.D.

who claimed to be the Son of a heavenly King accept such a terrible humiliation? The scorn and disbelief with which many derided the idea are crudely expressed in a graffito discovered on the Palatine Hill in Rome, which, in order to sarcastically mock someone by the name of Alexamenos who had recently converted to Christianity, depicts a crucified man with a donkey's head with an inscription that says "Alexamenos worships his god." In the cruel satire, Christ's gentle meekness is compared to the stupidity of a donkey. Because of such hostile attitudes, for many centuries Christians preferred to depict the cross as a banner of victory—one where the tortured body of Christ was persistently missing.

THE NEW VOCABULARY
OF FAITH AND SPIRITUALITY

As we have seen, one of the thorniest aspects that confronted Christianity was how to justify Christ's sacrifice on the cross. To push back on the accusations of those who claimed that such a humiliating death was incompatible with a divine being, the early Christian apologist Tertullian (ca. A.D. 155–ca. 240) resorted to a highly emotional form of rhetorical discourse: "The son of God died; it must be believed because it is absurd. He was buried and rose again; it is certain because it is impossible."

By using a technique called *ad absurdum* because it denied the safe ground of logic, Tertullian wanted to prompt in his readers the same kind of mental spark that Paul demanded when he wrote in 1 Corinthians 1:19, "For it is written, I will destroy the wisdom of the wise, and will bring to nothing the understanding of the prudent."

Using a paradox to praise the value of ignorance over the intellectual pride of pagan philosophers, Tertullian went on to compare the wisdom of faith to a fresh flower spontaneously blooming at the margin of a country road, far from the useless chatter of urban schools,

academies, and libraries. He wrote, "I don't appeal to the soul that has been formed in schools, educated in libraries and made full of itself by the wisdom of Greek academies. I rather appeal to the simple, rough, ignorant, primitive soul . . . the one that one can find along crossroads and deserted country roads."

The idea that reason unguided by faith was to be distrusted as one of the most dangerous instruments of satanic seduction derived from Genesis, where the selection of Eve as the first sinner (having been the first to pick the forbidden fruit from the Tree of Knowledge) implicitly gave a sexual connotation to the excessive desire for intellectual knowledge. Aside from the traditional misogyny, so similar to the feeling expressed by the myth of Pandora, what's fascinating about that association is that due to its organic nature the craving for knowledge was somehow made comparable to all other human instincts and functions.

Why would God condemn the urge that humans had to know and understand if that instinct appeared to be as natural and necessary as breathing, eating, and reproducing? Although ambiguous, the answer provided by Christian dogma remained unabashed: the goal of man was not to understand the secret ways of God but to submit to His will by responding to His call in view of a restored dialogue between heaven and earth. This attitude, which marked the end of all worldly disciplines deemed incompatible with the approach demanded by faith, such as philosophy and science, gave way to cultural models that ostensibly condemned all forms of critical thinking. Within this new context, the epitome of the upright man became Abraham, who blindly obeyed God's command to kill his son Isaac, even if the heavenly Father gave him no reason for such a cruel action.

Salvation belonged to the obedient man who didn't question the will of God nor dare to doubt His intention. Asking for better evidence was definitely unacceptable from a Christian point of view. "What has Jerusalem in common with Athens?" Tertullian famously asked, and then added, "For ourselves there is no need or any wish to learn, except of Jesus Christ."

With similar fervor, another early church father, Irenaeus

(A.D. 130–202), said, "It's better to know nothing but believe in God and remain in His love, rather than risk to lose Him with subtle questions."

To vent the distrust toward the mind and its analytical tools, some early Christian preachers went as far as calling philosophy a despicable abomination, while others derided the subtle elaborations of Plato and Aristotle, dismissing them as useless and ridiculous blabber.

In developing such arguments, many Christians of the first centuries were influenced by the belief that the Second Coming of Christ was imminent. When that cataclysmic event failed to occur, the urgency to negate the value of previous intellectual accomplishments slowly waned, leaving room for more inclusive views in regard to the classical heritage. Among those who argued that philosophy was to be considered an asset rather than an obstacle were some Greek theologians belonging to the school of Alexandria, like Clement of Alexandria and Origen. In an effort to rehabilitate past cultural contributions, these Christian thinkers came up with the concept of gradual redemption. The scholar Nicola Abbagnano explains that this interpretation gained particular traction when the hope in the imminent return of Christ began to fade away. As a consequence, the concept of an instantaneous regeneration of the world was replaced by "the idea of a gradual regeneration occurring along the centuries through the progressive understanding and assimilation of the lesson of Christ."

The new narrative that the Christians developed after the Second Coming failed to occur was that salvation, rather than a short and dazzling drama, was a long and slow process of maturation in which different expressions of culture could be accepted as initial stages of God's revelation. The view allowed the inclusion of all sorts of past cultural contributions on the basis that they were preparatory steps toward the ultimate knowledge of God. Lactantius (A.D. 240–320) addressed the issue when he affirmed that despite their incompleteness the works of Socrates, Plato, and the Stoics were to be considered useful "fragments" of the ultimate Truth.

As the concept of history became intertwined with Providence,

Christianity came to be perceived as the most glorious bloom of a mighty evolution aimed at bringing to maturity the spiritual readiness of the world. The idea that history was the fulfillment of God's divine plan gave license to the assumption that everything of value produced in the past belonged to Christianity. The view reflected what Justin Martyr had already stated in the second century: "Everything beautiful that has been said belongs to the Christians."

Guided by that principle, freely borrowing from the pagan heritage came to be seen as a fully acceptable practice if useful to the message of Christianity. The attitude proved particularly handy for Christian artists, who often tapped the well-tested reservoir of past mythology and folklore to advertise the content and meaning of the new religion. Examples include the parallel established between Christ and Apollo, the Greek god of light and reason, and between Christ and the *Sol Invictus* that many Roman emperors had used to celebrate

In the Mausoleum of the Julii, images of Christ and Apollo the sun god were conflated.

the superior quality of their heavenly derived authority. (In Pagan art, the principal reminder of that connection was the golden halo placed behind the emperor's head.) In a third-century mosaic, found in the Mausoleum of the Julii under the Basilica of Saint Peter in Rome, references to Apollo and to the *Sol Invictus* are applied to the image of a resurrected Christ triumphantly rising toward the sky in a manner that appears wholly compatible with the apotheosis of an emperor.

Another famous myth frequently employed to describe the mission of Christ was that of Orpheus: the magic musician who tamed all the animals with the sound of his lyre, just as Christ did when, as the Christian Clement of Alexandria wrote, he came to "tame men, the most intractable of animals." Using a similar parallel, Eusebius wrote that the Son of God was the healer Who had come to retune man's discordant instrument:

> The Greek myth tells us that Orpheus had the power to charm ferocious beasts. He could tame their savage spirit by striking the chords of his instrument with a master hand. This story is celebrated by the Greeks. They generally believe that the power

Christ as Orpheus, the supreme musician

of melody, from an unconscious instrument, could subdue the
savage beast and draw the trees from their places. But the author
of the perfect harmony is the Word of God, and He wanted
to apply every remedy to the many afflictions of human souls.
So He employed human nature—the workmanship of His own
wisdom—as an instrument, and by its melodious strains he
soothed, not merely the brute creation, but savage endowed with
reason, healing each furious temper, each fierce and angry pas-
sion of the soul, both in civilized and barbarous nations, by the
remedial power of His Divine doctrine.

In other instances—for example, in the Roman mausoleum of
Saint Costanza, daughter of the emperor Constantine—the essence of
Christ's mission is conveyed through the symbolism of the vine that
the pagans had consistently associated with Dionysus or Bacchus.

A multitude of frantically laborious putti compete with birds to
pick the mature grapes that fill a fecund and abundant vineyard. As we
have seen in Roman times, the references to Bacchus that often deco-
rated the dining rooms of the patricians were used to symbolize the
worldly pleasures, including the consoling oblivion of wine. Absorbed
and metabolized by the Christian doctrine, the altered-mind condi-
tion provoked by wine inebriation was symbolically fermented anew
to indicate the transformative experience of Christ's True Vine, as
expressed in the Eucharistic ritual. Within that new frame of refer-
ence, the "sober drunkenness," produced by the wine-blood of Christ,
was used to signify the enhanced state of awareness that man was
granted when he opened himself to Christ's saving action.

The first people who had converted to Christianity had come,
for the most part, from the lower and poorer strata of society. But
when Christianity became legal, many prominent members of the
upper classes were added to those early converts (interestingly, the
word "pagan," from *paganus,* meaning "rustic" in Latin, was used by
the Christians from the fourth century on to define the uncultivated
country people who still worshipped many gods). The demographic
change is made evident by the appearance, around the fourth century,

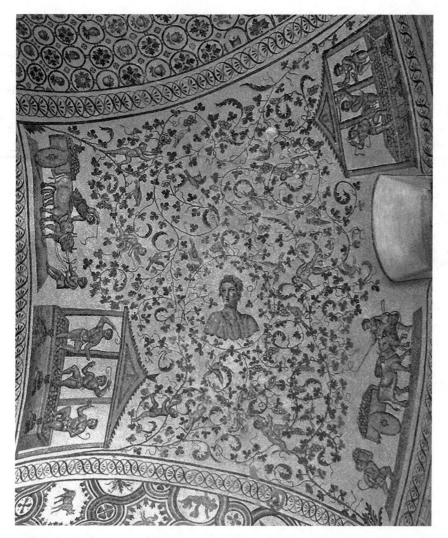

A Christianized version of the Dionysian realm of grapes and wine

of expensive sarcophagi, beautifully decorated with Christian themes, that the members of the upper class began to sponsor. One of the best examples of this kind of funerary art is the sarcophagus of the Roman prefect Junius Bassus.

The affinity that the reliefs seem to share with the naturalistic approach of Roman style is challenged as soon as we realize that what binds together the episodes that the columns frame and separate is not a consequential progression but the unfolding of a symbolic order

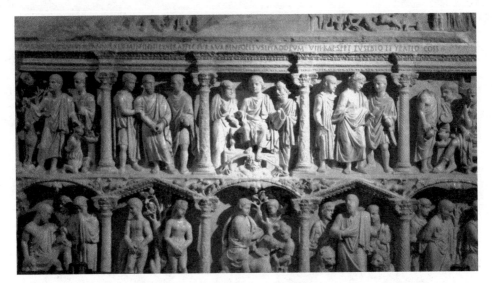

The sarcophagus of the prefect Junius Bassus demonstrates the spread of
Christianity to the Roman upper classes.

that emphasizes the mystery of eternity over the linear narrative of
secular temporality.

In the lower register, two stories are presented: on the right, the
arrest of Peter and Paul, and Daniel in the lions' den, on the left, Job,
and Adam and Eve. In the center, the victorious but also humble Mes-
siah enters Jerusalem on the back of a donkey or an ass—a symbol
that the Christian iconography frequently used to allegorically signify
the return of the redeemed soul into the city of God.

The scenes in the upper register represent the sacrifice of Isaac, the
arrest of Christ, and his encounter with Pontius Pilate. Even though
all those events allude to the sacrifice on the cross, the gruesome
depiction of the Passion is avoided. In its place, we see the resurrected
and enthroned Christ handing the Law to Peter and Paul while tri-
umphantly resting his feet on the vault of the firmament (represented
in a pagan-like manner by a male figure holding a veil over his head).

Eventually, the use of privately sponsored art came to be strongly
discouraged by the church, especially when, having acquired more
prominence between the fifth and the sixth centuries, the ecclesiasti-
cal leadership tightened its control over all religious matters. As a

consequence, works of art disappeared from private use to be reassigned to the sole decoration of the House of God. The implicit message was that the only legitimate purpose of art was the collective celebration of God, as expressed by the church, which was at the head of the Christian family.

When the Christian religion became legal, the need to create a temple capable of accommodating the large congregations assembled for the Mass became of primary importance. Using the plan of pagan temples proved useless, because the inner shrine was nothing more than a small room designed to contain a statue of the god. The brilliant solution that Constantine's architects eventually came up with was to apply to churches the plan of the Roman basilicas—the spacious assembly halls that had once been used as courts of law. The semicircular apse, where in the past stood the seat of the judge, became the place for the altar, which was the fulcrum of the church. To reach the altar, people had to traverse the long stretch of the central hall (later flanked by two additional lateral aisles). The nautical term given to that central hall, "nave," perfectly fit the Christian narrative that claimed that by entering the ark of Christ's salvation, the believer initiated a whole new odyssey toward the homeland of paradise.

Once the structure of the church was completed, what remained to be decided was what kind of art was most appropriate for the decoration of the temple. Eventually, it was determined that paintings and mosaics were to be used because they were best suited to the spiritual and visionary nature of the religious message, while high reliefs (like the ones placed on early sarcophagi), and especially statues, were to be strictly avoided. The fear was that the realism of statuary and stone carving might induce the sin of idolatry.

In the Bible, the prophet Isaiah had denounced, with biting sarcasm, the stupidity of idol worshippers who bowed with reverence in front of images of which they forgot that they were themselves the authors: "They lavish gold out of the bag, and weigh silver in the balance, and hire a goldsmith; and he maketh it a god: they fall down, yea, they worship" (Isaiah 46:6).

The power of seduction associated with the art of sculpture had also been addressed in pagan times, most famously in the tale of Pygmalion, who fell in love with the marble figure of Galatea, which he had sculpted, as if it were a real woman. If Galatea had awakened the desire of Pygmalion, it was because his masterly touch had given her cold and stony flesh the softness of a real woman's body. As a consequence, the artist, blinded by erotic passion, ended up idolizing the object of his own creation.

The fear of delusional passions that the realism of statues could elicit strongly resonated among Christians, as Cyprian, the third-century bishop of Carthage, confirmed when he urged, "When you see a statue, lower your eyes and divert your sight!"

The trepidation that the early Christians felt in regard to the art of statuary also had much to do with the belief that those stony images were not just lifeless objects but hiding places of ghosts and spirits. The fear was compounded by the Christians' assumption that the pagan gods were in reality demons fond of taking shelter in the stony images erected in their honor.

Considering the great number of statues that filled the cities of antiquity, the Christians certainly had a lot to worry about. A list compiled during Constantine's time mentions the presence, just in Rome, of at least thirty-five hundred statues. As we have seen, many of those statues represented local and foreign divinities that through war or commerce had found their way into the melting pot of Rome, as well as portraits of emperors, military leaders, and mythological figures. Among the many statues placed in stadiums or bath complexes were also the images of athletes, depicted in the nude, that were meant to celebrate, in a Greek-like fashion, the beauty and strength of the human body.

The most prestigious statues stood on large bases or were raised on top of splendid columns made of marble, jasper, porphyry, or alabaster. Except for the tutelary home divinities, which were represented by small figurines often made of simple materials like wood, clay, or wax, the majority of statues were made of marble or bronze, while a smaller number of more costly examples included silver, ivory, and

gold. All marble statues were decorated with brilliant colors, with particular emphasis on the eyes, which were considered windows to the soul.

The alarming feelings that such a profusion of stony presences must have produced among the first Christians, so intensely aware of the seductive power of images, are easy to imagine. From the private to the public sphere—homes, markets, theaters, public baths, forums—the silent stares of a multitude of statues stood at every corner, mingling reality and fiction in an extraordinary and rather surreal coexistence.

In many popular legends, statues were said to have talked, moved, and even stepped down from their pedestals to walk in the streets, disguised among the multitudes of people who crowded the cities of the empire. To counteract the power of those ghostly presences, nothing was considered more effective than the power of sanctity. A Christian legend described Saint Peter crumbling to pieces the statues that stood in the temple of Neptune in Naples by simply calling them down from their exalted position. Another story, concerning Pope Gregory the Great (A.D. 540–604), claimed that just by staring at those hideous works of art, the saintly man caused the heads and limbs of various statues to shake and fall to the ground, shattering them into many pieces.

Terms such as "mad," "laughable," "loathsome," "disgusting," "abhorrent," "wicked," and "ignorant" were used to legitimize the zeal with which the Christians condemned to destruction thousands of statues. If the demolition of a huge statue proved too difficult, ground burial was recommended. The decimation that Western art suffered during those fanatical and puritanical years of Christian righteousness was immense. The proof is that the only statue that survived the great campaign of destruction that took place in Rome was that of Marcus Aurelius, which the Christians erroneously took as a depiction of Constantine.

The fear that by seducing the viewer, sculptures could become blasphemous idols always remained a concern among the Christians. After all, the pious Christians asked themselves, wasn't dis-

The famous statue of Marcus Aurelius was spared only because he was mistaken for Constantine, the first Christian emperor.

guise what Satan so often used to enslave his human victims? Addressing the argument, Christian theologians had no doubt: if not closely monitored by the church, nothing could have been more dangerous than an art that appealed to the seductive power of false beauty.

Further articulating the argument, Clement of Alexandria contended that the greatest risk that man incurred when he crafted copies of reality was to fall into the prideful belief that he could somehow compete with God's creative talent.

How deeply those feelings resonated is proven by the total lack of ego that characterized the anonymity of the medieval artists. Art, in those profoundly religious times, was considered a collective effort: a tribute to God that categorically excluded the praise of any single artist. The medieval craftsman thought of himself not as an independent creator but simply as an artisan, the fashioner of images whose symbolism and style completely depended on the religious dogma decreed by the ecclesiastical authorities.

Because most paintings from that time have disappeared, the only way for us to see how the Christians of the first centuries developed their visual language is through the mosaics that best withstood the ravages of time. The Greeks and the Romans had mostly used mosaics for surfaces that would have been unsuitable for paintings,

such as floors or the inside of fountains. Although a new use of mosaics had developed in the late empire, it was mainly with Christianity that the technique reached its climax, also thanks to the influence of Byzantine art. Mosaics were made of a multitude of little cubic stones, called tesserae, whose color, brilliance, and iridescence were enhanced by the addition of pieces of glass masterfully tilted at different angles. Intensified by the flickering light of the candles that illuminated churches, the dazzling sparks produced by the irregular refractions of color and light gave a transcendental quality to those glow-saturated forms. Overwhelmed by the dematerialized magic of the vision, the spectator would have been led to perceive, in those images, the intangible world of the spirit.

The mosaic in the apse of the Church of Santa Pudenziana in Rome, executed toward the end of the fifth century, is a good example of the confidence that the church acquired once it morphed from a small, persecuted set of devotees to a large and influential institution enjoying a position of full prominence within society.

Instead of a young shepherd placed in a simple, pastoral setting, what is presented here is a bearded and mature Christ whose authority has been raised to an imperial status by means of iconographic association—from the gravitas of His expression, also evocative of the intense look of a philosopher, to the halo that shines behind His head, to the jewel-studded throne that elevates Him above the apostles clothed with white togas, just like senators of ancient Roman times. In a position of prominence, Peter and Paul are crowned by two women with laurel wreaths.

Behind the figures, an encircling wall defines the perimeter of a city that looks like Rome but in reality is the celestial Jerusalem. Above, as if emerging from the sky that surrounds the hill of Golgotha, we see the symbolic representations of the four evangelists, portrayed as mysterious creatures: a winged man (Matthew), a lion (Mark), an ox (Luke), and an eagle (John). Derived from the visionary prophecy of Ezekiel and from the Apocalypse, the images are used to represent the evangelists as portentous figures endowed with the gift of divine prophecy. Within that symbolic representation, the message

The mosaic of the apse of the Church of Santa Pudenziana in Rome,
fifth century

of Christ is evoked over and over: the winged man indicates Christ's
incarnation, the lion His majesty, the ox His sacrifice, the eagle His
ascension.

In a popular passage by Augustine, John is described as follows:
"John . . . soars like an eagle above the clouds of human weakness,
and gazes upon the light of permanent truth with the keenest and
steadiest eyes of the heart." In ancient folktales, the eagle was believed
to be a magical bird capable of flying as high as the sun, at whose light
it could directly stare with its powerful eyes. Through the Christian-
ization of the myth, the eagle became a perfect equivalent of John's
prophetic capacity to look, deeper and stronger than anyone else, into
the blazing light of God's mystery.

In the fifth-century mosaics in the Basilica of Santa Maria Mag-
giore in Rome, the use of art as a thought-provoking instrument of
meditation finds particularly interesting solutions. See, for example,
the scene of the Nativity.

Choosing the abstraction of symbolism over a factual narrative, the mosaic presents Jesus not as a baby resting in a manger but as a small adult sitting like a king on a triumphal throne decorated with a great abundance of precious gems. Shining behind the throne is the star of Bethlehem, surrounded by four angels dressed in white. To the left of Christ, on an elevated throne, the figure of Mary is portrayed as a queen mother proudly looking at her royal son. The sumptuously dressed figures approaching from the right represent the Magi bringing presents to the divine baby.

The lack of realism and factual chronology was used to suggest that the advent of Christ was to be considered not a transient moment that had occurred once in time but an eternal miracle happening, each time anew, in the heart of the true believer, as Gregory of Nyssa in the fourth century wrote in his treatise *De virginitate:* "What happens to the immaculate Virgin, when the divinity shined through her virginity, happens to each soul that spiritually delivers Christ."

The disregard of the temporal dimension is echoed in the incongruous depiction of space, where the proportion between the figures and the environment is consciously altered to stress a vision that is metaphysical rather than realistic and spatially coherent—a vision

The Nativity, as rendered in a fifth-century mosaic in the Basilica of Santa Maria Maggiore in Rome

that addresses the "eyes of the spirit" rather than the "eyes of the flesh," as Paul indicated in 2 Corinthians 4:18, "For the things which are seen *are* temporal; but the things which are not seen *are* eternal."

One of the most striking techniques used by the early Christians to express the ineffable nature of the divine was the reverse perspective. An example of reverse perspective is contained in the scene representing Abraham and Sarah (also in the Basilica of Santa Maria Maggiore, in Rome) offering a meal to the three mysterious guests who, as the upper register reveals, are personifications of the divine (Genesis 18:1–8).

According to the rules of perspective, which were known since classical times, the frontal line of a depicted object is always longer than the back one. The reverse perspective that the mosaic adopts (with the frontal line shorter than the back one) completely changes

Abraham and Sarah and the three mysterious guests, rendered in reverse perspective in the Basilica of Santa Maria Maggiore

that dynamic: instead of receding backward toward the wall, the image extends forward as if reaching toward the viewer. As a result, the viewer gets the impression that he or she has suddenly become the object rather than the subject of observation. The aim of that reversal was to give the Christian viewer the impression that he or she was looked upon by the sacred images and not vice versa.

What the image essentially demanded was a correspondence: an invitation to enter into an encounter/dialogue with the divine. As an ongoing conversation with God, faith also involved a process of soul-searching and self-exploration—that particular conversion of attention that occurred when, reawakened by the message of the divine, the individual returned to contemplate the inner meaning of life and self.

LATIN WEST VERSUS GREEK EAST

As we have seen, the turmoil that shook Europe gained particular momentum between the fourth and the fifth centuries, when, in order to flee the violent Huns coming from the East, many barbarian tribes migrated toward the West. The Goths, who were divided between Visigoths and Ostrogoths, invaded Italy and Spain; the Vandals took over northern Africa and southern Spain (the name "Andalusia" was initially "Vandalusia"); the Franks and the Burgundians (from which derives the regional name of Burgundy) invaded Gaul, modern France, while the Anglo-Saxons settled in Britain in the fifth century.

The moment that sealed the end of the Western Empire occurred in A.D. 476, when the barbarian Odoacer, a Germanic soldier serving in the Roman army, forced the abdication of the last Roman emperor, Romolo Augustolo. To criticize the rough ways of the barbarians and their lack of appreciation of Roman culture and law, many writers of the time described them with terms more suited to animals

than humans, like the poet Prudentius (348–ca. 413) did when he wrote, "But Romans and barbarians stand as far apart as biped from quadruped."

Some barbarian habits contributed to those derogatory views. The Huns, for example, spent so much time on the backs of horses that they were seen as strange creatures almost fused with the animals they rode. The Roman historian Ammianus Marcellinus reported that riding was also used by the Huns for preparing the raw meat they ate, which they made tender by placing it under their rears tightly glued to the saddle!

Such rough portrayals ended up giving all barbarians a similar reputation. In reality, they were not all the same: if the brutal Huns were principally interested in raids and looting, others, like the Ostrogoths, felt a profound sense of reverence toward Rome. Theodoric, king of the Ostrogoths, who got rid of the German chieftain Odoacer and ruled Italy from Ravenna, expressed his profound admiration of Roman civilization when he declared to the Eastern emperor Zeno that he wanted to make his kingdom "a copy of yours without any rivalry."

Theodoric's aspiration was to become a custodian of what was left of the Western Empire (which, at that point, only included the Italian territories) and also a promoter of the cultural process of reconciliation that, he hoped, would have taken place between Ostrogoths and Romans. To show his peaceful intentions, Theodoric ordered that only one-third of the occupied territories be assigned to the Ostrogoths, while the rest of the land was to be left under the control of its previous owners. Theodoric also passed laws that forbade the destruction of Roman monuments, which he made sure to preserve by assigning money to their maintenance and restoration.

Like other barbarians, the Goths, early on, had been converted to Arianism by an apostle by the name of Ulfilas (Arianism was the Christian dissident sect that, as we have seen, the Council of Nicaea had declared heretical). Despite that religious difference, Theodoric continued to assure freedom to all Christians and to the Jews, whom he protected against all acts of harassment. As an admirer of Rome,

Theodoric often surrounded himself with Roman advisers. Among them was the philosopher Boethius (ca. A.D. 475–524), whose contribution to culture consisted of a number of important translations of major Greek authors.

During the heyday of the Roman Empire, all educated people were bilingual, meaning that besides Latin they also spoke Greek—the language used in the Eastern provinces of the empire from where the Romans had gained access to Hellenistic philosophy, poetry, and literature. As education disappeared amid the chaos produced by the barbarian invasion, the Greek language was also forgotten. The reason Boethius is considered so important is that, being one of the very last intellectuals who still had knowledge of the Greek language, he was able to provide to the West the Latin translation of important Greek texts by authors such as Euclid, Archimedes, and Ptolemy that otherwise would have been forgotten. Among the works that Boethius saved from oblivion was Aristotle's *Organon,* which included six treatises on logic. That work remained the only Latin source of the Greek philosopher until the cultural revival that took place in Europe between the thirteenth and the fourteenth centuries.

The relation between the barbarian king and the Roman emperor dramatically deteriorated when the new Byzantine ruler, Justin I, abandoning the tolerant policy of his predecessor, enforced laws against all dissenting sects of Christianity, Arianism included. As a result, Theodoric became increasingly suspicious about a Byzantine conspiracy aimed at removing him from the Italian territories he controlled. The most prominent victim of that sudden turn of events was Boethius, who, unjustly accused of treason, was imprisoned for one year and eventually killed. In the book he wrote in prison, *The Consolation of Philosophy,* Boethius imagines a fictional dialogue between himself and Lady Philosophy. After talking about the randomness of Fortune, Lady Philosophy, in a way that appears to be a blend of Platonism and Stoicism, reminds Boethius that consolation can be found only in the permanence of virtue and in the beauty that the mind finds in its intellectual pursuits. Although religion is not directly mentioned, the book gained the admiration of many future genera-

tions of Christian thinkers because it showed that the Platonic ideas could be harmoniously linked with the principles of Christianity.

The years that followed left little hope for a reconciliation between Goths and Byzantines. In 535, the new emperor, Justinian (to whom we will return more extensively later), determined to reclaim the western territories of the old Roman Empire, initiated a war against the Goths that lasted eighteen disastrous years, during which the degradation of Italy reached a new, dramatic climax. The Byzantines came out of the conflict victorious. But when, fifteen years later, a new wave of tough and determined barbarians called Lombards or Longobards descended from Pannonia (modern Hungary), the Byzantines were forced to retreat toward the south, leaving control of northern Italy to the Lombard occupants, who kept their rule for the next two hundred years. (The Italian region called Lombardy derives its name from the Lombard barbarians.)

The worst consequence of those violent years was the collapse of cities and the destruction of farmlands, which caused famine, poverty, disease, and the consequent decrease of the overall population of Europe. As the great network of Roman roads fell into disrepair, commerce and trade came to a halt, as did culture and the exchange of ideas and traditions. While wilderness reclaimed large pieces of land once tamed by human work and ingenuity, the West turned into a loose conglomerate of small and self-sufficient villages isolated from one another, while the remains of Roman theaters, baths, arenas, aqueducts, temples, and bridges gradually crumbled amid the indifference of an ever-increasing poor and ignorant population.

In 543, a devastating plague arriving from the East ravaged even further the blighted condition that so many suffered. Like the wild animals that prowled in the darkness, the constant proximity of death filled the minds of people with fear, superstition, and nightmare visions. Pope Gregory I mourned in dismay, "What remains that is pleasant in the world? Everywhere we look we see pain, everywhere we hear cries. Cities are destroyed, the fortified places are ruined, the land abandoned and left to solitude. Few people are left in the countryside and the cities."

What Augustine predicted seemed to have come true: human sin had provoked the fury of God, precipitating the final destruction of the world. *"Mundus senescit,"* prophets of doom cried, meaning that the world, having grown old, was drawing closer and closer to its last and final chapter.

In view of that fast-approaching end, religious preachers advocated the need to repent while committing their souls to the only possible means of salvation, the church that Saint Ambrose, in the fourth century, had described as follows: "Amid the agitations of the world, the Church remains unmoved; the waves cannot shake her. While around her everything is in a horrible chaos, she offers to all the shipwrecked a tranquil port where they will find safety."

In those years of uncertainty and confusion, the image of the church floating like a safe ark above the deluge of misery brought a great amount of hope and consolation—at a spiritual level but also at the practical one. Will Durant explains that because the barbarians knew very little of social and political organization, it was left to the church, the "Foster Mother of Civilization," to assure some sort of stability and continuity in the functioning of society. The tasks that the church performed, especially through its provincial organizations presided over by bishops, included administrative functions, the management of churches and hospitals, the sponsorship of religious art, the organization of tribunals where the clerical representatives presided over judicial matters, and all sorts of charitable initiatives created to alleviate the difficult conditions of the less fortunate. Even if the mechanism might have been somehow rudimentary, during the most troubled years of the early Middle Ages the organization of the church remained the only institution capable of keeping in place some level of order and civility among the disrupted communities of the old Roman Empire.

The church's center of power was Rome. The bishop of Rome, the pope, was considered the successor of Saint Peter, whom Jesus called the "rock" upon which his church was to be built. Commenting on the symbolic transformation that Rome underwent, from persecutor to defender of Christianity and seat of the papacy, Richard

Tarnas writes, "As the Roman Empire became Christian, Christianity became Roman." As such, the church gradually became the ideal counterpart of the empire, while the Pax Romana was transformed into the triumph of the Pax Christiana.

Initially, the patriarchs, who were the bishops of the great cities of Constantinople, Antioch, Jerusalem, Alexandria, and Rome, had been recognized as equal in authority. With Leo I (400–461), who assumed the title of *pontifex maximus* that had previously belonged to the emperor, the prestige of the Roman papacy grew to an unprecedented level. The event that lifted the reputation of the pope to a legendary status took place when Attila, the king of the Huns, having ravaged the northern city of Aquileia—Venice was founded by the fleeing population that took shelter on the islands of the nearby lagoon—began to proceed south toward Rome. Leo I, who, in legend and possibly fact, persuaded the ferocious Attila to give up his plan and withdraw from Italy, gave the papacy an authority that appeared to be, at the same time, religious, moral, and political.

The other pope who, like Leo, was granted a superlative was Gregory the Great, who during his pontificate (590–604) vastly contributed to the spreading of Christianity, which he accomplished by personally converting the Arian Lombards and by sending missionaries to Spain, Britain, and Ireland. Gregory, who like Leo came from an aristocratic family, abandoned all privileges to lead a life of humble austerity filled with penance, prayer, and the care of the poor and the needy. Gregory's prolific activity as a writer included a manual called *Pastoral Care,* which applied the image of the Good Shepherd, traditionally associated with Christ, to all church representatives—namely, popes, bishops, and parish priests. Besides an important commentary on the book of Job, Gregory wrote the *Dialogues,* a collection of four books, of which the second one was entirely dedicated to the life of Saint Benedict, who, as we will see, was the founder of the first monastic rule in the West. Widely read, Gregory's book was filled with fantastic stories of the medieval imagination: ghosts and evil spirits persistently looking for ways to gain control of the human soul, amid a great variety of wondrous miracles—holy men reject-

ing Satan with the sign of the cross, or healing the sick using a holy object, or moving rocks with the simple power of prayer. Gregory was also the protagonist of many popular medieval legends. One of them took place during the plague that had devastated the city of Rome. When Gregory, the legend reported, saw the archangel Michael putting away his sword on top of Hadrian's mausoleum, he understood that the plague had finally come to an end. The statue of an angel on top of the mausoleum, which from then on was renamed Castel Sant'Angelo, evokes to this day the wondrous magic of Gregory's time.

Gregory made a history-shaping claim when he affirmed that the pope, as a direct successor of Saint Peter, held a primary authority within the Christian world. The assertion could be compared to a declaration of independence of the Western Church from its Eastern counterpart, which was under the direct control of the emperor, who, in a way that was reminiscent of Roman imperial practices, arrogated to himself a power that was secular and religious at the same time. Just as in Constantine's time, the argument used by the Byzantine emperor was that he was directly anointed by God as His vicar and representative on earth. The aura of holiness that such status granted gave the emperor absolute power over state and church: it was the emperor who chose the chief officer of the Eastern Church, the patriarch, and it was the emperor who summoned councils, issued doctrinal edicts, and reviewed the liturgy.

After Constantine, Byzantium's most ambitious emperor was Justinian (A.D. 482–565), who, as we have seen, sought to re-create the unity of the old empire. To do so, he waged war against the Goths in Italy, the Vandals in North Africa, and the Visigoths in southern Spain. The victorious outcome gained Justinian the title of "last Roman emperor." The title is fitting also because Justinian was the last Eastern ruler to use Latin as the official language of the empire— a policy that was reversed by the emperor Heraclius (575–641), who asked to be called Basileus ("king" in Greek) rather than Augustus and decreed that Greek, the language used by the people, replace Latin as the official language of government.

During Justinian's time, the multiethnic and multicultural By-

zantium reached a population of almost one million. The wealth that the city enjoyed derived from its active port, whose mercantile activities reached as far as Africa and Asia. When silkworms, smuggled from China by two monks, were brought to Byzantium, the city became the capital of silk weaving: a prestigious and lucrative position that the city maintained until the disastrous events of the Fourth Crusade in 1204.

During his reign, Justinian dedicated himself to the aggrandizement and beautification of Byzantium, which he filled with palaces, porticoes, monuments, promenades, and public baths. His greatest accomplishment was the magnificent church of Hagia Sophia (Greek for "Holy Wisdom"), in which the Roman style was mixed with features clearly borrowed from Persia, like the gigantic dome supported by four arches springing from pillars placed at each corner of the rectangular base. Commenting on the engineering wonder that had made possible the creation of a dome 183 feet tall, the sixth-century historian Procopius exclaimed, "It does not appear to rest upon a solid foundation, but to cover the place beneath as though it were suspended from heaven by a fabled golden chain."

With its silver throne reserved for the patriarch, Hagia Sophia was a tribute to the power of Christianity, but also to an emperor who aspired to give biblical proportions to his memory and legacy. Procopius wrote that when Justinian inaugurated the grandiose church, filled with glittering mosaics and its colorful marbles, he uttered with pride, "Solomon, I have outdone thee!"

Right opposite Hagia Sophia, across a big and open colonnaded forum, was the monumental palace of the emperor. In front of the palace stood a bronze-covered column almost as high as the dome of the church; on top of it stood the equestrian statue of Justinian holding a globe in his left hand, while his right one pointed toward the east to symbolize the never-setting glory of his power.

To strengthen the Christian identity of his empire, Justinian started a vigorous campaign of suppression of all remaining pagan practices. Those who did not undergo the compulsory ritual of baptism were punished with imprisonment, torture, and even death.

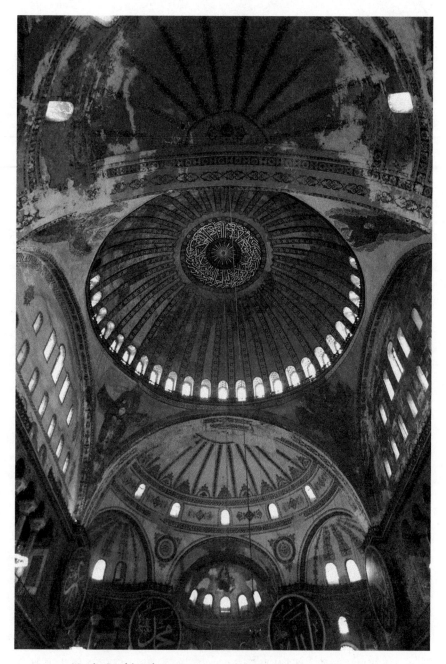

Hagia Sophia, the emperor Justinian's most magnificent
and lasting achievement

To erase the most emblematic trace of the pagan past, the emperor ordered the closing of the famous Academy that Plato had founded nine hundred years earlier, and rededicated to Mary, the mother of Christ, the Athenian Parthenon.

Justinian was also famous for undertaking a comprehensive revision of the Roman law, which was codified with the name of *Corpus iuris civilis,* also known as the Code of Justinian (534). The statutory laws and legal decrees that the code included were also used by Justinian as a means to sanction the absolute quality of his authority. What pleased the emperor was turned immediately into law. If things went wrong, responsibility was readily and conveniently diverted toward the usual scapegoats—Jews, heretics, and homosexuals.

The emperor's inflexible rule was reflected in the organization of a complex bureaucracy that proved particularly useful for the collection of taxes and fines, which Justinian enormously increased to finance the great amount of art he commissioned to lend grandeur to the capital of his empire. When the exasperated citizens, oppressed by the excessive taxes, staged a rebellion (known as the Nika uprising), the emperor resorted to violent means to repress the revolt. The bureaucracy that characterized the Byzantine government was also used by Justinian as a sophisticated espionage system through which to control the activity of his subjects.

To underscore the uniqueness of the emperor, complex norms of protocol and etiquette were developed, especially within the imperial palace, where ritualized behaviors, choreographed with theatrical flair, accompanied every moment of the ruler's daily routine. To convey the impression that the emperor held a status that was almost supernatural, he was often lifted by mechanical means above visitors and court members, only to magically reappear dressed each time in a new rich and colorful costume. In his presence, everyone was forced to prostrate to the ground and kiss his silky slippers, while avoiding directly staring at his bigger-than-life persona. Reports of the time said that the emperor's nobility was clearly revealed by the extraordinary quality of his demeanor: he never scratched or blew his nose

in public, or spit or turned his head "here and there." When a guest was ushered into the throne room, two mechanically activated lions roared, accompanied by a chorus of artificial birds perched on golden trees. The people who directly served the emperor were castrated eunuchs who could never pose a threat to the manly superiority of the emperor and to the purity of the empress. With their high-pitched voices, hairless bodies, and inability to procreate, the eunuchs were purposely altered to evoke, within the artificial paradise inhabited by the emperor, the pure presence of angels.

Because the mosaics that decorated the inner walls of Hagia Sophia were erased after the Ottoman Turks conquered Constantinople and turned the church into a mosque in 1543, the best way to have a sense of the pomp that surrounded the Byzantine court is to look at one of Italy's most famous artistic jewels: the magnificent mosaic displayed in the Church of San Vitale in Ravenna that Justinian sponsored.

The mosaic depicts the celebration held by the emperor and his wife, Theodora, when the church was offered as a gift to the city to honor its protector, Saint Vitale. Following an old tradition, the image was used as a proxy that was believed to fully substitute for the physical presence of the emperor, who in reality never left Byzantium to attend the ceremony in Ravenna. The same was true for his wife, Theodora, the daughter of a bear tamer, who had been a notorious prostitute before the emperor scandalously selected her as his wife and co-regent to the consternation and outrage of the Byzantine elite. But the chronicles of history have no place in the myth of power that the mosaics celebrate through the formal pageantry of court life. The crowns, the halo, the robes, and the jewels give prominence to the emperor and the empress, frontally depicted among a sumptuously dressed group of dignitaries and ladies-in-waiting. The stillness of the wide-eyed figures, aligned as in a ceremonial procession, combined with the flatness of the bodies disguised under the geometric folds of ample tunics, lend an immaterial remoteness to the entire scene. For the people of the time, used to promptly casting their stare downward

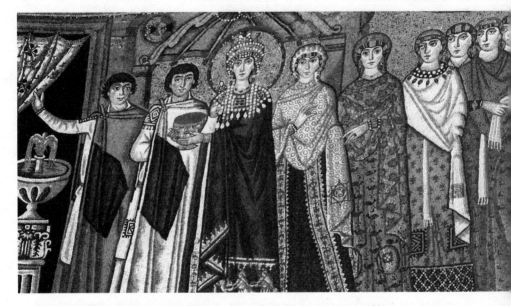

Empress Theodora and her court in an early sixth-century mosaic,
Church of San Vitale, Ravenna, Italy

when in the presence of their regents, the sight of the mosaic must
have been overwhelming, like being granted a rare glimpse, behind
the curtain of secrecy, into the dazzling beauty of the divine.

Byzantine style and techniques greatly influenced Western art.
The main difference, of course, concerned the subject matter: whereas
the Byzantine artists endowed the emperor with godlike charac-
teristics, the Western Christians attributed holiness only to Christ
and His saintly representatives, as in the mosaic of the Basilica of
Sant'Apollinaire, which was dedicated to the bishop of Ravenna.

The image of Christ that appears in the upper part of the mosaic,
next to the symbols of the four evangelists, emerges out of a sky lay-
ered by blue and red clouds. Right below, twelve sheep symbolically
representing the twelve apostles are seen exiting the gates of Jerusa-
lem and Bethlehem to start their upward ascent toward the sky. The
hand that emerges from the clouds, just below Christ, is that of God
the Father blessing the globe of stars in which a cross, encrusted with
jewels, triumphantly shines. The three sheep next to the cross repre-
sent Peter, James, and John.

Underneath, we see Saint Apollinaire is frontally portrayed with arms raised as in the ancient pose of prayer. The background, filled with trees and flowers geometrically arranged, presents paradise as a place of perfect order and beauty. The avoidance of realism in favor of morally edifying symbols is particularly evident in the suppression of all human figures: with the exception of Saint Apollinaire, the twelve apostles are depicted as sheep standing next to the bishop portrayed

The mosaic in the dome of the Basilica of Sant'Apollinaire in Ravenna, an example of specifically Western Christian iconography

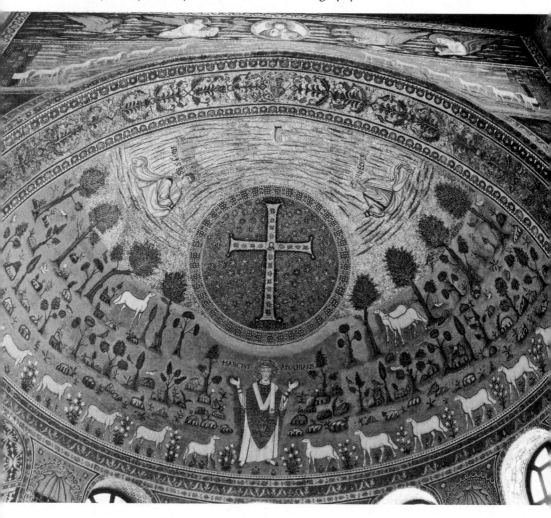

as Christ the Shepherd. The emphasis given to the image of the sheep was also a way to remind Christians that the kingdom of God was accessible only to those who had been proven to possess the moral purity of Christ's humble and selfless simplicity.

<p style="text-align: center;">✳</p>

THE MONASTIC EXPERIENCE

Among the many spiritual expressions that flourished during the Middle Ages, the cult of saints was particularly vigorous. The martyrs, whose blood was said to have seeded Christianity, were of course considered the most important of all saints. But once Christianity became legalized, and martyrdom ceased to be common, the concept of holiness was extended to include hermits, virgins, monks, or any other individual who, next to moral distinction, also proved able to perform miracles. In time, the number of saints grew to the point that each day of the ecclesiastical calendar became a tribute to one of their names. Some scholars believe that the veneration of saints was in fact a residual form of polytheism. The fact that just like the innumerable divinities of Greek and Roman Olympus each village and town had a patron saint, and that every aspect of life had a divine protector, lends credibility to that assumption. When a problem arose, whether material, spiritual, or health related, a specialized saint could be readily invoked: perennially on duty, perennially merciful, and perennially ready to intercede with God on behalf of his or her followers. The business of sainthood was so pervasive that even crafts acquired their holy guardians: Saint Bartholomew became the protector of tanners because he had been flayed alive, while Saint John was the advocate of candle makers because he had been thrown into a huge pot of boiling oil. Animals were not excluded: Saint Cornelius protected oxen; Saint Gall, chickens; Saint Anthony, pigs.

Initially, important theologians had frowned on simplistic expressions of faith that appeared closer to paganism than Christianity. But

the great amount of superstition that continued to linger, especially among the less educated, soon erased any attempt to control the many unorthodox ways in which Christianity was practiced. Among the traditions that blurred the line between faith and superstition was the veneration of relics that turned saints into precious commodities, often more useful in death than in life. When a candidate for sanctity died, his or her body was immediately boiled so that the clean skeleton could be easily divided into pieces, which were then distributed (or sold) to be venerated for their miraculous powers. If a bone was not available, an object—for example, a piece of cloth worn by the saint—could be designated as a relic bearing the same healing powers possessed by skeletal fragments. The first collector of Christian relics was Helena, the mother of Constantine, who traveled to Palestine when she was eighty years old. Here, legend held, she found the True Cross. The event is depicted in the Basilica of San Francesco, in Arezzo, in a chapel famously painted by the fifteenth-century artist Piero della Francesca. In time, every Christian church claimed the ownership of a relic. The Basilica of Santa Maria Maggiore in Rome still displays five wooden planks that, allegedly, were taken from the manger where Christ was born, while the Lateran Basilica owns twenty-eight marble steps (referred to as the Holy Ladder) that Christ supposedly climbed the day that Pilate condemned him to death.

The most significant expression of early Christianity was the development of monasticism. The founder of Eastern monasticism was Saint Anthony, an Egyptian Coptic Christian who lived between about A.D. 250 and 355. When he turned twenty, Anthony, who was born into a wealthy family, abandoned his privileged existence to live in the desert, where he led a life of poverty, penance, prayer, and solitude that lasted for thirty-five years. Throughout the Middle Ages, many legends concerning Anthony became popular, especially those that described his battles against the army of demons who, determined to challenge his purity, relentlessly attacked him using the most efficient tools their arsenals possessed. To describe Anthony's discipline and determination, Athanasius, the author of a book about

the life of the saint, used the metaphor of a wrestler in training: for his capacity to constantly strive toward spiritual perfection, Anthony, Athanasius wrote, deserved the title "athlete of God."

In the fourth century, the ascetic life of solitude and deprivation, initiated by Saint Anthony, spread throughout Egypt, Syria, and Palestine. The great variety of methods of self-mortification that the hermits created raised the art of suffering to unprecedented heights. Of all the various temptations, the most feared were the sensual ones because, as Saint Jerome thundered, even the slightest improper thought was to be considered a horrible sin: "Virginity can be lost even by a thought. . . . Let your companions be those who are pale of face and thin with fasting. . . . Let your fast be of daily occurrence. Wash your bed and water your couch nightly with tears."

To mortify the body and silence its demands, many took to exposing their naked skin to the burning rays of the sun, while others preferred to bury themselves in deep, dark, and often snake-infested caverns from which they refused to emerge for months or even years. Each monk lived on a minimum amount of food and water, and each rejoiced at the sight of his thin body growing weaker and weaker every day. Cleanliness was abhorred as a decadent habit, and lice, which were called "pearls of God," were displayed with great pride as a badge of sanctity.

The most extravagant anchorite of all was Simeon Stylites, who lived perched on a sixty-foot-high column for thirty uninterrupted years. When the rope with which he had anchored himself to the pillar penetrated his skin, his flesh started to putrefy. To the worms that appeared on his open wounds, he said with tenderness, "Eat, eat; eat what God has given you!"

Eventually, people like Basil of Caesarea tried to discourage those extreme practices, praising the virtue of a monastic existence that, although strict, was free of the fanatical excesses that the hermits had displayed.

In A.D. 529, the same year that Justinian closed Plato's Athenian Academy, Benedict of Nursia founded the first monastery of the West. Benedict's monastery, first located in Subiaco and then trans-

ferred to Monte Cassino, south of Rome, was a self-contained and self-sufficient community of men who chose to set themselves apart from the world with the purpose of immunizing themselves from all earthly temptations.

To make sure that no moments of idleness, so dangerous for the wanderings of the mind, threatened the integrity of the monks, Benedict imposed the rule known as *ora et labora,* which should be interpreted as "work and pray" as well as "to work is to pray" and which regularly divided the day in hours of work, prayer, and meditation. The success of the Benedictine model was such that a great number of similar monasteries soon mushroomed throughout the Western world. (Benedict wrote his rule for men, but in time similar monastic institutions were also created for women.)

The respect and admiration that surrounded the monasteries was immense. Because people believed that the pious way in which the monks conducted their existence made them ideal intermediaries between the earth and the sky, they often commended to the monks' prayers for the well-being of their souls. The abundant offerings that people gave in exchange for those services immensely enriched religious and monastic institutions.

The three main vows that the head of the monastery, called the abbot (from the Aramaic *abba,* meaning "father"), required from those who wished to join those fortresses of purity and morality were the vows of chastity, poverty, and obedience. The Bible had never specifically advocated the need for chastity. But the trouble that the body, with its animal-like impulses, presented remained a puzzling issue for the Christians. If Christ had accepted the need to die so that the spirit could be free from the flesh, how was a devotee supposed to relate to the body? After many considerations, the answer reached by the fathers of the church was that the body per se was not to be rejected, but rather the fallen flesh belonging to the sinful Adam and his progeny. Christ, they said, had made the point clear by reappearing to the apostles, after his death, carrying the wounds of the Crucifixion on his hands and feet. The detail was used to conclude that on the final day of judgment the saved souls, rising from their tombs,

would require their original bodies, or, more precisely, asexual versions of them.

The explanation did not seem to mitigate the puritan fury with which the body continued to be humiliated with the purpose of frustrating what were considered its sinful needs and desires. The attire worn by the monks, which consisted of long, dark hooded tunics fixed by a cord at the waist, was in itself a reminder that the purity of the flesh was obtainable only through the suppression of the body, whose aberrant appetites constantly impeded, like heavy weights, the free rise of the soul. The story that Pope Gregory the Great reported in his biography of Saint Benedict was meant to be a lesson to all: One day, remembering a woman he met, Benedict was overcome by lust. To quench that fire, he took off his clothes and ran naked into a thorny bush until his body was lacerated and covered with blood—so, Gregory concluded, "by the wounds of his body he cured the wounds of his soul."

Poverty and obedience, the other two monastic vows, were designed to keep in check the most dangerous fault in human nature—the hubris associated with an excessive feeling of self-importance. To avoid it, all private properties were annulled; in the simple life of the monastery, everything was communally owned, and cooperation was stressed over selfish pursuits. Joining the monastery was like entering an alternative reality where all negative aspects of the outside world ceased to exist. Stripping class privileges was part of that effort: because all men were equal in the eyes of God, sharing similar duties became paramount in Benedict's rule. Accordingly, each individual was equally required to contribute to the menial work of everyday life, including the cultivation of the land—a task that was given particular importance, because it provided sustenance to the community and also because it lent dignity to the most humble of all manual labors.

Among the monks' activities was also the raising of animals, such as sheep and goats, whose skin was used to produce the parchment needed for writing. The most precious skin was the vellum, which was extracted from baby lambs and even fetuses. Given the great

amount of skin needed—it took an entire flock of sheep to obtain enough parchment for a single book—it is not surprising to learn that in time monasteries became increasingly dedicated to sheep breeding, while others owned the right to hunt wild animals such as deer and wild goats. The high cost of parchment limited the use of writing, which for that reason remained, for a very long time, available for only the most precious uses. To fully exploit a parchment, a technique known as palimpsest was often used. It consisted in scraping a written parchment in order to place on it a new text. The use of parchment came to an end only when paper, invented in China, finally reached Europe in the twelfth century.

Providing shelter, assistance, and food to the poor and the sick was also given great importance within the life of the monastery, as was the education of the novices. It is important to remember that due to the absence of state-sponsored schools, education and literacy until the twelfth century remained essentially a privilege of monastic life. That does not mean that monastic education was an organized and uniformly applied system. In many cases, due to disorganization or lack of commitment, many monks and clerics remained illiterate and profoundly ignorant. However, when applied correctly, the ideal monastic system was the following: When a boy entered the monastery, sometimes when he was only twelve years old, he was taught to read and write. Afterward, the pupil was exposed to the work of important pagan authors selected from a syllabus, called *Institutiones,* put together by Cassiodorus, a younger contemporary of Saint Benedict's. Once the reading of the pagan authors had sufficiently developed the novice's mental and verbal acuity, the most important aspect of learning was introduced: the study of theology.

The crowning activity was the *lectio divina:* the reading, meditation, and memorization of the sacred texts. The intellectual, emotional, and even physical intensity with which the monks confronted the *lectio divina* is described by Jean Leclercq, who writes, "In medieval times, as in antiquity, in contrast with today, people read not with the eyes but with the lips and the ears, pronouncing aloud the words." Reading was a vocal and auditory practice that fully engaged the

body and the spirit of those who entertained it. Within the monastic communities, that activity was compared to a form of rumination: by mumbling over and over the words of God, the monk was urged to meditate on their meaning, not to grasp their ultimate secret, but to taste the flavor of their nourishing essence.

In the Bible, the Word of God is often compared to bread, milk, and honey. In their visions, Ezekiel and John, the author of Apocalypse, were asked to internalize the Word of God by eating, respectively, the scroll and the book.

The Word of God as food for the soul, as represented in Apocalypse

The monks who spent hours pronouncing aloud the words of the Bible were compared by Saint Bernard (1090–1153) to cows chewing over and over the product of their mastication: "Be pure like a ruminating animal so that what is written can be heard, 'a precious gift is in the mouth of the sage.'"

The reference reiterated a fundamental Christian belief: the Bible was addressed not to the eyes but to the heart, meaning that it was to be not superficially read but deeply experienced. The rumination of the sacred text represented the organic, almost visceral process that took place when the monk entered in communion with the nourishing and therefore transforming message of Christ's Living Word.

In *City of God,* Augustine compared the Word of Christ to a living seed promoting virtue by bringing new life into the "womb of thought." Like in the ritual of the Communion, that assimilation meant not that one possessed the essence of God but rather that by accepting the nourishment of His Word, one agreed to be possessed by the Grace of God.

To describe the overwhelming rapture that such an encounter produced, Christians used the term "illumination." To explain the concept, Christian thinkers used the metaphor of the mirror. Before discussing the significance of that metaphor, we need to remember that it was only in the thirteenth century that Europe, through China, acquired the technological ability to manufacture clearly reflective mirrors made of mercury. Before that time, mirrors were rudimentary bronze or metallic objects that, if not constantly polished, reflected vague and blurry images. Only by keeping this notion in mind can one fully understand what Paul meant when he wrote, "For now we see through a glass, darkly; but then face to face: now I know in part; but then shall I know even as also I am known" (1 Corinthians 13:12).

Because man's intellectual vision was clogged by the dirt of ignorance and sin—Paul's reasoning went—when man looked at himself through the mirror of matter, he only saw a foggy and vague image of his true self. How could the shadowy and imperfect *here* of man be reunited with the perfect purity of the *there* of God? The answer, Paul said, was to be found in the intermediary function provided by

the mirror of Christ, which simultaneously reflected God ("But we all, with open face beholding as in a glass the glory of the Lord"— 2 Corinthians 3:18) and the prototypical image of the first man created in God's image and likeness.

Illumination occurred when, having internalized the message of the Word, the soul reacquired the moral clarity of Christ—the perfectly polished mirror capable of reflecting, in all its intensity, God's radiant goodness and beauty.

The Eastern father of the church Gregory of Nyssa expressed the concept with these words: "As a mirror that has been thoroughly cleansed, the soul that has been purified of all its stains receives in its purity the image of the non-corrupted beauty of the divine."

The soul that opened itself to the light of Christ's purifying action was reawakened, and consequently transformed, by the incandescent brilliance of God's superior truth.

"Everything exposed to the light becomes itself light," as Gregory of Nyssa concluded.

By linking illumination to the actualization of Christ's moral lesson, the Christian doctrine circumvented the obstacle of intellectual explanations and demonstrations. The duty of man was not to know and understand God but to welcome God within by returning to the pure and uncontaminated creature He had originally created.

Christ the Word, Who had come to earth to assist the inner growth of man, was the symbol through which man could recognize, as in a mirror, the splendor of his true, original identity. "Look at the symbol as if it were a mirror," Augustine wrote.

In a similar manner, Gregory the Great advised the believer to gaze deeply into the sacred letters (that is, Christ, the Word/Book) in order to recognize, as reflected in a mirror, the original beauty of his or her inner spiritual self.

FROM THE ICONOCLASTIC REVOLT
TO THE SPLENDOR OF BYZANTINE ART

The idea that the artistic endeavor was to be perceived as a means, rather than an object of devotion, had been a well-established notion since the early years of Christianity. Gregory the Great had famously said that the edifying images delivered by religious art were essential to spread the message of Christianity because they did for the illiterate what writing did for those who could read.

While the West never repudiated the use of images, the East was shaken by two iconoclastic revolts: the first one took place between 726 and 787 and the second one from 814 to 842. The iconoclastic (meaning icon-breaking) controversy was ignited by a group of fanatics who, overwhelmed by the series of defeats that Byzantium had received from the Avars, the Persians, and the Muslims, had started to interpret those disastrous events as a consequence of God's wrath. The main reason for God's anger, they claimed, was to be linked to the production of holy images that had occurred against the prohibition that the Old Testament imposed on all "graven images." The first iconoclastic revolt occurred under the Byzantine emperor Leo III, who, with an edict issued in 726, ordered the removal and destruction of all church images. Even the private possession of an icon was considered a crime punishable with torture, mutilation, or blinding. The policy of Leo III was continued by his successor, Constantine V, who claimed that images were abominable products inspired by the devil, under whose spell ignorant artists had fallen when with their "unclean hands" they had dared to give shape to that which was to remain beyond all human descriptions and representations.

The iconoclastic turmoil finally came to an end in 843. As before, the strictest taboo remained the one concerning the indescribable nature of God the Father, Who was to be visually rendered only through the intermediary image of Christ. Saint John of Damascus,

who was one of the most influential supporters of the use of images, sanctioned that principle when he wrote, "If we fabricate an image of the invisible God we would certainly commit a transgression because it is impossible to represent an image that is incorporeal, without form, invisible and that is not circumscribed. . . . But that's not what we propose to do. It is the Incarnation of God, who made himself visible on earth and who chose, through love, to live among men and took the nature, the consistency, the form and the color of the flesh that we reproduce in images. . . . As the divine apostle says 'We only see now as in a mirror and in enigma.'"

To avoid the danger of idolatry, John of Damascus claimed that the only acceptable art was the one that inspired a deeper form of spiritual understanding. In the West, the concept had been clearly spelled out by Gregory the Great when he wrote, "It is one thing to adore a painting, another is to learn, through the story the painting represents, what has to be worshipped."

To make sure that the artists respected the rules imposed by the doctrine, the Second Council of Nicaea, which took place at the end of the first iconoclastic revolt, issued the following rule: "The composition of images is not the invention of painters, but is based on the tradition and tried legislation of the Catholic Church and the composition and this tradition are not things that concern the painter. To him is entrusted only their execution. Rather do they depend on the order and disposition of the holy fathers."

The artists' obligation was to faithfully follow the guidelines provided by the ecclesiastical authority, and, as such, had absolutely no right to interpret, on their own, the norms of the doctrine. Consequently, art was inevitably stripped of the very thing that we, since the Renaissance, consider its most precious asset—namely, the unique and original expression of the artist. Despite such constraints, the tantalizing quality that Byzantine artists were able to achieve by enhancing spirituality over materiality cannot be denied.

To fully understand the mystical quality that images were given, we have to briefly explore the philosophy of Plotinus, the third-century Neoplatonic philosopher whose writings enormously influ-

enced medieval Christianity. As we know, Plato had condemned art because, as an imitation of the shadowlike appearance of the world, it was "a copy of a copy," twice removed from the ultimate perfection of the Ideas. Plato's position was challenged by Plotinus, who stated that the beauty of the artistic creation consisted not of the dull reproduction of material reality but of the spiritual spark that art could draw out of the deepest essence of things. That spiritual spark was equated, by Plotinus, with light.

Plotinus's vision of the universe was like an immense pyramid. At the top of that pyramid rested the essence of what Plotinus called the "divine One." Standing above all things, the divine One was like a mighty sun from whose radiations the entire universe derived. Unlike Plato, who had sharply divided the realm of matter from the realm of the spirit, Plotinus made the divine immanent within the cosmos. According to that vision, the universe, which derived from the brilliant One, was like an indivisible organism hierarchically structured: a cascade of light growing increasingly faint as the distance from the point of origin increased. What lay further from the source of the divine Light possessed a level of brilliance that was inferior to that which was closer. The opacity of matter indicated the distance that separated the world from its Creator. Because humans possessed a nature that was simultaneously material and spiritual, Plotinus defined them as "amphibious"—creatures who were given the freedom to choose where they wanted to reside and who they wanted to be. If they decided to follow the sensual appetite of the body, they would remain trapped within the gray vestige of the material world, but if they worked at shedding matter on behalf of spirit, they would return as bright as God's incandescent Love.

Plotinus, who, like Plato, felt contempt toward the material world to the point of feeling ashamed of inhabiting a body, used the metaphor of the sculptor to describe the process of spiritual purification: "If your beauty is not apparent, do as the sculptor does while making a statue: he chips, he scratches and he takes away until a beautiful image appears out of the stone. You should do the same: you should take away all that is superfluous and adjust all that is crooked; you

should clean the surface until you make it brilliant. Do not stop to sculpt your own image." (The metaphor was redeployed by Michelangelo, who said that, as a sculptor, he took away the excess of matter to reveal the image that the stone already contained within. This associated the action of man with the blow of the sculptor's hammer that chipped away the excesses of matter. That clash between will and materiality was meant to break free the spark of the divine trapped within the material consistency of the world.)

The absence of realism that Byzantine artists applied to their sacred images, coupled with the sense of remoteness that those visions exuded, was meant to be a visual translation of Plotinus's precept. To suggest the ineffable quality of the divine, realistic references to the material world, such as movement, perspective, and contrast of light and shadow, were eliminated, to be replaced by a pool of golden light out of which the figures almost magically emerged.

If asked about the meaning of all that gold, a medieval viewer would have had no hesitation: the gold represented not the natural light of the world but the non-created light of the divine. The study of light, as an earthly source of energy illuminating from different angles and in various degrees of intensity the surface of material objects, gained interest only much later, in the secularized art of the Renaissance. Certainly not in the times we are discussing, when metaphysical concerns left unexplored all natural aspects of the material world, light included. The reason, the scholar Pavel Florenskij tells us, is that the only light that was meaningful to the producers of the icons was the one that belonged to the "creative principle" from which everything emanated and to which everything returned: in other words, the effulgent substance of eternity evoked by Plotinus when he said that the only true light was the one that belonged to the creative force of the sun-blazing One.

From the point of view of the believer, for whom the icon was a vehicle of divine revelation, the abundance of gold that appeared to emanate from Christ, Mary, or a saint (who were the only permissible subjects of art) reflected, as in a mirror, the closeness that those saintly figures enjoyed vis-à-vis God's divine light. The same symbol-

The mosaic of Christ Pantocrator (Greek for "Almighty"), surrounded by an intense golden hue

Note that the light in this illuminated manuscript matches that of the above mosaic of Christ Pantocrator.

ism extended to the viewer: to be able to discern the true meaning of those holy icons, the believer had to absorb the lesson that the sacred images imparted, which consisted in cleansing the inner self of all material residues so as to turn it into a mirror perfectly receptive of God's divine light. Again, God was to be not understood but accepted within by a soul willing to be filled, transformed, and purified by His divine light. "Only like can know like," as Plotinus affirmed.

The influence of Byzantine art, with its tremendous stress on gold as the symbol of God's divine light, did not remain confined to the East, as we see in the increasingly mystical art that the West produced, especially from the ninth century on, which included the splendid miniatures that the monks placed in the margins of the sacred texts that they copied. The monks who were taught to visualize the lesson imparted by the sacred texts decorated the manuscripts with a mix of brilliant colors and liquid gold. In a world so oppressed by darkness, the beauty of the parchment page emitting a rainbow of light when placed near a

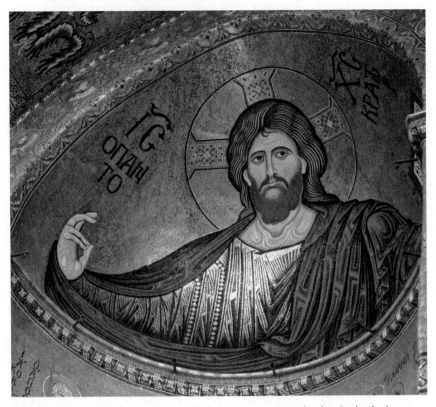

Another medieval representation of Christ Pantocrator, in the Cathedral
of Monreale in Palermo

flame must have been an overwhelming experience. No wonder the
monks, comparing that dazzling view to a mystical experience, called
those manuscripts "illuminated."

The triumph of golden light that we see in the twelfth-century
mosaics of the Cathedral of Monreale in Palermo fully expresses the
impact that Byzantine style had on Western religious art. (The south
of Italy was particularly receptive to Byzantine art, because of its early
contacts with Byzantium.)

Immersed in gold, God's message of salvation is repeated over
and over: from Mary, in the lower part, depicted like a queen on a
throne holding the divine baby on her lap, to the triumphal Christ,
or Pantocrator, rising like an enormous sun on a semicircular niche.
Christ's two raised fingers on the right hand and the sacred Book held

in his left indicated the unity of human and divine delivered by His Logos—a Logos awaiting to be resurrected over and over by those who, by reading and accepting the essence of His divine message, gained the blissfulness of eternal salvation.

※

CHARLEMAGNE AND FEUDALISM

While through the work of monks and missionaries Christianity kept extending its reach across the lands of the old empire, a new religion emerged in the Arabian Peninsula, announced by a merchant named Muhammad who was born in the Arabian city of Mecca in A.D. 570. When he was forty, Muhammad declared that the angel Gabriel had come to anoint him as the messenger of the true God, Allah. Although Muhammad, who never claimed to be divine, recognized Moses and Christ as prophets, he also said that he was the last and most important of them all.

During his twenty-two years of preaching, Muhammad established the set of teachings that, he said, he had directly received from Allah through different revelations. Those teachings were eventually collected in the book known as the Koran (meaning "Recitation").

Probably because the arid lands of the Arabian Peninsula could not provide sufficient sustenance, Muhammad encouraged his followers to conquer as much land as possible. Taking the Prophet's direction to heart, the Muslims in less than one hundred years after his death were able to extend their domain well beyond the Arabian Peninsula to include Persia, Egypt, Syria, Palestine, and most of North Africa. The fusion of cultures that followed went both ways: while the Arabs absorbed a great deal of elements drawn from the Greek heritage and the Judeo-Christian tradition (the Muslims' disdain of all graven images, for example, was likely influenced by their encounter with Judaism) populations that for centuries had thought of themselves as part of the Hellenistic, the Roman, and then the Byzantine world

began to undergo the slow metamorphosis that eventually completely redefined their identity as Muslim people.

After North Africa, the conquest of major parts of Spain (which up to that moment had been ruled by the Visigoths) marked the farthest point of the Muslims' progression. Because Muhammad had forbidden the killing and persecution of those who belonged to other religions, the Jews of Spain, who had greatly suffered under the Visigoths, welcomed the Muslim rule because it allowed them much more freedom than before.

For the rest of Europe, the greatest threat occurred when the Muslims crossed the Pyrenees, in northern Spain, and spilled into France. That implacable march was finally stopped by the Franks, who, guided by the military leader Charles Martel, defeated the Muslims in the famous Battle of Poitiers in 732.

The Franks were Germanic people who, after having waged war against other barbarian tribes, had been able to carve for themselves a kingdom out of the Roman province of Gaul (modern France). In the fifth century, the Franks abandoned their old religion to convert to Christianity under the Merovingian dynasty of King Clovis. The conversion to Christianity plus the victory at Poitiers gave the pope a very favorable view of the Franks. That feeling underwent an exponential growth when, after the death of Charles Martel, his son Pepin the Short, having become king of the Franks (which assured the rise of his Carolingian dynasty), answered the appeal for help of Pope Stephen II, who feared that the Lombards were planning an attack on Rome. The Franks' immediate intervention and their defeat of the Lombards were followed by the donation to the church of a large chunk of territories across central Italy that formed the basis of the Papal States. Pepin's Donation was advertised by the church as a legitimate restitution of territories that had belonged to the church since the time of Constantine. Legal validation for the claim was based on a document called the "Donation of Constantine." The story that accompanied the Donation was that the emperor Constantine, having contracted leprosy, was advised by doctors to slaughter a number of infants and then bathe in their pure blood. The emperor was dis-

suaded from that macabre action by Peter and Paul, who, appearing in a dream, told him to meet with Pope Sylvester. When they met, the pope persuaded Constantine to spare the children's blood and undergo instead the ritual of baptism. When the sacred water of baptism washed away all traces of leprosy, the grateful Constantine donated to Pope Sylvester Rome as well as all the lands of the Western Empire. In the fifteenth century, the scholar Lorenzo Valla proved that the Donation of Constantine was a false document probably forged by some shrewd hacker working on behalf of the pope.

When Pepin died, his son Charles, eventually known as Charlemagne (reigned 768–814), succeeded him. During his reign, Charlemagne, meaning Charles the Great, enormously expanded the kingdom of the Franks to include, besides northern Italy, most of the lands that today correspond to France, West Germany, the Netherlands, and Belgium. Charlemagne was hailed as a hero also for confronting the Muslims in Spain. In 799, in one of the gorges among the jagged cliffs of the Pyrenees, a Basque division allied with the Moors, having been tipped off by a traitor, fell upon a Frankish division led by one of Charlemagne's most valiant knights, Roland. The brave resistance and eventual death of Roland, who heroically refused to call for help by blowing his horn, was transformed, over the following three hundred years, into a series of orally transmitted ballades, put in writing only around 1100, known as the *Chanson de Roland.* Because of the code of military value and honor it taught, the *Chanson de Roland,* which eventually became part of the larger collection of ballades known as *Chanson de Geste* (Song of heroic deeds), can be considered the medieval equivalent of the *Iliad* and the *Odyssey.*

In the same year in which Roland died, a group of conspirators, probably instructed by the Roman aristocracy who did not approve of Pope Leo III's humble origin, made an attempt on his life. The pope, who was badly injured but able to survive, turned again to the Franks to bring order back to Rome. Charles's prompt response was rewarded by the pope on Christmas night of A.D. 800, when Charles was crowned in a solemn ceremony by the pontiff and given the title of Roman emperor.

The coronation sanctioned the unity of secular and religious authority within the Christian world. But in the years and centuries that followed, great controversy continued to swirl about that crucial night: Who, between emperor and pope, was to be recognized as the highest authority? The church, which in the political vacuum of the early Middle Ages had become used to assuming spiritual and temporal responsibilities, affirmed that the pope was to be considered more important than the emperor, as proven by the fact that he (the pope) had put the crown on Charlemagne's head. Those who sided with the emperor disagreed: the fact that the pope, at the end of the ceremony, had knelt in front of Charlemagne indicated that the emperor was to be considered superior to the pope. The truth was that they equally depended on each other: the pope needed the political and military protection of the emperor, while the emperor needed the pope to validate the sacredness of his position.*

The most relevant aspect of Charlemagne's reign was that four hundred years after the fall of Rome it represented the first attempt to re-create the great political unity of the Roman Empire, perceived as a distinct entity from Byzantium. The act, which was deemed profoundly disloyal by the Byzantine emperor, placed a heavy strain on East and West relations. After many failed attempts to find some sort of reconciliation, the East-West Schism of 1054 occurred, which forever divided the Eastern Church from the Roman Catholic Church.

Although geographically vast, the empire built by Charlemagne was hardly strong, given the loosely knit connection of its inhabitants, who were separated by customs, languages, and traditions. Perhaps because he understood that without being bound by some sort of cultural cohesiveness the empire would not have survived, Charlemagne promoted a major revival of culture, which included a great effort to

* It is important to remember that our modern view of the state and the church as two autonomous entities operating independently from each other took centuries to mature. In the times we are considering, such a separation would have been unthinkable given the profound religiosity with which the medieval mind was imbued.

preserve the pagan heritage. The task was deemed consistent with Christianity, to which that older legacy was believed to belong. As we have seen, the theory was that everything good that the past had conceived was somehow part of a divine plan aimed at promoting the intellectual ripeness needed to receive the message of God. The acceptance of the pagan legacy that such a view promoted proved a very useful tool for the church scholars, who through the study of classical grammar and rhetoric learned to articulate with ever more subtle and sophisticated argumentations the tenets of Christian doctrine.

The most tangible result of Charlemagne's commitment was the institution of the Palace School in the northern city of Aachen, where the emperor resided. There scholars and intellectuals from all over Europe converged under the direction of the English ecclesiastical scholar Alcuin, who became the prime architect of the cultural revival know as the Carolingian Renaissance. In planning the basic curriculum for the school, Alcuin adopted the division of the seven liberal arts, introduced by Martianus Capella in the fifth century, which included the trivium (grammar, rhetoric, logic) and the quadrivium (arithmetic, geometry, astronomy, music).

Since it had been converted by Saint Patrick in the fifth century, Ireland had become the most important site for monastic learning in all of Europe. Among the most famous Irish scholars, the name of John Scotus Eriugena (ca. 815–ca. 877) stands out. Eriugena's contributions included the translation from Greek to Latin of the writings of the fifth-century Pseudo-Dionysius the Areopagite, who was erroneously identified with an Athenian converted by Saint Paul. The fictional story greatly enhanced the authority of the Pseudo-Dionysius, whose Neoplatonic vision immensely influenced the mystical expressions of medieval times. Within that contemplative approach, particular importance was given to the *via negativa,* which stated that because God was beyond all forms of human understanding and description, He could only be defined in a negative way by what He was not, rather than what He was.

The preservation of classical culture sponsored by Charlemagne produced hundreds of copies of major pagan books. The task was

greatly facilitated by the replacement of the contorted Merovingian handwriting with a simplified and more legible script, known as Caroline minuscule.

Notwithstanding the admiration directed toward pagan writers and thinkers, Christians continued to feel a sense of superiority toward the culture that had preceded them. The attitude led many monks, who were copying old manuscripts, to omit, distort, and even misquote words or passages that, in their view, did not fit the Christian ideology. Jean Leclercq explains that what counted for the monks "was not what the pagan author had specifically wanted to say, within his time and his reality, but what appeared important to a Christian." The prejudice was compounded by some closed-minded abbots who instructed their monks to scratch one of their ears, just like a dog does with fleas, when copying a pagan text because, they said, it was good to compare the writings of a nonbeliever to an animal.

The emperor's solicitude to promote culture might also have stemmed from his personal shortcomings. Einhard, the Frankish courtier and scholar who wrote a biography of Charlemagne, claimed that the emperor's greatest regret was that although he relentlessly practiced, he never succeeded in mastering reading and writing: "He also tried to learn to write. With this object in view he used to keep writing tablets and notebooks under the pillows on his bed so that he could try his hand at forming letters during his leisure moments, but although he tried very hard, he began too late in life and he made little progress."

Charlemagne's creation of a universal kingdom, Latin in culture and Christian in religion, inspired people for many generations to come, gaining him a mythical place in history. Ironically, more than his actual deeds, what people remembered about Charlemagne were the legends that grew around his persona. By the twelfth century, the image of the wise, white-haired emperor had grown to become that of an archetypal father closely associated with God Himself. From that elevated status, Charlemagne was also credited with actions he never undertook, like going to Jerusalem on pilgrimage or completely pushing the Muslims out of Spain.

Charlemagne's iconic stature was matched by his nephew and vassal, the brave and loyal Roland, who died in Roncesvalles and was hailed as the greatest hero in the *Chanson de Roland*. Although, in the actual events of history, Roland had been killed by a division of rebellious Basque soldiers, in the romanticized account of the *Chanson* that detail was conveniently changed to make the Moors, or Muslims, responsible for the hero's death. As we will see, the switch would serve an important purpose, especially in later times when the Crusades opened a bloody new chapter in the already tense relations between the Muslim and the Christian worlds.

Charlemagne's dream of a unified empire revealed its fragile foundations as soon as, after his death in 814, political discord exploded among his successors. The conflict came to an end with the Treaty of Verdun (843), which ultimately divided Charlemagne's kingdom among his three grandsons: one took over the western part of the empire, another one the eastern, while the third one assumed control of a long and narrow strip of territory that included the Low Countries, Alsace and Lorraine, and north and central Italy. With the Treaty of Verdun, the embryonic shape of modern Europe began to emerge, with France occupying the western part of continental Europe and Germany the eastern. The problem that arose within those vast geographic expanses was this: In the absence of a centralized and well-organized political system, how could such huge kingdoms be sustained, administered, and protected?

The solution was the pyramidal distribution of power called feudalism. The king, who was the apex of that ideal pyramid, assigned to his vassals or lords grants of land (called fiefs) on the condition that they wisely administer and defend them and continue to obey his command in case of war. Below the lords were the knights, who did not own land but lived and served as vassal-tenants on the lords' estates. Dukes and counts included heirs of lords or people who were granted special military and administrative positions.

As with all emperors before him, Charlemagne thought that his position allowed him to exercise a power that was simultaneously political and religious. That assumption led him and his successors

into believing that they had the right to appoint bishops and abbots and turn them into vassals. As we will see, assuming that the emperor had the right to interfere in religious affairs sparked the major clash that divided church and state for many centuries to come.

The solemn ceremony that took place when the king appointed someone as his vassal held an aura that was made to appear as inviolable as the blood bonds of tribal culture. The need to charge with so much value the code of feudal honor was crucial because no other way of compelling the vassal to duty was available besides the appeal to conscience. The vassal's obligation to serve his superior is expressed with these colorful words in the *Song of Roland*:

> This is the service a vassal owes to his lord:
> To suffer hardships, endure great heat and cold,
> And in battle to lose both hair and hide.

The vassal was presented as a man who faithfully dedicated his entire life to the loyal service of his superior. Because Christian values pervaded society, the ethical validation of that military chain of command directly involved the presence of God. At the end of the *Chanson de Roland,* the heroic Roland, mortally wounded, lifts his right arm toward the sky to offer his right glove to God. The gesture, which reproduced the vassal's offer to his lord, was meant to indicate that as a Christian Roland's ultimate promise of vassalage was toward the greatest lord of all—God.

The rule of honor and respect enforced among the members of the military aristocracy did not extend to the lower strata of society: The farmers, who were considered inferior serfs tied to the land, were forced to give more than half of what they produced to their masters in order to receive, in return, their protection against any external foes. Serfs were at the mercy of their lords, who could impart justice on them as they wished. In the absence of a state-controlled jurisdiction, every feudal lord automatically became the primary judge of his people. A lord who decided to flog, maim, or even kill one of his

serfs did not fear consequences, not because he felt above the law, but because he was himself the law.

Despite the great emphasis placed on loyalty, the two centuries that followed Charlemagne's death witnessed the frequent rebellion of ambitious lords seeking greater autonomy from their superiors, as well as the reckless behavior of landless knights who began to roam the countryside in search of adventure and easy enrichment through looting and pillaging.

PART FOUR

✳

THE LATER MIDDLE AGES

CHURCH AUTHORITY VERSUS
STATE AUTHORITY:
A DIFFICULT BALANCE OF POWER

Toward the end of the eighth century, the invasion of the Norsemen or Vikings from Scandinavia and, a century later, that of the Magyars from central Asia precipitated Europe into a new period of violence and chaos. A relative stability was reestablished only around the eleventh century, when the wave of foreign disruption finally came to an end, and the invading populations became absorbed within the culture and religion of those whom they had initially attacked. With the return of more secure times, kings, eager to reassert their authority, looked for new ways to strengthen their kingdoms through the creation of stronger institutions and more centralized bureaucracies. The process proved particularly difficult in France, where unruly lords had been able to assume full ownership of their fiefs. Among the powerful potentates that became independent from the Capetian authority (the royal dynasty that succeeded the Carolingian) was the duchy of Aquitaine that controlled almost half of France. Very different was the situation in England, where a more centralized system of government had emerged, especially after the Norman king William I invaded Britain (1066) and expropriated lands from the Anglo-Saxons to put his Norman strongmen in charge of the feudal districts into which the country was divided. The powerful bond of loyalty that linked the lords to the king gave England the political unity and stability that other European countries had been unable to achieve.

The eleventh century was also the time in which the church initiated a vigorous campaign aimed at regaining its stewardship position

as the central fulcrum of Christianity. In great part, the movement was a reaction to the policy of the kings, who had continued to use Charlemagne's policy of investing bishops and abbots and then turning them into vassals so as to assure to the crown the alliance of friendly fiefs and domains. The prestige of those royal appointments made clerical careers very desirable, especially among the members of the upper class. The danger of considering the church an appendix of the state emerged as soon as priests began to act as laypeople, selfishly pursuing worldly interests to the detriment of morality and spirituality. The worst expression of corruption and moral decadence that the church experienced during those years was simony, which consisted in the illegal buying and selling of religious offices.

A major push toward spiritual renovation came from the Abbey of Cluny in France, which was founded in 910. Unlike the Benedictine rule that allowed each monastery to be independent, the new system made the Abbey of Cluny the spiritual and administrative center of a large quantity of satellite monasteries. The originality of Cluny also consisted of the fact that unlike the secular clergy, which had become subservient to secular powers and interests, it was a monastic institution that only pledged its allegiance to the church. In less than a century from its foundation, the paradigm instituted by Cluny became so popular that more than two hundred monasteries adopted its tenets. The high standard of integrity and decency that Cluny enforced was used to advocate the duty that all priests had to cultivate morality and spirituality apart from mundane interests and secular rewards.

The pope who most effectively worked at reestablishing the integrity of the church was Gregory VII (reigned 1073–1085). Gregory, who believed in the right of the church to operate independently from the state and who feared the overreaching ambition of secular institutions, vigorously denounced the kings' practice of appointing bishops and archbishops with the purpose of making them royal administrators, saying that those offices, being spiritual, could only be assigned by the church. The long dispute that ensued was called the Investiture Controversy. The major opponent of Gregory VII was the German emperor Henry IV.

By the time of the Investiture Controversy, the German kingdom had successfully extended its possessions to include Bohemia, Burgundy, and northern Italy. A major turning point in the history of Germany had occurred when the Saxon king Otto I delivered a major blow to the invading force of the Magyars in the Battle of Lechfeld in 955. Thanks to that victory, Otto I, just like Charlemagne 155 years before, was hailed as a savior and defender of Christianity—an achievement that was rewarded by Pope John XII with the solemn coronation of Otto I as Roman emperor, in 962.

The event further emboldened the German emperors who, next to the exploitation of clerical appointments for the benefit of the crown, felt that it was their prerogative to decide who was going to be elected pope. Among those who resisted that assumption was the Roman aristocracy, who had long regarded the papacy as their own privilege. The year 1046 had been particularly difficult for the church. The trouble started when the corrupt pope Benedict IX, having sold his office to Gregory VI, changed his mind and tried to reclaim his title. To make the situation worse, the Roman aristocrats elected as pope one of their members in opposition to Benedict IX and Gregory VI. The emperor of Germany, who at the time was Henry III, decided to take control of the situation by ordering the dismissal of the three contenders, whom he replaced with an appointee of his own choosing. When that pope and also the following one died within a very short amount of time, rumors spread that they had been poisoned (a favorite means to resolve rivalries in the Middle Ages). The ascent of the German aristocrat Leo IX to the seat of Peter in 1049 marked a new beginning for the church. Leo IX was a strong man who firmly believed that the church had to operate independently from the state and its feudal organization. Those principles culminated in the Council of 1059, where it was decided that the election of the pope exclusively depended on the vote issued by the College of Cardinals (cardinals, with reason, were called Princes of the Church). The reform was bound to displease the Roman aristocracy, the secular heads of state, and many members of the clergy who resented the pope for denouncing, as an impropriety, the secular privileges they had long enjoyed.

When Henry III died, he was succeeded by his five-year-old son, Henry IV (1050–1106). The new pope, Gregory VII, who had been one of Leo IX's advisers, took advantage of the situation to reiterate that the church was not at the service of the state and that no laymen, not even a king or an emperor, had the right to interfere with matters that were only of ecclesiastical competence. When Henry IV, no longer a child, resumed his father's policy of turning bishops into royal administrators, the pope forcefully denounced his encroachment. As a response, Henry tried to depose the pope and replace him with a loyal appointee. The pope's reaction was to dismiss the move as illegal, excommunicate Henry, and launch the following appeal: "I forbid all Christians to obey him as a king." As soon as the news spread, powerful German vassals and magnates began to plot on how to take control of the throne that had been declared vacant by the pope. Fearing the political avalanche that Gregory had unleashed, Henry was forced to back down: if he wanted to keep the throne, he had to seek the pope's forgiveness. With that intention, Henry IV went to Canossa, in northern Italy, where he tried to arrange a personal meeting with the pope. After three days in which the penitent Henry was left begging in the snow outside the castle of Canossa, the pope finally rescinded his sentence in 1077.

The Concordat of Worms of 1122 only partially mitigated the conflict between church and state. Gregory's intent had been that if a pope judged a monarch morally unfit to rule, he (the pope) had authority to depose him. Because of the opposition of the laity, the concordat eventually established that the emperor could invest bishops and abbots with the "scepter" of secular appointments but not the "cross" and "ring" of religious authority—a privilege that only the pope had the right to bestow. Enforcing the celibacy of priests (which reversed the practice of marriage and fatherhood that had become common among the secular clergy) was also a way for the church to protect its privileges, in that it prevented the handing down, from fathers to sons, of its assets and territories. In regard to the papal election, the concordat established that it was uniquely a church privi-

lege to be strictly kept off-limits from all temporal influences and interferences.

Greek and Roman thinkers had considered society a man-made reality where government and laws existed to serve and improve human ends. In opposition to that view, Augustine had claimed that because it was a direct outcome of Adam's sin, the City of Man was an imperfect entity driven by selfish ambition and competition, and the obsessive desire to accumulate material goods. Sharing Augustine's view, Gregory concluded that to assure the existence of a just state, the secular authority had to remain subservient to the monitoring presence of the only institution impervious to moral corruption— the church. Unfortunately, the recurrent scandals that continued to rattle the church proved that what was missing in Gregory's idealistic equation was that despite the sacred role it was attributed, the church remained a man-made institution vulnerable to the same human weaknesses that threatened the stability and well-being of the state.

※

CITIES AND UNIVERSITIES:
THE DAWN OF A NEW CULTURAL ERA

In the twelfth century, the spirit of reform that Cluny had introduced was raised to an even higher standard of probity by two new monastic orders: the Carthusians, who preached the benefit of a solitary life wholly set apart from the contaminated reality of secular existence; and the Cistercians, who reverted to a monastic existence more rigorously faithful to the original rule established by Saint Benedict. A crucial moment for the Cistercians occurred when a twenty-one-year-old man, called Bernard (1090–1153), joined the order. The spiritual zeal and the persuading oratory that in the years to come were going to make Bernard the most influential man of his time came to light as soon as, having become a monk, he was able to persuade his father,

mother, and sister, as well as an uncle and all his brothers, to join him in becoming nuns and monks, claiming that "unless thou do penance thou shalt burn forever . . . and send forth smoke and stench."

Three years after his admission into Cîteaux, the passionately devout Bernard was given permission to move with twelve other monks to an isolated spot in the middle of the woods to establish a new Cistercian house. The place chosen by Bernard was named Clairvaux, meaning "Clear Valley," in reference to the work that was performed to create an opening in the woods in which to build the new abbey. In the years that had marked the decline of the church, many monks, mimicking the snobbish behavior of the landed nobility, had started to assign to serfs the working of the land. Bernard, who was a strong believer in the original Benedictine rule, reimposed that duty on his followers, affirming that it was the noblest way to learn the humility that the service of God demanded.

The importance that Bernard assigned to nature suffuses his spiritual writings. For him, the transformation of the wilderness into beautiful and orderly openings (like the one he created to build his abbey) was comparable to the transformation that moral cleanliness brought into the dark landscape of the soul. To remind his brothers that paradise was only available to those who, in following Christ, had reached that inner transformation, an open cloistered area was built in the middle of all monasteries—a carefully ordered and manicured space, full of a splendid variety of colorful plants and flowers to which was attributed the symbolic name of "paradise."

Led by Bernard, Clairvaux became a model of austere discipline and devotion. The influence of the monastery grew so much that by 1140 more than 350 new Cistercian houses had been erected.

Around the same time, the introduction of new, revolutionary farming techniques, such as iron shoes for horses, more functional oxen collars, windmills, heavier plows, and wheelbarrows, greatly improved the exploitation of the environment throughout Europe. As starvation receded and the population grew, greater stretches of land were reclaimed for agricultural purposes through a massive work of

deforestation that took place between the twelfth and fourteenth centuries. The herculean endeavor of a few generations of brave farmers who drained marshes, embanked rivers, bridged brooks, cut roads, and cultivated fields was greatly enhanced by the collaboration and agricultural expertise provided by the Benedictine monks.

Until the eleventh century, Europe had remained essentially an agrarian and feudal society orbiting around the life of castles and monasteries. That reality began to change with the rapid growth of cities that came to life thanks to the entrepreneurial mercantile activity of a spirited middle class. As prosperity grew, the burgeoning cities became magnets for many serfs escaping the condition of servitude they had suffered in the countryside. The expression "town air makes you free" was born in an epoch that, in contrast with the social immobility of feudal times, was now able to offer a safe alternative to many who, until that moment, had had no possibility of fleeing the despotic bondage of rural lords.

The improvement of life that took place between 1100 and 1300 was also marked by the intense movement of people—merchants, missionaries, pilgrims—traveling along the new artery of roads that had begun to cross Europe. In the twelfth century, the building of the first stone bridge across the river Thames modernized London, while the bridge over the Cam River allowed the rapid growth of Cambridge.

One of the most important consequences of progress and urbanization was the creation of new centers of learning outside the enclosures of monasteries that, since the time of Saint Benedict, had monopolized culture and education. After the cathedral schools came the universities, which were conceived as corporations dedicated to higher forms of learning. Between the eleventh and the twelfth centuries, the first major universities, such as Bologna, Oxford, and Paris, were created. When a student completed the basic courses, which included the disciplines of the trivium and the quadrivium, he became a master licensed to teach. Those who wished to specialize in more specific fields of knowledge could go on with their studies and earn the title of

doctor. Universities offered different specializations: Salerno in Italy became famous for medicine, Bologna for law, Paris for philosophy and theology.

With that dramatic improvement in literacy and education, many ruling households began to hire advisers with master's degrees earned in universities. Thanks to the legal and juridical expertise that these experts provided, the instruments of government were revised and improved for the benefit of stronger and much better organized states seeking greater and greater independence from the authority of the church.

The new intellectual fervor, which was fueled by the lively debates that took place in the universities' open forums, soon unleashed all sorts of new questions. The most pressing was this: How could a religion that for centuries had been obsessed with the afterlife be adapted to a world that was becoming more prosperous, more self-confident, and more proud of its accomplishments?

Complexity grew with the expansion of a money-based economy that the church, despite its own power and wealth, looked on with suspicion because profitable affairs and material enrichment were considered activities that run counter to the principles of religious humility and renunciation.

One of the major consequences of the market economy was the creation of a banking system that also included the lending of money at interest. The practice, which the Old Testament condemned as a mortal sin because it involved profit earned without work, was forbidden among Christians since the Council of Nicaea in 325. Jews followed the same rule, but because lending money at interest to non-Jews was permitted, usury became a lucrative activity for many. The stigma that usury produced went on to feed feelings of anti-Semitism that lasted for many centuries to come. Eventually, and in spite of the church's opposition, interest prevailed over moral restraint, and banking activities expanded beyond Jewish control. By 1400, usury had become a common practice of many Christian banking companies.

Initially, the shift from rural to urban life was felt as a threat on the part of the church. But to remain relevant in a world that was so

rapidly evolving, the cloistered rigidity that the church had maintained for so long was forced to change. Evidence of that change was the appearance of Scholasticism, which was the name given to the attempt to reconcile the logical methods of reason with the tenets of Christianity.

The first rapprochement between philosophy and religion occurred through the writings of the eleventh-century archbishop of Canterbury Anselm. Anselm's premise was that everything has an initial cause and that deductive logic could be used to gradually trace back a long list of effects and causes. His conclusion was that because everything had to be linked to an initial cause, the point of departure of the entire universe was God, Who existed above and beyond all rational explanations and justifications. As such, the rational quest was ultimately bound to declare its incapacity to contain the highest truth and consequently acknowledge the absolute superiority of faith, without which God could not be reached.

To understand how Anselm could be feted as such an innovator, we have to think of his work as part of a slow thawing process, a mellowing of the crystallized dogma that the Christian religion began to experience from the twelfth century on. Within that premise, Anselm's attribution of an auxiliary role to philosophy, which he called *ancilla* (handmaid) of theology, and his willingness to apply some principles of logic and dialectic to the Christian argumentation, can be recognized as a small yet significant step forward in the development of culture.

In a more decisive way, the link between philosophy and religion was explored by the ambitious and pugnacious Abelard, who was born in Nantes in 1079. Abelard's method consisted in aligning a series of pertinent propositions and then exploring them through a mix of dialectic and Aristotelian logic (which in his time still included only Boethius's translations). The technique, which he called *Sic et Non* (For and Against), was conceived by Abelard as a way to sharpen the mind in view of the high considerations that doctrinal argumentations required. As we will see, the need to attribute greater importance to experimentation led thinkers such as Roger Bacon and

William of Occam to dismiss Abelard's disquisitions on the ground that, being purely abstract and linguistic, they lacked the empirical dimension needed to assess reality.

To describe the importance of his critical analysis, Abelard wrote, "By collecting contrasting divergent opinion, I hope to provoke young readers to push themselves to the limit in the search for truth, so that their wits may be sharpened by their investigation. It is by doubting that we come to investigate and by investigating that we recognize the truth."

In a world still so tremendously fearful of the limitations set by the barbed wire of Christian dogma, Abelard's assertion that reason and even doubt had a place within man's existential inquiry was received as a highly controversial and dangerous proposition. Abelard, who in more than one way was an unconventional man, became painfully aware of that when, already a famous teacher in Paris, he was hired as a tutor for a beautiful, gifted young girl named Héloïse, with whom he immediately fell in love. When Héloïse, who fully reciprocated Abelard's passion, became pregnant (she eventually gave birth to a baby boy), her uncle, to avoid a scandal, allowed the two to marry. But the uncle, who was never able to forgive and forget Abelard's transgression, did not allow their love to prosper: he hired a group of ruffians who captured Abelard and castrated him. In a typical medieval manner, the story ends with the protagonists' true feelings being brushed aside to bring to the fore the central ingredients of Christian piety: shame, guilt, remorse, penance. The two lovers ended up doing what all sinners were expected to do: Abelard withdrew to the Abbey of Saint-Denis, where he spent the rest of his life working at purging his soul, just like Héloïse, who became a nun.

In his logical analysis, Abelard had uncovered a number of discrepancies and inconsistencies within various theological propositions. The *Sententiae,* or moral sayings, written by Abelard's pupil Peter Lombard (ca. 1096–1160), represent an attempt to eliminate those discrepancies and organize in a systematic manner all doctrinal issues. Having gained great authority, the *Sententiae* became the basic medieval textbook used by scholars and students of theology.

Abelard's great rival was Bernard, the mystic and conservative abbot of Clairvaux, who vehemently condemned what he called the *vana curiositas* (useless curiosity): the blasphemous interest of those who claimed, like Abelard, that philosophy could somehow become an aid to religion. Ecstasy, he said, was an *excessus mentis:* an overcoming, not an empowerment, of the mortal mind. Paradoxically, though, it was that very stern moralist who revitalized the tender cult of Mary, the loving and nurturing mother of Christ—a choice that assumed particular importance for the church at a time when the institution was desperately looking for a way to revive its image as the champion of purity and probity.

In Bernard's sermons on the Song of Songs, the *Fiat* (let it be done) with which Mary answered the angel of the Annunciation (which in turn echoed the *Fiat* through which God called the world into existence) was used by Bernard to affirm that the renewal of life was possible only if humanity answered the call of the divine with the same unquestioned devotion with which Mary had responded "Yes" to God's terrible command to bear a divine child destined to suffer and die on the cross.

Praising Mary as the perfect example of devotion and obedience, Bernard revamped a tradition that had been popular at the beginning of Christianity, when Mary was described as the perfect opposite of the first woman, the treacherous Eve, or Eva in Latin, whose very name was evoked (in an inverted manner) in the *"Ave Maria, gratia plena"* of the angel of the Annunciation, as a Marian hymn confirmed: "Welcoming the Ave from the lips of the Angel Gabriel, give us peace, transforming for us the name of Eve." The play of words between "Eva" and "Ave" was used to indicate that Mary's obedience had reversed Eve's sinful disobedience. (Also notice the strong connection between "Eve" and "evil.")

To a certain extent, the exaltation of Mary helped to reduce the prejudice against women, but, as many critics have noticed, it also fostered great ambiguity because it implied that a woman could be either a saint, as replica of Mary, or a sinner, as replica of Eve, with no other option in between.

As the earthly dwelling of the divine mystery, Mary was trans-
formed by Bernard into the primary symbol of the church, just as
Augustine had confirmed when he wrote that the church was like
a maternal womb through which the faithful could attain an inner
regeneration. The church was like a maternal uterus, an incubator
for the spirit through which those who believed could be reborn to
eternal life.

The abbess Hildegard of Bingen, the famous German mystic
and composer (1098–1179), wrote that all humans were invited to
make room in their heart for the "crèche" of baby Jesus. In a simi-
lar way, Meister Eckhart, the German theologian and mystic (1260–
1327), affirmed that just like Mary every human being was invited to
become mother of the *Puer Aeternus* (Immortal Baby).

In ways that Bernard might not have foreseen, the tremendous
success that the cult of Mary experienced also served an important
function among people who, having enjoyed the benefits of a much-
improved existence after centuries of poverty and destruction, were
now increasingly tempted to appreciate the world as a beautiful and
promising place rather than just a valley of penance and tears. Was it
possible—the Christians of this new era asked themselves—to attri-
bute more charitable characteristics to the wrathful Almighty (so
similar to the God of the Old Testament), who had predominated in
the earlier part of Christianity? The image of baby Jesus and that of
the loving and forgiving Mother interceding with God on behalf of
humanity were the answer that the new age was unconsciously look-
ing for.

The scholar Joseph R. Strayer writes that the twelfth-century
obsession with the Virgin, the Nativity, and the infancy of Jesus
reveals the need to emphasize "the human side of the Christian story."
In that sense, Strayer continues, the twelfth century could definitely
be described as the beginning of a more forgiving era characterized by
a much more emotional, personal, and intimate relationship between
man and God. "Human beings were frail, but Jesus had been a help-
less child and the Virgin a suffering mother; they could understand
and have compassion on human weakness. Therefore the thousands of

churches dedicated to the Virgin, the countless statues and reliefs of the Mother and Child, the stories of the Miracles of Our Lady—all emphasizing divine love and forgiveness."

It was within this increasingly lenient environment that the notion of purgatory was revived. The idea, which had initially been introduced by Augustine, was mostly abandoned by later Christians who concluded that heaven and hell were the only options available in the afterlife. The reintroduction of purgatory, advocated by theologians such as Peter Damian and Saint Bernard, signals the beginning of an era eager to moderate the harshness of God's judgment with a place of penance that was temporary rather than eternal, because the sins involved were venial instead of mortal. The influence that the prayers of the living had in shortening the serving time of the expiating souls helped in making purgatory a much-appreciated option, also among priests who were often generously paid by families who hired them to add credit value to the spiritual account of their beloved so that they could be alleviated of the burden of hours and hours of prayers.

※

A NEW ART FOR A NEW SENSIBILITY

The effect of the social and cultural transformation that took place between the twelfth and the thirteenth centuries was made visible, in a very concrete way, by the creation of the vast "robe of white churches" with which, as a medieval chronicler wrote, the Christian world dressed itself. Between 1170 and 1270, at least eighty cathedrals were built and more than five hundred churches. Although the prime purpose of the great architectural achievements was the celebration of God, those buildings were also representatives of the municipal pride that animated the life of the cities.

Initially, the most active sponsors of art were the monks of Cluny, who distinguished themselves by introducing ceremonial and liturgical innovations, like the use of music and special dances to accompany

the recitation of the psalms. The slow gestures and movements that characterized those dances were designed to suggest the welcoming procession that would take place in honor of Christ's Second Coming.

Besides the work of talented northern artists (to which we will return later), it was largely thanks to the Cluniac monks that, particularly in France, the long-abandoned use of stone-carved reliefs reemerged. The first attempts were hesitant, but like a twig stubbornly emerging out of the smallest crack, new figurative expression soon grew to become well-established fixtures within the ornamental programs of medieval churches. Not that a full-blown realism reappeared. Religious concerns were still too strong for that to happen. But the pleasure of finding more convincing ways to describe the world is certainly an important trait of those early religious carvings, as it appears in the beautifully sculpted foliage, flowers, and birds that were now decorating capitals on top of columns, next to a vast army of extravagant figures: monsters and gargoyles placed in guardian-like positions on the external walls of churches. Why artists indulged in creating so many variations of those nightmarish presences is easily explained: because the control of the church left little leeway when it came to the depiction of holy figures, the only repertoire that allowed some sort of personal freedom on the part of the artists was the one that belonged to the kingdom of evil and darkness—a kingdom that folklore and storytelling had never ceased to visit, mostly led by the desire to exorcise fear through grotesque and at times even satirical descriptions of demons endowed with all sorts of animal-like features such as fangs, claws, tails, horns, and pointed ears.

When the uncompromising moralist Bernard, visiting the Benedictine abbey in Cluny, saw those decorations, he wrote with indignation, "In the cloisters, under the eyes of the monks who read, what do these ridiculous monsters seek to do? What do these unclean monkeys mean, these dragons, centaurs, tigers and lions . . . ? What business here have these creatures who are half beast and half man?"

According to Bernard's conservative views, church decorations were nothing more than useless distractions: abhorrent creations of an unbridled imagination that could easily have led the mind astray

from its dutiful path. For Bernard, whose attitude was reminiscent of the Old Testament distrust of images, beauty only resided in raw and unadorned simplicity—the beautiful and proportioned yet completely bare solemnity belonging to the Cistercian churches.

Notwithstanding Bernard's opposition, change was occurring and could not be stopped, as seen in the rapid development of stone carving, whose purpose was a visual underlining of the Bible's moral teachings. The most important carvings were placed on the tympanum, the space above the main entrance portal whose arched form, evocative of the Roman triumphal arch, indicated the spiritual victory that access to the sanctuary was announcing. The scene that was generally reserved for that important threshold was of the Last Judgment. The choice stressed the fact that in entering the church, the individual started a journey that was simultaneously moral, spiritual, and metaphysical, as expressed by the cruciform layout that marked the basic plan of the church.

An interesting example of a sculpted portal is the one belonging to the twelfth-century Cathedral of Autun, in France, possibly

The portal of the Cathedral of Autun in France, representing the resurrected Christ and His Last Judgment

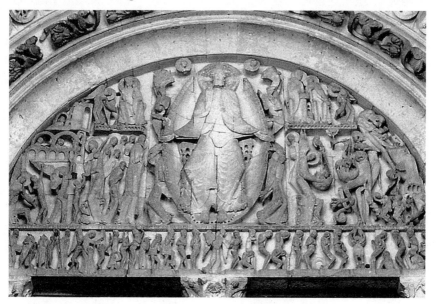

crafted by a man named Gislebertus, whose name appears under the sculptures. The center of the scene is occupied by the image of an enormous resurrected Christ showing the stigmata on his hands in memory of his sacrifice; beside him are people reawakened from their graves to be subjected to God's Last Judgment.

As we have seen, with the exception of Mary, Christ, or a saint, the depiction of ordinary people had been avoided for centuries in Western art. In this tympanum, that rule is reversed to present the dead being resurrected by angels vigorously blowing their trumpets to announce the day of judgment. The subject produced a lot of debate among Christian authorities: How were those who had been resurrected supposed to be depicted? Did they have to look young or old? If scars, blemishes, or other defects marked them in life, would those signs appear in the afterlife? Would people rise from their graves naked or dressed?

The solution offered by the sculptural reliefs of Autun was to portray all the resurrected humans as look-alikes sanitized of all sexual connotations. Aside from that, the sculptures include two variations: the individuals still waiting for judgment are depicted as adults wearing the burial shrouds they had on when they were put to rest (in a few cases, we even see people dressed like pilgrims and monks),

The joyous souls of the saved

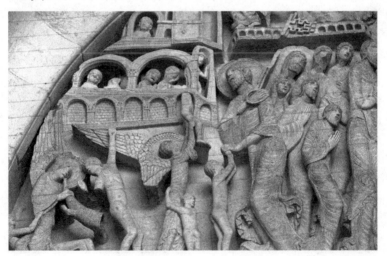

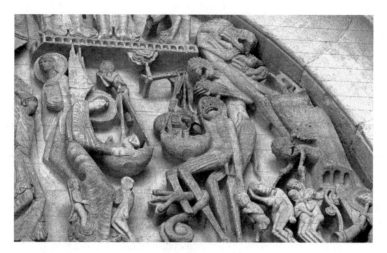

The tortured souls of the damned

while those who have already received the blessing of God look like naked children being led to paradise by angels. The clever solution was meant to indicate that a soul destined for paradise was as clear and pure as that of an innocent child. Those who already reached the celestial abode are seen peeking out of an arched building representing the celestial Jerusalem in joyous anticipation of the next arrivals.

On the left of Christ, we see the archangel Gabriel weighing the souls on the scale of justice. Next to him, horrendous demons with large, grinning mouths are waiting to see which souls will be assigned to their kingdom of darkness and pain. The contorted bodies of the damned show in a very dramatic way the fear of those who are facing the eternal torments of hell. The figure whose head is trapped in the enormous claws of a devil recalls the powerful sense of drama later expressed by Dante in his *Inferno*.

A damned soul in the claws of a demon

The reappearance of sculptural reliefs within the context of the church was a dramatic inno-

vation, but other revolutionary changes were on the way, especially in the field of architecture. Until the middle of the twelfth century, the style of architecture used for churches had remained essentially that of the Roman basilica: a heavy rectangular space composed of round arches and thick pillars supporting a solid structure covered by a flat ceiling often made of wood. That model was drastically altered in 1140 when the abbot of Saint-Denis, Suger (ca. 1081–1151), introduced a new, revolutionary architectural style called Gothic.

Next to Plotinus, the thinker who had most influenced Suger was the fifth-century mystic Pseudo-Dionysius the Areopagite, whose relics the Abbey of Saint-Denis was erroneously believed to possess. Dionysius's major point of contention was that because God was beyond all human demonstrations, the only way to talk about Him was through analogies that indirectly suggested that which could never have been directly described. In line with that principle, Suger made his church look like a world that, instead of being pulled downward by gravity, appeared to be lifted upward by an invisible yet irresistible magnetic force, as indicated by the ascending thrust of slender piers, acute arches, soaring spires, ribbed vaults, and flying buttresses. Besides thick walls, pillars, and round arches, Romanesque architecture was characterized by very small windows. To symbolize that God's grace had pierced the dark dullness of matter, Gothic architecture reversed the overpowering presence of the Romanesque stone walls through the use of enormous windows decorated with color-stained glasses in which biblical stories were represented. When the sun illuminated the windows, those stories shone, filling with a magical iridescence the inner space of the church.

The philosopher and critic Ivan Illich poetically related the Gothic emphasis on light to the magic of an illuminated manuscript. Like the parchment when lit by a candle, the windows when illuminated by the sun release a sudden burst of gem-like colors. Transformed by the light, the opacity of matter dissolves, filling the inner space of the church with the shimmering beauty of a miraculous vision.

Otto von Simson, in his book *The Gothic Cathedral,* states that light, in Romanesque architecture, was made to appear as "something

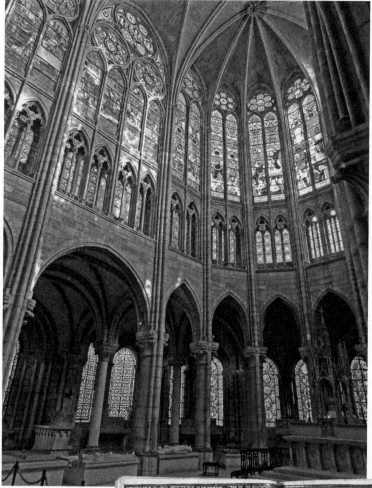

The radiant vision of light offered by the Basilica of Saint-Denis is matched by that of an illuminated manuscript.

distinct from and contrasting with the heavy, somber, tactile substance of the walls." In the Gothic structure, on the other hand, walls were consciously made to look "porous" by the stained-glass windows that, filtering the light, transformed the inner space of the church into a rainbow of glittering colors. That translucent effect, combined with the upward trajectory of the overall structure, is summarized by the scholar as follows: "As Gothic verticalism seems to reverse the movement of gravity, so, by a similar aesthetic paradox, the stained-glass window seemingly denies the impenetrable nature of matter, receiving its visual existence from an energy that transcends it. Light, which is ordinarily concealed by matter, appears as the active principle; and matter is aesthetically real insofar as it partakes of, and is defined by, the luminous quality of light."

The ultimate lesson was that the pool of light and color in which the churchgoer was immersed stood for the transformation of the carnal into the spiritual; in other words, the melting away of the universe of matter into the dazzling brilliance of God's metaphysical kingdom. The great art historian E. H. Gombrich wrote that the purpose of the Gothic cathedrals was to deliver a vision of the Heavenly Jerusalem. "The new cathedrals gave the faithful a glimpse of a different world. They would have heard in sermons and hymns of the Heavenly Jerusalem with its gates of pearl, its priceless jewels, its streets of pure gold and transparent glass. Now this vision had descended from heaven to earth. The walls of these buildings were not cold and forbidding. They were formed of stained glass that shone like precious stone. The pillars, ribs, and tracery were glistening with gold. Everything that was heavy, earthly, or humdrum was eliminated. The faithful who surrendered himself to the contemplation of all this beauty could feel that he had come nearer to understanding the mysteries of a realm beyond the reach of matter."

Because the church was meant to chart, as a sacred path, the return of the soul to its celestial homeland, the altars were always pointed toward the east, where the sun rises, opposite the west, where the main entrance of the church was placed. The choice indicated that in stepping into the church, the faithful embarked on a voyage of ini-

tiation meant to reverse the course of the terrestrial destiny, reorienting it from the darkness of sinful existence—the west, where the sun sets, was always associated with death—toward the luminous Orient and the dawn of Christ's new beginning.

The gigantic rose window, traditionally placed on the western entrance of all Gothic cathedrals, symbolically indicated the cosmic renewal that Christ's rebirth had made possible in a world that would otherwise have been condemned to death, darkness, and sorrow. Christ was the *Sol Invictus* whose radiance had forever defeated the sunset of death.

There is no doubt that the spirit that animated Gothic art and architecture was profoundly metaphysical. But there is also no doubt that the proud desire for recognition that, contrary to the anonymity

The north rose window of the Cathedral of Notre-Dame

of the past, its creator, Suger, expressed belonged to an era much more willing to acknowledge, in a singular manner, the uniqueness of the human subject.

On the western facade of Saint-Denis, Suger made sure to carve his name and also the verses that he wrote to celebrate his own achievement:

> Marvel not at the gold and the expense but
> At the craftsmanship of the work,
> Bright is the noble work; but being nobly
> Bright, the work
> Should lighten the minds, so that they may
> Travel, through the true lights. . . .
> The dull mind rises to truth through that
> Which is material
> And, in seeing this light, is resurrected from
> Its former subversion.

In the thirteenth century, the Gothic architectural style spread throughout Europe. Particularly original results were reached in England, where audacious solutions made possible masterpieces such as the Wells Cathedral, Salisbury Cathedral, and Westminster Abbey. In Italy, the Gothic style was initially rejected as a violation of classical elegance. (The term "Gothic," used by Italian humanists, derived from "Goth," a catchall term used to describe all the barbarians who lived beyond the Alps.) The style that eventually emerged there was a mixture of Gothic, Byzantine, and Romanesque, like the Basilica of Saint Francis in Assisi, the Cathedral of Orvieto, and the Duomo of Siena.

<div align="center">※</div>

THE CRUSADES

As we have seen, between the eleventh and twelfth centuries, the papacy had regained a great amount of authority and prestige. But

that position was perpetually threatened by the instability that in many parts of Europe rivalries between ambitious feudal lords were causing. The opportunity to shake the West from its chronic addiction to petty clashes came from the new political development occurring in the Near East.

Until the eleventh century, good relations between the ruling Fatimid dynasty in Egypt and Byzantium had assured stability in the Near East, including Palestine, where Christian pilgrims were free to travel without the fear of harassment by the ruling Muslims. The situation degenerated when the more aggressive Seljuk Turks (Seljuk, or Seljuq, is the name of the Muslim dynasty from which they derived) coming from central Asia took over Persia and occupied almost all of Asia Minor, including major cities such as Damascus, Antioch, and eventually Jerusalem in 1076. The Turks, who being new followers of Islam were much less tolerant than the Arabs, barred access to the holy places for all Christian pilgrims.

Tension rose when the Turks, progressing across the Anatolian plateau, were confronted by the opposing Byzantine forces in the Battle of Manzikert in 1071. After the terrible defeat that the Byzantine army suffered, the emperor Alexius Comnenus turned to Pope Urban II for help. What motivated the pope to promptly respond to the emperor's call and travel throughout France and Italy to seek the alliances necessary to form an armed coalition? Was Urban pushed by the desire to reconcile the Christian West with the Christian East? Or was the war simply a convenient excuse used by Urban II to unify the West under the leadership of the church and use the war against the Muslims as a way to overcome the internal fights that constantly disrupted Europe?

We cannot be sure. What is certain is that at Clermont, where he summoned a council in 1095, the pope delivered a gripping speech meant to rally the Christians to join a holy army. More than pressing for assistance to the Byzantines, the pope focused on the need to liberate Jerusalem from the impure hold of the infidels, who, as the pope said, were now shamelessly desecrating God's holy city. In this speech he gave in Claremont, the pope declared:

From the confines of Jerusalem and from Constantinople a griev-
ous report has gone forth that an accursed race, wholly alienated
from God, has violently invaded the lands of these Christians,
and has depopulated them by pillage and fire. They have led
away a part of the captives into their own country, and a part
they have killed by cruel tortures. They destroy the altars, after
defiling them with their uncleanliness. The kingdom of the
Greeks is now dismembered by them, and has been deprived
of territory so vast in extent that it could not be traversed in
two months time. . . . Let the deeds of your ancestors encourage
you—the glory and grandeur of Charlemagne and your other
monarchs. Let the Holy Sepulcher of Our Lord and Saviour, now
held by unclean nations, arouse you, and the holy places that
are now stained with pollution. . . . Let none of your posses-
sion keep you back, nor anxiety for your family affairs. . . . Let
hatred, therefore, depart from among you; let your quarrels end.
Enter upon the road to the Holy Sepulcher; wrest the land from
a wicked race, and subject it to yourself. Jerusalem is a land
fruitful above all others, a paradise of delight. The royal city,
situated at the center of the earth, implores you to come to her
aid. Undertake this journey eagerly for the remission of your
sins, and be assured of the reward of imperishable glory in the
Kingdom of Heaven.

The speech, which was crowned by the cry of battle *"Deus vult"*
(God wills it), had all the ingredients necessary to inflame the Chris-
tian spirit. The war against the Muslims, the pope assured, was a holy
mission destined to be victorious because it was directly approved
by God.

To make the call to war as appealing as possible, Urban also
declared that those who agreed to defend the cross ("crusade" derives
from the Latin *crux,* "cross") would receive absolution for all their sins.
The sign of the cross that was pinned on the crusaders' chests was
used as a banner of victory, but also a reminder that crusading was

comparable to a pilgrimage and, as such, was considered a supreme act of penance that would have assured immediate access to paradise.

As an extra incentive, people were also made aware that as long as they valiantly served the Christian cause, looting enemy cities for booty was not a sinful act. The prospect of a war that would have simultaneously assured salvation, adventure, glory, and also land and riches sealed the deal for many knights.

Although more than twelve thousand knights, mostly from France, responded to Urban's appeal, none of the actual kings of Europe participated in the First Crusade. Each had his own reasons: The Spanish ruler was engaged with the *Reconquista*. (The term indicates the 780 years that the Christians battled the Muslims, who had invaded the Iberian Peninsula in 711. The *Reconquista* came to an end with the Christian liberation of Granada in 1492.) The German emperor did not go, because he had bad relations with the pope. A similar tension troubled the king of France, who had just been excommunicated by the pope for bigamy. England did not pay much attention to the cause, as it was too preoccupied with its own internal affairs.

Before the actual troops departed, a fanatic by the name of Peter the Hermit quickly put together a disorganized, makeshift militia of peasants and headed toward Byzantium. While traveling, those self-proclaimed crusaders took the opportunity to slaughter all the Jews they encountered on their way, with the hope that the act would please God and increase their chance for salvation. When that ragged army arrived at Byzantium, the horrified emperor Alexius immediately shipped the group away to the Middle East, where they were promptly massacred by the Turks.

When the French knights, accompanied by women, children, and monks, finally reached Byzantium, the emperor's worries increased. His intention had been to receive a small contingent of well-trained mercenaries who would help him to regain the territories he had lost to the Turks. In his mind, the liberation of Jerusalem was not as urgent as pushing back the Muslims from Anatolia, from whence they dangerously threatened Byzantium. Because he was unsure about the real

intentions that animated the Western crusaders, the emperor Alexius proposed the following deal: If he provided the food, the supplies, and the military support that the Western forces demanded, would they promise, in return, the restitution of all the Byzantine territories that they might recapture with their mission? The crusaders gave their word but begrudgingly. What were—they asked themselves—the true intentions of this emperor who had previously entertained such a friendly relationship with the Muslim Fatimids? Was a ruler who did not feel the need to wipe from the face of the earth all those who served Allah worthy of their trust?

While still brooding on these considerations, the army finally took off for Jerusalem. The long journey proved to be extremely challenging, especially for people so ill prepared for the heat and the sun of those arid regions. Many got sick for lack of water, shade, and supplies; others died from being almost boiled alive in the metal armor in which their bodies were enveloped. Fulcher of Chartres, a chronicler of the time, wrote that at a certain point, in addition to the lack of water, a tremendous scarcity of food occurred. The situation got so bad that the soldiers, tormented by hunger, were forced to do the unthinkable: "I shudder to say that many of our men, terribly tormented by the madness of starvation, cut pieces of flesh from the buttocks of Saracens [Muslims] lying there dead. These pieces they cooked and ate, savagely devouring the flesh while it was insufficiently roasted. In this way the besiegers were harmed more than the besieged."

Yet despite all odds, the crusaders managed to liberate Antioch and reach Jerusalem. When the soldiers of God saw in the distance the city that they had known only from the words of the Bible, they fell on their knees, overwhelmed by awe and emotion. The moment long awaited had finally arrived. Inflamed by the enthusiasm, the crusaders pushed their way into the city, determined to inflict as much harm as possible on all the infidels they encountered. "Some of our men," wrote the chronicler Raymond of Agiles, "cut off the head of their enemies; others shot them with arrows, so that they fell from towers; others tortured them longer by casting them into flames. Piles

of heads, hands and feet were to be seen in the street of the city." With gleeful pride, the witness adds that in the Temple of Solomon the blood of enemies was so abundant that the Christian soldiers were immersed in it up to their knees. He concludes, "Indeed it was a just and splendid judgment of God, that this place should be filled with the blood of the unbelievers, when it had suffered for so long from their blasphemies."

Such cruelty seemed perfectly justified to the self-anointed soldiers of God who believed that freeing the world from the enemy of Christ was not an act of violence but one of pious and passionate devotion. Fulcher of Chartres wrote that after pushing the enemy's army out of Antioch, the crusaders found the city empty, except for the women who were left behind. With blunt brutality, Fulcher reports, "The Franks did nothing evil to them except pierce their bellies with their lances."

Shortly after the capture of Jerusalem, many crusaders, perhaps disappointed to discover that life in those faraway lands was more difficult than they had imagined and that, unlike what they had read in the Apocalypse, no pearls and gems encrusted the walls of the holy city, decided to return home. The few who remained were left with the task of managing what was now called the Latin Kingdom of Jerusalem.

With the First Crusade, the cross was made, once again, a banner of war, just as it had been in Constantine's time. The institutions that took that belligerent ethos to its most zealous extremes were the military orders of the Templars, the Knights of Saint John, and the Hospitallers. The vows of poverty, chastity, and obedience that the members of those orders took made them similar to monks but with a license to kill. With their mix of intense devotion, fanatical intolerance, righteous ferociousness, and military skills, those orders best epitomized the spirit that animated the crusade in medieval times.

In the twelfth-century carvings of the Cathedral of Angoulême in France, a battle scene inspired by the story of Roland appears under the representation of the apostles spreading the message of Christianity around the world with the assistance of an angel. The connection between the two scenes exalts the Crusades as a morally just enter-

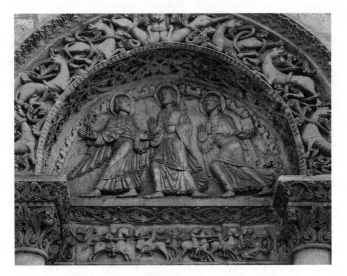

Twelfth-century tympanum sculpture, Cathedral of
Angoulême, France. The knights on horses battling the
enemies of God appear in the narrow lower register under
the depiction of the apostles.

prise: a Christian-spreading undertaking to be considered, just like
the evangelical mission of the apostles, part of the awesome scheme
of God's Providence.

In 1144, the Turks took over the city of Edessa, which for a long
time had been a stronghold of Christianity. This time it was Bernard
of Clairvaux who urged the launching of a new crusade against the
Muslims. To inflame the crowds against the infidels, Bernard gave a
passionate speech in front of the Abbey of Vézelay, in Burgundy: a
well-calculated political move, as indicated by the depiction of the
Pentecost on the tympanum (completed in 1130, fifteen years before
his speech), where Christ's hands spread rays of light that, in turn,
illuminate the minds of the apostles, who are about to start their
missionary journey to evangelize the world. All those untouched by
the message of Christ are portrayed, in the upper part of the tympa-
num, as strange and repulsive creatures whose features, derived from
ancient tales and legends, include people with dog heads, pig snouts,
big feet, and elephant ears, and pygmies so ridiculously small as to
need a ladder in order to climb on a horse. The prejudiced view was

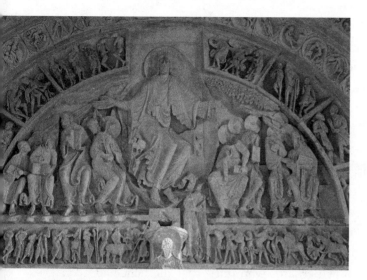

The tympanum of the Abbey of Vézelay, in Burgundy, with details depicting repulsive creatures untouched by the grace of Christ

easily extendable to the Muslims: infidels who, by virtue of being non-Christians, were imagined by the majority of Western people (most of whom had never met a Muslim) as more akin to animals and monsters than human beings.

Relying on prejudice to demonize and dehumanize the Other was, and still remains, the best way to incite man's zest for hate and killing. By embracing intolerance as a virtue, the medieval Christians became masters at it, as Bernard proved when he wrote, "The death of a non-Christian exalts Christ and prevents the propagation of errors."

Despite such effective propaganda, the dire outcome of the Second Crusade, which this time was led by the French king Louis VII and Conrad III of Germany, was a devastating blow for Christianity and also for the reputation of Bernard, who until that moment had been considered the most reliable representative and spokesman for God.

Forty years after the end of the Second Crusade, the Muslims, united under the guidance of their leader, Saladin, were able to recapture all of the cities won by the Christians, including Jerusalem, in 1187. In contrast to the Christians who had never hesitated to slaughter the inhabitants of the cities they conquered, Saladin, who was a fierce soldier but also a noble and chivalrous man, made sure to spare as many civilians as possible. The matter aroused a great amount of fascination but also surprise among the Christians: How could a Muslim possess positive characteristics? Puzzled by that mystery, some Franks went as far as to spread the rumor that Saladin was secretly a Christian, and not a Muslim, having converted when he was briefly held captive by the crusaders.

The Third Crusade (1189–1192) witnessed the direct involvement of three of the most powerful monarchs of Europe: the Holy Roman emperor Frederick I, also known as Barbarossa (Red-Bearded); Richard I of England, known as the Lionheart; and Philip II of France. The coalition was impressive, but the lack of unity among the rulers produced a result that was as embarrassing and disappointing as the two preceding missions. All the following Crusades proved to be nothing more than an uninterrupted string of humiliating defeats stained by a vast amount of senseless death. The shame reached its

peak in the Fourth Crusade (1202–1204), which started as an expedition against the Muslims in Egypt. To reach the Levant (the lands of the eastern Mediterranean), the crusaders asked the help of Venice. Because the crusaders were unable to raise the funds necessary to pay Venice, the latter, using as an excuse a controversy that had erupted between two aspiring candidates to the Eastern throne, persuaded the crusaders to conquer Byzantium, rather than Jerusalem, claiming that the imperial city had always regarded them with great suspicion. The treacherous excuse that in reality hid Venice's desire to cripple the successful activity of its great commercial rival led to a terrible expedition against Byzantium. The amount of murder, rape, destruction, and looting that in three days the crusaders inflicted upon the city reached a scale that, as a historian put it, "even the Vandals or the Goths would have found unbelievable." The four bronze horses that are still visible today in the Piazza San Marco, in Venice, are a reminder of the sack of Byzantium of 1204 and the terrible act of greediness and disloyalty that it represented.

Like other maritime powers, such as Genoa and Pisa, Venice was a republic that began to rise in power and wealth from the tenth century on thanks to commerce and trade. Among the goods that Venice traded were Christian slaves to Muslim buyers. When the church prohibited the use of Christians as slaves, Venice with cynical determination began to sell non-Christian Slavs. ("Slav" is the origin of the English word "slave.")

Of all the Crusades, the one that displayed the most grotesque amount of ignorance and superstition was the Children's Crusade that took place in 1212. Convinced that the holy wars had failed because God was displeased by the lack of purity of the Christian soldiers, two delirious visionaries, named Nicholas of Cologne and Stephan of Cloyes, put together an army of children with the belief that the waters of the Mediterranean would miraculously open, like the Red Sea for the Israelites, to allow that army of perfect innocence to march directly into Palestine. When the waters failed to open, the children were brought to Marseilles, where they were placed on ships heading to the Middle East. On their way, the ships were intercepted by Mus-

lim pirates who captured the children, brought them to Tunisia, and sold them into slavery.

Two more Crusades were led by the king of France, Louis IX. Besides those two unsuccessful expeditions, Louis IX, who for his piety and martial devotion was recognized by the church as a saint, is also remembered for having commissioned the Sainte-Chapelle in Paris, one of the greatest jewels of Gothic art.

To inflame the spirit of the crusaders, Urban II, as well as the popes who came after him, had claimed that because God was on their side, the holy wars would certainly harvest tremendous successes. But the series of humiliating defeats that the Christian armies suffered dramatically contradicted those expectations. People were left dumbfounded: How could God have permitted the victory of Christianity's major enemy? Because no answer could be found, cynicism and mistrust aroused serious doubt about the infallibility of the pope.

Taking advantage of the situation, many monarchs attempted to define in a clearer way their secular competence with the intention of reducing the influence of the church on the affairs of the state. As mentioned before, among the European monarchies England had been the first to solidify the power of the crown. The prestige that England enjoyed was further enhanced when the ruler of Aquitaine, Eleanor (1122–1204), annulled the marriage from her husband, the French king Louis VII, to marry Henry II of England. By adding Aquitaine to Normandy, England could now boast a dominion that included a big chunk of continental Europe. To circumvent the authority of the church, King Henry II, who conducted a major reorganization of England's judicial and administrative system, established that when the king deemed it necessary, royal courts could be used to put to trial also members of the clergy. The most famous victim of that policy was Thomas Becket, who, for having defended the right of the clergy to remain immune from royal prosecution, was assassinated in his own cathedral in 1170.

During the reign of Henry's son John, England lost Normandy to the capable King Philip II of France. When John, who could not accept the loss of Normandy, tried to bolster his army with the money

produced by the high taxes imposed on his subjects, the English nobles rebelled, forcing the king to sign Magna Carta, or the Great Charter. With Magna Carta, strong limitations were put into place to contain the power of the king, who from then on could no longer enforce the passing of legislation without the consent of his vassals.

Philip II of France (1165–1223), who was the first French monarch to be called "king of France," rather than "king of the Franks," was given the title of Augustus for taking back from England the major northern territories of Normandy, Brittany, and Touraine and for exploiting the crusade against the Albigensians (to which we will return shortly) to establish a foothold in the southern part of the country. The legally trained appointees whom Philip II sent to local jurisdictions to supervise their administrative and military activity strengthened the authority of the king as well as the unity of France, which again assumed a position of prominence within Europe. As with many other monarchs, Philip II had a rocky relationship with the church: in part because he reduced the influence of the clergy within the administration of the state, in part because he divorced his wife, the Danish princess Ingeborg, to marry the woman he truly loved, Agnes of Merania. It took the church's greatest weapon, excommunication, to eventually persuade Philip II to obey the pope and take back Ingeborg as his lawful wife.

After the Investiture Controversy, the weakened German emperors had been unable to contain the factionalism that had turned their domain into a multitude of independent regional powers. When he became king of Germany, in 1152, Frederick Barbarossa, who belonged to the Hohenstaufen dynasty, tried to regain control of the various duchies and principalities into which his country was split, using an array of political actions: from military pressure to monetary enticements, alliances, convenient marriages, and the careful game of diplomacy. But opposition was everywhere: in Germany, where Frederick was confronted by the Welfs of Saxony, a rival dynasty to the Hohenstaufen; and in Italy, where he faced the opposition of the northern cities that, although nominally still part of the empire, fiercely refused to accept imperial interference in their affairs. In an

attempt to reverse the situation, Frederick promised the pope his protection in exchange for a formal coronation, which he received in 1155, when he was anointed Roman emperor by Pope Adrian IV. Frederick eventually took the liberty to add the adjective "Holy" to the title of "Roman emperor," a defiant act toward the pope in that it suggested that his imperial power derived directly from God and not the church.

After six failed expeditions aimed at restoring German control in Italy, Frederick, defeated in 1176 by the Lombard League (formed by the union of the northern cities), was ultimately forced to acknowledge the political and administrative autonomy of the self-governed Italian communes.

His only true diplomatic success was the arranged marriage between his son Henry VI and the heiress of the Norman kingdom of Sicily. (The kingdom of Sicily, which included all of southern Italy, had been established by the Normans between the eleventh and the twelfth centuries.) When Henry VI prematurely died, his son Frederick II (1194–1250), who was only three years old, was crowned king of Sicily. Despite his Norman and German blood, Frederick II felt a great affinity with Sicily, where he spent most of his life. Under his leadership, southern Italy thrived, while Germany, neglected by its ruler, became a land racked by internal rivalries and ever more rebellious principalities.

Frederick II was a highly intelligent and cultivated man. He spoke six languages (German, Latin, Greek, Sicilian, French, Arabic), wrote poetry, and had a passion for mathematics, anatomy, philosophy, and falconry. In his court, Christian, Jewish, and Muslim scholars were equally welcomed. Because of his wide spectrum of interests, he was awarded the title of *stupor mundi* (wonder of the world) by his contemporaries. Frederick was also known for having sponsored a private zoo in Palermo where he conducted scientific experiments, particularly concerning new forms of bird breeding. Among his greatest accomplishments was the foundation of a famous university in Naples. Frederick, who was a sponsor of art, also promoted the first vernacular school of poetry where an educated Sicilian idiom was

used. The theme of courtly love, which the Sicilian school of poetry cultivated, derived from the troubadours' tradition that reached its peak in southern France between the twelfth and the thirteenth centuries. Frederick, who studied the Koran, also adopted the Muslim custom of keeping a harem.

Naturally, the Roman papacy had very little sympathy for such an unorthodox sovereign and always opposed his desire to unify the south of Italy with the cities of the north for fear of the papal state becoming squeezed in between German-controlled territories.

The main point of friction between the papacy and Frederick II was his refusal to go to war to liberate the Holy Land. Pope Gregory IX, who was at the same time a devout Franciscan (it was Gregory IX who canonized Saint Francis) and a fierce opponent of the Muslims, excommunicated Frederick for failing to obey his order and go on a crusade. Gregory was further enraged when Frederick, still excommunicated, finally decided to go to Jerusalem on his own initiative. Once there, Frederick organized a meeting with the Muslims, and with great diplomatic ability was able to conclude an agreement that gave control of Jerusalem to the Christians for ten years. The only place that the Muslims kept under their control was the Dome of the Rock, a site that they considered sacred because it was from there, they believed, that Muhammad had started his journey to heaven. Gregory IX, who thought that negotiating with rather than fighting the Muslims was a terrible sin, was angered rather than delighted by Frederick's bloodless success.

Eventually, the protracted clash between the papacy and the emperor, who by the end of his life had collected four excommunications, led to the demise of both sides. The church had its reputation severely compromised by its constant meddling in politics, while the German Empire continued to remain a scattered puzzle of small principalities to become, as Voltaire later stated, an amorphous entity that was neither holy, nor Roman, nor an empire.

WEALTH AND POWER VERSUS POVERTY AND HUMILITY: THE TWO FACES OF CHRISTIANITY

The military spirit that had animated the church during the Crusades, and the desire to assign to the church the role of arbiter within the chessboard of European politics, had given the papacy a temporal stance that was quite at odds with the spiritual commitment of early apostolic times. The pope who most vigorously tried to enforce the supremacy of the church over the temporal power of the states was Innocent III (reigned 1198–1216). According to Innocent III, the authority of kings and popes derived from God, but the secular state was inferior to the papacy because, like the moon, it would have remained insignificant if not illuminated by the superior wisdom of the sun that the church represented:

> Just as the founder of the universe established two great lights in the firmament of heaven, a greater one to preside over the day and a lesser one to preside over the night, so too in the firmament of the universal church which is signified by the word heaven, he instituted two great dignities, a greater one to preside over the souls as if over day and a lesser one to preside over bodies as if over night. These are the pontifical authority and the royal power. Now just as the moon derives its light from the sun and is indeed lower than it in quantity and quality, in position and in power, so too the royal power derives the splendor of its deity from the pontifical authority.

To counterbalance the growing assertiveness of secular governments, Innocent III, in 1215, summoned the Fourth Lateran Council, in which it was declared that salvation was impossible outside the church. To make sure that the church's vast jurisdiction kept its tight control on all aspects of human life, sacraments (baptism, marriage, Communion, confession, and so on) were carefully reviewed and for-

malized, and sins were meticulously divided into mortal and venial infringements. To marginalize the non-Christian citizens, the Fourth Lateran Council also established that Jews and Muslims were to wear a special badge that distinguished them from Christians.

Innocent III was the first pope to launch a crusade in the very heart of Europe against two groups that the church considered heretical: the Albigensians (or Cathars, as they called themselves, meaning "pure" in Greek) in southern France, and the Waldensians, founded by Peter Waldo, a merchant of Lyons. The Albigensians, who in a Manichaean-like fashion believed that the world was a constant struggle between good and evil, had become the target of the pope's repressive action because they rejected the authority of the church, which they considered a greedy and corrupt institution. The Waldensians, who like the Albigensians were critical of the venal attitudes of the clergy, refused to accept as valid any sacrament imparted by priests. The fact that in both movements women were recognized as equal to men was used as further reason to condemn the Albigensians and the Waldensians as heretics. Innocent III did not formally establish the Inquisition, but his intolerant views and his brutal methods greatly contributed to the establishment of the ferocious mechanism that soon became the most efficient means with which the church got rid of all those it deemed undesirables: heretics, Jews, prostitutes, lepers, sodomites, witches, and so on. Punishment varied from torture to imprisonment to death. (The recommended method of killing heretics was burning at the stake because it "piously" prevented the shedding of blood.)

The violent repression unleashed against the heretics, who, according to the pope, had committed treason against Christ, was intended as a warning to all those who dared to criticize the church—a valid concern indeed, given the widespread dissatisfaction that many Christians felt toward an institution that had become too rich, too powerful, and too political, an institution filled with priests more concerned with their own selfish interests than the spiritual needs of their communities.

A side consequence of the campaign of repression against the

Albigensians was the destruction of the many courts that, especially in southern France, had sponsored the vernacular tradition of poetry made famous by the troubadours. The use of the vernacular, rather than Latin (the language reserved for religion and high culture), for poetic and literary purposes had begun with the epic tradition made famous by the *Chanson de Roland* and by the later cycles dedicated to the British king Arthur. The choice of the vernacular expressed the desire to reach wider audiences among an increasingly educated population.

Unlike the epics mentioned above, the themes addressed by the troubadours dealt with a reality that, rather than the battlefield, belonged to the court environment, where decency, gentility, and politesse were increasingly cultivated. The central motif of those poems was the deferential passion of a knight for a woman of noble origin. The civility and respectability that the theme conveyed were greatly welcomed by princes and rulers, who hoped that poetry would help refine the coarse manners of the often unruly men who filled their households. Rather than the embodiment of carnal desires, the troubadours' poems exalted women as ennobling objects of venera-tion that, in a Neoplatonic fashion, inspired in men a totally pure and chaste passion. A useful poetic expedient was to portray the woman (always of noble origin) as someone else's wife. The woman, who remained beyond the reach of the male lover, harnessed the tension of masculine eroticism through the catharsis of a sentimental experience that remained purely Platonic, meaning only emotional, intellectual, and spiritual rather than physical. (Unfortunately, non-noble women did not enjoy the same kind of Platonic respect!)

After being dispersed in southern France, the troubadours' tradi-tion reappeared in Sicily, where, as previously mentioned, Frederick II sponsored a great vernacular school of poetry. In later times, that school proved of great inspiration for the Tuscan lyric tradition known as *Dolce Stil Novo* (Sweet New Style), from which Dante emerged.

Among the events that the church was forced to confront during the thirteenth century was the emergence of two new religious orders: the Dominicans and the Franciscans. Both orders received the appel-

lation of "mendicant order" because they lived on charitable contributions (*mendicare* means "to beg" in Italian) and were representative of the growing longing for the purity and simplicity of early apostolic times.

The Dominicans were founded by Dominic de Guzmán (1170–1221), who was born in Castile in Spain. Dominic believed that spreading the message of the Gospels was the primary duty of those who gave their lives to God. But that duty, for Dominic, could not be properly fulfilled if the friars were not culturally prepared and theologically trained. That imperative was so important for the Dominicans that they were the first order to dispense priests from fasting or even performing liturgical duties if it interfered with their studies. Not surprisingly, the Dominican was the order that produced the most brilliant intellectuals of medieval times, such as Albertus Magnus and his pupil Thomas Aquinas, whom we will discuss shortly. Nevertheless, the rigor with which the Dominicans followed the precepts of the church turned many of them into zealous inquisitors dedicated to the eradication of all movements that, in their view, betrayed the Christian orthodoxy and were therefore to be condemned as heretical. It was in reference to that role of stern guardians of God that the Dominicans were often referred to as *Domini canes* (God's dogs).

The Franciscan order was founded by Francis of Assisi (ca. 1181–1226), who abandoned all the privileges of his rich family to fully serve and celebrate God. To describe Francis's commitment to the humility and poverty that the original lesson of Christianity had imparted, Dante wrote that Francis had chosen to be happily united in "mystical marriage" to "lady poverty." For his absolute dedication to the spirit of the Gospel, Francis came to be considered almost an alter ego of Christ, from Whom, the legend claimed, he had miraculously inherited the stigmata—wounds similar to those that Christ suffered on the cross. As a close follower of Christ's teachings, Francis also had an unshakable commitment to peace and nonviolence—an attitude that definitely stood in contrast with the disciplinary actions that the church had started to so willfully enforce. The humility at

the heart of Francis's order is expressed by the name *frati minori* (friars minor), which was used to indicate that they were the least deserving among the servants of Christ.

According to Francis's luminous creed, the world was not, as Plato had believed, a shadowy realm to fear and reject but a place of harmony brimming with the essence of the divine. All that was needed to recognize the presence of God was to open oneself to the wonders of nature. For the mystic and poetic Francis, nature was meant not to reveal to the mind the mystery of God but to fill man with wonder at the way each aspect of the universe celebrated, as in a perfectly coordinated chorus of joy, the goodness and beauty of its Maker.

What characterized the humble man of Assisi was the immense love that made him feel akin to all the things that God had created. According to legend, he preached to birds, fish, and reptiles, and had a lamb join a chorus with its bleating and a wolf pledge respect toward the town it had previously terrorized. Francis, who addressed the sun, the moon, the stars, the wind, the water, the fire, and even death as brothers and sisters, always gave his undivided attention to all the creatures of the world, even the most forgotten and despised, like the lepers to whom he never denied his tender embrace. For a religion that for centuries had preached that the world was a contaminated reality stained by sin, Francis's heartfelt celebration of all aspects of nature had tremendous appeal.

Thomas of Celano, the thirteenth-century author of the saint's biography, wrote that Francis founded his order following the command of Christ, who said to him, "Go and repair my house, as thou see, is wholly fallen into ruin." Even if the words appear to be an indictment of the church, Francis never showed disrespect toward the ecclesiastical authority. Perhaps for that reason, when Francis went to the pope to ask for recognition for his order, Innocent III granted his permission. It's hard to know precisely what influenced the pope's decision: he might have been sincerely touched by Francis's purity of faith, or he might have understood that absorbing rather than repressing the order established by a man who had become an inspiration for so many was a powerful way for the church to rebuild its reputation.

The appreciation of nature that in a manner similar to Francis many Christian writers of the twelfth and thirteenth centuries expressed indicates that a mental rehabilitation of the world of matter was in the making. The twelfth-century Bernard of Chartres defined the world as a "university" from which one could discover the vestiges of God in the world. In a similar manner, Honorius of Autun stressed the correlation between "universe" and "university," while the thirteenth-century Alain de Lille claimed that Nature was the true "vicar of God." The mystic Hugh of Saint-Victor (1096–1141), from the Augustinian Abbey of Saint-Victor in Paris, wrote, "All nature speaks of God, all nature teaches man, all nature allows an understanding; there is nothing sterile in the universe." Within that view, nature became a jungle of symbols waiting to be interpreted by man. Of course, the ultimate purpose of that quest was always and only the ultimate truth of God. Studying nature for its own sake, as in a secular and scientific perspective, would have been considered absurd and totally blasphemous. Only by grasping that view can we understand what Hugh meant when he said that the study of the seven liberal arts helped the restoration of God's image in man: "Learn everything; later you will see that nothing is superfluous."

The definition that best captured the growing correlation between the visible and the invisible worlds was the one that characterized man as a microcosm whose reality was connected to the greater macrocosm, which, in miniature, he mirrored and reflected. The German mystic Hildegard of Bingen poetically expressed the concept in one of her hymns: "O man, look at yourself as you have within you the sky and the earth." Linking Francis's mysticism with Plotinus's philosophy, the influential theologian Saint Bonaventure (1221–1274) wrote that the visible universe was like a mirror reflecting, in different degrees of intensity, the luminous vestige of the divine Wisdom: "The whole world is like a mirror, bright with reflected light of the divine wisdom; it is like a great coal radiant with light."

THE REHABILITATION OF MAN
WITHIN THE ORDERED UNIVERSE OF GOD

As we have seen, the debacle of the Crusades ended up being a true humiliation for the Christians. But that negative outcome should not be considered the only effect of the Crusades. If regarded from an economic and cultural rather than an ideological perspective, those expeditions ended up providing a very positive outcome, principally because they allowed the reopening of the trade routes that reconnected the West with Byzantium and the Muslim world. As a result, the Mediterranean became once again a conduit for travel, commerce, and the exchange of knowledge and ideas. As the demand for luxury products coming from the East grew, so did the lucrative activity of lively markets importing perfumes, incense, silks, cotton, damask, rugs, tapestries, ceramics, enamel works, as well as a vast array of delicacies such as spices, sugar, cloves, sesame, lemons, apricots, plums, spinach, and asparagus.

Of course, the greatest gift that these new routes of communication produced was cultural. To fuel the spirit of the Crusades, the church had portrayed the Muslims as brutish, violent, and uncivilized people. But what the Christians discovered when they directly encountered the cities built by their enemies was that the Muslim civilization, unlike what Christian propaganda had been claiming, was extremely rich and sophisticated—so much so that in almost all fields of knowledge the Muslims were much more advanced than the Christian West. In Baghdad, for example, where the Muslims had moved their capital after Damascus, a center of culture called the House of Wisdom had been established, in 832, for the preservation of old manuscripts, including many Hellenic texts that had been transferred there by Greek scholars during the repression campaign against pagan culture launched by Justinian.

Paradoxically, the revival that the Christian West enjoyed from the twelfth century on, in fields such as medicine, philosophy, astron-

omy, astrology, and mathematics (of particular importance were the Arabic numerals and the concept of zero), owed an enormous debt to its most vilified enemies—the Muslims.

Muslim cultural contributions principally filtered into Europe through three geographic locations: Toledo in Spain, southern Italy, and Byzantium. The most important was Toledo, the city that the Christian monarch Alfonso VI of Castile recaptured from the Moors in 1067, marking an important step in the Christian *Reconquista* of Spain. The event attracted scholars from all over Europe who, frustrated with the scarce availability of classical texts, came to Toledo to study the city's rich collection of books. One of these scholars was Gerard of Cremona (1114–1187), who taught himself Arabic in order to translate into Latin the work of Greek authors whose books had come into the possession of the Muslims when, almost four hundred years earlier, they pushed the Byzantines out of North Africa and the Near East. The seventy books Gerard of Cremona translated included works by Ptolemy, Euclid, Archimedes, and Aristotle. With a similar dedication, the archbishop Raymond of Toledo founded a school for the training of translators and scribes. It was thanks to Raymond's school that many books of major Greek philosophers were translated from Arabic to Latin, including the work of many Arab and Jewish scholars who had enriched those texts with important commentaries.

Muslims had always nurtured a great amount of respect toward philosophy, which within the encyclopedic approach that their mentality favored also included the study of astronomy, astrology, alchemy, and zoology. Because of his encyclopedic approach, Aristotle had been particularly admired by Muslim scholars, who intensely studied his writings and tried to adapt their principles to Islam. The most respected and influential Muslim commentators on Aristotle were Averroës and Avicenna.

The early church fathers had been suspicious of Aristotle, whom they considered a profane materialist, in contrast with the spiritual Plato, whom they celebrated as a sort of precursor of Christianity. But in the thirteenth century, when all the works of Aristotle became available to the West, a fierce debate exploded among Christian schol-

ars: while some conservative theologians continued to denounce Aristotle, others fascinated by his ideas saw in his approach a way to bring reason closer to the spirit and to create a new connection between philosophy and religion. The scholar who in his monumental work called the *Summa Theologiae* best succeeded in elaborating a synthesis that, in a convincing way, harmonized Aristotle's ideas with the precepts and principles of Christianity was Thomas Aquinas (1226–1274).

Thomas belonged to a noble family from southern Italy. From his mother's side, the family could boast a direct tie to the emperor Frederick II. The prestigious position of the family did not impress Thomas, who since a very young age showed no interest in fine clothes and gentlemen's pursuits like hunting and falconry. He was fat, introverted, and so quiet as to be given the nickname of "dumb ox." He never opened his mouth except for suddenly summoning up the attention of his schoolteachers with imperious questions, such as "What is God?" Not knowing how to handle him, the family sent Thomas to the monastery of Monte Cassino to become a Benedictine monk. After a few years in Monte Cassino, Thomas moved to Naples to attend the university newly founded by Frederick II.

Coming home during a break from his studies, Thomas declared to his family that he wanted to become a Dominican friar. The family was shocked: Why would Thomas want to abandon the prospect of a prestigious position, such as that of abbot of Monte Cassino, to join a new order (the Dominican order was founded only twenty years earlier) so extravagantly devoted to poverty as to advertise begging as an acceptable way of survival? For the aristocratic mentality of the Aquino family, obsessed with the reputation and prestige of their name, Thomas's wish was absolutely unacceptable. To prevent him from joining the Dominican order, he was kept prisoner in his father's castle for two years. One day his brothers, who hoped to dissuade him from his plan, hired some prostitutes and sneaked them into his room. Thomas's reaction was immediate: as if confronting the very presence of Satan, he chased the screaming women out of the room by brandishing an iron rod that he kept near the fire.

When the family eventually gave up on restraining him, Thomas

was finally left free to follow his calling. His devotion to learning took him to Paris, where he became the pupil of another great Dominican friar, Albertus Magnus (ca. 1193–1280), who introduced him to the study of Aristotle. Albertus, who was called the "father of modern science" because of his immense contribution to the burgeoning study of nature, was the first medieval thinker to separate the sphere of revelation from the sphere of reason and draw a sharp distinction between knowledge derived from theology and knowledge derived from science. Even if science was inferior to theology, Albertus claimed, it had validity in that it made man aware of God: not the intrinsic mystery of God, but how God revealed Himself through the magnificent workings of nature that human intelligence was able to grasp and comprehend. Taking Albertus's teachings as a point of departure, Thomas came to the conclusion that human reason was to be considered a legitimate instrument of knowledge and that logic could be applied to empirical observation and experimentation. As the historian Gerrit P. Judd puts it, Thomas's essential belief was that "reason, if properly used, always supports faith."

From Augustine on, Christian thinkers had conceived of the soul as an essence imprisoned within the tomb of the fallen body. Thomas, inspired by Aristotle, assumed a whole new position: because Providence had conceived nothing in vain, man's organic reality, made of reason and the senses, was to be considered a gift from God—a gift that, in allowing man to recognize the rational laws of the universe, also made him aware of the wisdom of his Creator.

Plato had stated that to reach the ultimate Truth, a drastic detachment from the shadowy world of the senses was necessary and that knowledge was based not on perception but on a kind of reminiscent awareness. Thomas could not accept such a denial of reality. Even if the mind and the senses were somehow limited, Thomas affirmed, their conclusions remained valid steps toward the knowledge of God's supreme Truth. From a desolate place full of evil traps and dangerous temptations, the world, in Thomas's thinking, was transformed into a land of potentialities and possibilities: a meaningful reality waiting to be decoded by human initiative and ingenuity.

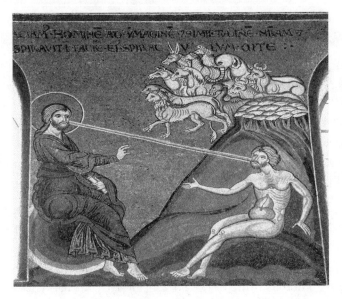

This mosaic in the Cathedral of Monreale visualizes God
endowing Adam with an aspect of the divine.

Applying the principles of Aristotle to Christianity, Thomas
described God as an "Unmoved Mover": the point of departure of an
immense flux of a life-producing force expanding in growing ripples
of signification before irresistibly returning to the source of its origi-
nal beginning. Within this grand dynamic, no room was left for a
useless and insignificant state of inertia. Everything in the universe
grew and moved toward the ultimate goal that God had assigned
to each aspect of His creation. To *be* was to *become:* in other words,
to realize the purpose for which each living thing had been cre-
ated. To respect the intention of God, man had the duty to actual-
ize the latent possibilities he was endowed with by nature. Nothing
was more sacred than that engagement: to restore within himself the
image of the divine, man had to embrace the role that God had given
him in Genesis when He made him His closest and most important
collaborator.

In striving to perfect nature and bring to realization the potential
he possessed, man did not violate but rather paid tribute to God's
tremendous generosity. As Richard Tarnas puts it in *The Passion of the*

Western Mind, "To strive for human freedom and for the realization of specifically human values was to promote the divine will. . . . To be as God intended, man had fully to realize his humanity."

Thomas's acceptance of human knowledge as compatible with rather than antithetical to divine revelation released a tumultuous joy of thinking: a wave of enthusiastic intellectual activities that fed the long-repressed hunger for knowledge and understanding. The point is addressed by Georges Duby in *Art and Society in the Middle Ages* with these words: "By a complete reversal of the dominant ideology, men realized, in towns that were growing and in the face of the indicators of economy growth, that the material things were not inexorably doomed to corruption by the passage of time, but that, on the contrary, a continuous progress carried them along. The corollary was that creation was not finished, that it continued day by day, and that human beings were required by their Creator to collaborate with him, to assist him with their labor and intelligence to perfect the universe, and that they ought, in consequence, to know more of the laws of nature, that is to say, God's scheme."

The focal point of this intellectual revival was the new relationship between man and God. To know himself, the Bible had stated, man had to rediscover within the resemblance with the divine. That awareness was now believed to include the central place that God assigned to man within the scheme of an ever-evolving universe.

Within that view the dignity of man was forcefully reaffirmed: because he was the point of juncture between matter and spirit, man was again assigned a central role within the magnificent drama of creation. In improving the world through intelligence and creativity, man felt that he was somehow continuing the work of God: imposing order over chaos to make the earth once again resemble an ideal Garden of Eden.

Theology remained supreme but without the exclusion of other disciplines that, for the first time, were now recognized as having a specific function within the greater horizon encompassed by Christian knowledge. Thomas expressed the concept by always relating the particular to the universal, which, in his view, was the divinely

established hierarchical and all-encompassing order he had tried to synthesize in his *Summa*.

The study of natural sciences that during the early Middle Ages had almost completely disappeared benefited from that approach (as demonstrated by empirical experimentation advocated by Robert Grosseteste and Roger Bacon), as did the disciplines dedicated to the sharpening of the human mind, such as rhetoric, dialectic, and logic. The Scholastic innovation proved positive for the church that fully embraced Thomas's approach. But the danger implicit in an excessive empowerment of the mind, with its never satisfied desire to question and analyze was soon manifested by the reasoning of new thinkers like the fourteenth-century British philosopher William of Occam, who affirmed that contrary to Thomas's conclusions, linking philosophy to theology was impossible because reason, which was based on experience, could never assess metaphysical truths. What Occam's thesis implied was that, although completely separate from faith (which was the only means to reach God), reason was a perfectly valid and legitimate instrument of knowledge, even if that knowledge served no purpose within the scheme of religion.

THE GRADUAL SECULARIZATION
OF CULTURE

With the revival of the urban milieu, the demand for educated professionals who could deal with the administrative complexities of the state and the challenges of industry and trade vastly increased the attendance at schools and universities. For centuries, the church's exclusive dominance over culture had fostered the myth that, as the scholar Charles F. Briggs puts it, by "being learned" the clerics had a privileged access to the holy: "Learning to read then, and especially learning to read Latin, put someone one step closer to God."

In the fourteenth century, the rapid expansion of literacy and cul-

ture, the greater production of texts written in the vernacular, and the social recognition that education granted greatly dimmed the aura of exclusivity and cultural superiority that previously had belonged only to the church representatives. Briggs writes, "In the fourteenth century holders of degrees in civil law began to refer to themselves as 'knights,' and even as 'lords' and 'counts' of law. . . . In late fifteenth-century France a new category of nobility, the *noblesse de robe* was established to reward educated men, most of them lawyers, who had distinguished themselves for their loyalty and competence in royal services."

The new cultural attitude also upgraded the role of the artists, who, having received an increased amount of leeway from old religious constraints, began to represent in more realistic terms the tangible reality of the world to which Thomas, in agreement with Aristotle, had given new value and appreciation. The revolutionary results that this new cultural and religious predisposition ushered in emerge in the variety of themes that thirteenth- and fourteenth-century artists used in their encyclopedic compositions, which included the depictions of human work during different seasons of the year; astrological signs; symbols and allegories derived from bestiaries and/or popular legends endowed with a moral message; as well as references to the disciplines of the trivium and the quadrivium. In Chartres Cathedral, the importance given to different fields of human knowledge is expressed by the portrayal of Mary surrounded by the seven liberal arts, each accompanied by its most important representative, with no qualms about the fact that many of those representatives are pagan philosophers, mathematicians, and political thinkers. Within this new order, Pythagoras is placed next to Music, Aristotle next to Dialectic, Cicero next to Rhetoric, Euclid next to Geometry, Nicomachus next to Arithmetic, Priscian next to Grammar, Ptolemy next to Astronomy.

To our uneducated eye, the complex number of images and symbols that form the sculptural program of Gothic cathedrals may appear quite confusing. But for the rigorous Scholastic logic that animated the builders and decorators of those awesome symphonies of stone, the images had a very precise meaning. The overall message was that the emphasis attributed to each singular detail made sense

only if placed in direct relation to the greater meaning that the cathe-
dral as a whole represented. The art historian André Chastel writes
that in typical Scholastic manner (evocative of Aristotle's insistence of
connecting the parts to a greater whole), each figure and each event
was made to play its part but always in a way that remained subordi-
nated to the higher scheme that the greater composition expressed—
a scheme that by reconciling all the different expressions of life and
nature indicated the unifying greatness of God's truth, toward which,
ultimately, everything flowed and everything converged. In a similar
manner, the allegory of numbers was often used to show how the
divine had woven into a single unity all the aspects of His creation:
from the four seasons with which the four evangelists were associated
to the twelve months of the year, which, symbolically, were connected
to the twelve apostles. Another interesting correlation was the sym-
bolic association of Mary with the moon: the celestial mirror that
most perfectly reflected the sunlight of God.

The didactic message was aimed at the edification of all members
of the community: the illiterate, who probably could only grasp a
fraction of the theological complexity but could still enjoy the repre-
sentation of moral fables and popular legends (like the whimsical one,
often depicted, that showed Aristotle becoming the slave of an Indian
girl who saddled and rode him as if he were a horse), as well as the
intellectually sophisticated, who could improve their meditative skills
by exploring the many layers of meaning that the images proposed.

The theme of salvation remained the principal frame of reference
of the iconographic program, but the road to salvation was widened to
include the entire progress that man had achieved throughout history.
John of Salisbury (ca. 1115–1180), who was active in the school of Char-
tres, invoked his teacher Bernard of Chartres to describe with these
words the forward process that cultural achievements represented:

> Our age enjoys the benefit of the age preceding, and often knows
> more than it, not indeed because our intelligence outstrips
> theirs, but because we depend on the strength of others and
> on the abundant learning of our ancestors. Bernard of Chartres

used to say that we are like dwarfs sitting on the shoulders of giants so that we are able to see more and further than they, not indeed by the sharpness of our own vision or the height of our bodies, but because we are lifted up on high and raised aloft by the greatness of giants. With these words I will readily concur.

The metaphor of the dwarfs on the shoulders of giants describes progress in a cumulative fashion: the human intellect grows more acute and critically perceptive with the accumulation of knowledge and experience that each generation hands down to the next.

By offering to God that encyclopedic summa of stone, man offered to the Creator everything he possessed: faith and prayer but also what the God-given gift of human intelligence had achieved through work, dedication, and ingenuity. In that sense, as a famous critic puts it, the Gothic cathedral could be defined as a true "apotheosis" of "thinking, knowledge, and art."

The new appreciation of human life is conveyed in an extraordinary relief from Chartres Cathedral, which depicts the creation of man. The gentle way in which God (always represented as Christ) molds Adam out of clay is evocative of a loving father caressing his child, affectionately reclining on his leg.

The representation of God into a loving and forgiving Father, rather than a stern and severe Judge, is echoed in the depiction of Mary, seen not as a distant queen of heaven but as a young mother holding her child with a tenderness that makes her completely familiar to the viewer's perception. See, for example, the depiction of Mary as it appears in Amiens Cathedral (page 300).

The humanness of the mother is also stressed in the scene of the Annunciation depicted in Reims Cathedral, where Mary's youth is emphasized by a detail that would have been considered outrageous in earlier times: the curve of her young breast slightly appearing under the soft veil that covers her body.

The loving mother destined to experience the terrible death of her son possessed all the range of emotions (happiness, sorrow, despair, hope) needed to become an ideal mediator between man and God and

ABOVE LEFT: God molding Adam from clay in this relief from Chartres Cathedral

ABOVE RIGHT: Mary represented on the south portal of Amiens Cathedral—the *Vierge Dorée*

RIGHT: The Annunciation, Reims Cathedral, mid-thirteenth century

respond with merciful compassion to man's plea for divine acceptance, forgiveness, and recognition.

The realistic bent that Gothic art had begun to entertain reached the peak of drama with the first representations of Christ dying on the cross. As we have discussed earlier, Christians for almost a thousand years consistently skipped the scene of the Crucifixion. The first images that confronted that theme were for the most part completely devoid of drama: even if nailed to the cross, Christ was shown with eyes open and head lifted as if immune to the torments and sufferings of the flesh.

From the twelfth century on, more naturalistic examples began to appear, especially in northern Europe, where the first representations of Christ suffering on the cross were produced. Powerful examples can be found on the bronze doors of the Church of Saint Michel in Hildesheim and at the entrance of Naumburg Cathedral (shown at left).

In Italy, the first realistic representation of the death of Christ can be found in Parma and Cremona, in the works of artists like Antelami and Wiligelmo. In the thirteenth century, Nicola Pisano (active 1250–1260) sculpted the pulpit in the Pisa Baptistery.

Despite the small space in which they are squeezed, the realism of the highly

Christ on the cross, flanked by the mourning figures of Mary and John, Naumburg Cathedral, Germany

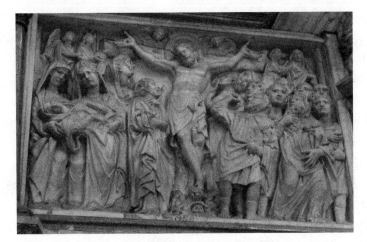

The pulpit panel on the Pisa Baptistery (ca. 1250–1260) is an
early realistic representation of Christ's crucifixion.

individualized figures reveals the stylistic influence of the Roman
sarcophagi that Nicola must have seen on the backs of many Chris-
tian churches. (It was common practice to keep the fragments of old
funerary sarcophagi near churches, as a sign of respect for the dead.)
The intensity of feeling that Nicola is able to express is particularly
strong in the scene that represents the death of Christ on the cross
surrounded by a crowd that includes his mother dramatically fainting
at that terrible sight. The vertiginous depth of Mary's sorrow, which
seems to be acknowledged by Christ, who looks directly at her from
the cross, transforms the Passion into an act of compassion that for the
first time also recognizes the magnitude of human sorrow and vulner-
ability. The only reminder of the triumphal purpose of Christ's sacri-
fice is the skull of Adam, placed at the foot of the cross, with which
the religious iconography traditionally signaled that real death was
to be associated with human sin, while real life belonged to Christ's
redemptive mission.

In painting, the development of a new style was greatly influ-
enced by the scientific views that the Franciscan Roger Bacon (ca.
1214–1292) described in his *Opus Majus:* an encyclopedic work that
contained his contributions to mathematics, optics, alchemy, and
astronomy. (A passage of the book also discusses the essential ingre-

dients that the Chinese used to create gunpowder.) Bacon's decision to send his manuscript to Pope Clement IV (reigned 1265–1268) was a plea to consider the more naturalistic and persuasive approach to art that the knowledge of optics and perspective could provide. Behind Bacon's argument was the belief that because nature mirrored the wisdom of the divine, representing nature in its most tangible concreteness was the best way to enrich, with evocative and inspirational power, the message contained in religious art. The pope who was most influenced by Bacon's suggestions was Nicholas III (reigned 1277–1280). The frescoes that Nicholas III ordered for the Chapel of Saint Lawrence (Sancta Sanctorum) in Rome are described by many critics as the first example of Italian religious realism. In the scene shown below (attributed to a "Roman school of painting" with no specific names added), we see the martyrdom of Saint Peter. The inverted cross that Peter requested because he felt unworthy of Christ's sacrifice appears before an urban landscape where, placed at different spatial levels, stand a series of monumental buildings evocative of Rome's imperial time.

The man who, more than anyone else, was responsible for introducing in painting a whole new sensibility was Giotto di Bondone (ca. 1266–1337), who was a pupil of Cimabue's. In contrast with the remote quality of Byzantine style, Giotto's novelty, wrote the Florentine historian Giovanni Villani (ca. 1276–1348), was that he drew "all the figures and their postures according to nature." The vividness

The Martyrdom of Saint Peter, an unusually realistic fresco in the Chapel of Saint Lawrence in Rome

of such a realistic approach so impressed Giorgio Vasari that in his book *Lives of the Most Eminent Painters, Sculptors, and Architects* (1550) he made Giotto the initiator of the "rebirth" that the Renaissance represented. Among Giotto's many works is the famous cycle of frescoes he did for the Arena Chapel in Padua. While in the early Middle Ages all works of art were sponsored by the church, in this new era many wealthy citizens had begun to pay artists for privately funded endeavors. Enrico Scrovegni, who sponsored the Arena Chapel, was the son of the rich banker Reginaldo degli Scrovegni, whom Dante placed in his *Inferno* because of his practice of usury, which was forbidden by the church. Although, as we have said, usury eventually came to be accepted as an unavoidable necessity within the business world, the superstitious fear of divine retribution lingered, as proven by the countless contributions that guilt-ridden wealthy patrons made to pious endeavors. The cycle of painting concerning the life of the Virgin and that of Christ in the Arena Chapel was sponsored by Enrico Scrovegni because he worried about his father's soul and also about the reputation of his family's name, which he wanted to shield from criticism. Scenes like Christ chasing the money changers out of the temple were intended to show that the sponsor was aware of the danger of the corrupting effects of money and greed. Giotto's depiction of Enrico kneeling in front of the Virgin, to whom he offers a model of the chapel, was a way to suggest the reforming spirit that now animated the Scrovegni family.

But besides the intention of the sponsor, of what consisted Giotto's originality? To provide an answer, see the scene from the Arena cycle of paintings—the *Lamentation*.

The body of Christ, which has just been deposed from the cross, lies on the ground surrounded by a crowd of mourning figures displaying their sorrow through the rhetorical expressiveness of a variety of gestures. Among the characters, we recognize a desperate Mary cradling with heartbreaking tenderness the head of her son in her arms. The unknown woman who holds the hands of Christ, and Mary Magdalene, who holds his feet, seem to reflect Mary's attempt to lift up the lifeless body, as if to deny its intolerable sinking toward the

LEFT: Scrovegni offering a model of the chapel to the Virgin Mary

BELOW: Giotto's *Lamentation,* from his Arena cycle of paintings

ground. The barren tree that stands directly opposite Mary on top
of a rock as white as the cold flesh of Christ enhances the winter-like
desolation that appears to have gripped the world, the same desolation
expressed by the frantic movements of little angels openly displaying
their anguish in a blue sky devoid of all the supernatural golden hue
typical of Byzantine art. The grief and disbelief that the figures sur-
rounding Christ so vividly display add a tangible quality to the horror
of death: in Giotto's painting, Christ's sacrifice is portrayed not as a
calm, hieratic, and triumphal moment of glory but as a moment of
brutal finality too big and painful for the human heart to bear.

It is often said that Giotto's views were forged by Saint Francis,
who had preached a closer communion with God. Even if that is true,
the question remains: What would Francis (who addressed death as
"sister" in his famous poem "The Canticle of the Sun") have thought if
he had seen Giotto's frescoes? How would he have judged the lack of
stoic acceptance on the part of Mary, the saints, and even the angels?
Would he have appreciated that immense display of sorrow, or would
he have felt uneasy to see people, who should have been aware of
Christ's divine mission, display such a human kind of despair? We
will never know. All we do know is that human feelings that the early
theologians had dismissed as unworthy of Christian dignity found
here the loving and charitable recognition they were never granted
before. For centuries, beauty had been considered the main attribute
of everything that was holy. Giotto's choice to represent angels, who
had traditionally epitomized the regal beauty of God, in anguished,
contorted positions is in itself an amazing violation of that rule. What
Giotto's art seeks is not elegance, beauty, and order but the rough
directness of an absolutely uncompromised realism—as disarmingly
crude as the wounded vulnerability of Christ's dead body. The desire
for a closer communion with God is certainly present but within an
inverted dynamic that, instead of elevating man to God, seems to
bring God so close to earth as to almost blur the line of division that
for so long had separated humanity from the divine.

DANTE'S SUMMA: THE DIVINE COMEDY

Giotto's innovative spirit was matched, in literature, by Dante Alighieri (1265–1321), a citizen of Florence who had played a very active role in the political life of the city until he was exiled in 1302, when the party that he opposed came to power. For a long time, the two main factions, the Ghibellines and the Guelfs, fought within the Italian territories: the first faction wished for the Holy Roman emperor to take control of the Italian domains, while the other, which sided with the pope, wished for Italy's independence from imperial control.

When, in order to curb the influence of the emperor, Pope Boniface VIII appointed Charles of Valois, brother of the king of France, as his vicar in Tuscany, Dante's adversaries were able to seize political control in Florence—a move that caused the exile of the poet, who was never allowed to return to Florence. A good amount of the remaining nineteen years of his life were spent in Verona, which was ruled by Cangrande della Scala, who became Dante's most important patron.

The political experience turned Dante into a harsh critic of popes and bishops, whose greed and corruption violated the apolitical principles of poverty, love, and humility that Christ had preached. Dante was not opposed to the church but rather to the political maneuvering of a papacy that had inappropriately extended its claim on temporal matters that, for the poet, were solely the competence of the emperor. According to Dante, church and state had equal but different powers: the first was spiritual, the second one secular. Dante's approval of the politics of the Holy Roman emperor Henry VII of Luxembourg, who tried to regain control of the Italian territories, reveals the poet's nostalgic belief that only by re-creating a single empire, like that of Charlemagne, would a long-lasting peace finally occur.

Dante's *Divine Comedy* (the adjective "divine" was added to the title by Boccaccio) is often defined as a summa of everything that Christianity had produced in more than a thousand years. The definition is

pertinent when we consider the vast breadth of knowledge that Dante shows to possess, not only in theology but also in philosophy, rhetoric, politics, ethics, and literature. In Dante's time, almost all poetry was written in Latin—the only language considered noble enough to be the voice of authority and culture. In selecting the vernacular for his own poetry, Dante was influenced by the tradition of courtly love, as developed by the troubadours in France, the Sicilian school, and the Tuscan tradition known as the *Dolce Stil Novo* (among the most important representatives of this latter style, Guido Guinizzalli, Cino da Pistoia, Guido Cavalcanti). Besides wanting to reach a wider audience, the vernacular was chosen by Dante for the great opportunity it gave him to forge a jargon that, unencumbered by the strict rules of Latin, could suit the needs of his poetic inspiration.

The *Divine Comedy* describes Dante's journey in the afterworld. During that journey, Dante (the fictional character who, as a symbol of humanity, undergoes that supreme voyage of spiritual initiation) witnesses the many complexities that characterize human nature: the selfish greediness of some, next to the amazing virtue and generosity of others. What for Dante, in agreement with Saint Thomas, was at the base of those human differences was the most precious and inalienable gift that God had given man: free will.

Following the medieval enthusiasm for numerical symbolism, each of the three canticles of the *Divine Comedy* is divided into thirty-three cantos (the age of Christ when he died), written in terza rima (a three-line scheme that rhymes the second line of a stanza with the first and the third of the next one), which also represented a celebration of the Trinity. In a letter to Cangrande della Scala, Dante explains that a superficial reading of his poem will not suffice because the true spiritual meaning of his *Comedy* is in the depth, not in the surface, of its words. To guide the reader, Dante names increasingly deeper levels of meaning: literal, allegorical, moral, and anagogical.

The first part of the *Divine Comedy,* the *Inferno,* describes hell as a series of descending circles divided by gravity of sin. Each sin is accompanied by a punishment that is an allegorical representation of the offense commited. For example, heretics who lived life buried in

error are placed by Dante in fire-burning sepulchres; violent people who stained their hands with someone else's blood are kept in a pool of boiling blood and constantly pierced by arrows shot by mythical figures called centaurs; those who committed simony (the sale of religious offices) are stuck upside down in a hole while a flame burns the soles of their feet, in a grotesque distortion of the flame of the Holy Spirit on the heads of the apostles that appeared during Pentecost.

The vast array of characters that Dante presents in his journey includes many of his contemporaries. In the circle where those who committed simony are punished, Dante encounters Pope Nicholas III, who, with a sarcastic pleasure, announces the imminent arrival of other important sinners, like Pope Boniface VIII, still active and alive at the time Dante was writing, and Clement V.

Dante imagines hell as an immense, canyon-like hole formed when Lucifer, falling from paradise, plunged into the earth with the force of a crashing meteor. The displaced earth that the impact created formed the mountain of purgatory. The configuration of purgatory, which is almost entirely Dante's invention, is represented by a mountain layered by nine spiraling terraces where the purging souls sing and pray in hopeful expectation of their future salvation. On the top of the mountain stands the earthly paradise, where Dante is first reunited with his beloved Beatrice.

Paradise includes nine heavens. The division is based on the Ptolemaic view of seven rotating planets (with the earth in the middle), with which the medieval tradition associated the four cardinal virtues of Prudence, Fortitude, Justice, and Temperance (which Christianity directly adopted from the classical heritage) and the three theological ones of Faith, Hope, and Charity. At the very top, Dante places the primum mobile and the empyrean, which the author depicts as the seat of God. To describe the various angels inhabiting the celestial kingdom, Dante relied on the mystic of the fifth-century Pseudo-Dionysius the Areopagite, who, in his *Celestial Hierarchy,* described with great precision the order in which the celestial court was organized.

The *Divine Comedy* opens with Dante lost in a dark wood. The only comfort for the terrified traveler is the faraway glow that appears

behind the summit of a high and distant mountain. The symbolism
of Christ that the rising sun symbolically represents is used by Dante
to anticipate the moral quality at the heart of his epic: the quest of
a soul, lost in the dark and confusing maze of the material reality,
trying to find its way back to God's realm of light, order, and truth.

The Roman poet Virgil, who suddenly appears, tells Dante that he
has come to redirect toward the right way (*"retta via"*) the true course
of his life that mundane concerns had led astray. To Dante's surprise,
Virgil explains that his presence is the result of a celestial intervention
that, from the Virgin Mary to Saint Lucy, directly involves Beatrice,
the angelic woman whom Dante met and fell in love with when he
was still a very young boy. The story of Dante's love for Beatrice was
told by the poet in an earlier book, titled the *Vita nuova* (The new
life)—a book that fully reflected the characteristics of the Platonic
passion made popular in the *Dolce Stil Novo,* the Italian version of
courtly love poetry. Dante, who saw Beatrice for the first time in a
church when she was eight and he was nine, became immediately
enthralled by her beauty and purity. Nine years later, when he saw
her again, Beatrice was already married to another man. In the years
that followed, Dante enjoyed only few fleeting glimpses of her in the
streets of Florence—not much, but enough to inflame, each time with
more ardor, the love of her hopelessly passionate and faithful admirer.
When Beatrice prematurely died, the despondent poet concluded the
Vita nuova, announcing that he would say of her what no other man
had ever said of a woman before.

That promise is realized by the composition of the *Divine Comedy:*
a poem in which Beatrice (literally "she who delivers beatitude") is
transformed into a poetic heavenly presence that, as Dante claims,
is wholly infused with the Grace of God. In making Beatrice an
instrument of salvation, Dante intends to greatly surpass the formal
gentility of courtly and chivalric poetry. In making Beatrice the per-
sonification of theology, Dante attributes to the beloved the redemp-
tive quality that, in Neoplatonic fashion, transforms human love into
the superior Love of God.

But that awesome process of Love initiation involves many stages,

and Dante has to experience them all before being able to reach the promised land of God. Virgil, who guides Dante in the first phase of the journey, is the allegorical representation of reason and the creator of the highest expression of pagan literature before the advent of Christianity. For Dante, as for all his contemporaries, Virgil was the poet who had prophesied the birth of Christ in his *Eclogue 4* and, in so doing, had foreseen the work that Providence had established in order to bring the secular ascent of Rome to a final convergence with the triumph of Christianity. As the critic Erich Auerbach wrote, "In Dante's eyes the historical Virgil is both poet and guide. He is a poet and a guide because in the righteous Aeneas' journey to the underworld he prophesies and glorifies universal peace under the Roman Empire, the political order which Dante regards as exemplary, as the *terrena Jerusalem;* and because in his poem the founding of Rome, predestined seat of the secular and spiritual power, is celebrated in the light of its future mission."

In drawing a parallel between his journey and that of Virgil's hero Aeneas into the underworld, Dante implicitly suggests that he considers himself a direct heir to the classical tradition as epitomized by Virgil, the greatest of all pagan authors. The higher status that Dante assigns to the *Divine Comedy* rests on spiritual and religious ground: in spite of his admiration for the author of the *Aeneid,* Dante claims to be superior to his pagan precursor because his work represents a morally inspired elevation of speech and reason to truths unreachable to a non-Christian poet like Virgil.

For that reason, even if he shows tremendous respect for the pagan author whom he sees as a forerunner of Christianity, Dante ends up placing Virgil, along with many other great pagan thinkers and writers, in Limbo, where there is no physical torture but also no happiness, because the place is deprived of the joy of divine contemplation.

But how did a secular artist come to feel so free to use religious concepts to enrich his own poetry (like assigning to Beatrice a mediatory role almost equivalent to Christ), and how could he claim to possess the same prophetic virtues traditionally attributed to biblical figures or to saints? Answers to these questions can be found only by

taking into consideration the historical context in which Dante lived, when the reputation of the church, seriously damaged by its corrupt clergy, had lost much of its authority in moral matters and in matters relating to what artists could or could not do in their creative works. Additionally, Dante was able to invent such a daring work because, much like Giotto in the Arena Chapel, he was sponsored not by the church but by a secular authority, specifically that of Cangrande della Scala, prince of Verona.

But a church less vigilant as an enforcer of morality did not mean a loosening of the theological rigor among people of faith. Dante was profoundly conscious of that responsibility: even if he dared to attribute to himself a role that was closer to a prophet than a poet, the fear that the immense poetic scope he was pursuing could in some way offend God always haunted his mind. The famous canto 26 of the *Inferno,* where the poet describes his encounter with Ulysses, offers a powerful argument for the moral justification that Dante provides on behalf of the innovative use of his poetry. Ulysses, whom Dante places in the circle of the "bad advisors," recalls the last journey he undertook when he encouraged his men to push their quest westward beyond the Pillars of Hercules (the Strait of Gibraltar), which were considered in medieval times the ultimate barrier before the unknown world. The price that Dante has Ulysses pay for his daring adventure is enormous: as soon as he and his men violated that forbidden boundary, a powerful storm engulfed the explorers and pushed their boat down into the abyss.

In Homer's story, Ulysses is a man of integrity and reason who successfully completes his journey by returning home to Ithaca, where, having killed the usurpers, he resumes his rightful position as king next to his beloved wife, Penelope. Completely changing the old myth, Dante turns Ulysses into a sort of modern navigator (someone akin to the Venetian traveler Marco Polo, who reached China in 1271) willing to trespass all forbidden limits for the sake of human advancement and knowledge. The words that Ulysses utters to instill in his companions the courage and curiosity needed to push their quest forward are powerful and unforgettable:

Consider well the seed that gave you birth:
you were not made to live your lives as brutes,
but to be followers of worth and knowledge.

(*INFERNO* 26.118–20)

Ulysses's words profoundly resonate because they are equally fit-
ting for Dante's own daring journey. Ulysses, the famous Argentine
writer Jorge Luis Borges noted, "is a mirror of Dante, because Dante
felt that perhaps he too deserved this punishment." The reason is that
writing such a detailed account of the afterworld necessarily implied
a transgression of divine secrets that was similar to the sin commit-
ted by Adam. (It is not a coincidence that canto 26 of the *Inferno*
finds its counterpart in canto 26 of *Paradiso,* where Dante encounters
Adam.) To give legitimacy to his journey, Dante contrasts his experi-
ence with that of Ulysses, claiming that, unlike the classical hero who
just relied on himself to push forward his exploration, his mission is
led by the higher force of divine inspiration.

In contrast with Ulysses's horizontal and earthbound adventure,
Dante's quest follows a vertical trajectory that, instead of attempting
to encompass reality through reason, chooses to follow the inspira-
tion provided by divine Love, leaving untouched the mystery of God's
ultimate essence.

The thought is expressed in *Purgatorio* 24.52–54:

I am one who, when Love breathes
in me, takes note; what he, within, dictates,
I, in that way, without, would speak and shape.

As in many medieval depictions of prophets and saints, who are
seen writing under the dictation of the Holy Ghost, often represented
as a dove whispering in their ear, Dante affirms that his poetry owes
its ultimate truth to the voice of the divine Love that has infused a
whole new strength into the verbal seeds of his poetical words. The
challenge is extended to the reader: the poet, who is possessed by

the dictates of God, offers his audience a narrative that, much more than a passive reception, requires on the part of the reader the same arduous task of cathartic transformation to which the poet is being subjected.

> O you who are within your little bark,
> eager to listen, following behind
> my ship that, singing, crosses to deep seas,
> turn back to see your shores again: do not
> attempt to sail the seas I sail; you may
> by losing sight of me, be left astray.
>
> (PARADISO 2.1–6)

The readers who will be able to proceed on the journey proposed by the *Divine Comedy,* Dante forewarns, are only those willing to fully share the experience described in the poem. Like all sacred writings, the *Comedy,* Dante suggests, is a perilous adventure demanding full involvement on the part of the reader.

Dante's words recall the basic Plotinian principle we discussed in part 3: "Only like can know like." The statement can be paraphrased as follows: illumination is a gift that only belongs to those who are willing to transform the self in conformity with the will of God.

The theme of the journey, which holds such an important place in the *Comedy,* derived from Judaism, as well as from the Aristotelian theory, elaborated by Thomas Aquinas, that described life as a dynamic process of *becoming* aimed at bringing to realization the talents and virtues inherent in the human personality.

Accordingly, within Dante's Christian universe, the greatest offense toward God is represented by the lack of spiritual progression on the part of those who refuse to change. That is why, at the very bottom of the inferno, Dante places the image of an enormous Satan: a three-headed monster who, by slowly flapping his bat-like wings, produces a freezing wind that turns into ice the water that surrounds him. Trapped within that ice, the traitors, who reside in the deepest

abyss of hell, mimic in their frozen condition the greatest sin of all: the spiritual death caused by the absolute stasis of a cold, hardened, and emotionally immobile heart.

For Dante, the epitome of the three main traitors, who are chewed in Satan's horrible mouths, are Judas, who betrayed Christ, and Brutus and Cassius, who betrayed Caesar. The image is a reminder of Dante's strong belief in the equal importance of church and state. Those whose actions put at risk the fundamental pillars of human existence are, for Dante, the greatest sinners because they tried to impede the progress of human history as it advanced secularly and religiously toward the Christian ideal of a world universally united in goodness, justice, and peace.

Purgatory, which follows hell, is a place where the souls purge themselves in order to become worthy of the kingdom of God. The sins that Dante presents along the terraces of purgatory, whose scale of sinfulness decreases as the ascent progresses, are once again accompanied by punishments that mirror the transgressions committed. Those who sinned for excess of pride, for example, have to carry enormous rocks that keep their heads bent down, while those who had been envious of others have their eyelids sewn with iron wire. As an intermediary kingdom, purgatory is the place where Dante meets the greatest amount of poets, of past and present ages, who had influenced and inspired his own work (the Roman poet Statius, the troubadours Sordello and Arnaut Daniel, the Italian Bonagiunta degli Orbicciani, and Guido Guinizzelli, founder of the *Dolce Stil Novo*). Even if he praises the contribution of these authors, Dante makes sure to point out that their poetry fell short of true glory because it is deprived of the light of faith that instead guides his own poetic achievement.

To balance such a self-congratulatory tone, Dante, especially in *Paradiso,* makes sure to remind the reader that when it comes to God's ultimate truth, human memory and language are bound to remain insufficient. The critic Joan M. Ferrante clarifies the poet's strategic intent this way: "In the *Paradiso,* Dante attempts to achieve the impossible. He describes an experience which occurred and which remains

beyond the scope of human language. Protesting all the while that not even the memory, let alone speech, can retain or recapture what he has seen, Dante conveys the essence of his vision by stretching his medium to its limits, by using words that do not exist, images that contradict each other, by distorting sequential and logical order, and by ignoring the boundaries of separate languages. He draws on the complex nature of his subject to furnish the style as well as the structure of his description: his language and imagery reflect the essence of the divine."

The inventiveness that Dante displays in describing the total otherness of the realm of God makes *Paradiso* the most impressive canto of the *Comedy* and the single best poetic testimony to the beauty of medieval mysticism.

Just before beginning his ascent to paradise, Dante recalls the myth of the satyr Marsyas, who was so confident of the music he produced by playing his flute that he dared to challenge Apollo, with his lyre, to a musical contest. As punishment for the sin of hubris that made him think that he could surpass the god, Marsyas was tied by Apollo to a tree and flayed alive. To avoid Marsyas's transgression, Dante promptly declares the impotence of his poetic words, which, he says, would remain insignificant without the help of Apollo's life-giving breath. In invoking Apollo—the sun god that Christianity adopted as a symbol of Christ—the poet declares his willingness to become the exact opposite of Marsyas: a poet ready to abandon all arrogant and egotistical claims in order to become a docile and passive instrument in the hands of God:

> O good Apollo, for this final task
> make me the vessel of your excellence
> what you, to merit your loved laurel, ask.
> .
> Enter into my breast; within me breathe
> the very power you made manifest
> when you drew Marsyas out from his limbs' sheath.
>
> (*PARADISO* 1.13–15, 19–21)

As Virgil was Dante's guide in the inferno and part of purgatory, Beatrice is the character who leads Dante in the higher realm of the terrestrial and then celestial paradise. In hell, the material consistency of the body was described by Dante in a very concrete and organic manner. Things change in paradise, a dematerialized realm that Dante describes as a dimension completely devoid of any earth-related gravitational pull. To express that odd condition, Dante says that his body, having lost all weight, is able to swiftly rise upward and glide through the heavens in the company of Beatrice.

Among the most important characteristics that Dante attributes to paradise are order, harmony, and light in contrast to the violent disunity he witnessed in the dark kingdom of hell. To express the concept, Dante comes up with all sorts of fantastic solutions, like having the blessed, who have overcome the need for language, convey their message through a choral display of music and dance.

When he gets close to the peak of paradise, the celestial music suddenly ceases, leaving the pilgrim-poet surrounded by total silence. When he asks what happened, Beatrice replies that the angels have stopped their singing because the intensity of their voices would have been too overwhelming for Dante's terrestrial capacity to bear. Paradise is imagined as a superior realm where the blessed appear endowed with a supernatural degree of intellectual and sensory faculties. To be able to ascend, Dante has to be empowered by Grace—an energy that is infused in him by the mediatory intervention of Beatrice.

Notwithstanding the privilege he is accorded, Dante makes sure to constantly reiterate the humble sense of impotence that, next to the immeasurable mystery of God, his verbal and mental capacity experience:

> The glory of the One who moves all things
> permeates the universe and glows
> in one part more and in another less.
> I was within the heaven that receives
> more of His light; and I saw things that he
> who from that height descends, forgets or can

not speak; for nearing its desired end,
our intellect sinks into an abyss
so deep that memory fails to follow it.

(*PARADISO* I.I–9)

As we have seen in the visual arts, the quality that for the Christians best represented the mystical reality of God was light. In perfect agreement with that view, Dante writes that as he ascends, he sees the beauty of Beatrice increase, in the fashion of a mirror reflecting in greater and greater degrees of perfection the sunlight of God.

In the empyrean, the highest point of paradise, Dante's sensory capacities are overwhelmed by what appears to be a flowing river of light. To strengthen his capacity, Dante is encouraged by Beatrice to undergo a sort of visual baptism that consists in submerging his eyes into that stream of light. Dante obeys by, he says, drinking the light through his eyes. With his extraordinary talent for special effect, Dante uses that paradoxical association to express the miraculous empowerment that he receives when illuminated by the supernatural effects of Grace.

Beatrice comments on his experience with these words:

we now have reached the heaven of pure light,
light of the intellect, light filled with love,
love of true good, love filled with happiness,
a happiness surpassing every sweetness.

(*PARADISO* 30.39–42)

In the empyrean, intellectual brilliance coincides with the sweet joy of those who shine in eternity filled with the Love and Light of God.

The high vision that Dante has been granted finds a visual realization in the sudden transformation of the river of light into a splendid rose made of a great number of petals containing the souls of the blessed. It is at that point that Beatrice leaves Dante to return to her assigned place within that celestial rose.

On the very last leg of the journey, Dante is met by his third

guide: the mystic Saint Bernard. Before proceeding, Saint Bernard addresses a prayer to the Virgin Mary to ask for help and assistance in order to reach the final vision of God. That final vision is described by Dante with these words:

> What little I recall is to be told,
> from this point on, in words more weak than those
> of one whose infant tongue still bathes the breast.
>
> .
>
> How incomplete is speech, how weak, when set
> against my thought! And this, to what I saw
> is such—to call it little is too much.
> Eternal Light, You only dwell within
> Yourself, and only You know You; Self-knowing,
> Self-known, You love and smile upon Yourself!
> That circle—which, begotten so, appeared
> in You as light reflected—when my eyes
> had watched it with attention for some time,
> within itself and colored like itself,
> to me seemed painted with our effigy,
> so that my sight was set on it completely.
> As the geometer intently seeks
> to square the circle, but he cannot reach,
> through thought on thought, the principle he needs,
> so I searched that strange sight: I wished to see
> the way in which our human effigy
> suited the circle and found place in it—
> and my own wings were far too weak for that.
>
> (PARADISO 33.106–8, 121–39)

It is often mistakenly said that at the very end of the *Divine Comedy* Dante gains a direct vision of God. That's not exactly true. Perfectly adhering to Christian dogma, what the traveler claims to see at the end of his spiritual journey is not God the Father but the image of Christ looking at man (the universal "man" that Dante symbolically

represents) as if through a "mirror." The image directly evokes Paul's metaphor: for the Christian pilgrim, the ultimate illumination occurs when he finally sees and recognizes, through Christ (the Mirror and Mediator), the double essence of his own human/divine nature. Dante's vision echoes Plotinus, who said: "When the soul begins to mount it comes not to something alien, but to its real self."

Salvation occurs, Dante concludes, when man, through the experience of Love, reacquires the spiritual purity of his celestial, original self, as expressed by Christ, the second Adam. As for Paul, the apex of Dante's metaphysical journey consists of the final overlapping of seeing and being seen: the miraculous merging of man's finitude with God's infinite mystery.

In human terms, that mystery is bound to remain unsolvable, just like the geometric impossibility, evoked by Dante, of the squaring of the circle—the mystery of fitting the finitude of man (as represented by the square) within the infinity of God (as represented by the circle). Paradoxically, we can say that Dante reaches his goal precisely because, unlike Ulysses, he ends up accepting the inevitable shipwreck of all rational argumentations and all verbal discourses.

The *Divine Comedy* closes with the disappearance of the miraculous vision and Dante's return to his worldly dimension, consoled by awareness that the universe is filled with the Love of God—a Love that, just like an immensely powerful spark of physical energy, gives motion to the "sun and other stars."

> Here force failed my high fantasy; but my
> desire and will were moved already—like
> a wheel revolving uniformly—by
> the Love that moves the sun and other stars.
>
> (PARADISO 33.142–45)

The doctrinal consistency that Dante maintains throughout the *Divine Comedy* shows a solid respect for the spiritual and moral rules of Christianity. Except in this aspect: even if Dante keeps humbly denouncing the deficiencies of his art vis-à-vis the greatness of God,

the fact that he attributes to himself a role that is prophetic and biblical reveals that what the poet is seeking is not just the bliss of spiritual salvation but also the very concrete dream of everlasting fame.

The self-confidence that Dante the artist reveals places him at a pivotal crossroad—the sunset of the Middle Ages and the dawn of the Renaissance.

HUMANISM
AND THE RENAISSANCE

THE FOURTEENTH
AND FIFTEENTH CENTURIES:
THE HISTORICAL CONTEXT

The intermittent series of conflicts that England and France engaged in from 1337 to 1453 is known as the Hundred Years' War. The conflict was sparked by the death of the last king of the French Capetian dynasty, Charles IV, who left no male children and therefore no direct heir to the throne. The closest relative with right of succession was the son of his sister: the fifteen-year-old king of England, Edward III. Alarmed by the prospect that an Englishman could become their master, the French nobility elected as ruler King Philip VI of the Valois dynasty. Edward III promptly opposed the decision, but when the French threatened him with the confiscation of English holdings in the southern part of France (what remained of the vast fief that the English had acquired in the twelfth century, through Eleanor of Aquitaine), Edward III was forced to back down and reluctantly recognize Philip VI as the new king of France.

Tensions reemerged when Philip VI, taking advantage of the war between England and Scotland, moved to take hold of the English possessions in southern France and also gain control of Flanders (present-day Belgium). In the end, disappointed England lost its French fief and was unable to annex Scotland to its domain. France's success in regaining its territorial unity was curbed by its failed campaign against Flanders, which maintained its independence. Flanders's prosperity greatly increased with the English conquest of Calais in 1347, which allowed a collaborative trade between the two countries: England shipped wool to Flanders, where it was processed into fine cloth

that was then turned into highly profitable merchandise. (The women who spun the wool into yarns were called "spinsters." The term came to be associated with unmarried women who had to work because they did not have husbands who could provide for them.)

As the countries of Europe were beginning to stabilize their boundaries and political identities, and also develop more competent secular institutions, a collision with the church became inevitable. A significant moment occurred at the beginning of the fourteenth century when the king of France, Philip IV, imposed heavy taxes on all French citizens, clergy included. The pope, who at that time was Boniface VIII, angrily protested, saying that members of the church could not be taxed without papal approval. To retaliate against the pope, Philip IV blocked all monetary contributions to the Roman papacy. The jubilee of 1300, which was proclaimed by Boniface VIII, was in great part prompted by the need to compensate, with the contributions provided by the pilgrims who flocked to Rome, for the considerable loss of money that the church suffered from its feud with France.*

The tremendous success of the jubilee, which saw the arrival in Rome of 200,000 pilgrims, was linked to the pope's promise that all those who made the pilgrimage to the sacred city would have their sins forgiven.

The quarrel between Boniface VIII and Philip IV reached a dramatic climax when the French king, rejecting the idea that the clergy was to be considered immune from secular law, allowed his courts to put on trial and imprison a French bishop. In response, Boniface VIII excommunicated the French king and promulgated the papal bull (or decree) *Unam sanctam* (1302), in which, with extravagant imperiousness, he proclaimed the absolute temporal and spiritual supremacy of the pope over all human beings, kings included. "Every human creature is subject to the Roman Pontiff," he stated with finality.

* Initially, jubilees were set to take place at the beginning of every new century. However, because of the economical advantages they offered, the time between jubilees was soon shortened to fifty years and then to twenty-five.

In reaction to that extreme statement, the exasperated king of France attacked the pope with a scathing list of accusations, which included simony, heresy, and immorality. Subsequently, he dispatched to Anagni, in central Italy, where the pope resided, a group of royal emissaries who arrested Boniface and threw him in prison. After three days with no food or water, the pope was finally released. But the humiliating experience proved too harsh for a man close to seventy. Boniface VIII never recovered and died shortly after. The brief pontificate of Benedict XI was followed by a clash between Italian and French cardinals fighting for the election of their own candidate. Eventually, the French cardinals prevailed, and Clement V was elected pope in 1305. Because he feared a vendetta on the part of the Roman aristocracy, Clement V decided to transfer the papal Curia to Avignon, in the southeastern part of France.

The sixty-seven years in which the papacy resided in Avignon is known as the Babylonian captivity. As described in the Old Testament, the exile of the Jews in Babylon had earned the city a very negative reputation as a hotbed of depravity and sin. In Apocalypse, that reputation was revived once again to describe Rome as the "mother of harlots and abominations of the earth." When the Curia left Rome, the appellation was repurposed to criticize the worldliness of the huge and luxurious court of Avignon, where the popes enjoyed a princely existence surrounded by a multitude of assistants and servants paid with the money collected from ecclesiastical taxation. After visiting Avignon, a Spanish prelate wrote, "Whenever I entered the chambers of the ecclesiastics of the papal court, I found brokers and clergy engaged in weighing and reckoning the money that lay in heaps before them. . . . Wolves are in control of the Church, and feed on the blood of the Christian flock." The biting rhetoric and scathing words that the fourteenth-century Italian poet Petrarch employed to criticize the church's betrayal of its apostolic origin went even further. The church, Petrarch wrote, is

the impious Babylon, the hell on earth, the sink of vice, the sewer of the world. There is in it neither faith nor charity nor

religion nor the fear of God. . . . All the filth and wickedness of the world have run together here. . . . Old men plunge hot and headlong into the arms of Venus; forgetting their age, dignity, and powers, they rush into every shame, as if all their glory consisted not in the cross of Christ but in feasting, drunkenness, and un-chastity. . . . Fornication, incest, rape, adultery are the lascivious delights of the pontifical games.

It took the supplicant appeals of people like Saint Catherine of Siena (1347–1380) to finally persuade Gregory XI to bring the papal Curia back to Rome in 1377. But it was not a smooth transition: after the death of Gregory XI, the clash of interests between French and Italian cardinals caused the election of a pope in Rome and a so-called antipope in Avignon. At one point the rift, which is known as the Great Schism, produced as many as three popes, each denouncing as invalid the appointment of the others.

Among the widespread criticism that the monarchical attitude of the church generated were many popular tales full of mockery toward the pope and the clergy. Authors such as Giovanni Boccaccio (1313–1375) and Geoffrey Chaucer (ca. 1340–1400) vividly captured in the *Decameron* and the *Canterbury Tales* the intensity of the anticlerical feelings that dominated the times. Among the amusing stories that Boccaccio wrote in his *Decameron* is the tale of a Jew by the name of Abraham. After having traveled to Rome, Abraham tells a friend that he found that the church dignitaries were "gluttons, winebibbers, and drunkards without exception, and that next to their lust they would rather attend to their bellies than to anything else, as though they were a pack of animals." That terrible realization, Abraham concludes, firmly persuaded him to convert to Christianity. In response to the utter surprise of his friend, Abraham explains that the simple fact that Christianity has been able to survive despite all attempts of church dignitaries to destroy its reputation appears to him as a definite proof that it is a powerful religion with a mighty Holy Ghost as "foundation and support."

The greatest threat that confronted the church in the fourteenth

century came from dissident movements that, offended by the corrupted behavior of the papacy, preached a humble and apostolic faith based on an intimate relation with God that did not require the mediating intervention of the ecclesiastical hierarchy. Among those movements, the two most influential were the one inspired by John Wycliffe (ca. 1320–1384) in England and the one led by Jan Hus (1369–1415) in Bohemia. Both men and their respective followers, the Lollards in England and the Hussites in Bohemia, took a firm position against the infractions committed by the church: the selling of indulgences, the laxity of clerics, and the papal meddling in secular and political affairs. Wycliffe rejected the pope's claim that he was the vicar of God, arguing that the papal institution had been established by man, not God, and that the teaching of the Bible could be directly acquired without the intermediary help of priests. For that reason, he translated the Bible into English. After his death, the ecclesiastical authorities, concerned with his influence, condemned to destruction all the copies of Wycliffe's Bible. The flames that destroyed piles of books also incinerated many people accused by the church of being heretics. Hus, who did not hesitate to publicly condemn the church for its moral depravity, its political ambition, and its indifference toward the needs of the poor, was accused of heresy. By condemning Hus to death and burning him at the stake, the church turned the Bohemian preacher into a hero and martyr with much greater influence in death than in life.

In 1347, the bubonic plague, also known as the Black Death, appeared in the West, carried by ships coming from the East. In only five years, twenty-five million people perished, one-third the overall population of Europe. The psychological scar left by the devastating epidemic caused the spreading of superstition, magic, and witchcraft, as well as the fanatical excesses of the flagellants who publicly whipped themselves as a way to expiate the sins that, they believed, had induced God to punish the world. Conspiracy theories were also fast to spread. As usual, the first to be accused were the Jews, who were charged with poisoning the water supplies in order to kill all Christians.

Yet, like a fire whose destruction ends up regenerating the soil, the dramatic loss of population that the plague caused ultimately benefited those who survived: the shortage of food that Europe had experienced the preceding century, due to the sharp increase in population, coupled with several years of adverse climate conditions, ceased to be a concern after the plague, while the diminished availability of people resulted in more job opportunities for a new generation of workers. As the demand for manpower grew, so did the leverage of a working class that now felt entitled to fight for better living conditions and wages. Class-based insurrections, such as the Jacquerie that occurred in France in 1358, the Peasants' Revolt in England in 1381, and the revolt of the Ciompi or wool carders in Florence in 1378, were symptomatic of that gigantic shift in the attitudes and expectations of commoners and, in general, those belonging to the lower, working class. The cry for justice with which the poor confronted the abuses of the rich directly appealed to the values of Christianity that the English peasants, revolting in 1381, framed with these powerful words: "We are made men in the likeness of Christ, but you treat us like savage beasts."

The events described above show that the fourteenth and fifteenth centuries were certainly very turbulent times in the history of Europe. Yet despite the many setbacks, Europe had begun to undertake a course destined to provide significant improvements in the general well-being of all people.

<p style="text-align:center">✳</p>

THE ITALIAN CITY-STATES

After the eleventh-century emergence of the powerful maritime republics of Amalfi, Pisa, Genoa, and Venice, the Italian cities that began to experience a greater cultural development were those that, although nominally part of the German Empire, had been able to resist imperial and feudal control to become self-sufficient centers of

industry and commerce. With the exception of Flanders and the Hanseatic towns, in northern Europe, the prosperity that those Italian cities enjoyed had no equal in the rest of Europe. That prosperity also rested on a wide range of accounting and banking techniques developed by Italian financiers, such as insurance contracts, credit, and double-entry bookkeeping. Lombard Street, in the financial district of London, owes its name to the Italian moneylenders who settled there in the thirteenth century.

The civic pride that the commercial middle class enjoyed, due to such successes, became one of the most prominent characteristics of those Italian municipalities, which were called communes because their government was based on the collaboration of assemblies formed by the representatives of the major guilds or trade unions, without any external interference from imperial and clerical control.*

The freedom and independence that characterized those self-governing cities found an obvious comparison with the Greek city-states and especially the Roman Republic. In his book *History of the Florentine People,* the historian Leonardo Bruni (ca. 1370–1444) used classical references to law, order, and civic devotion to affirm that Florence was a place of justice where merit, rather than privilege, determined social status and where all citizens had an equal say in the management of the state. Contemporary scholars warn us not to take those optimistic claims too literally: in the Florentine Republic, as in the other Italian city-states, participation in government was limited to the members of the wealthy guilds to the exclusion of the less affluent citizens. In that sense, writes the historian John Larner,

* The guilds, which emerged with the urban development of the high Middle Ages, were craft associations created to protect and regulate trade. Every craft had its own guild, and each guild had its own system of apprenticeship. Members of a guild were connected through a solemn pact of mutual protection and respect. The high standards of civility that the members of the guilds maintained among themselves were extended to the city toward which all those involved in trade and business felt profoundly connected. Every guild had a patron saint to whom specific festivals were dedicated.

the equality that the humanists praised was a myth produced by a narrow class that had succeeded in equating its specific interest with the larger, common good. The oligarchic nature of Florence is confirmed by numbers: in a population of approximately 100,000, only 4,000 had the right to vote.

In Florence, the seven major guilds, which constituted the *popolo grasso* (the richest members of society), included Judges and Lawyers, Cloth and Wool Merchants, Doctors, Silk Weavers and Vendors, Furriers, Tanners, and, most important, Bankers. The lesser bourgeoisie, the *popolo minuto,* belonged to the minor guilds of Butchers, Cobblers, Blacksmiths, Locksmiths, Bakers, and Winemakers. The proletariat, which constituted the poorer strata of society, was mainly formed by peasants who had abandoned the countryside with the hope of finding better opportunities in the city but ended up performing the most menial work. What we should remember is that apart from a few interludes, like the Ciompi revolt mentioned earlier, political control in Florence remained firmly in the hands of the richest guilds. As the historian Alison Brown writes, "Apart from a few 'radical interludes,' as [the scholar Philip] Jones calls them, the policies of these communes remained conservative and restrictive, their outlook upper-class, not populist."

The blatant discrepancy that separated reality from that idealistic narrative didn't dim the citizens' civic and political pride, as also shown by the many references to Roman architectural style with which they filled their urban environment. In his *History of the Florentine People,* Bruni, in a way that was evocative of Greek and Roman writers, asserted that the beauty of Florence revealed the nobility of spirit of its citizens.

In the past, the only structure that had dominated the landscape of the city was the cathedral. The relevance that grand and austere private buildings were now given, as well as the imposing presence of public town halls, reveals the enormous importance that the secular world had gained vis-à-vis the church. In Florence, the commanding presence of the massive Palazzo Vecchio was further enhanced by the nearby Loggia dei Lanzi: an open space framed by three wide arches

topped by Corinthian capitals decorated by Agnolo Gaddi's allegorical representation of the four cardinal virtues: Fortitude, Temperance, Justice, and Prudence. The space was built to display the statues whose symbolic meaning best conveyed the political ethos cherished by the city. Today the Loggia dei Lanzi contains masterpieces such as *Perseus* (with the severed head of the Medusa), executed by Benvenuto Cellini between 1545 and 1554, and Giambologna's *Hercules Beating the Centaur Nessus* (1599). In 1353, the first mechanical clock, placed on the tower of the Palazzo Vecchio, secularized the sound of church bells that until that moment had marked the phases of the day. The precise measure that from then on the passing of the hours received gave an efficient but also accelerated quality to time: in a city so committed to business, time became money and as such a precious commodity that could not be wasted.

The paintings that Ambrogio Lorenzetti (1290–1348) was hired to execute in the Palazzo Pubblico (town hall), which was the seat of Siena's republican government, are helpful in understanding the pride that animated the republican spirit of the Italian city-states. Like Florence, the commune of Siena had become a rich economic enterprise: a city led by merchants and artisans who used art to commemorate their achievements and advertise the virtuous quality of their civic engagement. Lorenzetti's four frescoes are an allegorical representation of the positive effects that Good Government had in the city and its surroundings, in contrast with the evil disunity produced by Bad Government (see pages 334–5).

The figure of the old man with a white beard, placed at the center of the first composition, is the allegorical personification of the Commune. Above his head are placed the three main theological virtues, Faith, Hope, and Charity, while at his side are the cardinal virtues of Temperance, Prudence, Fortitude, and Justice with two other figures representing Peace and Magnanimity. The figure on the right of the Commune, sitting on a throne, is Justice. Right below Justice is Concord, which is also the point of departure of a long cord held by a procession of twenty-four citizens (the representatives of the upper guilds that led the city government). The image symbolizes the spirit

The frescoes of Lorenzetti in the Palazzo Pubblico in Siena—allegories of the positive effects of Good Government

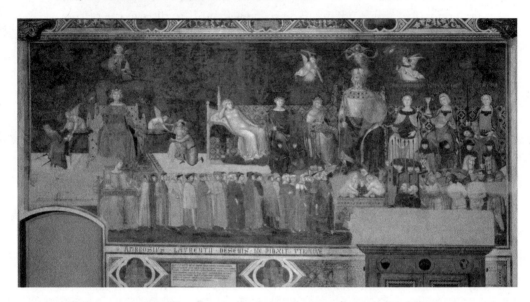

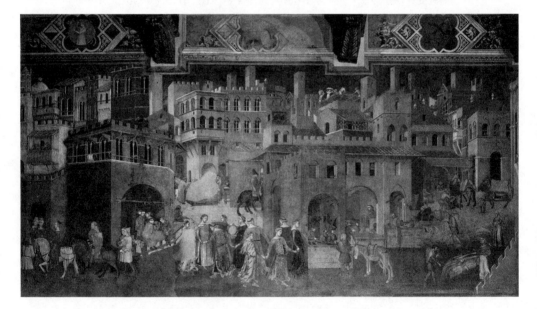

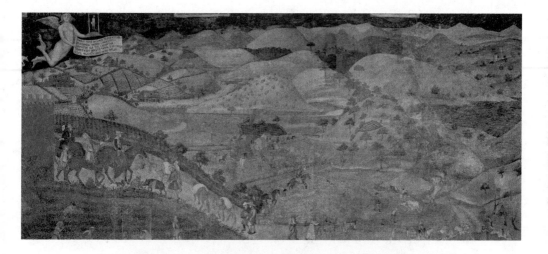

of collaboration that allowed the community to thrive, as shown in
the portrait of the city buzzing with the activity of merchants, arti-
sans, and labor workers. Against a background of imposing palaces,
churches, towers, and shops, a dancing group of young and elegantly
dressed women further enhances the harmony that exudes from that
overall image of cheerful prosperity.

The bird's-eye view of the Tuscan countryside, in the next image,
delivers a similarly positive message: as in the city, Good Government
assured safety and prosperity in the surrounding lands, as shown by
the villas, the castles, and the rich abundance of the plowed fields.
In stark opposition to Good Government, Bad Government is repre-
sented as a dark, satanic monster with horns and fangs accompanied
by Tyranny, Greediness, Ambition, and Vanity.

The image of two little, naked children, placed at the center of
the composition under the personification of the Commune, is a proud
reminder of the Roman origin of Siena. The pedigree was used to
validate the ethical link that connected Siena to the values of ancient
Rome. Religion was not forgotten but rather fused with the concept
of civic virtue that mixed Christian principles with the exemplary
lessons of Rome's heroic past.

A few years after Lorenzetti completed his work, the government
of Siena asked Taddeo di Bartolo (ca. 1362–1422) to paint a cycle
of frescoes, again for the town hall, dedicated to Roman republican
heroes. A central inscription explained with these words the signifi-
cance of those exemplary images: "Take Rome as your example if
you wish to rule a thousand years; follow the common good and not
selfish ends; and give just counsel like these men. If you only remain
united, your power and fame will continue to grow as did that of the
great people of Mars. Having subdued the world, they lost their lib-
erty because they ceased to be united."

Describing Lorenzetti's frescoes, John Larner writes that they are
a "document of singular importance" in that they highlight the con-
trast between past and present: whereas the city of medieval times
was a random maze of tortuous streets and precarious houses, the
commune was exalted as a model of rationality where beauty went

hand in hand with efficiency and functionality. The need to trumpet, in such a forceful way, that greatness of the commune reflected the pride of an emerging bourgeoisie, which for centuries had been dismissed with contempt by the landed nobility as ignorant and vulgar nouveaux riches. The prejudice was reinforced by the church, which claimed that the pursuit of wealth was a corrupting practice because it encouraged self-promotion and the excessive attachment to luxury and riches. In contrast with that view, what the merchants who led the government of the commune were eager to convey was that their rule produced not simply wealth but also progress, peace, collaboration, justice, beauty, and civilization.

But the blissful atmosphere of communal happiness celebrated in Lorenzetti's paintings didn't fully reflect the actual events of history: with constant infighting among competing wealthy families and rivalries with neighboring powers, the city-states were perennially rocked by tremors that were as constant and unpredictable as the moods of a live volcano. In that sense, more than altruism and cooperation what prevailed in the Italian city-states was ambition and competition—the passionate desire to surpass and outshine all competing rivals in the quest for money, power, fame, and recognition. Contrary to the feudal Middle Ages, which were all about the solid immobility of authority and tradition, humanism and the Renaissance were all about the forward dynamic of an entrepreneurial and feisty mercantile society.

In time, the tug-of-war between the richest families led to the demise of the communes and the birth of the *signorie,* from *signore,* to indicate that a single ruler was in charge of the city-state. Among those ruling families were the Visconti in Milan, the Gonzaga in Mantua, the Bentivoglio in Bologna, the Montefeltro in Urbino, the Este in Ferrara, the Scaligeri in Verona, and most famously the Medici in Florence. As in previous times, martial activity remained a constant feature of the *signorie,* with bigger cities constantly striving to annex and control smaller ones. Florence, for example, ruled Pisa and Pistoia, Venice Padua and Verona, Milan Pavia and Lodi, and so on. The trait that most persistently seemed to link all those powerful rul-

ers was the tenacity with which they worked at imitating, in manner and style, the snobbish attitudes that had belonged to the landed aristocracy. The enormous amount of art that the Renaissance produced was sponsored by a merchant class eager to use the splendor of the city as a testimony of its own greatness. In pursuit of that purpose, the court of Milan sponsored artists such as Leonardo da Vinci and Bramante, while Mantua boasted Andrea Mantegna, Pietro Perugino, and Correggio, and Florence patronized Donatello, Brunelleschi, Verrocchio, Ghirlandaio, and Botticelli, to mention just a few.

The term "Renaissance," which is based on the French word meaning "rebirth," was first used by the French historian Jules Michelet in 1858. Shortly after, the term was given further popularity by the nineteenth-century Swiss historian Jacob Burckhardt, author of *The Civilization of the Renaissance in Italy*. Burckhardt's claim that the Renaissance was a sudden explosion of talent and creativity after centuries of dull and ignorant darkness was largely influenced by fifteenth- and sixteenth-century authors—people like the philosopher Marsilio Ficino and the painter and author Giorgio Vasari, who in his 1550 book, *Lives of the Most Eminent Painters, Sculptors, and Architects*, described as "golden" the time that Florence was experiencing under the rule of the Medici family. Even if no one can deny the excellence and originality of the many artists whom Vasari's book takes into consideration, to describe their activity as symptomatic of the birth of a new, free, and self-determined man, as Burckhardt and other scholars of his generation suggested, can be deceiving in that it does not take into consideration the fact that what those artists produced was not so much the expression of their free creativity, but the visual translation of what their rich patrons demanded. Furthermore, as many contemporary critics underline, the Renaissance was not a widespread phenomenon but the expression of a small and wealthy elite eager to declare its superiority in relation to an era (the Middle Ages) that they discarded as nothing more than an insignificant parenthesis placed in the middle of two extraordinary times: the classical past and the Renaissance.

In contrast with those views, modern scholars argue that the

Renaissance did not burst out of nothing but was the result of a long process of maturation (which, as we have seen, started in the twelfth century), without which the new era would never have borne its fruits.

Bearing this in mind, we will continue to use the practical term "humanism" to name the first part of the period called the Renaissance, whose overall dates are generally set between 1300 and 1550. As we will see, humanism was characterized by scholars who, following the example set by Petrarch, crisscrossed Europe in search of old manuscripts. From the lesson of the illustrious forebears that those old manuscripts brought to light, the humanists derived new models with which to improve art and also the basic principles concerning politics, ethics, and philosophy. The discussion that follows will focus on (a) the literary quality that humanism assumed under the influence of Petrarch and (b) the change that occurred a generation later, when, with the rediscovery of authors such as Livy and Cicero, writers and intellectuals switched their interest from literature to politics.

PETRARCH'S LITERARY HUMANISM

After Thomas Aquinas, the Scholastic method of learning with its rigorous, logical analysis had slowly exhausted itself by turning into an ever more abstract and arid intellectual exercise. (The common question "How many angels can dance on the head of a pin?" is meant to mock the extremes of Scholastic inquiry.) The cultural revival that followed the waning of Scholasticism was called humanism. The term "humanism" is a nineteenth-century expression used to describe a new generation of scholars who, placing aside the concerns of theology and metaphysics, passionately dedicated themselves to the revival of what Bruni called the *studia humanitatis,* meaning the study of endeavors, specifically human, whose qualities made them valuable for the forward progress of civilization.

The beginning of humanism coincides with the work of two major

Tuscan authors: Giovanni Boccaccio and Francesco Petrarch (1304–1374). Boccaccio's most famous work was the collection of novellas, written in Italian vernacular, called the *Decameron.* The protagonists of the *Decameron* are a group of seven young women and three young men who leave Florence for the countryside when the city is struck by the plague. The stories that they tell during ten days of their sojourn constitute the one hundred tales of the *Decameron.* Boccaccio's tendency to focus on everyday life, his irony, his loose morality, and the witty and irreverent way with which he addresses the church and the clergy show the secularized mentality that the new urban culture had introduced.

After the *Decameron,* the other influential book by Boccaccio is the *Genealogy of the Pagan Gods,* a compendium of pagan mythology that became a rich source of inspiration for writers and visual artists eager to find fresh images and ideas with which to replace the by then stale language of the old Christian devotion.

Petrarch, who is commonly considered the father of humanism, was born in Arezzo in Tuscany in 1304. Compelled by his father, he initially studied law in Montpellier and Bologna. But he soon abandoned those studies to dedicate himself to his literary passion, in particular the study of the classics. Petrarch's father, who was a very traditional man, did not take lightly his son's change of heart. To express his disdain toward pagan culture, he burned many of what he considered his son's "heretical books." Undeterred, Petrarch continued to follow his literary calling for the rest of his life. Most of his literary activity took place in Avignon, where he held different clerical positions at the papal court, and then in the Vaucluse in Provence, where he pursued his work under the patronage of rich sponsors. The echo of the troubadours who had once thrived in Provence is strongly audible in the Neoplatonic celebration of love and beauty that Petrarch expresses in his verses.

Because he was a fervent admirer of the classics, Petrarch traveled all over Europe in search of old manuscripts kept in remote monastic libraries. Cicero's oration called *Pro Archia* and his *Letters to Atticus,* which Petrarch found in Liège, were among his most valuable discov-

eries. Petrarch, who died in Arquà, in the Veneto region, in 1374, left his vast collection of books to the city of Venice.

Petrarch's passion for antiquity was so vivid that he kept up an imaginary conversation with his favorite classical authors—people like Cicero, Virgil, Homer, and Horace—to whom he wrote fictional letters. Petrarch was a devout Christian, but that did not prevent him from criticizing the cultural poverty that, in his view, had dominated the Christian Middle Ages: an age, he claimed, that was responsible for the gross distortion of the classical heritage that the Christians had labeled sinful and dark because not illuminated by the grace of God. Petrarch used the same attribute to condemn as "dark" the Middle Ages, saying that it had been a period dominated by ignorance, prejudice, and superstition. The definition of the Renaissance as a rebirth derived in large part from Petrarch's belief that the cultural achievements that the classical era had bequeathed humanity were a precious reservoir of wisdom that could have helped, rather than hindered, the progression of the Christian world.

Dante had advocated the re-creation of the Holy Roman Empire, with the emperor in charge of temporal matters and the pope of spiritual ones. Petrarch, who lived in an epoch when the ideal of the empire was rapidly declining, sided with Cicero and Livy, who praised instead the virtues of the Roman Republic. To those values Petrarch dedicated his books *Africa* (about Scipio Africanus, the famous Roman general who defeated Hannibal during the Punic War) and *De viris illustribus* (On illustrious men): a book, inspired by Livy, that was an attempt to establish a continuity between pagan and Christian wisdom by pairing exemplary characters equally drawn from ancient history, mythology, and the Old Testament.

Petrarch's fame was so great that in 1340 he was asked to choose between Paris and Rome as his favored setting for a ceremony to award him the title of poet laureate (a recognition comparable to the prestige of today's Nobel Prize). Petrarch, who chose Rome, was crowned on the Capitol, April 8, 1341. On that occasion, he visited the Forum, the Colosseum, and other ancient ruins and lamented the indifference that had allowed such majestic splendor to rot in dirt and neglect. His

hope to revive the ancient *romanitas* made him welcome, a few years later, the rise of a flamboyant character, named Cola di Rienzo, who used a skillful rhetoric to advocate the restoration of Rome's antique glory. Touched by that nostalgic dream, the Roman populace, who just a few years before had seen the papacy move to Avignon, put their trust in that self-proclaimed "tribune of the people" and did not oppose the coup d'état that he staged to take control of the city. For a short period of time, Cola's rule maintained a relative level of stability, but when the delusional promoter of that alleged revolution, theatrically dressed with a white toga trimmed in gold, declared that as a restorer of the Holy Roman Empire he had the authority to free all the Italian cities from their rulers and then become emperor thanks to their support, people understood that they had fallen for a charlatan and chased him out of the city.

Despite his many talents, Petrarch's incapacity to recognize Cola's shortcomings is revealing of his lack of acuity when it came to practical and political matters. Petrarch might have been aware of that: except for his short-lived enthusiasm for Cola, he never got involved in politics, praising instead the value of a solitary life. Petrarch was a moralist who bitterly criticized the corruption and hypocrisy of his times but never questioned his own aristocratic refusal to engage in the political arena nor his opportunistic association with wealthy patrons for purely convenient and self-serving purposes. By his own admission, his greatest concern was his own reputation. He was unapologetic about it: true genius, he believed, deserved recognition and the imperishable glory of eternal fame.

Petrarch was a bundle of contradictions. Like Dante, he was a man torn between the excitement for the new and the fear of change that his time was experiencing. The poet laureate was at his best when, in the *Canzoniere* (Book of songs, also known as *Rime Sparse,* "scattered verses"), as his vernacular collection of poems was called, he acknowledged those fears and hesitations and confessed the doubts that tormented his Christian consciousness. Similar to the tradition of the *Dolce Stil Novo,* from which Dante also had emerged, Petrarch modeled his *Canzoniere* on the Neoplatonic fashion of describing love

as a purely mental exercise: because the woman remains unapproachable, the lover withdraws to contemplate within the image of beauty created by the power of his own imagination. His idealized love object, Laura, who like Beatrice is married to someone else and dies at a very young age, is a symbol of beauty and purity rather than a real woman. The male speaker, who laments her perennial absence, uses that absence as a springboard of poetic inspiration. Petrarch reminds us of that connection by persistently associating the name Laura with the *lauro,* or "laurel": the tree of poetry and eternal fame.

In the first sonnet of the *Canzoniere,* Petrarch directly addresses his audience to affirm that the "scattered verses" they are about to hear represent an "error" of youth: the futile hopes and sorrows of a painful love experience for which the poet desires to receive pity and forgiveness. The beginning of the *Canzoniere* is disconcerting: Why does the poet ask us to listen to his verses if he is the first to reject, as an illusion, the value of his passion and that of his poetry? Rather than providing an answer, the sonnet that follows further confuses the reader's expectations. His first encounter with the beloved, Petrarch says, occurred the day of Christ's death (Good Friday), when the sun withdrew its rays from the world. The darkening of the scene audaciously acknowledges the sinful violation implicit in the amorous experience: the passion that the poet describes in his verses is placed in direct opposition to the all-absorbing devotion that a Christian was expected to pursue. That ambiguous tone is maintained throughout the *Canzoniere:* while a melodious style delivers images of Laura that are as transfixing as heavenly visions, Petrarch continues to remind himself, and the reader, of the danger that the poetic illusion poses to the spiritual clarity required by religious engagement.

Unlike the fictional Beatrice, whom Dante transforms into a celestial vessel of salvation, Petrarch's Laura represents a poetry that, like the laurel she evokes, remains inextricably rooted within the poet's human and secular reality. That does not mean that Petrarch's verses aim at describing a real woman. On the contrary, the image of Laura that Petrarch conjures up from the most delicate aspects of nature (a murmuring brook, a whispering breeze, a perfumed shower of flow-

ers) is an enchanting yet completely ephemeral symbol of beauty that is abstract and poetic rather than tangible and concrete. What fascinated the author of the *Canzoniere* was not an actual woman but the visionary power of his own creative imagination, explored from an angle that was emotional, artistic, and psychological rather than spiritual and religious.

The fact that the idealized image of the woman conveyed by poetry did not necessarily improve the way women were regarded in real life emerges in a letter where Petrarch, writing to a friend, uses these chauvinistic words to describe his feelings toward the opposite sex: "The woman is the embodiment of the devil, the enemy of peace, the cause of impatience, the source of discords and disputes, and man should try to avoid her if he wants to find tranquility in life."

The moral dilemma that in the *Canzoniere* divides the poet's earthly and spiritual concerns is explored by Petrarch in a prose book called the *Secretum,* which is a fictional dialogue between himself and Augustine—the personification of the Christian dogma that Petrarch fears and respects, even when he desperately tries to bend the rigid rules of its dictate to grant a greater legitimacy to his passion and ambition. To convince Augustine that his literary pursuit is not inappropriate, Petrarch says that as a muse of love and poetry Laura has filled his mind with lofty thoughts and virtuous desires. Augustine remains untouched by the poet's argument: as an inflexible judge and a severe alter ego, he tells Petrarch that all those who prove incapable of leaving behind the *cupiditas,* or desire for earthly attachments (beauty, poetry, and fame), fall into error, because nothing besides God is worthy of human interest and attention.

After a long discussion, Petrarch is forced to concede that Augustine is right. The dialogue ends with the poet promising Augustine that he will abandon his illicit pursuit, but not before the completion of his *Canzoniere,* on which he had pinned his hope for eternal fame.

The religious anguish that torments Petrarch is completely medieval, but the stubbornness with which, despite his sense of guilt, he refuses to give up the devotion toward his literary endeavor announces the beginning of a new era in which religion is not so much dismissed

as reshaped into a faith less austere and dogmatic; in other words, a faith capable of accepting man's accomplishments as concordant with rather than antithetical to the values of Christianity.

Petrarch's dedication to the classics shows the unorthodox approach he maintained in regard to culture. Art, for Petrarch, was an expression of freedom and, as such, deserved a respect that was to remain free from prejudiced views dictated by doctrine or ideology. Eugenio Garin writes that Petrarch and his fellow humanists truly "discovered" the classics not just because they brought to light old manuscripts buried in dusty and secluded monasteries but because they learned to appreciate them as unique expressions of singular talents belonging to a specific historical time. Rabanus Maurus, who lived between the ninth and the tenth centuries, had characterized the medieval handling of past knowledge this way: "When we find something useful we convert it to our faith," and when we find "superfluous things, that concern the idols, love or the preoccupation with things of this world, we eliminate them."

In total contrast with the medieval habit of channeling all past accomplishments within the narrow parameters fixed by Christianity, the humanists were the first scholars to teach that the classics had to be appreciated for their own unique merits, free from the shackles imposed upon them by ideology and religion.

Following the moral imperative of rescuing the classics, many humanistic scholars spent years combing all corners of Europe in search of manuscripts "held captive" (to use the expression of the humanist scholar Poggio Bracciolini) in monastic and cathedral libraries. The great number of manuscripts that were assembled, of authors such as Cicero, Tacitus, Seneca, Ovid, Lucretius, and Vitruvius, were used by the humanists to undertake a major work of philological restoration aimed at bringing back the original integrity of the texts. At the core of the humanistic approach was the view that, as in classical time, virtue was to be expressed in action rather than contemplation and that education was essential to assure man's moral and intellectual maturation, without which the stability of society could not be guaranteed.

POLITICAL HUMANISM

After Petrarch, the majority of humanists abandoned the poet's sol-
itary striving toward literary perfection to emphasize matters that
were more specifically related to the civic and political life of the
city-state. Mostly inspired by the rediscovery of Cicero, the creed that
animated this new generation of scholars was that the highest and
noblest way of life was the one placed at the service of the state. This
mental attitude ushered in once again the secular belief that history
was a process shaped and put in motion by human work and aspira-
tions. Aristotle's statement that "he who is not a citizen is not a man"
was at the root of that conviction and with it the corollary belief that
a free state was essential for the realization of man's destiny as prime
agent of civilization.

 To promote the knowledge of the classics, Coluccio Salutati, who
was chancellor of Florence from 1375 to 1406, persuaded the city
government to invite the Byzantine scholar Manuel Chrysoloras to
teach the Greek language in Florence. (Unlike Boccaccio, neither
Dante nor Petrarch could master Greek.) The importance that Salu-
tati and his followers attributed to Greek and Latin culture alike
was based on the belief that the study of ancient authors was neces-
sary to build man's moral character, without which a just and strong
society could not be created. The *studia humanitatis,* which replaced
the medieval emphasis on the trivium and quadrivium, included
rhetoric, eloquence, history, and moral philosophy: in other words,
disciplines that had to do, primarily, with the moral and rational
strengthening of the human personality for the sake of an active and
engaged political existence. In a similar way, the term *artes libera-*
les (liberal arts), which was made complementary to the definition
of *studia humanitatis,* indicated that culture assured the freedom of
the human spirit. Eugenio Garin summarizes with these words the
essence of that new mentality:

The humanistic culture that flourished in the cities of Italy in the fourteenth and fifteenth centuries manifested itself above all in the field of the moral disciplines by means of a new access to ancient authors. It took concrete shape in new educational methods practiced in the schools of grammar and rhetoric. It became a reality in the formation of a new class of administrators of the city-state to whom it offered more refined political techniques. It was used not only in order to compose more efficient official letters but also to formulate programs, to compose treaties and define ideals, to elaborate a conception of life and the meaning of man in society.

Despite the optimism that humanists placed in republican virtues, many communes were short-lived, soon replaced by the *signorie.* Salutati's confidence that as a civically engaged city Florence would have avoided the destiny of other city-states was put to the test during the clash with Milan, which had fallen under the rule of the Visconti family at the end of the thirteenth century. The power that the Visconti gained when they became sole rulers of the city made them similar to monarchs, but the fact that as businesspeople they lacked a proper title was often a source of profound insecurity. For that reason, the Visconti family paid 100,000 florins to the king of France to buy the title of dukes. The same thing was done by the Gonzaga, the ruling family of Mantua, who, having acquired the title of marquises in 1433, sported their right to wear the English royal livery, which featured proudly in an Arthurian fresco cycle they commissioned from the artist Pisanello.

Gian Galeazzo Visconti, who assumed full control of Milan after the brutal murder of his uncle with whom he had initially co-ruled, was an extremely ruthless and ambitious man, determined to extend the Milanese possessions throughout the northern territories of Italy. The official justification for that expansion was that Italy would have benefited by being unified under a single ruler. After conquering Padua, Verona, and Vicenza, Gian Galeazzo turned his

interest toward Bologna and Florence. Fearing an imminent attack, Salutati rallied the patriotic spirit of the Florentines with a powerful speech that denounced the evils of tyranny. As the city, pressed by Salutati, prepared to resist the enemy's attack, news arrived that Gian Galeazzo had suddenly fallen sick and died in 1402. Salutati chose not to diminish the symbolic importance of the moment: by praising the Florentines' courageous determination to defend their liberty, the eloquent chancellor greatly contributed (just as Pericles had done so many centuries before) to the optimistic belief that against the threat of tyranny nothing was more powerful than people's love for freedom and independence.

The historian Leonardo Bruni, who like Salutati was a passionate supporter of the republican system, believed that the example of social and political rectitude provided by Florence represented a universal principle valid for all of humanity. To understand how the humanists considered ideal a society that, in essence, was led by a small oligarchy of rich and influential families, we have to remember how still ingrained was the notion that the universe was a hierarchically ordered system. The metaphor most commonly applied to society was that it was comparable to the human body: a unity of different parts each contributing, in its own specific way, to the overall well-being of the organism. What differentiated the new era from the medieval past was social mobility: whereas in the Middle Ages class status was considered an unalterable trait inherited at birth, those in charge of the republic believed that they had gained access to government through skill, wit, and ingenuity. Discussing the positive effects produced by the republican system, Bruni wrote,

> The hope of winning public honors and ascending is the same for all, provided they possess industry and natural gifts and lead a serious-minded and respected way of life. . . . Whoever has these qualifications is thought to be of sufficiently noble birth to participate in the government of the republic. . . . But now it is marvelous to see how powerful this access to public office, once it is offered to a free people, proves to be in awakening the tal-

ents of the citizens. For where men are given the hope of attaining honor in the state, they take courage and raise themselves to a higher plane; where they are deprived of that hope, they grow idle and lose their strength. Therefore, since such hope and opportunity are held out in our commonwealth, we need not be surprised that talent and industry distinguish themselves in the highest degree.

Bruni's assertion that nobility was not a hereditary trait but an outcome of virtue and that competition within a free society was the best way to assure the blossoming of the human personality formed the core of an ideal that influenced political thinkers for many generations to come. In his *Panegyric of the City of Florence,* Bruni painted this idealized portrait of Florence and its people: "The men of Florence especially enjoy perfect freedom and are the greatest enemies of tyrants. So I believe that from its very founding Florence conceived such hatred for the destroyers of the Roman state and underminers of the Roman Republic that it has never forgotten to this very day. . . . Fired by a desire for freedom, the Florentines adopted their penchant for fighting and their zeal for the republican side, and this attitude has persisted down to the present day."

The notion that civic engagement was a moral imperative that allowed man to express his better self and, in doing so, also favorably sway to his advantage the course of destiny was shared by the humanist Leon Battista Alberti (1404–1472), who epitomized the concept of "Renaissance man": the multitalented and broadly learned individual who also came to be embodied by Leonardo da Vinci (1452–1519). Alberti, who was fond of saying that "men can do all things if they will" and was known for his boundless energy, was a master of archery, an excellent rider, and an intellectual who could juggle with equal ability a conversation about literature, law, linguistics, mathematics, astronomy, music, and geometry. Additionally, he was a great architect—the Tempio Malatestiano in Rimini, the facade of Santa Maria Novella, and the Palazzo Rucellai are among his most famous achievements—and a skilled painter. In his treatise *On the Art*

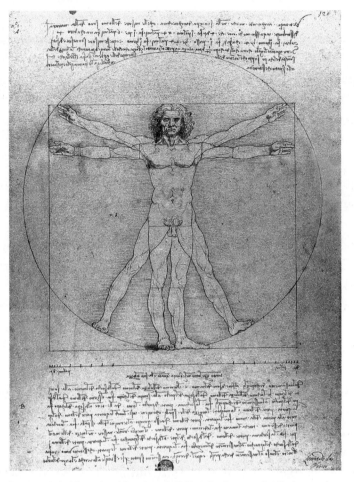

Leonardo's *Vitruvian Man* (ca. 1490)—the human body in
perfect harmony with the cosmos

of Building, Alberti used the precepts of the newly rediscovered *De
architectura,* written in the mid-20s B.C. by the Roman architect and
author Vitruvius, to conclude that to produce a beautiful building,
the architect was to reproduce the same geometrical and arithmetical
proportions that God, the supreme Architect, had imposed on the
body of man. This belief, which derived from the Greeks, who had
first linked the harmony of the human body to the harmony of the
cosmos, was re-proposed by Leonardo da Vinci in his *Vitruvian Man*
(ca. 1490)—a perfectly proportionate male body with extended arms

and legs, enclosed within a square (symbol of earthly reality) and a circle (symbol of God's eternity) to indicate that man represented a scaled-down version of the divinely infused universe.

Alberti, who also wrote the books *On Painting* and *On Sculpture,* was among the first writers to elevate to a higher status the role of the artist, who in the past had simply been defined as a craftsman, meaning a manual worker dealing with the manipulation of matter—an activity felt to be vastly inferior to the disciplines that had to do with the world of ideas. Challenging that prejudice, Alberti affirmed that the ingenuity displayed in the work of painters and architects made their crafts deserving of being placed among the liberal arts. For Alberti, as for Leonardo in later years, an artist was not simply an "artisan, but rather an intellectual prepared in all disciplines and all fields."

In the treatise *On the Family* (1443), Alberti stressed the important role that family and education had in the creation of a well-rounded personality. Unfortunately, the harmonic equilibrium between different social forces that Alberti so passionately advocated did not include women. By enforcing the old belief in the absolute authority of the father figure, Alberti, like most men of his age, kept women relegated to the same secondary role they were assigned to since antiquity.

Despite that stubborn prejudice, many women of the fifteenth and sixteenth centuries were able to distinguish themselves by becoming scholars, writers, and poets in their own right. The majority of these women, like Isotta Nogarola, Veronica Gàmbara, Gaspara Stampa, and Vittoria Colonna, came from wealthy families, but others, like the Venetian Veronica Franco, were courtesans whose cultural sophistication earned them the respectful title of *cortigiana onesta* to distinguish them from lower-class prostitutes.

The celebration of man as a uniquely endowed creature was also articulated by the humanist Giannozzo Manetti (1396–1459), who wrote a book titled *On the Dignity and Excellence of Man in Four Books.* The work was written in response to the pessimistic ideas that Pope Innocent III had expressed, almost two hundred years earlier, in his *On the Misery of Man.* The scholar Charles G. Nauert writes that

whereas the pope in order to exalt the soul had focused "on the putre-fying decay and the excrement of the body as symbols of true human nature, Manetti lauded the harmony and beauty of the human body, reflecting man's creation by God in his own image."

The humanists had good reason to be optimistic, especially in a place like Florence whose cloth and textile industry had allowed it to become the richest city in Europe. One of Florence's great advantages was a secret dye derived from a lichen, brought home from the East by the Florentine merchant Federico Oricellari, that added a beau-tiful violet pigment to the high-quality wool that was shipped to Italy from England, Scotland, and North Africa. Another factor that allowed Florence to become a superpower was its banking activity, which was conducted by major Florentine families, like the Bardi, the Peruzzi, the Strozzi, the Albizzi, and especially the Medici, who turned the *fiorino* into the strongest currency of Europe.

As prosperity grew, the guilds became increasingly engaged in the improvement of the city. The Arte della Lana (Wool Guild) and the Arte della Calimala (Cloth Guild) contributed funds for the building of the duomo, the Gothic-style church designed by Arnolfo di Cambio, which was built in 1296, as well as for the nearby bap-tistery, the bell tower designed by Giotto, and the oratory and grain market called Orsanmichele.

The great amount of money that the secular and business-dominated government of Florence assigned to artistic projects that in most cases were religiously inspired tells us that even if the reputa-tion of the church as an institution had been devalued, religion, albeit often tinted with superstitious feelings, was still prominent just as the fear of God's ultimate judgment. As we have seen, bankers who practiced usury in violation of the church's ban often invested great sums of money in family chapels as a way to seek forgiveness for the "sin" they committed. The Florentine family of the Bardi and Peruzzi, for example, spent a huge amount of money for the decoration of the two chapels they owned in the Franciscan Church of Santa Croce, one dedicated to the life of Saint Francis and a second one to John the Baptist and John the Evangelist. Knowing that Saint Francis had

repudiated the wealth of his merchant family for a life of poverty makes the choice quite odd—unless, of course, we conclude that the Bardi-Peruzzi did so as a means of penitential contrivance, which, they hoped, would have gained them God's forgiveness for the transgressions committed in their professional activity. Additionally, Saint Francis might have been a convenient way to hide behind a mask of humility the enormous ambition that fueled their success—a necessary requirement in a city so sensitive to the danger of tyrannical aspirations. (The Bardi-Peruzzi eventually suffered a major blow from England: when King Edward III, who had received substantial loans from the Florentine family to finance his war against France, failed to repay those loans, he caused the disastrous demise of the Bardi-Peruzzi bank.)

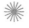

FLORENCE: THE CITY OF SPLENDOR

Among the many wealthy members of Florentine society, a particular place of prominence was occupied by the Medici family, whose banking activity was initiated by Giovanni, a smart businessman who managed to become the official banker of the pope. The charitable benefactions on behalf of the city, like his contribution to the Ospedale degli Innocenti, an orphanage sponsored by the Silk Guild and designed by Filippo Brunelleschi (the building, with its classical references, is considered the first example of Renaissance architecture), were used by Giovanni to gain the benevolence of his fellow Florentines. When he died in 1429, Giovanni was succeeded by his son Cosimo (1389–1464), who, like his father, was not only a clever businessman but also an astute politician, keenly aware of the importance that cultivating a good reputation had for the family's success. To present himself as fair and balanced, Cosimo always made sure to keep a low and unassuming profile. When the architect Brunelleschi, whom he had asked to design a project for the family residence, pre-

sented him with a plan for a palazzo that was extremely grand and lavish, Cosimo prudently refused, turning to the architect Michelozzo Michelozzi, who came up with a much less showy design.

Jealous of the high regard in which the head of the Medici family was held, a competitor, Rinaldo degli Albizzi, spread the rumor that Cosimo intended to take over the Florentine Republic. As a result, Cosimo was pushed into exile. But only for a very brief time: when Rinaldo degli Albizzi tried to assign to himself a position of political preeminence within the city, Cosimo was promptly called back and elected chief magistrate, or *gonfaloniere,* which was the highest executive office of the republic. Confirming his cautious approach to politics, Cosimo in the years that followed was able to gradually amass greater and greater power, but always with moves carefully conducted behind the scenes, such as briberies and political maneuverings that left intact the illusion that Florence was still a republic when in reality it was slowly morphing into a *signoria.* Cosimo's capacity to mute his critics and sway in his favor the political winds without ever acknowledging, in an official fashion, the fact that the city was gradually becoming his own private princedom shows a deep affinity with the emperor Augustus, who did not hesitate to corrupt the electoral system to rise to power while astutely presenting himself as savior, rather than usurper, of the republic. The impression is confirmed by the title assigned to Cosimo, who, just like Augustus, was called *pater patriae* (father of the nation) by his fellow Florentines.

Among the many qualities that made Cosimo popular was his diplomatic ability. For example, to keep Florence safe from Milan's expansionist ambition, Cosimo funneled a great amount of money to Francesco Sforza, the Milanese condottiere (military leader) who was eventually able to snatch control of Milan away from the Visconti. The alliance that Cosimo forged with the new ruler of Milan gave Florence leverage against Venice, the ambitious Queen of the Sea whose aggressive politics were a constant threat to the rest of Italy.

Cosimo's approval was also kept high by his generous contributions to the city of Florence, whose fame and prestige he enhanced through the work of the many artists he sponsored, like Ghiberti,

Paolo Uccello, Luca Della Robbia, Domenico Ghirlandaio, Filippo Lippi, Brunelleschi, and Donatello. Because, like other super-wealthy people, he feared the judgment of God, he never neglected to invest a lot of money in pious enterprises, like the reconstruction of the monastery of San Marco that became famous for the magnificent mystical frescoes executed by Fra Angelico. Influenced by humanist scholars, like the rich Niccolò Niccoli, Cosimo also established in San Marco the first public library. Thanks to the great resources that Cosimo deployed for the search and purchase of manuscripts, the library of Florence became the largest collection of books in all of Europe. That precious repository of culture was later moved to a building originally designed by Michelangelo in 1523, the Biblioteca Laurenziana. The cult of books that the humanistic movement fostered was greatly facilitated in the middle of the fifteenth century by the invention of the printing press by the German Johannes Gutenberg, which rapidly transformed the privilege of culture that once belonged to a few into a tool widely available to many.

While many European cities thrived, Byzantium continued to experience a slow decline, despite the efforts of the emperor Michael VII Palaiologos, who tried to restore the city's old prestige after the dramatic events that had occurred in the Fourth Crusade. But Byzantium's frail condition, which was worsened by the constant threat of the Muslims, remained problematic. To find a solution, new diplomatic contacts were developed to attempt a reconciliation between the Latin and the Greek churches. Among the people who came to Italy to explore the possibility of some sort of entente between West and East was George Gemistus Plethon, a highly regarded Byzantine intellectual whom Cosimo befriended and invited to Florence for a series of lectures on Plato. At that time, Plato was still largely unknown in the West because, as indicated before, apart from indirect references from authors such as Cicero and Augustine, the only book that the Middle Ages possessed of the Athenian philosopher was the *Timaeus,* which had been translated into Latin by Calcidius in the fourth century A.D. The lectures on Plato that Gemistus Plethon gave in Florence set humanists, scholars, and intellectuals aflame with

enthusiasm. Caught by the wave of interest that Plato's mystical phi-
losophy prompted, Cosimo decided to invest money in the creation
of a Platonic Academy, which was founded in 1445. At the helm of
the Academy, Cosimo placed the philosopher Marsilio Ficino (1433–
1499), who went on to translate from Greek to Latin all of Plato's
and Plotinus's work and also the writing of Hermes Trismegistus, a
mythical figure who was erroneously believed to be an Egyptian wise
man who had lived shortly after Moses (scholars now believe that the
Hermetic writings belong to an unknown group of Greek authors
who lived between A.D. 100 and 300). The work of Ficino and that
of the humanists who attended the Platonic Academy were essential
for making Plato central to the interests of most Renaissance scholars,
thus bringing to an end the Scholastic passion for Aristotle that had
dominated the Western mind for almost four hundred years.

Ficino's most important work was the *Theologia Platonica*. The
work that Will Durant defines as a "confusing medley of orthodoxy,
occultism, and Hellenism" exalted Plato as an enlightened philoso-
pher whose prophetic ideas anticipated truths eventually validated
by Christianity. The pivotal concept of Ficino's Neoplatonic philos-
ophy was that by being a point of encounter between matter and
spirit, man was an exceptional creature capable of recognizing in love
and beauty the conduits necessary to reach higher forms of feeling
and understanding. By exalting the Golden Age of Florence, Ficino
wanted to exalt the makers of art who, as the critic Arthur Herman
explains, had been moved by the desire to achieve virtue through
creativity using the beauty of their work to draw themselves and their
viewers closer to the divine creator of the universe—God.

Since the thirteenth century, Florence had indeed become the
stage of an enormous amount of astounding artistic achievements.
The thread that linked all those innovations was based on a revived
interest in everything that the classical world could offer. But study-
ing the models of the past had not been easy, given that Rome, the
main showcase of antiquity, lay shattered in ruins, with most of its
ancient treasures neglected and half buried in dirt. Brunelleschi
and Donatello, who for ten years repeatedly returned to Rome to

draw sketches of statues and reliefs and to measure the proportions of old buildings, would have been quite aware of those difficulties. The names Monte Caprino (Goat Hill) and Campo Vaccino (Field of Cows), which were given to the Capitoline Hill and the Forum because of the cows, goats, sheep, and pigs that were brought there to graze, give us a sense of the dilapidated condition into which the Roman antiquities had fallen.

Despite that widespread squalor, Rome had remained a popular destination for many Christian pilgrims who came to visit the city carrying with them a guide called *Mirabilia urbis Romae* (The marvels of Rome). But the wondrous remains that attracted those travelers were religious rather than secular, like the holy finger of Saint Thomas in Santa Croce in Gerusalemme; the arm of Saint Anne, mother of Mary; or the head of the Samaritan woman converted by Christ, which was kept in the Church of San Paolo Fuori le Mura. The fact that Brunelleschi and Donatello were not part of those pious crowds must have greatly puzzled the people of Rome: What were those two men doing wandering among the Roman ruins, and what were they looking for with their endless diggings? Maybe, people thought, they were treasure hunters in search of golden coins or some other precious object from the past. Superstition told them that men like that had to be avoided at all cost: disturbing the pagan spirits was a dangerous venture, and no one wanted to be part of it. Little did they know it was that very activity that would inspire the masterpieces that initiated the great artistic revolution known as the Renaissance.

In Brunelleschi's case, the trip to Rome had come after his defeat by the artist Lorenzo Ghiberti, who won the competition that the city of Florence had organized to select the artist assigned to produce the bronze doors that were to decorate the baptistery. Losing to Ghiberti—who went on to produce those magnificent doors, which Michelangelo honored by naming them the *Gates of Paradise*—had been a painful disappointment for Brunelleschi, but vindication came when he was later chosen for the design of the cupola that was to be placed on top of the Cathedral of Santa Maria del Fiore. Brunelleschi, who brought that amazing task to completion in 1434, used as inspi-

ration the Roman Pantheon. The cupola he designed was conceived
as a double shell supported by a strong internal framework made of
brick and stone that rested on an octagonal drum. The beauty of the
massive dome rising effortlessly above Santa Maria del Fiore came to
be praised as one of the major wonders of the world fated to inspire,
for centuries to come, legions of future architects. In later years, while
planning the cupola of Saint Peter in Rome, Michelangelo paid trib-
ute to Brunelleschi's masterpiece by saying, "I will do a bigger one but
not more beautiful than that of the Duomo."

Brunelleschi also became famous for his studies on linear per-
spective. As we have seen, because they favored God's infinity over
man's relativity, medieval artists had consciously neglected the real-
ism of three-dimensionality in favor of abstract and alogical visions
of the divine, seen as complete *otherness* from the world of matter. In
a radical reversal of that optical and mental perspective, Brunelleschi
developed the mathematical and geometrical rules necessary to mas-
ter the vanishing point that Renaissance painters used to prioritize

Brunelleschi's cupola of the Cathedral of Santa Maria del Fiore,
1434—the duomo

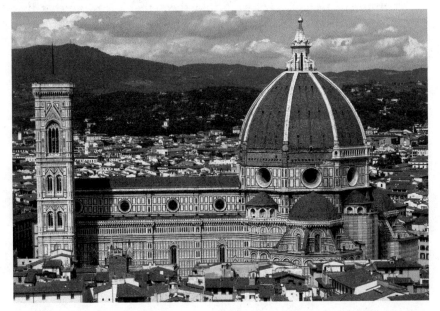

the human subject's point of view, thus making man, once again, the measure of all things.

With Donatello, the influence of classical times was translated into a vigorous realism that forever revolutionized the art of sculpture. We see this, for example, in the biblical figure of Habakkuk, which the Florentines named the *Zuccone* (dialect for "big head"), destined for one of the niches placed on top of Giotto's bell tower. In contrast to the idealized serenity that Gothic artists had invariably attributed to biblical figures, Donatello's Habakkuk is given a completely true-to-life likeness: an unflattering and odd-shaped bold head, a harsh face, and a strong body covered with a shapeless cloak that, less than a prophet, makes him look like a Roman senator unafraid of throwing himself into the messy affairs of the world (see page 360). In his pursuit of realism, Donatello, who mastered all sorts of materials (stucco, marble, bronze, wood), was able to convey in an unprecedented way the drama of human life. Among his other powerful images are the bronze statue of John the Baptist that he produced for the Cathedral of Siena and the shockingly emaciated wooden-carved image of the penitent Mary Magdalene, who, as a medieval legend believed, had searched for salvation in the wilderness and in loneliness (see page 360).

It seems fitting that it was such an extraordinary man who finally emancipated sculpture from the subordinate position it had been relegated to for more than a thousand years as a mere appendix of religious architecture. Besides the bronze equestrian statue of the military leader Gattamelata, the first statue that Donatello conceived outside the context of a church was the David—the first freestanding statue on the round to reappear in the West since the fall of the Roman Empire (see page 361).

The bronze statue, which was probably commissioned by the Medici for the courtyard of their palace, portrays the young shepherd David as a naked adolescent proudly placing his foot on the head of the giant Goliath, the massive warrior who, as the Bible narrates, had spread fear among the Israelites during their war against the Philistines and was eventually killed by the rock flung from David's sling. The intense eroticism that the statue exudes is accentuated by the

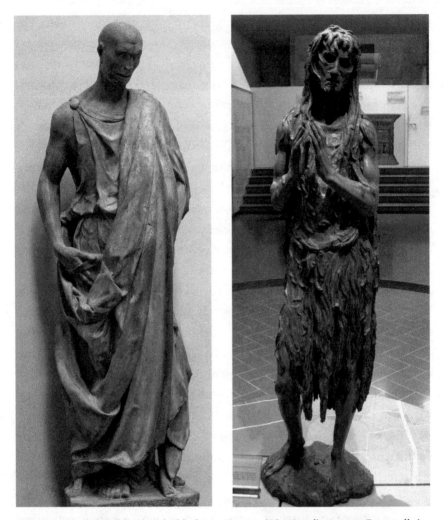

LEFT: Donatello's biblical Habakkuk, or *Zuccone* (Big Head); RIGHT: Donatello's emaciated Mary Magdalene; FACING PAGE: Donatello's bronze David, the first freestanding statue in the West since the Roman Empire collapsed

long feather attached to Goliath's helmet, which seems to caress the inner part of the boy's right leg while reaching up to his groin. Nothing ethereal and spiritual can be found in this image: drastically severing the ties with tradition, Donatello not only gives the statue autonomy from the religious context but also makes the sensual and purely organic reality of the body a subject worthy of the admiration and celebration of art.

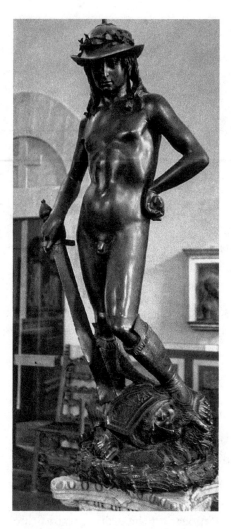

As the works mentioned show, the spirit that moved Brunelleschi and Donatello was not to reproduce old models but to use them as inspiration for the creation of something completely new and unique. This principle had been advocated by Petrarch, who said that culture consisted not of arid erudition but of an active process of assimilation in view of a new, original synthesis. To explain that principle, Petrarch used as metaphor the work of bees that pick pollen from different flowers to then create their own unique honey.

As Brunelleschi did in architecture and Donatello in sculpture, the first painter who, after Giotto, articulated, in his own original way, the classical lesson was Masaccio (1401–1428). Masaccio, who died when he was only twenty-six years old, is essentially remembered for two main works: the *Holy Trinity* in the Church of Santa Maria Novella, which profoundly impressed his contemporaries for his skillful use of perspective (we will return to it later), and the frescoes he did for the Brancacci Chapel in the Church of Santa Maria del Carmine, in Florence. A sense of Masaccio's style can be ascertained from the famous scene called *The Tribute Money.*

The scene visualizes the story told in the Gospel of Matthew: a tax collector stops Christ and His disciples to demand money for the state. The range of meticulously choreographed gestures, movements,

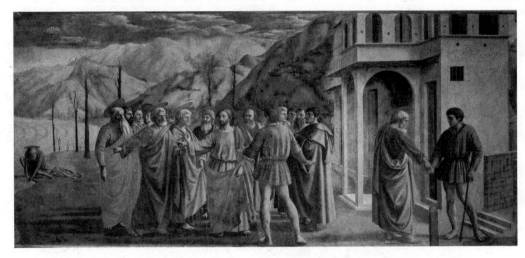

Masaccio's *The Tribute Money*, the Brancacci Chapel, Florence

and expressions performed by the solidly built figures (so evocative
of Roman senators) conveys the variety of thoughts and emotions
described in the story: assertiveness, surprise, hesitation, and indig-
nation, all rotating around the calm presence of Christ, Who tells
Peter to go to the lake to catch a fish and find a coin in its mouth.
(Peter executing Christ's command is seen in the rear of the picture.)
The spatial depth, which demonstrates Masaccio's familiarity with
the rules of perspective, adds realism to the representation, as does
the depiction of the natural light (which, as we have seen, had been
abandoned for more than a thousand years) that the painter under-
lines through the long shadows that appear on the ground to indicate
the afternoon hours of a cold winter day.

The masterly technique used by Masaccio to enhance Christ's
humanity and immerse His presence in a completely realistic context
was met with a chorus of praise by his contemporaries. Those com-
pliments must have greatly pleased the silk merchant Felice Bran-
cacci, who, like many other wealthy citizens, sponsored that work not
only for devotional purposes but also to enhance his worldly status by
showing that money and success had in no way diminished his sense
of responsibility and commitment to civic duty. The money theme
that Felice Brancacci chose for the painting is in itself an evident wink

to his fellow citizens, who, pressed by the high expenses that the war with Milan required, had been discussing a possible increase in taxes, which Brancacci, who wanted to show off his civic virtue, was positively advocating.

Masaccio's use of a religious theme to disguise secular intentions is also present in the work of his teacher Masolino (1383–ca. 1440), whose painting appears in the same chapel. The well-known scene, shown on page 364, puts together two events separately narrated in the New Testament: Saint Peter miraculously raising the dead Tabitha and Saint Peter healing a crippled man.

The background that connects the two scenes depicts a sunny open space lined by an elegant group of pastel-colored houses, typical of the fifteenth-century Florence in which Masaccio and Masolino lived and operated. Placing biblical scenes in familiar contemporary surroundings was a fashion developed in Bruges, Ghent, and Brussels by fifteenth-century artists such as Jan van Eyck, Rogier van der Weyden, and Robert Campin. In a similar manner, Masolino seems to take pleasure in lingering on details of everyday life: from the blankets hanging out of windows to be dusted off, to flowerpots, birdcages, and even an exotic pet monkey brought from some faraway land that we see on the ledge of one of the buildings. The calm routine of the beautiful morning is further animated by the presence of people going about their business in the streets of the city. Particularly relevant is the image of two men, clad with fancy Renaissance hats and garments, placed in the middle of the scene who appear so absorbed in their conversation as to remain completely unaware of Saint Peter's miraculous actions that are occurring right next to them. The feeling that the viewer gets is of two completely independent and unrelated planes of reality: a secular plane and a religious one running on parallel tracks, with no evident connection to each other. How are we supposed to interpret that enigmatic choice? A comparison between the fancy richness of the city and the particularity of the two miracles is the key to the enigma: the crippled man and the dead woman restored to a healthy life were probably intended as a clever, indirect praise of the city of Florence, which, *resurrected* by

ABOVE: Masolino's rendering of Saint Peter's dual miracles, also in the Brancacci Chapel, with detail, left

the mercantile activity, had gained an unprecedented level of splendor and prosperity.

Using religious themes to praise secular achievements reached a whole new level of audacity in the work of the famous painter Gentile da Fabriano (ca. 1370–1427), who was hired by the banker Palla Strozzi, the great rival of the Medici family, to produce an altarpiece titled

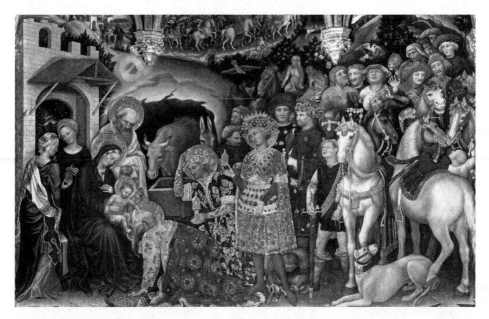

Gentile da Fabriano's altarpiece *The Adoration of the Magi,* in the sacristy of Santa Trinità, in Florence

The Adoration of the Magi, to be placed in the family chapel located in the sacristy of Santa Trinità in Florence.

What appears unique in this painting is where and how the sponsors of the artwork are depicted within the scene. In the mature phase of the Middle Ages, placing sponsors within a religious composition had become a common practice. But when it happened, two strict rules were maintained: the sponsor, who was always given a secondary position vis-à-vis the religious figures, had to show a humble and respectful deference toward the holy event. What makes this painting so strikingly different is the almost defiant way with which Gentile da Fabriano gives the members of the Strozzi family a size comparable to that of the Magi, while assigning them a place of enormous importance right next to the three kings. Behind them is the great procession of elegantly dressed people who represent the Strozzi's fancy entourage.

But there is more: according to Christian tradition, Mother and Child were to be assigned a prominence that no other figure or event

could overshadow. By placing the scene of the Nativity as the final destination of the long procession, Gentile da Fabriano at first seems to respect that rule. But what we realize, as soon as we linger a little longer on the image, is that the lively crowd, the colorful costumes, the exotic monkey, the hunting falcons, the restless horses, and the purebred dogs keep pulling our eyes away from the contemplation of that sacred moment. Our distraction appears shared by the characters portrayed in the painting: except for Palla Strozzi (recognizable by the falcon he holds on his left arm), none of the people who accompany him appear to pay attention to the Nativity scene. Even the big star glowing on top of the manger fails to attract their curiosity: caught by the excitement of the hunting day from which they have just returned, people look at each other as if sharing stories or simply marveling at two birds fighting right above their heads. Their eyes wander everywhere, *except* in the direction of baby Jesus. Such irreverence, in less permissive times, would have been condemned as an appalling sacrilege, only good to feed the flames of hell.

In spite of the morally ennobling claims of people like Alberti and Ficino who insisted that virtue was behind man's celebration of beauty, what seemed to consume the rich Florentines were mainly temporal and political concerns. To prove the point, one need only look at the frescoes that Benozzo Gozzoli did for the Medici between 1459 and 1461 in the chapel situated in the family palace.

The pretext for the frescoes was an event that had occurred a few decades earlier: the Council of Florence (1438–1439) organized to try to reconcile the Roman and the Byzantine churches. Cosimo, for prestigious reasons, had been able to transfer the council from Ferrara to Florence, where he lavishly lodged and feted his famous guests, among whom was the emperor of the Eastern Empire and the patriarch of Constantinople. The council's failure to achieve its purpose did not discourage the Medici: what they had wished to get out of the occasion was exposure and notoriety, and in that sense the council, for them, had definitely been a great success. For that reason, they chose a grand theme to honor the event: the Magi's journey to Bethlehem, just as in Gentile da Fabriano's altarpiece. The suspicion

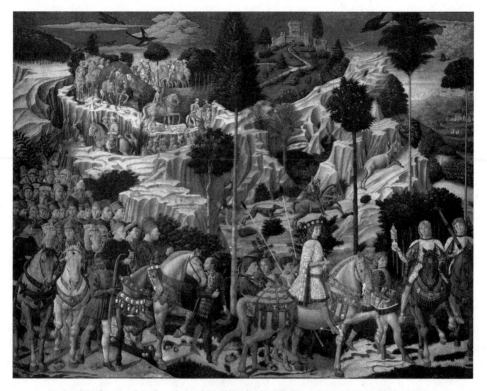

Gozzoli's fresco for the chapel in the Medici palace (ca. 1459–1461)

that the choice might have also been an attempt to upstage the rival family of the Strozzi derives from the huge size given to the project, which runs along three walls of the chapel, as well as the Medici's choice to appear in the painting as personifications of the biblical Magi. Wealth was the justification for that daring choice: the Medici felt entitled to identify themselves with the Magi because of their rich contribution to the Christian world that they had provided with the organization of the Council of Florence. The additional implication, of course, was that among the wealthy Florentines no one was as deserving of the approval and recognition of God as the great Medici family.

The figure that in Gozzoli's frescoes is given greatest prominence is the young Lorenzo, recognizable by a royal turban decorated with gems and golden spikes. Right behind him, we see his father, Piero, and his grandfather Cosimo. The awesome cavalcade that follows the

Medici-Magi shows a long line of lavishly dressed nobles, dignitaries, court members, squires, and pages within a landscape glistening in colors and fairy-tale beauty. Among that long parade of people we see the emperor of the Eastern Empire, John VIII Palaiologos, and the patriarch of Constantinople. Other celebrities include the Italian humanists Marsilio Ficino and Cristoforo Landino and the artist himself, identified by the name inscribed around the red cap he is wearing. The fact that Gozzoli dares to place himself in his own painting reveals the new level of self-awareness that artists had acquired, in particular when they realized how essential their role had become in buttressing the glory of those who held power.

Soon many artists began to depict themselves within their own paintings. The image on the facing page shows a later painting by Sandro Botticelli, the *Adoration of the Magi,* executed in 1476, which, again, was a tribute to the Medici. (Cosimo, kneeling in front of the Virgin, and his two sons, Piero and Giovanni, are presented as the Magi, while his grandsons Giuliano and Lorenzo look at the scene from the crowd.) The haughty look that Botticelli adopts while staring directly at the viewer from his own painting conveys the proud self-awareness that the Italian artists had now achieved.

There is no doubt that Gozzoli's frescoes are aesthetically magnificent, but there is also no doubt that exploiting religious symbols to heighten their political power was quite an amazing display of hubris on the Medici's part. What had happened to Cosimo, who was always so careful in avoiding all ostentatious displays of showiness? Confronted with that puzzling dilemma, many scholars have concluded that Cosimo only supervised the beginning of the work, while his son Piero (nicknamed *il Gottoso,* "the Gouty," because he suffered from gout), who was much more taken with the pomp and pageantry of power, took charge of its ultimate completion. That Cosimo is the only figure riding a brown mule, rather than a horse (a clear reference to Christ, who rode a mule when he entered Jerusalem), might have been a way for Piero to pay tribute to the famous humbleness of his father, from whom he had learned so little.

One last thing about the chapel: when one enters, the dazzling

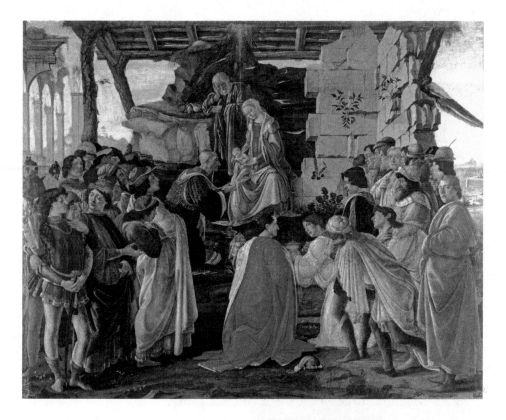

beauty of the paintings is so overwhelming that it is easy to forget that what is missing in the composition is the main point of the biblical story—the scene of the Nativity. The small painting by Filippo Lippi that used to stand above the altar provided that detail, but almost as an afterthought that easily goes unnoticed. What that indicates is that while the Middle Ages had been pervaded by the desire to make the soul immortal, the only

TOP: Botticelli's *Adoration of the Magi* (1476), with detail of the artist himself, above

immortality that many rich Renaissance people appeared to truly crave was that of fame, applause, and recognition.

That said, some expressions of pure spirituality remained. Among those who continued to use art as an instrument of religious meditation—and for that reason still relied on Byzantine style and techniques, with images lacking movement, perspective, and natural light—was Simone Martini (1284–1344), who lived and worked in Siena. In Florence, the religious approach found an extraordinary representative in Fra Angelico (1395–1455), who decorated with magnificent mystical visions the cells of the monks in the convent of San Marco.

Also Filippo Lippi (1406–1469), whose painting hung in the chapel decorated by Benozzo Gozzoli, exclusively devoted his art to religious themes. But his personality was quite different from that of the pious Fra Angelico. Having lost his parents at a very young age, Filippo was put in a convent where he took his priestly vows when he was only sixteen years old. He was a great painter but an erratic man who often failed to complete the work he was assigned. Cosimo often had him locked in a room to force him to work, but Filippo regularly escaped through the window. Eventually, he was accused of immorality because he fell in love with a nun whom he abducted from the convent. The many portraits he did of the Virgin Mary bore the features of the ex-nun who had become his lover. As we will see, the Dominican priest Savonarola sternly denounced those kinds of infringements as profoundly offensive to the spirit of Christianity.

※

LORENZO THE MAGNIFICENT
AND HIS COURT

After Cosimo's death, Piero took over the reins of power but died only five years later, leaving his twenty-year-old son, Lorenzo, in charge of the family business. According to his contemporaries, even if Lorenzo

lacked Cosimo's knack for making money, he certainly had his grand-father's facility for handling the clever maneuvering of politics. Like Cosimo, he staged a prudent approach to power, manipulating the decisions of the *balìa,* or Council of Seventy (established in 1480 as a permanent political council), by assuring for himself the loyal support of the majority of its members.

The prosperity and order that the city enjoyed under Lorenzo appeased, at least for a while, the rivalries between opposing parties: as long as the free circulation of trade and money continued, people appeared content, despite the loss of freedom. The transformation of Florence into a capital of light, elegance, gaiety, and amusement was used by Lorenzo to give even further prominence to the benevolent mask that the Medici's rule had become so apt at staging. "If Florence was to have a tyrant," wrote the sixteenth-century historian Francesco Guicciardini, "she could never have found a better one."

Lorenzo was an intelligent and highly cultivated man. He mastered Latin and learned Greek at a very young age. He appreciated art, literature, and philosophy and surrounded himself with scholars and artists. Besides that engaged and serious side, Lorenzo was a cheerful person who enjoyed the light and entertaining aspects of life. Under his leadership, spectacular tournaments, beautiful processions, extravagant carnivals, and whimsical masquerades became trademarks of the city, as well as brilliant creative exploits of all sorts of artistic expressions: literature, poetry, painting, sculpture, and architecture. As a sign of grateful recognition, the city to which Lorenzo had brought so much liveliness and prestige assigned him the title of *il Magnifico,* "the Magnificent." But, as Lorenzo wrote in one of his poems, the future can often bring calamities unforeseen during the enchanted springtime of youth.

For Lorenzo, that sobering encounter with reality came when members of the rival Pazzi family, acting with the complicity of Pope Sixtus IV—a Franciscan who, in direct opposition to his vows, was a fierce political man who supported the Inquisition and shamelessly practiced nepotism—attacked him and his younger brother, Giuliano, with daggers while the two were attending Mass in the duomo, on

Easter Day 1478. Lorenzo was able to escape, but the young Giuliano succumbed to the brutal attack of the killers. Lorenzo's retaliation was fast and implacable as a bolt of lightning: he had the conspirators not only arrested but also immediately executed and hung for several days outside the windows of the Palazzo del Bargello as an admonition to any other possible plotters. The presence of the archbishop of Pisa among the men who were executed shocked the pope, who excommunicated Lorenzo and suspended business with the Medici's bank. Lorenzo was too shrewd to let the tension last: using diplomacy with the same adeptness that had characterized his grandfather, he was able to eventually reestablish a good relationship with the pope and also maintain a delicate equilibrium with other major cities like Milan and Naples.

In Lorenzo's multifaceted personality, the statesman, the tyrant, the warrior, the diplomat, the scholar, the poet, and the art lover seamlessly coexisted. It is hard to believe that the man who, among other things, ordered the sack of Volterra, which was an abominable act of violence, was the same man who penned the most delicate and nuanced praises of love and beauty in his book of poetic songs. Under such a leader, Florence became a de facto *signoria* but with an aura of glitter and glamour that ended up seducing even those from whom the dignity of self-rule and independence had been taken away.

With Lorenzo, the court of the Medici became a major locus of encounter of artists such as Domenico Ghirlandaio, Sandro Botticelli, Piero and Antonio Pollaiolo, Andrea del Verrocchio, Leonardo da Vinci, and Michelangelo, as well as authors like Luigi Pulci and Politian, and philosophers such as Marsilio Ficino and Pico della Mirandola.

Pulci (1432–1484) and Politian (1454–1494), both friends and protégés of Lorenzo's, could not have been more different in taste, style, and personality. Pulci's main work, *Morgante,* was a biting parody of chivalric ideals, while Politian, who was a classical scholar, poured his romantic heart into lyrical verses that were a direct tribute to Petrarch's elegant and delicate style. His most famous poem, titled *Stanze per la giostra di Giuliano de' Medici,* was dedicated to the famous

tournament that took place in the Piazza Santa Croce in honor of Lorenzo's brother, Giuliano. The composition of the poem, which was written in Italian but was full of pagan and classical references, was interrupted by Giuliano's death.

While Politian was the mentor to Lorenzo in poetry and literature, Marsilio Ficino, who, as we have seen, Cosimo had put in charge of the Platonic Academy, was the man who inspired in Lorenzo the love for Platonic philosophy whose spiritual depth appeared to agree so well with the principles of Christianity. Richard Tarnas writes that the most extraordinary outcome that the exposure to Plato produced on Ficino was the realization that the search for wisdom and spiritual perfection had characterized the human quest since the dawn of time. That realization led Ficino into believing that a fundamental continuity linked Christianity to all of the great traditions that had preceded it, from the Egyptian hermetism to the Hebrew Kabbalah (a mystical and esoteric method used to interpret the mystery of Scripture), as well as the wisdom of Pythagoras and Plato and that of all the major Neoplatonic philosophers. Charles G. Nauert writes that according to Ficino, "all of these ancient sages were divinely inspired. Their mission down to the Incarnation was to prepare the world for Christian faith by teaching the superiority of spiritual over material goods."*

According to Ficino, the world was a living thing animated by a "divine influence emanating from God, penetrating the heavens, descending through the elements, and coming to an end in matter." Man, who was placed by God at the center of that awesome hierarchy of beings, was given the freedom to choose what he wanted to be: either to remain trapped at an animal level or to rise above material-

* It is interesting to note that the Renaissance's indiscriminate enthusiasm for all sorts of past theories and traditions also led to the support of disciplines devoid of any true empirical validity, like occultism, astrology, divination, magic, and alchemy. Ficino's fascination with magic, occultism, oracles, and spells was also shared by the skeptical Machiavelli (whom we will discuss more at length later), who, despite his materialistic views, often connected prodigies and prophecies to actual events of history.

ity to follow the inner spark of divine creativity that allowed him
to reach the vertiginous heights that his nature was capable of. The
devotion to artistic beauty that the Renaissance so fervently culti-
vated was also a way to celebrate the role of co-creator that God had
assigned to His favorite creature—man.

Along with Ficino, the other important scholar and intellectual
belonging to Lorenzo's entourage was Giovanni Pico della Mirandola
(1463–1494), who acquired fame for his vast and eclectic culture,
which included several languages: Greek, Latin, Hebrew, Arabic,
and Aramaic. Pico, who like Ficino believed that all knowledge was
interwoven, proposed a synthesis of Christianity, Greek philosophy,
the Jewish Kabbalah, the teaching of the mythical and mystical
philosopher Hermes Trismegistus, and that of the Persian prophet
Zoroaster. That complex amalgam was described by Pico as different
stages of illuminations: what the wise men of antiquity had stated
was reconcilable with Christianity as expressions of the same uni-
versal Soul that pervaded and regulated the whole of creation. The
scholar Arthur Herman, in *The Cave and the Light,* writes that Pico's
"staggering range of interests and his inexhaustible scholarly energy
were aimed at a single mission. This was to prove that all religions
and philosophies, ancient and modern, pagan and Christian, actually
formed *a single body of knowledge.*"

The Middle Ages' view of man as a feeble creature scarred by sin
had made the role of Grace an indispensable instrument of human
salvation. In Pico's *Oration on the Dignity of Man* (1496), none of that
can be found. For Pico, man was a heroic creature endowed by God
with the gift of intelligence and creativity and the absolute freedom
to choose whatever he wanted to be: "Oh highest and marvelous felic-
ity of man. To him it is granted to have whatever he chooses, to be
whatever he wills."

Sidestepping the story of the Fall, which, according to religious
dogma, had made indispensable the redemptive action of Christ, Pico
imagined God's words to Adam this way: "I have placed you at the
center of the world, so that you may easily survey all that is in the
world. I have made you a creature neither of heaven nor of earth, nei-

ther mortal nor immortal, so that exalted and empowered as the maker and molder of yourself, you may fashion yourself in whatever form you choose. You will have the power to degenerate into the lower forms of life, which are bestial. You will have the power, by the judgment of your soul, to be reborn into the higher forms of life, which are divine."

To explore these ideas, Pico proposed a public gathering of scholars in Rome. The meeting's ambitious agenda was to discuss the nine hundred topics put together by Pico with the intention of finding the essential concordance that linked all philosophies and religions. Pico had wished to entertain a dialogue with the major scholars of his times; what he received, instead, was a veto from the church, which condemned as heresy twenty-three of his theses.

The works of Ficino and Pico sparked all sorts of sophisticated discussions, but the connection with the political ideals that the early humanists had so passionately cultivated remained mostly ignored within the cultural milieu of these later thinkers. Some scholars have suggested that the Medici deliberately promoted the abstract reasoning of Plato over thinkers who had more of a pragmatic approach because, as Charles G. Nauert writes, it "drew the educated classes away from civic ideals and republican liberty." The exclusion from art of all the themes that had to do with a civically committed life seems to positively confirm that hypothesis: what developed, especially under Lorenzo's leadership, was an aesthetically stimulating but politically and ideologically hollow culture typical of the taste and style of a court-like mentality.

In Botticelli's paintings *The Birth of Venus* and *Primavera* (Spring), probably dedicated to Lorenzo di Pierfrancesco de' Medici, cousin of Lorenzo, that intrinsic contradiction inevitably comes to the surface: after being enthralled by the beautiful references to mythology, the viewer comes to realize that beneath the splendid veneer what the painting truly wants to express is not so much the ethereal joys of spiritual and Platonic contemplation as the greatness of Florence's bosses—the Medici.

As the myth narrates, after Cronus cut off and threw the genitals of his father, Uranus, in the ocean, a wave of foam was formed

out of which Venus emerged. In Botticelli's painting, the newly cre-
ated Venus is brought from sea to land on a huge shell. The winds
that push the drape off her body represent erotic passions, while the
nymph who rushes to cover her nudity is the chaste purity of spiritual
love. The lack of material consistency in the rendering of the graceful
figures (so far from the realism of Donatello or Masaccio), combined
with the dreamy atmosphere that exudes from the painting, seems to
point to a transcendental Neoplatonic dimension. But it is only an
illusion created for purposes that, being partisan and propagandis-
tic, are completely at odds with the purity and spirituality that the
painting purports to suggest. Venus's arrival is used by Botticelli not
to promote an ascetic withdrawal from life but to proclaim, with the
inflated adulation typical of a courtier, that with the triumph of the
Medici, Florence has been blessed with a beauty as noble and pristine
as that of a Platonic ideal.

In the other famous painting by Botticelli, Venus, the goddess of
love, is placed one more time in a center-stage position. Above her, we
see a flying Cupid shooting his arrow at the central figure of the three

Botticelli's most famous painting, *The Birth of Venus*

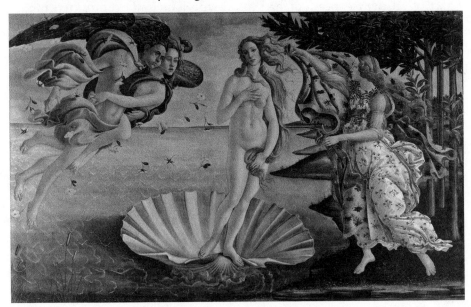

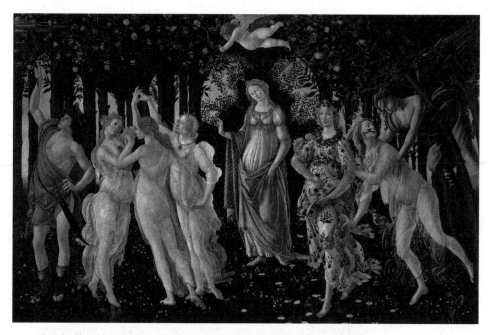

Botticelli's almost equally famous painting, *Primavera* (Spring)

dancing Graces that represents Chastity. The blooming of nature that occurs when Chastity is revived by Love is expressed by the advancing Flora, the spring goddess, who scatters flowers all around her. The nymph behind her is Chloris, who, according to the myth, was turned into Flora by the passion of the spring wind Zephyr (emerging from the trees behind her). At the opposite side stands Hermes, the messenger of the gods, who pushes away a cloud that threatens the bright serenity of the scene. The rhetorical question that the painting seems to raise is this: Where does the earthly paradise inhabited by Venus and the Graces reside? The answer, which was clearly "Florence," was once again a sophisticated way to flatter Lorenzo, who, just like the philosopher-king dreamed by Plato, was said to have turned the city into a magical garden of perfect beauty and love. The etymological connection between Florence and *fiorire,* meaning "bloom" in Italian, was used as a metaphor for that mythical rebirth.

The esoteric nature of the painting with its learned pagan references was designed to please the intellectual coteries who, by decod-

ing the visual riddle, could exhibit their cultural wit and in so doing affirm the exclusive superiority that their perch among the privileged guaranteed.

Within a few years, that court mentality found a champion in Baldassare Castiglione, who used the Montefeltro's court in Urbino, one of the most active centers of Renaissance art and culture, as the setting of his *Book of the Courtier,* published in 1528 by the Venetian printer and publisher Aldus Manutius. Castiglione's book was conceived as a manual on etiquette: how a perfect gentleman was expected to dress, talk, and behave in the sophisticated milieu of the court. The main point of the manual, which was based on the Ciceronian model expressed in the *De Officiis* and *De Oratore,* was that because elegance could not be attained without intellectual refinement, the courtier had to be a "universal man," meaning someone who, besides excelling in various physical activities, could master Greek and Latin and also have knowledge of history, philosophy, literature, music, painting, sculpture, and architecture. The effortless nonchalance with which the courtier was supposed to display his culture and quick wit was called *sprezzatura.* An interesting aspect of Castiglione's book is the role assigned to women. The educated noble lady is described by Castiglione as a companion for the courtier, equal to man in wit and intellectual capacity. That said, the sense of individuality that the mature Renaissance brought to fruition should not be misinterpreted: the "self" that was exalted was built not on a concept of pure freedom and self-reliance but rather on the desire to be part of the highly exclusive universe that the court existence represented.

A similar caution should be used when considering the great artists of the Renaissance who, as mentioned ealier, were not completely free agents of their crafts but extremely talented people whose work was put at the service of their princely patrons.

Next to Botticelli, a good example in this sense can be offered by another famous painter belonging to the Medici entourage, Domenico Ghirlandaio (1449–1494). Shown opposite is the work that Ghirlandaio did for the chapel of the Sassetti family in the Church of Santa Trinità in Florence, which was dedicated to Saint Francis.

The scene depicts the confirmation of the Rule of Saint Francis (paradoxically, the favorite saint of bankers!) by Pope Honorius III. Sassetti, who had an important position in the Medici bank, is seen on the right, witnessing the scene next to his employer, Lorenzo, and another friend of the family's, Antonio Pucci. Beside Sassetti is his younger son, while the three older sons, dressed in red, are placed on the left side of the painting. The most interesting aspect of the fresco is the background, which represents the Piazza della Signoria in Florence. Any contemporary tourist can easily recognize the Palazzo Vecchio on one side and the three-arched Loggia dei Lanzi on the other. The big arch that looks closer to the viewer is, however, that of the Temple of Peace built by Maxentius and Constantine in Rome. As we know, Saint Francis met the pope in Rome, not in Florence, and the acknowledgment of the order occurred in the Vatican, certainly not among the pagan ruins of ancient Rome. So, why such a bizarre jumble of places and events? The main reason was to exalt Florence

Ghirlandaio's *Confirmation of the Rule of the Order of Saint Francis*, Sassetti Chapel, Church of Santa Trinità, Florence

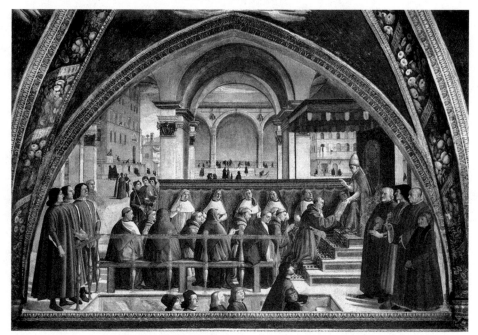

as a "new Rome," and Lorenzo as the ruler of the city that was the true heir of that legendary past. The reference to the Roman Temple of Peace was an allusion to the peace that had followed the break between Florence and Rome due to the Pazzi conspiracy. Antonio Pucci, standing next to Lorenzo, was the man who had helped to bring together the two parties—of the pope and of the Medici. The multiple layers of meaning that are compressed in a single scene is mind-boggling—as is the cavalier attitude with which secular and religious symbols are reassembled to convey a laudatory acknowledgment of the Medici that, ultimately, has very little to do with Saint Francis and his order. Worldliness and secular ambition had definitely trumped mysticism and saintliness.

THE GATHERING CLOUDS
OF DISENCHANTMENT AND CYNICISM

The Medici's golden years came to an end with the premature death of Lorenzo in 1492, when he was only forty-three years old. Two years later, Piero, who had succeeded his father, Lorenzo, found himself confronted with a terrible menace: the descent of Charles VIII of France, who invaded Italy to reclaim the kingdom of Naples that the house of Aragon (from eastern Spain) had taken from the French house of Anjou in 1435.

Suspicious of Charles's expansionist intentions, Piero de' Medici tried to gain the benevolence of the French king, by offering him the cities of Sarzana, Pisa, and Livorno. Offended by Piero's cowardly behavior, the Florentines expelled him from the city and restored the republic. The confusion that ensued favored the ascent of Girolamo Savonarola, the Dominican prior of the monastery of San Marco, who had been instilling fear in the hearts of the Florentines with apocalyptic sermons in which he fulminated against the moral depravity of the people, promising that God would soon punish the transgressions of

the corrupt city. The arrival of Charles VIII was interpreted by many as the realization of Savonarola's prophecy. Fanned by the implacable words of the priest, a combustible mix of guilt, fear, and superstition exploded, giving way to hysterical expressions of puritan frenzy.

Ironically, Savonarola, who was originally from Ferrara, had initially come to Florence at the invitation of Lorenzo, who had been advised to do so by Pico della Mirandola, who admired the priest's fervent faith and powerful rhetoric. Once in Florence, Savonarola became the head of the convent of San Marco. Lorenzo was soon surprised to discover the acrimony with which Savonarola condemned his fancy for art, beauty, and all sorts of intellectual pursuits. To try to appease the sullen monk, Lorenzo often sent gifts and contributions to San Marco, but his efforts were repeatedly rejected by the angry and scornful preacher. Lorenzo was a Christian more by formality than faith, but Savonarola must have touched some deep chord inside him: when Lorenzo suddenly fell sick and lay on his deathbed, he called for his harsh critic so he could receive his last rites and the absolution of his sins. According to Politian, who was present at the scene, Savonarola absolved Lorenzo on the condition that he repent of his transgressions and promise to change his life in case he recovered. A much less conciliatory version of the event was given by Savonarola's biographer Villari, who claimed that the priest demanded that Lorenzo restore liberty in Florence. Because Lorenzo refused to answer, Savonarola denied him absolution.

The obsession with sin turned Savonarola into a sort of Florentine Taliban fixated on punishment and hell. But not everything he said was extreme or indefensible. Being offended by the use of religious art as an ornament for power, for example, would seem an understandable objection coming from a man of faith. As we have seen, besides the Medici many rich Florentines exploited religious symbols as ostentatious badges of personal honor. Giovanni Rucellai, who sponsored the splendid marble facade of Santa Maria Novella designed by Leon Battista Alberti, did not hesitate to have his name printed in big, bold letters right below the sun symbol of Christ that appears on top of the church. Even for us today, accustomed as we are to the bombard-

ment of rich names splashed, in Trump-like fashion, all across our modern American cities, Rucellai's egotism seems definitely over the top. The same thing could be said about the beautiful frescoes that Domenico Ghirlandaio executed (always in Santa Maria Novella, for his patron Giovanni Tornabuoni, uncle of Lorenzo de' Medici), when he used Lucrezia, mother of Lorenzo and sister of Giovanni Tornabuoni, and other notable members of the Florentine elite as models for biblical figures. Savonarola's objection to these excesses would have been understandable, but certainly not the violence with which he instigated his followers to create the infamous "bonfires of vanities," where piles of books, objects of art, fancy clothes, cosmetics, and all sorts of luxury items were reduced to ashes. When Savonarola's attacks turned against the corruption of the Vatican, which under Alexander VI had reached unprecedented levels of shameless venality, the pope immediately tried to silence his accuser by excommunicating him and accusing him of heresy. Untouched by the pope's action, the unstoppable Savonarola continued to rail against all of those who, in his view, were staining the purity of Christianity with their satanic depravity. Among the many people who were shaken by the preacher's words was the court painter Sandro Botticelli, who, seized by guilt, suddenly denounced all his previous works and went on to dedicate himself solely to pious art. An example of that spiritually reformed art is the *Mystic Nativity,* in which a beautiful chorus of angels dances in harmony above the divine crèche.

Eventually, the Florentines, tired of the doom and gloom preached by Savonarola, hanged him and burned his corpse to ashes on May 23, 1498. The execution took place in the Piazza della Signoria, in the very same spot where his bonfires of vanities had previously raged. Perhaps the most lasting effect of Savonarola's legacy was to seed the Protestant revolution of Martin Luther, who greatly admired the apocalyptic priest whom he called a "saint."

The fight for power that followed Savonarola's death brought Florence to the verge of anarchy. To prevent the worst, the upper class elected the moderate Piero Soderini to the position of *gonfaloniere* for life. Among Soderini's advisers was Niccolò Machiavelli, who was put

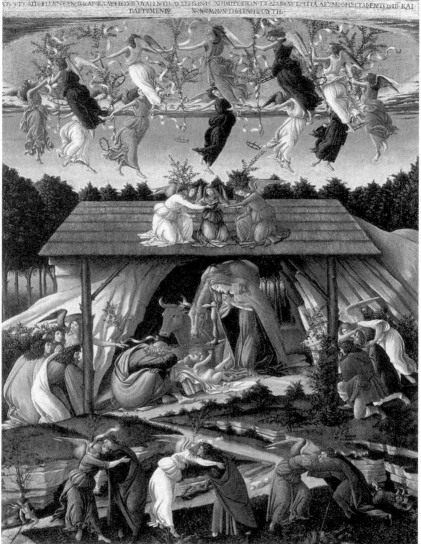

Botticelli's *Mystic Nativity*, his return to pious art

in charge of several diplomatic missions and also the organization of a militia that, rather than mercenary troops, was formed of citizen-soldiers—a proposition that Machiavelli had always strongly advocated as essential for the safety and protection of the republic.

Machiavelli's life took a sharp downturn in 1512, when the

Medici, having regained power in Florence, accused him of conspiracy and deprived him of political responsibilities. After being tortured and imprisoned, Machiavelli was forced to retire to his country house, away from the city of Florence. Despite his many pleading letters, Machiavelli was never able to reacquire the trust and benevolence of the Medici. In a famous letter to a friend, he confessed that the only consolation he was left with was the reading of classical authors, with whom, just like Petrarch, he entertained a daily dialogue. He wrote, "At nightfall I return home and seek my writing room; and divesting myself on its threshold of my rustic garments, stained with mud and mire, I assume courtly attire; and thus suitably clothed, I enter within the ancient courts of ancient men, by whom, being cordially welcomed, I am fed with the food that alone is mine, and for which I was born, and am not ashamed to hold discourse with them and inquire the motives of their actions; and these men in their humanity reply to me; and for the space of four hours I feel no weariness, remember no trouble, no longer fear poverty, no longer dread death; my whole being is absorbed in them."

It was during those difficult years that Machiavelli wrote his two main works: the *Discourses on the First Ten Books of Titus Livius* (1531), in which he praises the value of the republic; and *The Prince* (1532), which, in apparent contrast to the spirit of the *Discourses,* is a despot's manual on absolute authority. The cynical views contained in *The Prince* have puzzled generations of scholars: What inspired Machiavelli to praise a system that was so far from the republican ideal of which he had been an enthusiastic supporter for most of his life? Because Machiavelli never provided a direct explanation, many interpretations have been proposed: While some assume that the composition of *The Prince* was simply the result of his desire to ingratiate himself with the Medici, others emphasize the author's patriotic feelings. Because the French invasion had led Machiavelli to the conclusion that Italy would succumb if it did not become a unified country, he wished to prepare, with *The Prince,* the arrival of a strong leader capable of bringing under his sway all the Italian city-states, just as other monarchs had done throughout the rest of Europe. A third interpretation takes

into consideration the fact that Machiavelli, who had seen the government of Florence collapse three times during his formative years, had lost faith—not so much in the ideal of the republic per se as in the immediate capacity of his contemporaries to sustain a system based on selfless virtue and mutual collaboration. In Machiavelli's practical approach, despotism might have appeared as a necessary step to impose order and peace at that moment in time, but that did not preclude the hope that sometime in the future the Florentine character would have matured to finally acquire the qualities needed to establish what he believed to be the best of all systems—the republic.

What cannot be denied is that at the core of Machiavelli's argumentation is a profound sense of disenchantment in regard to human nature. Aristotle had claimed that man was born with the capacity to cultivate justice within a self-ruled community, based on respect for one another's dignity and freedom. Machiavelli, who had shared that creed at a young age, grew increasingly skeptical of that ideal after being confronted with endless examples of human wickedness and selfishness. "Men," he wrote in *The Prince,* "are fickle cowards, greedy and envious." The notion, which appears to contravene the glowing qualities that Aristotle and with him all the major Renaissance thinkers attributed to man, proves that Machiavelli, applying a secular twist to the Christian concept of a flawed humanity, had come to believe that man was essentially a corrupt and defective creature. The examples offered by history were for Machiavelli an important lesson in that sense: the greatest enemy of freedom and justice resided not outside but *inside* the very nature of man. What could be done about it? Machiavelli was too pragmatic to try to solve that impossible dilemma: his times demanded solutions that were too urgent to be delayed by insoluble theoretical disquisitions.

It was in that spirit that Machiavelli turned to his ideal of a perfect prince—someone who could assure order in society by adapting his actions to reality, unafraid of using violence if the circumstances demanded. Following that logic, Machiavelli advised the prince to be, simultaneously, half man and half beast, with the latter being a combination lion and fox: in other words, a combination of strength and

shrewdness that did not exclude, when necessary, the feigning of good and charitable intentions. Machiavelli's theory was that the theatrics politics always required a balancing act, the alternate use of stick and carrot, as he bluntly acknowledged with these words: "When seizing a state, the conqueror should consider all the injuries he must inflict, and then inflict them all at once, so that he doesn't have to repeat them day after day. In this way he can set the people's mind at rest, and win them over when he distributes favors."

The man who, for Machiavelli, best embodied the combination of cleverness and cruelty that leadership required was the unscrupulous son of the extremely corrupt pope Alexander VI, Cesare Borgia. With the help of his father, Cesare, who had received the title of cardinal when he was only eighteen years old, had tried to carve out for himself a powerful principality inside the papal territory of Marche and Romagna, which was full of turbulent men constantly locking horns to prevail over one another. To solve the problem, Cesare sent to the region a strongman, Ramiro dell'Orco, who in a short and very violent amount of time restored order and obedience in the land. Once the dirty job was done, Cesare, to convince people that he was not responsible for the brutality they had experienced, had Ramiro arrested and cut in half. The two parts of the body were then exposed in the public square to the jubilant approval of the population, who applauded Cesare for having saved them from such a horrible monster.

According to Machiavelli's shrewd yet crude assessment, that kind of quick wit could only command appreciation and respect: to be successful in the political arena, one had to cast aside goodness and empathy and replace them with cold tactics exclusively designed to preserve the safety of the state. The virtue that Machiavelli associated with leadership was a manly and master-like rule that in no way was to be connected with the principles advocated by Christian morality. Yet, in Machiavelli's view, it was advisable for the prince to *simulate* good qualities and *pretend* to respect religion, because nothing could induce men to behave more effectively than the fear of God's wrathful punishment. Of course, deceit and dissimulation had accompanied the theater of power and politics since the beginning of civilization,

but no one before Machiavelli had ever dared to talk about them in such an open way, let alone write a how-to manual on the proper way to lie and deceive in order to gain power. For Machiavelli, politics was an amoral business: the duty of a prince was to guarantee law and order, and if cruelty, dissimulation, and manipulation were needed to do so, it was fine, because the end justifies the means.

Machiavelli's cynicism shocked his contemporaries, most of all because his political theory refuted the old illusion of a divine cosmos justly ordered and rationally organized. For Machiavelli, the prince alone held the rudder of power in a universe deprived of all providential assistance. The only thing that the prince could count on, Machiavelli argued, was his own strength and his own capacity to withstand the relentless pressure of competing forces—not only those of rival men, but also those unleashed by the blind vagaries of luck and fate (which he called *fortuna,* Italian for "fortune").

In considering the theme of *fortuna,* Machiavelli was probably influenced by the Epicurean view of the Latin poet and philosopher Lucretius (ca. 94–ca. 55 B.C.), who in his book *On the Nature of Things* wrote that "chance" controlled destiny rather than some supernatural and divine plan. Humanists such as Poggio Bracciolini and Leon Battista Alberti had also discussed the issue of *fortuna,* but their melancholic approach was far from Machiavelli's combative tone— like when he compared *fortuna* to a woman who had to be tamed with force and violence: "It is better to be impetuous than cautious, because fortune is a woman, and if you wish to control her, it is necessary to restrain and beat her."

The fact that the same epoch produced the civic optimism of the early humanists, the religious mysticism of Fra Angelico, the elevation of man to a godlike status by Pico and Ficino, the fanatical excesses of Savonarola, and the pessimism of Machiavelli, with his disenchanted view of man, clearly reveals the complex intellectual tapestry of a period whose many threads cannot be easily disentangled with all their multiple, diverse, and often contrasting expressions.

In contrast with the optimism expressed by Jacob Burckhardt, the historian Eugenio Garin offers an eloquent account of the som-

ber feelings that, besides its brilliance, pervaded the Renaissance, in particular the anxiety that the age expressed when confronted with the disappearance of the old reassuring belief that the universe was a divinely infused and morally ordered cosmos. Garin writes,

> There was a way of writing history which pictured this rebirth of the free man as something like a triumphal march of certainties and resounding achievements. But if one peruses the most important testimonies of that age, . . . one will all the time discover that people, instead of being conscious of a beginning, were dimly aware that something was ending. The ending they sensed, though glorious, was nevertheless an ending. True, there is no lack of reminders that something new was being constructed. And there were assurances that man is indeed capable of carrying out a reconstruction of the world and of himself. But there was also an awareness of the fact that the secure tranquillity of a homely and familiar universe, ordered and adjusted to our needs, was lost forever.

THE ROMAN RENAISSANCE:
GLORY AND AMBIGUITY

As we have seen, the "Babylonian captivity," which was the name given to the years in which the papal residence was transferred to Avignon (1305–1377), and the Great Schism (1378–1417), which saw different interest groups fight for control of the papacy, had profoundly shaken the reputation of the church, which had already been tarnished by the failure of the Crusades and the disruption produced by movements, such as the ones led by John Wycliffe and Jan Hus, that gave voice to the grievances that many people felt toward the excessive wealth and corruption of the Curia.

The year 1417 was an important one for the church because it

finally marked the end of the Great Schism and because, with the election of Martin V, the papacy, fully reestablished in Rome, began the work that eventually allowed the city to become, once again, the central fulcrum of Christianity.

During the years in which the papal court had resided in Avignon, the Italian territories belonging to the church had fallen into disarray, being either occupied by strongmen or harassed by brigands and robbers. Martin V (pope from 1417 to 1431) confronted the problem by vigorously dedicating himself to the recovery of the papal state. To accomplish that purpose, Martin used the immense prestige and connection that his aristocratic family, the Colonna, enjoyed as one of the most prestigious powerhouses of central Italy. The disreputable outcome of that policy was the granting of political favors with which the pope compensated family members—a practice known as nepotism (from the Latin *nepos*, meaning "nephew").

During his very active years as pope, Martin V also addressed the dangerous state of decay into which the city of Rome had fallen. The task was daunting because of the poor hygienic conditions that the city was suffering especially from the lack of freshwater. (At that point, only one of its original twelve aqueducts was still functioning.) Because the only other source of water was the Tiber, many houses were huddled right next to the dirty river—a major misstep given the frequent inundations that regularly destroyed those poorly built shacks, leaving behind a swampy and polluted mess, filled with rats and mosquitoes that brought disease and death. To raise the large sums of money needed to restore the crumbling urban infrastructure, Martin V proclaimed a jubilee in 1423. The abundant revenues derived from the offerings of the many pilgrims who came to Rome were used to repair the city sewer system and also to employ thugs who got rid of the thieves and bandits who infested the city along with its many other pests. The money was further used to embellish important churches, like San Giovanni in Laterano, with the artwork of famous painters such as Gentile da Fabriano and Pisanello.

Like Martin V before him, Eugene IV (pope from 1431 to 1447), had visited Florence, where he had greatly admired the city's amaz-

ing beauty. Because he had been particularly struck by the masterful work that Ghiberti did for the doors of the baptistery, as soon as he became pope, Eugene hired the Florentine sculptor Filarete to cast the bronze doors of the old Basilica of Saint Peter. Filarete's choice to place Christ, Mary, and the apostles Peter and Paul right next to Greek and Roman mythological figures such as Jupiter, Ganymede, and Leda shows how far the humanistic enthusiasm for pagan themes had reached, even among the highest representatives of the church.

Among other works, Filarete was also famous for conceiving the first urban plan for an ideal Renaissance city. The city, which was never actually built, was named Sforzinda, in honor of Francesco Sforza, the Duke of Milan. Filarete's plan fascinated Leonardo, who became enthralled with the idea of creating an ideal city himself. In honor of the sacred principles of geometry celebrated since classical times, Filarete conceived Sforzinda as an eight-point star contained within a perfect circle. Colin Rowe and Fred Koetter, who in their book *Collage City* appropriately called Sforzinda "a city of the mind,"

The plan for Sforzinda, the ideal Renaissance city

wrote that its design compounds *"Revelation* plus the *Republic* or the *Timaeus,* plus a vision of the New Jerusalem."

Politically, one of Eugene's most daring actions was to order the return to the church of the many parcels of land that Martin V had illegally assigned to several of his family members. The reaction of the Colonnas, who like other powerful families were extremely jealous of their privileges, came down on the pope with such a fury that, fearing for his life, Eugene was forced to escape from Rome in a rowboat that went down the Tiber bombarded by the rocks and pebbles thrown at him by his rivals. From Florence, where he took refuge, the pope plotted his revenge. The man he eventually hired to do the job was a famously ruthless buccaneer who compensated his militia with the money he earned in robberies. His name was Giovanni Vitelleschi; he was of all things the bishop of Recanati. Bloody vendettas were as recurrent in Rome as its sunny days. If the Tiber could have been drained, piles of bones would have resurfaced: a sinister reminder of the many thousands of people who had ended their days in those murky waters. The Romans had grown too cynical to be scandalized by those kinds of events: when Vitelleschi, through all sorts of cruel means, was able to restore order in the city, the citizens of Rome voiced the intention of erecting in his honor an equestrian statue in the Campidoglio. Worried that such a great amount of admiration would have fostered the rise of a future antagonist, the pope hired another ruffian, who promptly murdered Vitelleschi.

Pope Nicholas V (reigned 1447–1455), who succeeded Eugene IV, was a humanist who believed in the need to reconcile philosophy with religion, pagan literature with Christian writings, and secular artistic themes with religious ones. The question that obsessed him was this: How could Rome assume its role as head of Christianity if its appearance paled when compared with the pinnacles of splendor that other Italian cities, like Florence, Venice, and Milan, could boast? For Nicholas as for the long list of Renaissance popes who, like him, resembled worldly princes more than pastors of souls, the choice ahead was clear: as the seat of the papacy, Rome deserved a grandeur and a beauty that were to be superior to those of any other city in the world.

To collect the funds necessary for that awesome endeavor, the pope proclaimed yet another jubilee in 1450. The enormous proceeds produced by the successful event were immediately employed by Nicholas to fix the walls and gates of Rome, pave its streets, and repair of the Acqua Vergine aqueduct. He hired the Tuscan architect Bernardo Rossellino to improve the Churches of Santa Maria Maggiore, San Giovanni in Laterano, and San Paolo and San Lorenzo Fuori le Mura and asked Leon Battista Alberti to design new palaces, porticoes, and open piazzas. The pope also sponsored the construction of the Palazzo Venezia (familiar to many people because *Il Duce,* Benito Mussolini, used to harangue crowds from the balcony of that very palace). Among the most famous painters hired by Nicholas V were Andrea del Castagno and Fra Angelico.

Aside from the much-needed restoration of the old Basilica of Saint Peter, the most ambitious project that Nicholas V envisioned (but died before its realization, and for that reason was carried on by later popes) was the creation of the Vatican Palace as a new residence for the popes, who had traditionally resided in San Giovanni in Laterano. With that project in mind, Nicholas had twenty-five hundred cartloads of marble and travertine extracted from the Colosseum and the Circus Maximus. The audacity of the act, which seems strangely at odds with Nicholas's humanistic sensitivity, was not uncommon. The Renaissance was passionate about collecting Roman antiquities, such as coins and especially statues, but when it came to Roman buildings, especially those that had already suffered the damage of time, careless attitudes were often taken, like quarrying them to provide the material for new constructions. The ancient temple of the Sun, for example, was dismantled to build a chapel in the Church of Santa Maria Maggiore, while the Sistine Chapel was built from material taken from the mausoleum of Hadrian. The same thing occurred during the construction of Saint Peter's, which was embellished with marble stripped from different Roman classical palaces. Even the most admired ancient building of all, the Pantheon, eventually received a similar treatment: to produce the cannons of Castel Sant'Angelo and in part also the famous sculpted baldachin designed

by Gian Lorenzo Bernini for the Church of Saint Peter, the Pantheon, in 1625, was completely stripped of the bronze roof that decorated its portico ceiling. Pope Urban VIII, of the Barberini family, who had ordered the removal of the bronze, was harshly criticized by the Romans with this satirical quote: "What the barbarians did not do, the Barberini did."*

The most tragic event that Nicholas V witnessed during his lifetime occurred in 1453, when the Ottoman Turks (Muslims from the Ottoman dynasty), who had repeatedly attempted to attack Byzantium, were finally able to breach the powerful walls that protected the imperial city using the deadly, explosive mix that the Chinese had invented in the ninth century—gunpowder. After plundering the city and reducing to slavery a great part of its population, the Ottoman Turks crowned their victory with the conversion of Hagia Sophia into a mosque.

With the coming to an end of the Byzantine Empire that had thrived for fifteen hundred years, and with the ever-growing fear of the Muslims that the Christian world was experiencing, raising the power and glory of the capital of Christianity appeared more urgent than ever. For Pope Nicholas V, who was an intellectual and a passionate man of letters, that goal also included the permanent protection of the great past heritage. With that intention, Nicholas V sent his representatives all over Europe to collect as many ancient manuscripts as possible and welcomed to Rome a great number of Greek refugees, who, fleeing Byzantium, had been able to smuggle books out of the vandalized city. The many volumes that, thanks to Nicholas V, were assembled formed the basic core of the Vatican Library collection (a later pope, Sixtus IV, began the building of the actual architectural structure that today houses that collection).

* The quote was posted on the famous talking statue, called Pasquino, placed near Piazza Navona in Rome. The badly damaged statue, from the third century A.D., was used from the sixteenth to the nineteenth century as a sort of billboard where the Romans placed satirical lampoons, often written in verses, directed to popes, prelates, and politicians.

Another influential pope was Pius II (reigned 1458–1464), who came from the noble family of the Piccolomini. He was a strong intellect with an unbound love for the classics but also for the pleasures of this world. Besides fathering many illegitimate children, Pius II produced a tremendous amount of poems, letters, and dialogues. The pompous style he employed in his memoirs, called the *Commentarii,* reveals his attraction for rhetorical flowering, especially when used to enhance the luster of his own persona. He attributed to himself the appellation of hero and athlete of the church and described his role as that of an agent of order within the chaos of the world. Besides nepotism, which he cultivated with particular devotion, Pius II, like Nicholas V, unsuccessfully tried to persuade the rulers of Italy and Europe to join forces in a crusade against the Turks. A memorable legacy of Pius II was the rebuilding of the small city of Pienza: his Tuscan city of origin that he turned into one of the great jewels of Renaissance art. During Pius II's tenure, a great amount of alum, needed by the dye industry to fix colors, was discovered at Tolfa in the Papal States. Pius II assured a lucrative business for the church when he forbade Christians to import alum from Turkey.

In 1475, under the leadership of Pope Sixtus IV (reigned 1471–1484), another jubilee took place in Rome. To commemorate the event, the pope had a bridge built across the Tiber—the first bridge in store to be erected in Rome since imperial Roman times. Sixtus IV was also responsible for opening the first public museum in Europe, known as the Capitoline museum. Among the many works showcased in that temple of art were the enormous head and hand of Constantine (the only fragments that remained of that massive sculpture) and the famous *Spinario,* a bronze statue of a young boy extracting a thorn from his foot that would inspire legions of Renaissance artists.

At this point in time, the passion for antiquarian artifacts had reached a fever-high intensity. Some humanists, like Giulio Pomponio Leto, who loved to mourn the past by wandering and weeping among the Roman ruins, assembled a huge collection of antiquities in his home and organized an academy where students could gather, talk, and pretend to still be living in the heyday of the Roman Republic.

It was within this passionate atmosphere that a major archaeological search for old art masterpieces was launched. Among the main discoveries: the *Apollo Belvedere* and the statue of Laocoön, which was unearthed in a Roman vineyard in 1506. When parts of Nero's Domus Aurea were first located, many thought that they were strangely decorated caves (*grotte* in Italian). Michelangelo and Raphael repeatedly visited the place, lowering themselves underground with the help of a ladder to study the frescoes. The style called *grottesco,* or "grotesque," from *grotta,* which they admired and copied, was later adopted by many other Renaissance artists.

Besides the Vatican Library, Sixtus's most ambitious project was the Sistine Chapel that was to be used for major papal functions. Perugino and Pinturicchio, both from Perugia, were the first two painters the pope hired to decorate the chapel. As we have seen, Sixtus IV was the pope who had been involved in the Pazzi conspiracy in Florence. After the break that had followed, Lorenzo de' Medici, who wanted to resume business with the church, sent as an act of ingratiation some of his best artists to Rome to work for the pope. The paintings in the lower part of the Sistine Chapel bear their names: Sandro Botticelli, Domenico Ghirlandaio, Cosimo Rosselli.

Sixtus's reputation was particularly tarnished by his unrepentant habit of awarding important positions to family members. No one, though, was able to bring that bad habit to the degree of refinement reached by Alexander VI (pope from 1492 to 1503), who tirelessly worked at assuring the preeminence and political prestige of his family members. Alexander's lack of religious vocation, his immoderate ambition, his taste for pleasure and luxury, and his cynical political astuteness gained him a reputation as one of the most corrupt popes of the Renaissance. He fathered many children, among them Cesare Borgia, who inspired Machiavelli's *Prince,* and the beautiful Lucrezia, with whom, apparently, both brother and father had an incestuous relationship. Alexander, whose original name was Rodrigo Borgia, was born in Xàtiva, Spain, in 1431. He was made cardinal at a very young age by his uncle Pope Callixtus III, who had occupied the seat of Saint Peter between Nicholas V and Pius II. To pave his way to

the papacy, Rodrigo generously disbursed money and favors to vari-
ous cardinals. When, through bribes and corruption, he was finally
able to realize his dream of becoming pope, Rodrigo chose to adopt
the name Alexander in memory of the legendary Macedonian leader,
whom he vainly wished to resemble.

Alexander VI was also the pope who gave the honorary title of
Reyes Católicos, or "Catholic Regents," to Ferdinand of Aragon and Isa-
bella of Castile: the monarchs who after eight hundred years of Mus-
lim occupation had finally been able to retake control of all of Spain
by conquering Granada, the last bastion of Islam within the Iberian
Peninsula. Of course, the other main achievement of Ferdinand and
Isabella was the sponsoring of Christopher Columbus, who discov-
ered America in 1492. Before Columbus's landing in the New World,
the Atlantic Ocean was believed to be an endless body of water that
people feared because it was said to engulf all those who dared to
cross it. The dictum that during the Middle Ages was connected
with Gibraltar was *Non plus ultra,* which meant "not further than
this point." Dante's metaphorical description of Ulysses's adventure
beyond the symbolic limit set by the Pillars of Hercules (as Gibraltar
was called) was an audacious attempt to acquire knowledge of what,
according to God's command, was to remain forever unknown. Some
scholars believe that the name of the Atlantic Ocean may derive from
the legendary island of Atlantis, which, as Plato claimed, had been
sunk by the gods to punish the excessive hubris of its inhabitants.

Because Alexander VI formally entrusted the lands of the Ameri-
cas to Ferdinand and Isabella (except Brazil, which was later assigned
to Portugal), he was rewarded with shiploads of gold sent back to
Spain from America. That precious material was used for the mold-
ings that we can still admire today on the ceiling of the Church of
Santa Maria Maggiore in Rome.

It was during the papacy of Alexander VI that Michelangelo
Buonarroti first came to Rome. Michelangelo was born in a small
town in the Tiber valley in 1475. At a very young age, the family
placed the young boy in the care of a nurse who was the daughter and
wife of two stonemasons. When he was an old man, Michelangelo

wrote to Giorgio Vasari, "Giorgio, if I have anything of genius, it came to me from being born in the keen sharp air of our town Arezzo; just as I drew in with my nurse's milk the chisels and the hammer that I use to make the figures." Michelangelo started his artistic career in Ghirlandaio's workshop, where he learned the art of painting. Very soon, though, he understood that his true passion was for sculpture more than brushes and colors. Ghirlandaio, who was notoriously envious of all those who could be a threat to his artistic reputation, was more than happy to see the talented young boy leave his shop to go to the Medici garden in San Marco, which, besides a place where great art was displayed, was a school of sculpture.

Soon attracting the attention of Lorenzo, who was always on the lookout for new talents, Michelangelo, who at that time was a fifteen-year-old boy, was invited to occupy a room in the Medici palace. During the three years in which he lived in the Medici palace, Michelangelo regularly attended dinners with Lorenzo and his close entourage—a privilege that would have been unthinkable for a sculptor or a painter in medieval times. For the inquisitive young boy, being exposed to the sophisticated discussions of the intellectual caliber of Politian, Marsilio Ficino, and Pico della Mirandola must have been an overwhelming and truly illuminating experience. Things changed when, after Lorenzo's death, his son Piero was expelled from the city because, as we have seen, he had so poorly handled the aggressive stance of the king of France, Charles VIII, and the fanatic Savonarola rose to power. Fearing the new atmosphere, the young Michelangelo fled Florence and wandered for some time between Bologna and Venice. Among the works that Michelangelo sculpted in those years is the image of a sleeping Cupid represented as a six-year-old child. The statue was so perfect that some friends of the artist suggested to artificially age the sculpture in order to sell it as a real archaeological find. Amused by the thought, Michelangelo agreed: he touched up the statue to make it appear ancient and sent it to Rome to a middleman who was able to sell it to the cardinal Raffaele Riario, a member of one of the most prestigious and well-connected families in Rome. The prank, which was eventually discovered, greatly offended

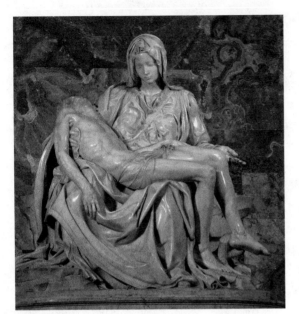

Michelangelo's immortal *Pietà* (ca. 1499)

Cardinal Riario, but not enough to prevent the angry (but also smart) art lover from inviting to Rome the extraordinary young artist who had been able to trick even his highly trained eyes. It was during that sojourn in Rome that Michelangelo was introduced to a French cardinal who was looking for a talented artist who would carve his funerary monument. The immortal *Pietà*, which the twenty-three-year-old Michelangelo executed in only one year, between 1498 and 1499, was the result of that commission.

Dramatically evoking, in a reverse manner, the Nativity scene, where the mother cradles her newly born baby in her arms, the completely lifeless body of Christ lies across His mother's lap. In contrast with the abundant mantle that envelops Mary, the stark nakedness of Christ appears incredibly vulnerable and frail. It is hard to perceive any sign of salvation in the dead body of that all-too-human son, whom the mother holds with one arm while the other is extended in a gesture that seems to indicate both surprise and bewilderment. Her tearless expression indicates her obedient submission to the will of God, so similar to the stoic acceptance of Abraham when asked to sacrifice his son Isaac. Despite such a stoic attitude, the burden of pain remains intolerable, heightened by the extraordinary youth that Michelangelo attributes to Mary.

In the meantime, in Florence the political winds had turned once again with Savonarola's being burned at the stake and the republic

restored under the guidance of the *gonfaloniere,* Soderini. To celebrate the moment, the Wool Guild, in 1499, offered Michelangelo a colossal piece of marble, which had been discarded by a previous artist, in order to carve out a statue that would symbolize the freedom of the newly reestablished republic. To embody the love of freedom that the republic represented, Michelangelo, for his seventeen-foot-tall statue, used the image of the biblical David.

Just as with the athlete/hero of classical art, rather than the action moment, what we see is its announcement, as we deduce from the small stone barely visible within the grasp of David's enormous hand and the intensity of the predatory gaze that guides, with unemotional resolution, that awesome mass of flesh and muscle. The daring choice to portray David in the nude (as Donatello had done before him) is meant to forcefully exalt the dignity of man and the redemption of its concrete, organic, material reality.

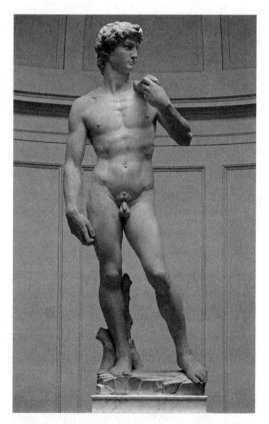

As a perfect consonance between psychological depth and physical strength, Michelangelo's *David* embodies the empowering beauty of virtue, reason, and patriotism that Michelangelo and his fellow humanists associated with the establishment of the Florentine Republic. Nothing more was needed to indicate who, between David and Goliath (the latter symbolizing all enemies who threatened the

Michelangelo's *David,* a celebration in marble of man's inner and outward strengths and beauty

freedom of Florence), was going to turn out to be the true winner at the end of the contest.

The grateful city had the statue placed in front of the Palazzo Vecchio as a reminder to all citizens that no tyrant was to be feared because no strength was comparable to the power possessed by those who loved the republic and defended its freedom.

Following the success of the *David,* Soderini proposed two huge frescoes to be placed in the Hall of Five Hundred inside the Palazzo della Signoria. The other painter Soderini wanted to work along-side Michelangelo was Leonardo da Vinci (the genius who brilliantly contributed to an astounding array of disciplines, such as painting, architecture, music, literature, mathematics, anatomy, and astron-omy). The idea was not too pleasing to Michelangelo, who resented Leonardo for having declared that painting was superior to sculpture. Fortunately for Michelangelo, he never had to confront Leonardo because he was suddenly summoned to Rome by the new pope, Julius II.

Julius II (reigned 1503–1513), who was close to sixty years old when he became pope, had been made cardinal at twenty-seven by his uncle Sixtus IV. Driven by an intense hate for his predecessor, Alex-ander VI, Julius II threatened to excommunicate all those who dared to remember or mention the Borgia pontiff. Like his uncle Sixtus IV, Julius II belonged to the Franciscan order established by the humble saint of Assisi. Being a Franciscan did not seem to mean much to Julius II, who resorted to plenty of corruption and manipulation to buy his election as pope. When asked what name he wanted to be called as pontiff, he chose a historical figure big enough to match his very inflated sense of self: Julius, as in Julius Caesar.

The name was fitting because, like Caesar, Julius II was an extremely ambitious and bellicose man. Like most Renaissance princes, he weaved his strategies with masterful and cynical ability, being deceitful even when he appeared conciliatory. He was called the *papa guerriero* (warrior-pope) because he personally led his troops to battle against the usurpers who, taking advantage of the absence of the church during the exile in Avignon, had taken control of the

papal territories of Umbria and Romagna. The victory over Bologna and Perugia gave the pope's reputation a legendary status.*

To make sure that his memory would live forever, one of the first things that Julius II did when he became pope was to plan his funerary monument. Michelangelo, who by now was recognized as the greatest sculptor of his age, was summoned by the pope to realize the project, which, in his intention, was to rival the mausoleums of emperors as famous as Augustus and Hadrian. To match the grandiose ambition of the pope, Michelangelo suggested a huge monument decorated with forty statues: some personifying the pope's territorial conquests, others the liberal arts in celebration of his humanistic contribution to culture. The symbolic association with Moses, whose image was to be placed on top of the monument, was meant to suggest that Julius II possessed qualities unmatched by all other previous leaders of the church.

Upon receiving the pope's approval for the project, Michelangelo went to Carrara, where he remained for several months to supervise the quarrying of the enormous quantity of marble that was to be shipped to Rome on big cargo boats. Initially, the pope had decided that his funerary monument was to be placed in the Roman Church of San Pietro in Vincoli. But while Michelangelo was in Carrara, the pope changed his mind and decided that the right location for the monument was the actual Basilica of Saint Peter. When he was told that in order to fit the gigantic work that Michelangelo was going to execute, the roof of the old basilica had to be raised, the pope decided that it was better to demolish the church altogether and build in its place a bigger and more lavish one.

Many people considered the idea outrageously disrespectful. The Basilica of Saint Peter, which had been built by Constantine, had witnessed many centuries of church history: Charlemagne had been

* Julius's troops were composed of mercenaries from Switzerland. Their colorful costumes, designed by Michelangelo, are still used today by the Swiss guards assigned to protect the pope.

crowned inside those walls, and the bones of many popes had been
put to rest next to that sacred edifice. But as everybody knew, trying
to dissuade Julius, who was known for his violent fits of anger, was a
lost cause. Better to suffer the destruction of the old church than the
fury of the *papa terribile* (the terrible pope), as he was known. To take
on that massive endeavor, the pope selected the architect Donato Bra-
mante (1444–1514). When Michelangelo, upset by the news, returned
to Rome and tried to see the pope to discuss his work and his retribu-
tion, the pope failed to grant him a meeting. Offended, Michelangelo
promptly left for Florence with the intention of never returning to
Rome to work for the pope.

It took a very long time for the pope to get Michelangelo to
reverse his decision. When he finally agreed, Michelangelo was again
disappointed: the reason the pope wanted him back in Rome, he
soon discovered, was to work not on the tomb but on the ceiling
of the Sistine Chapel. Michelangelo was convinced that the jealous
Bramante had plotted the change of plan: knowing that painting was
not the medium Michelangelo was most comfortable with, Bramante
had influenced the pope's decision with the hope of seeing his rival
fail. Michelangelo's suspicion was probably unfounded: Julius II knew
exactly what he was doing, and most likely no one, not even Bra-
mante, had influenced his decision.

As we have seen earlier, patrons were accustomed to establish-
ing the subject matter that artists had to execute. That was true also
in the case of the Sistine frescoes, which as the pope told Michel-
angelo were to represent the twelve apostles and some geometrical
designs in between. When Michelangelo protested, saying that the
design was too simple, the pope, instead of getting angry, gave per-
mission to Michelangelo to do whatever he preferred. That, at least,
is what Michelangelo's sixteenth-century biographer Ascanio Condivi
claimed. Some scholars believe Condivi's version of the facts; others
reject them as false. It is unlikely, the second group says, that the
pope would have left such a big responsibility in the sole hands of the
artist without any guidance on his part or that of some theological
expert. Those who believe Condivi's words disagree: Julius II was a

very impulsive man who was used to following what his immediate instinct suggested without regrets and second-guessing. For example, when he decided that Raphael was to decorate the Stanza della Segnatura, he did not show the slightest hint of hesitation in ordering the destruction of the works that previously decorated the walls, even if they belonged to painters as talented as Piero della Francesca, Signorelli, and Perugino. That said, this group of scholars continue, it is also the absolute originality of the frescoes that Michelangelo eventually did that seems to prove that the artist was allowed to conceive the program alone and was not obliged to submit his ideas to some pedantic expert who, for certain, would never have allowed such a swirl of naked bodies to occupy the sacred chapel.

We will never know for sure what really happened. However, what we can be completely sure about is this: if Julius II appeared so willing to postpone the building of his funerary monument, it was not because he had suddenly acquired a humble disposition but because he had come to realize that the Sistine Chapel had the potential of becoming a much greater tribute to his legacy and memory.

Because discussing the symbolic meaning of the 343 figures that Michelangelo depicted in the chapel would be inexhaustible, I will linger on just a few intriguing examples, like the replacement, on the lower perimeter of the vault, of the twelve apostles initially proposed by the pope with seven prophets and five mythological sibyls of pagan times. What united the prophets and the sibyls was the gift of prophecy, a gift that was meant to be an anticipatory allusion to the advent of the Messiah.

Some scholars believed that next to that most obvious interpretation a second intriguing suggestion is possible: that what the prophets and sibyls might have

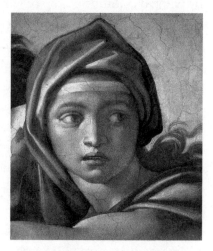

One of Michelangelo's prophetic sibyls in the Sistine Chapel

hinted at was also the birth of the new Rome, seen as a triumphal confluence of paganism and Christianity, made possible by the advent of another messianic figure—Julius II. Attributing to a mere human being, even a pope, such an inflated status may seem for us an unthinkable proposition, especially for a place of prayer. What we should not forget is that our contemporary view has been shaped by many centuries of tradition that, among many other things, include the long age of atonement that, after the Renaissance, the Counter-Reformation represented. But in the dangerously secularized version of religion that the times we are considering experienced, such exorbitant claims might not have appeared as unscrupulous and offensive, especially if coming from a pontiff who, acting like an emperor, used religion in the same calculating and politically advantageous manner that Caesar and later Augustus had done when they had assumed the title of *pontifex maximus*. For a pope, insatiably craving power and a long-lasting legacy, implying that God had selected in him a Moses-like avatar assigned to the messianic duty of spreading Christianity throughout the world—a world that with the newly discovered lands of America had become so much vaster—would have appeared as an opportunity much too great to miss and ignore.

The thrones on which the prophets and sibyls are seated are divided by painted columns on top of which are depicted a series of naked figures (called *ignudi*, from *nudi*, meaning "naked" in Italian). What role those muscular naked bodies represented has remained a mystery. Perhaps they were intended as a tribute to pagan art whose many masterpieces had recently been unearthed, for example, the statue of the Laocoön, which they so closely resemble. The garlands with big acorns on the heads of some of these *ignudi* were most likely allusions to Julius II, who belonged to the family Della Rovere, meaning "oak tree" in Italian. In time, the scandal that the depiction of *ignudi* provoked, especially during the years of the Counter-Reformation, led Pope Paul IV to order the painter Daniele da Volterra to cover those sacrilegious sights with a veil. The task earned Daniele da Volterra the nickname *il braghettone*, meaning "the pantaloon maker."

The most famous scenes of the Sistine Chapel frescoes cycle are

placed in the central rectangular space, where Michelangelo depicts several scenes derived from Genesis, such as God's division of light from darkness, the creation of the sun and the moon, and the division of the waters from the land, as well as the creation, temptation, and fall of the first two humans. Of all of the images, of course, the most striking is the moment in which Adam, newly created, is endowed with the miraculous spark of life by God, Who touches with His index finger the extended hand of His languidly reclined creature. The absence of any biblical reference to such a touch makes certain the fact that Michelangelo was the sole author of that highly moving and poetic gesture.

Nothing is more beautiful than this extraordinary image. But having examined medieval art, the way we have done in this book, it is easy to see how greatly Michelangelo dared to distance himself from the traditional tenets of theology. As we have repeatedly said,

God bestowing the spark of life on Adam—one of the most extraordinary (and revolutionary) images in Western art

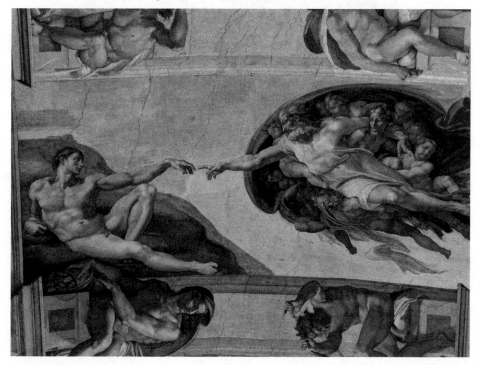

other than through a hand appearing from the sky or via the Christ, providing a visual representation of God had been categorically forbidden throughout the Middle Ages. The first clear transgression of that rule appears in Masaccio's *Holy Trinity* in Santa Maria Novella, in Florence, where perspective is used to push to further and further levels of depth and meaning the message of the Passion: from the level of reality that the donors occupy by being placed in the foreground, to the further vision contained within the arched niche where Mary and Saint John are seen standing next to the crucified Christ. At even

Masaccio's *Holy Trinity* (ca. 1427–1428) in Santa Maria Novella in Florence, one of the first real transgressions of the stricture against representing God the Father

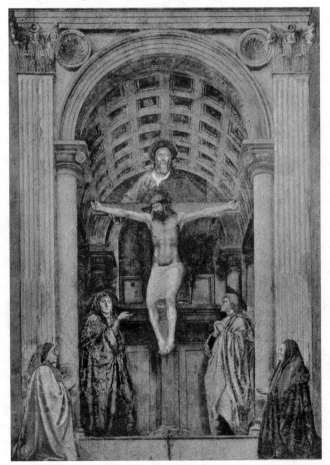

greater depth, farther removed from the viewer, we see the figure of God the Father, featured as an old man, placed behind the cross.

Masaccio's skillful adaptation of the modern technique of perspective to symbolically indicate the layers of meaning contained in the mystical vision must have greatly impressed some people but also scandalized many others, like the theologically conservative Savonarola, who must have felt that Masaccio had committed a deplorable transgression by attributing human features to the nonquantifiable and non-circumscribable mystery of God. The other artist who dared to give human features to God the Father was Jacopo della Quercia. The image is found in the scene representing the creation of Adam, which is part of a series of reliefs that Jacopo della Quercia did for the Basilica of San Petronio in Bologna. Yet, when compared with the frescoes of the Sistine Chapel, both examples pale. In Michelangelo's representation, God is an old man with a massive and semi-naked body barely covered by a short tunic Who appears surrounded by a group of angels on whom He almost seems to rely to remain airborne. The image was so alien to the people of his time that when Paolo Giovio, the bishop of Nocera, saw Michelangelo's frescoes in 1520, he was unable to recognize the "old man in the middle of the ceiling, who is represented in the act of flying through the air."

The abundant cloak that covers the body of God in other scenes does not do much to improve the theological correctness of the images. On the contrary: in the scene that depicts the creation of the firmament, the human-like description of God is so incredibly tangible, organic, and anatomically detailed that when it is seen from behind, we can even recognize the shape of God's buttock!

As we know, according to tradition, when scenes from Genesis were depicted, God was to be given the features of Christ, Who in turn perfectly mirrored the beauty that Adam possessed before the Fall. The solution was important because it avoided the representation of God the Father, Who was to remain a mystery to man, while stressing man's duty to imitate the lesson of Christ the Son. The essence of that lesson was not that man could become like God but that his life was a journey—a striving forward toward a greater and

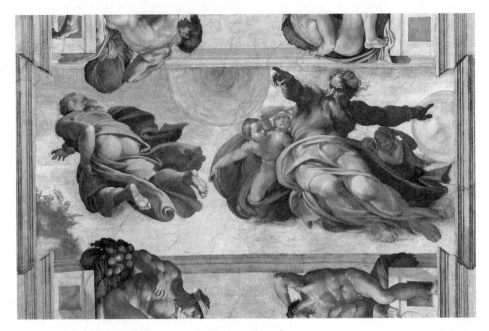

God, viewed from behind, in the Sistine Chapel

greater form of perfection, which nonetheless was never to find full realization here on earth.

Even though Michelangelo's frescoes make reference to the sin of Adam and Eve (with the tempting snake bearing a feminine face as a symbol of the sinful sensuality traditionally attributed to women), the central importance granted to Adam, seen as a beautiful and young-looking man, in contrast to an aged God, is amazing and puzzling at the same time. The first thing that comes to mind is, of course, Pico's *Oration on the Dignity of Man,* where, as we have seen, the dignity and freedom of man are celebrated by these words attributed to God: "Thine own free will shall ordain for thyself the limits of thy nature." The historian Arthur Herman, in his book *The Cave and the Light,* says that the most striking suggestion implicit in Pico's words is that man was granted the permission to become whatever he wanted to be, with no divinely imposed limits to his knowledge and will: "To [man] is granted the power to have whatever he chooses, to be whatever he wills."

Pico's extraordinary endorsement of the limitless potential of human life is reproposed in Michelangelo's work, where God and man appear to be placed on an equal plane of importance. Yes, God is suspended in space as if flying, while man's body is sustained by the ground on which he is reclining, but, apart from that unequal dimension, everything else about the figures—youth, beauty, vigor—seems to exalt man almost more than God. The choice, besides Pico's *Oration,* brings to mind Hesiod's *Theogony,* where each new generation of gods eventually comes to take possession of the powers and privileges previously held by their divine parents. If we accept such a proposition, Michelangelo's Adam can almost be compared to a Prometheus-like figure, proudly conscious of his titanic creative capacity to master, in a way that increasingly appears godlike, the forces of nature and life.

In attributing to God human features, man implied that his intelligence could contain God and encompass Him within his own dimension. The limits of human nature were gone. The Renaissance's greatest transgression was the invention of a God made in the image and likeness of man.

In the same years in which Michelangelo painted the Sistine Chapel, another amazing artist was working for Julius II, Raphael Sanzio. Raphael, who was eight years younger than Michelangelo, was born in Urbino in the Marche region in 1483. Under the rule of Federico II of Montefeltro, the court of Urbino had become a sophisticated center of culture and art. It is not a coincidence that Castiglione chose that refined court as the stage for his famous book, *Il cortigiano,* or *The Book of the Courtier* (written in 1514 and published in 1528). At the court of Federico, the young Raphael was introduced to the work of Italian and Flemish artists such as Paolo Uccello, Luca Signorelli, Piero della Francesca, Hieronymus Bosch, and Joos van Gent. The time he spent as an apprentice in the workshop of Pietro Perugino gave Raphael's brush the graceful elegance he never lost throughout his stellar career, which was cut short by an early death when he was only thirty-seven years old. The other important painter who had a formative influence on Raphael's style and technique was Leonardo, whom he met during

a sojourn in Florence. (By that time, Leonardo had already painted the *Mona Lisa* and *The Last Supper* in 1495–1497.)

In 1508, the same year in which he summoned Michelangelo to Rome, Julius II, maybe following the recommendation of Bramante, who was also originally from Urbino, invited the young Raphael to Rome to paint a series of rooms in the Vatican that were part of his apartment. It is believed that Julius's project was prompted by the desire to outshine Alexander VI, a man he detested, whose apartments were right below his. Because the task he was assigned was enormous, Raphael had to hire several assistants who contributed to the completion of the work.

Raphael started the work in 1509. The first room he painted was the Stanza della Segnatura, which was to house the pope's library and was intended for the official signing of documents. The subject matter of the frescoes, which contain the essence of humanism with its cocktail of pagan and Christian themes, is devoted to the beauty of poetry, the wisdom of philosophy, and the truth of theology. The first two walls that Raphael painted were *Disputation over the Most Holy Sacrament* and the *School of Athens*. In the first fresco, which focuses on the Eucharistic transformation of the body and blood of Christ, God the Father appears above His son, Who is seated on a throne surrounded by Mary and John the Baptist. In the crowd that surrounds them we recognize biblical characters like Abraham, David, Saint Peter, and Saint Paul, as well as theologians and saints such as Saint Augustine, Saint Ambrose, Saint Stephen, Saint Lawrence, and even Savonarola (possibly intended as an insult to Alexander VI, who dealt with the rebellious monk) and Dante. The fact that Dante is given a place of honor among so many saintly figures seems to sanction the poet's journey in the afterworld as theologically acceptable.

After that first representation, Raphael turned his attention to the *School of Athens*. The vast open space surmounted by a massive, Roman-like vault is the setting that Raphael used to present an imaginary gathering of philosophers—Pythagoras, Socrates, Diogenes, Heraclitus, and many others. The depth of the scene that the skillful use of perspective enhances well complements the intellectual depth that

those pensive figures convey. At the very center of that crowded scene are the two leading figures among all philosophers: Plato and Aristotle. Plato, who holds the *Timaeus,* points upward, while Aristotle, who hold his *Nicomachean Ethics,* points downward. The proximity of the two philosophers and the equal importance that they are given illustrate the unity of knowledge that the Renaissance had finally achieved.

On the third wall, Raphael placed the representation of Mount Parnassus with Apollo and the Muses and around them a gathering of famous poets such as Homer, Sappho, Virgil, Horace, Ovid, and, again, Dante. The representation of the cardinal virtues on the fourth wall completes the decoration of the Stanza della Segnatura.

THE PROTESTANT REFORMATION
AND THE SACK OF ROME

When Julius II died in 1513, Michelangelo's frescoes in the Sistine Chapel had just been unveiled. But according to the pope's plan for the Vatican a lot more was still to be done. For that reason, in the last days of his life, Julius issued a pronouncement that assured indulgence to all those who would have contributed money to the completion of the work that the Curia had planned. After his death, his successor, who was the Florentine son of Lorenzo the Magnificent, became pope with the name of Leo X (reigned 1513–1521). Like many wealthy and privileged people, Leo began a career in the church at a very young age. He became a priest when he was eight years old, abbot of the Benedictine monastery at Monte Cassino at eleven, and cardinal at thirteen. When he became pope, after years of never allowing faith and humility to distract him from his pursuit of power and glamour, he cheered, "Let us enjoy the Papacy, since God has given it to us." True to his word, he made entertainment and gaiety the trademark of his papacy. Some among his most deplorable predecessors had already

made Rome famous for the depravity that took place during festivals, which often included the spectacle of public executions. Among the most cherished traditions were the festivities that took place during Carnival, when bulls were let loose in the streets of Rome so that men on horses could chase and kill them with their lances. Another popular amusement was a race where Jews, dressed in silly costumes, were forced to run down the street while people mocked them and insulted them and soldiers terrorized them with their spears. During Leo's tenure, bullfights were organized in the Belvedere Courtyard, built by Bramante, in the Vatican Palace, while big hunting expeditions often took place in the Roman countryside.

Leo, who was fond of collecting exotic animals, such as monkeys, parrots, and lions, was surprised by the king of Portugal with the gift of an elephant named Hanno. When he arrived at the Vatican, the elephant, who was wearing two pairs of red shoes similar to the ones worn by the popes, knelt two times in front of Leo. The relation between the papacy and Portugal had become extremely cordial since Pope Nicholas V had issued a bull that allowed the colonial expansion of Portugal and also validated its profitable trade of slaves with these words: "We grant you . . . full and free permission to invade, search out, capture and subjugate the Saracens and the pagans and any other unbelievers and enemies of Christ . . . to reduce their persons in perpetual slavery." Similar privileges had been granted, in earlier times, to Spain by Alexander VI.

Because he was in need of revenues, Leo X promoted once again the selling of indulgences, a payment that was said to shorten the amount of time a sinner had to spend in purgatory. The decision sparked the anger of Martin Luther (1438–1546), a professor of moral theology at the University of Wittenberg in Germany, who, disgusted with the corruption of the church, nailed ninety-five theses against the indulgences on the door of the All Saints' Church in Wittenberg, Saxony. The essence of Luther's message was that faith alone—*sola fide*—could affect salvation and that the teachings of the Bible could be received without the intermediary intervention of the clerics and

the popes. With that claim, the assumption that the church, as the custodian of revelation, had the right to control the life of people through confession, penance, and the performance of rituals and sacraments (of the seven sacraments, Luther accepted only Baptism and the Eucharist) was suddenly pushed aside, leaving the individual free to confront, alone, the truth expressed by the Scriptures. The change should not be interpreted as an empowerment of man. For the German preacher, in fact, man remained a very wicked and insufficient creature who could find salvation only by totally submitting and annulling himself in the cultivation of faith, which was a direct gift from God.*

To confute Luther's proposition, the pope issued a bull that condemned his teaching and ordered him to recant his theses. When Luther refused, the pope excommunicated him. Probably not even Luther anticipated the earth-shattering effects that his action eventually produced, especially among the poor, who had come to deeply resent the venality of the church and the callous indifference that the institution, which was supposed to embody the charitable spirit of Christianity, reserved toward those who suffered. With the printing press, which, as we have seen, was introduced in the middle of the fifteenth century, becoming available, Lutheran principles spread with the speed of fire throughout Europe.

Luther's position proved particularly successful in Germany, which was still a mosaic of independent principalities that, lacking a centralized form of government, could not as effectively contain, as in France or in England, the power of the church and the excessive taxes that the Curia imposed on the Christian flock. The best description of the greediness that for so long had characterized the church was

* In Switzerland, the spirit of reformation assumed an even more radical stance with Ulrich Zwingli (1484–1531) and especially John Calvin (1509–1564), who articulated the concept of predestination: because he was a depraved and sinful creature, man's action, Calvin said, had no power in attaining salvation—an undeserved gift that could derive only from God's mercy and love.

uttered by an English king who said that the successors of the apostles "were commissioned to lead the Lord's sheep to pasture, not to fleece them."

Once it appeared clear that the widespread discontent could not be appeased, a diet, or congress, was organized in Speyer in 1526, where it was established that each German principality could decide if it wanted to be Catholic or Protestant. Three years later, the emperor Charles V of the Habsburg family, who through a complicated series of dynastic successions and marriages had simultaneously become the ruler of Flanders, the Netherlands, Austria, Hungary, and Bohemia, as well as Spain (with its colonial territories of Mexico and Peru), all of southern Italy, and Burgundy and Artois in France, revoked the agreement reached in the Diet of Speyer probably because he feared that the fast spread of Lutheranism would have weakened even further the already tenuous power he held on the German territories. But it was too late. When he realized that he could not contain any longer the ever-growing movement, the emperor was compelled to sign the Peace of Augsburg of 1555, which confirmed, once again, the edict of the Diet of Speyer.

Italy had enjoyed a relative peace almost until the end of the fifteenth century. But the frail condition of the politically fragmented peninsula soon became an irresistible temptation for many foreign powers. As we have seen, the French king Charles VIII first entered Italy in 1494 with the purpose of heading south to recover the kingdom of Naples that had been snatched away from the French house of Anjou by the Spanish house of Aragon. Charles VIII was forced to retreat when confronted by the Holy League formed by the alliance of powers that feared the expansionist intentions of the French king. The powers that joined the Holy League were Austria, Spain, England, Milan, Venice, and the papacy led by Alexander VI.

A few years later, when the French reentered Italy and occupied Milan, Pope Julius II formed a new Holy League (1511) with Venice, Austria, Spain, and England. The coalition was able once again to push the French out of Italy. But it did not last. By 1515, the French, led by

Francis I, again took hold of Milan. To curb the growing ambition of the rival country, Charles V, the Habsburg ruler, intervened against France. After a brief period of time in which Milan was tossed back and forth between the two powers, Charles V was able to capture and imprison the French king, Francis I. (Besides that shameful humiliation, Francis I is known for introducing the spirit of the Renaissance in France by sponsoring a great amount of art and also by inviting Leonardo and Benvenuto Cellini to live and work at his court.)

Only when he promised to give up his claim on Milan was the French king granted freedom. In a typical Renaissance manner, Francis I broke the promise and went on to form an alliance with several Italian states and Pope Clement VII (reigned 1523–1534), who was the illegitimate son of Giuliano de' Medici, Lorenzo's younger brother, who had been killed in the Pazzi conspiracy.

Clement's decision to change sides and align himself with France was probably dictated by the fear of the much greater threat that Charles V posed. The move proved disastrous for the pope, whose decision was punished with the sack of Rome in 1527. It was enacted by a German division of mercenary soldiers whom the emperor Charles V failed to pay for lack of funds. As a consequence, the Landsknechts, who as followers of Luther hated the papacy, diverted their course toward Rome with the intention of looting it with no opposition on the part of the emperor. When they reached Rome, the Landsknechts pillaged the city of its treasures and also gave free rein to the anger they felt toward those who had abused their role as pastors of the Christian flock. Churches were desecrated, reliquaries smashed, nuns raped, and thousands of people killed.

Clement VII was praying in the beautiful chapel that Fra Angelico, commissioned by Pope Nicholas V, had painted when the rebellious German troops made their way into the Vatican. The pope escaped using a corridor that connected the Vatican to Castel Sant'Angelo, which had been turned into a papal fortress by Alexander VI. Some mercenaries, who recognized him by the white toga he was wearing, tried to kill him, but Clement was able to escape.

THE LAST JUDGMENT

After the disastrous sack of 1527, Clement VII's successor, Pope
Paul III (reigned 1534–1549), of the prestigious Farnese family,
became convinced that a reform was necessary for the survival of
the church, and for this purpose he established the Council of Trent
that in 1545 initiated the Counter-Reformation. Paul III was also the
pope who instituted the morally and intellectually rigorous order of
the Jesuits (to which belongs the current pope Francis) and reorga-
nized the Inquisition to persecute heresy, blasphemy, and witchcraft.
When the king of England, Henry VIII, asked him to annul his
marriage with Catherine of Aragon to marry Anne Boleyn, the pope
refused. After Henry VIII declared the independence of the Church of
England from Rome with the Act of Supremacy of 1534, Paul III
excommunicated him. The inflexible severity that characterized the
pope's career did not translate in his private life: indifferent to the vow
of chastity that all priests were supposed to maintain, he had a mis-
tress and five children. His questionable morality is also illustrated by
the authorization, issued in 1548, in which he allowed ownership of
Muslim slaves within the Papal States. Paul III was also responsible
for calling Michelangelo back to Rome to paint *The Last Judgment* on
the altar wall of the Sistine Chapel.

When the first Medici, Leo X, had become head of the church, he
had sent Michelangelo back to Florence to complete the facade of the
family church of San Lorenzo. After three years of planning, the proj-
ect was suspended for reasons that remain unclear. The bare appear-
ance of the Church of San Lorenzo that to this day lacks a facade is an
odd sight in a city so resplendent with marble and stones of all colors.
The adjacent Medici Chapel, which was conceived as a mausoleum
for the family, was designed by Michelangelo, who also decorated the
interior with the magnificent reclining figures that appear on the sar-
cophagi that represent Evening, Dawn, Night, and Day.

When he called Michelangelo back to Rome, Paul III had in

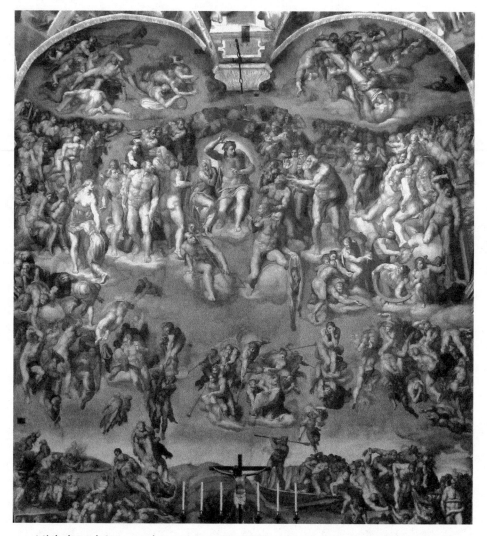

Michelangelo's *Last Judgment* (ca. 1536–1541), a fresco that covers the altar wall of the Sistine Chapel and that from the start aroused criticism and controversy

mind a variety of assignments that would employ all of the artist's talents as architect, sculptor, and painter. Besides the design for the cupola of Saint Peter's, the most memorable legacy that this last phase of Michelangelo's boundless artistic creativity produced is the scene of the Last Judgment that he painted, between 1536 and 1541, on the altar wall of the Sistine Chapel—a fresco that the pope, still shaken

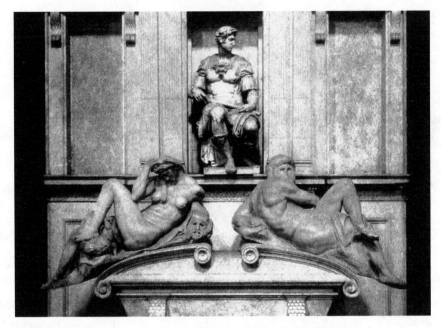

Two of Michelangelo's magnificent figures outside the Medici Chapel
of the Church of San Lorenzo

by the events that had taken place in 1527, intended as a warning
against all transgressors of the Christian teaching.

 The Last Judgment is characterized by a dark and thunderous qual-
ity conveying the terror of an apocalyptic storm (see page 417). The
focal point of the scene is occupied by the figure of a mighty judg-
ing Christ, Whose almost naked body bears a great resemblance to
the classical sculpture of the *Apollo Belvedere* kept in the Vatican. By
raising His hand in a powerful gesture of command, Christ divides
the blessed from the damned by assigning to each soul the place it
will occupy for eternity in paradise or hell. The whirlwind of figures
that surround the severe Pantocrator, or "Almighty," is composed of
saints and trumpeting angels awakening the dead, as well as a crowd
of martyrs, each carrying the instrument with which he or she was
tortured and killed. At the right and left corners, on the very top of
the scene, holy figures present the instruments of Christ's Passion, the
cross and the pillar. The intensity of *Dies irae,* or "God's wrath," is
fully felt on the left of Christ, where the damned souls are dragged

down to hell by horrible demons serving the king of darkness, Lucifer. Charon with his boat carrying the damned souls across the infernal river is a direct quotation of the same scene from Dante's *Inferno* that greatly inspired Michelangelo. When the frescoes were restored a few years ago, two wings along the side of Charon's boat came into focus. For Michelangelo, who was an assiduous reader of the *Divine Comedy*, the detail was probably a reference to Dante's Ulysses, whose winged boat (in *Inferno* 27.125, Dante's Ulysses compares the oars of the boat to wings and calls his journey a "mad flight") sank for having transgressed the limit imposed on human knowledge by God. Within the spirit of moral reform that now animated the times, the choice was very likely a way to cast judgment on the Renaissance—a time that, by encouraging all sorts of adventures in pursuit of knowledge, had ended up, just like Dante's Ulysses, going well beyond the limit that the Christian God had imposed on mankind.

The detail was probably also used to express the sense of guilt that the sixty-five-year-old Michelangelo felt toward some aspects of his own artistic journey. The sharp contrast between the theological consistency of *The Last Judgment* and the daring representation of God next to the Prometheus-like exaltation of man, to which more than a quarter of a century earlier Michelangelo, in that very same chapel, had given shape and form, speaks for itself.

What confirms that suspicion can be found in the upper section of the fresco, where Michelangelo depicts Saint Bartholomew, the martyr who was flayed alive, holding his own skin in his hand. In the folds of that skin, Michelangelo chose to place his own features. The echo of the *Divine Comedy* can be heard once again. As we have seen, at the opening of *Paradiso*, Dante places an invocation to Apollo, the god of poetry whom the poet symbolically uses as a representation of Christ. Asking Apollo to inspire his words was meant to suggest that the Christian poet would never have dared to describe paradise if his words were not directly inspired by the divine. The clever solution was used by Dante to declare that he was simply an instrument of the superior, divine power that had selected in him its messenger and prophet. Affirming otherwise, by implying that the sole power of his

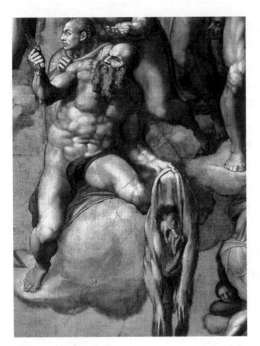

Detail in *The Last Judgment* of Saint Bartholomew holding his own skin—which has Michelangelo's own features—in his hand

human words would have been sufficient to describe the kingdom of God, would have been, for the Christian author, deserving of the same punishment that Apollo inflicted on the satyr Marsyas when the latter dared to compete with the god and for that reason was punished by being flayed alive.

The harsh judgment that Michelangelo appears to reserve for himself reflects the profound spiritual crisis that the artist was undergoing, which was probably also influenced by his close friendship with the very religious noblewoman Vittoria Colonna. His personal sense of guilt might also have been affected by the attraction he felt for Tommaso de' Cavalieri, a young Roman nobleman with whom he became infatuated.

Although homosexuality, especially in Florence, was widespread (Marsilio Ficino, Pico della Mirandola, Donatello, and Leonardo, to mention just a few, were all homosexuals), the church condemned relations between members of the same sex as a very serious infringement. Many people without a prestigious name and social position (such as the one held by Michelangelo and the artists and intellectuals mentioned above) ended up burned at the stake for that very same violation. Michelangelo, who was a highly intelligent and sensitive man, must have been keenly aware of that discrepancy: the characteristic that he witnessed most often in his lifetime was hypocrisy—especially among church members and representatives. Michelangelo's

anticlerical feelings clearly emerge in some major choices he made, like placing the darkest point of hell right above the door where the priest entered the chapel to perform the Mass, or applying the features of Biagio da Cesena, the Curia's master of ceremonies, to Minos, the monstrous guardian of hell.

The pessimistic view that Michelangelo especially in the last part of his life acquired appears to combine aspects of both Savonarola and Machiavelli. As the unity of the church was forever split by Luther's Reformation and as the dream of the republic was forever lost with the rise of despotic governments in all major Italian cities (Florence included), a growing sense of uncertainty about the greatness of human nature seemed to take hold of Michelangelo. The Renaissance had been called a rebirth, but the feeling we get when we look at Michelangelo's *Last Judgment* is that at the end of that dazzling era something deep in the mind and heart of man had shriveled and died away in a fast-expanding cloud of hopelessness and disenchantment. Faith remained, but it was a dark trust in a wrathful God with little space left for hope and charity.

In the scene of the Last Judgment, the representation of the blessed is indicative in this sense. According to Christian iconography, all those destined for paradise were imagined as souls finally freed from the heavy consistency of the body. In the frescoes that Luca Signorelli did in the Chapel Brizio at the Orvieto Cathedral, which were very familiar to Michelangelo, the point is clearly stressed: materiality fades as the blessed rise toward the spiritual purity of God's realm.

Nothing similar can be found in Michelangelo: ascending to paradise seems hard even for the blessed, oppressed as they are by the presence of their bulky and heavy bodies. For that reason, instead of easily rising up, they labor as if ascending with great difficulty a harsh and non-welcoming mountain. In one instance, a figure is seen pulling another one up using a rosary as a cord. Salvation, Michelangelo, seems to say, is a distant dream for a creature like man, burdened by so many ambiguities, flaws, and contradictions.

Even Mary, the loving Mother always so willing to intercede in favor of man, looks overwhelmed by the wrath of her Son. Instead of

Signorelli's fresco of the blessed destined for paradise in the Chapel Brizio at the Orvieto Cathedral

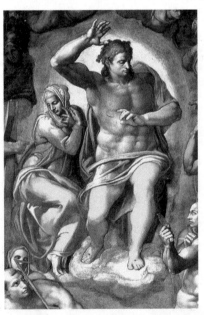

LEFT: In contrast with Signorelli, Michelangelo's blessed ascend to heaven with great labor.
ABOVE RIGHT: Mary almost recoiling in revulsion from the wrath of her Son

the supplicant position that she is traditionally given, she recoils in a gesture that seems to express, at the same time, horror, sorrow, and resignation.

The celebration of man, seen as the heroic maker of his own destiny, fades away with the waning of the Renaissance, leaving behind an overwhelming sense of sadness with only one gift left in the Pandora's box of the age: doubt.

<center>✳</center>

CONCLUSION

The Renaissance, which was sparked by the rediscovery of the brilliant heritage of the past, greatly revamped the confidence in man and in his capacity to be a free and self-determined agent of his own existence. Faith remained central but within a world where urbanization, secularization, and the broadening of the cultural horizon favored an attitude that, rather than dogmatic, was now increasingly open, unprejudiced, and inclusive. Even if unsystematic, this new critical disposition allowed a vast circulation of all sorts of new ideas aimed at discerning, as Eugenio Garin writes, the "hidden correspondences" and "occult sympathies" that pervaded the universe. The difference with the preceding era, Garin continues, is that while the Middle Ages had been extremely fearful of "the notion that man might use nature as an instrument," what now prevailed was a self-confident disposition that, instead of the self-erasing humbleness of earlier times, welcomed and even urged the active manipulation of reality for the sake of man's benefit and advantage. The fervid interest in magic, astrology, and alchemy (a proto-science aimed at the transformation of lead into gold) well represents the lively spirit of the epoch and the unbridled faith it associated with all the possibilities that man's genius and creativity were capable of conceiving. The underlying idea, as Pico della Mirandola articulated, was that man, being the central protagonist of creation, possessed the absolute freedom to be whatever

he wanted to be and also transform, as he wished, himself and the world. Art perfectly mirrored that belief. In fact, besides the great improvement in technical abilities, what characterizes Renaissance art is an increased pleasure in portraying reality: the beauty of the human body (studies in anatomy greatly helped to achieve that purpose) and the beauty of a world domesticated by the wit and talent of man. For that reason, rather than wild landscapes, what abounds in Renaissance art is the image of a perfectly ordered and manicured nature whose solar splendor is used as background to the elegant silhouette of geometrically harmonious cities.

As we have seen, toward the end of the sixteenth century that optimism was shaken by a series of disruptive events that, from politics to religion, tarnished the youthful zest that had animated the early part of the Renaissance. The feelings of disappointment and disenchantment that ensued prompted the problematic argumentations that have challenged, ever since, the modern mind: Why are humans bound to coexist with the persistent reappearance of instability, uncertainty, and contradiction? Why is chaos always interfering with the orderly cosmos created by our dreams and ideals? Why is the human journey bound to remain an unending quest rather than a final conquest of an everlasting truth?

The knowledge that followed did not help much in providing reassuring answers to those questions. On the contrary, the more knowledge advanced, the more man realized how secondary and small he was within the scheme of the universe. The greatest blow to the central position that the Renaissance had attributed to man came from the Polish astronomer Nicolaus Copernicus (1473–1543), who affirmed that the sun, not the earth, as Ptolemy had believed, was the center of the solar system. Probably because he realized how controversial his claim would have been, Copernicus, who apparently formulated his theory when he was forty, failed to reveal it for thirty years. When it was finally printed, shortly before his death, *De revolutionibus orbium coelestium* (On the revolution of the heavenly spheres) found an immediate opponent in Luther, who condemned the work as sacrilegious. The church, which did not immediately react to

Copernicus's theory, eventually did so when it accused Galileo Galilei (1546–1642), who was a supporter of the heliocentric theory, of heresy and forced him to recant.

The attempt to silence the voices that dissented from the dogma found its greatest victim in Giordano Bruno (1571–1600), the philosopher and mathematician who, pushing his conclusion even further than Copernicus, claimed that the universe was not a finite and perfectly hierarchically organized system, as Christian tradition had always claimed, but an infinity with no specific center that extended beyond all dimensions of space and time. No theory had ever reduced to such an extent the relevance of man within the scheme of creation. Because the vastness of such infinity proved irreconcilable with the Scriptures, the Inquisition accused Bruno of heresy. Bruno, writes Stephen Greenblatt in *The Swerve,* defended his position by saying "that the Bible was a better guide to morality than charting the heavens." The defiance of the philosopher did not go well with the church, which condemned Bruno to death. He was burned at the stake in Rome in 1600.

But the church's attempt to contain change proved useless, as shown by scientists like Johannes Kepler (1571–1630) and, later on, Isaac Newton (1642–1727), whose work provided a clearer understanding of the universe and the solar system. Christianity had consistently maintained that the heavenly bodies, led by angelic spirits, followed a circular motion because the circle, in its geometrical perfection, revealed the essence of God, whose love, as Dante had poetically written, moved "the sun and the other stars." Kepler's discovery that the motion of the planets was elliptical, not circular, directly challenged the dogma, as did Newton's discovery that gravity was the all-pervading force of the universe and that it was that pull that determined the orbital trajectory of the planets. Although Kepler's and Newton's views did not conform with the orthodoxy, the two men were in no way atheists. At that moment in time, religion was still too deeply ingrained in people's minds for that to happen. That said, it cannot be denied that a significant mental shift was in the making, especially in regard to science, which was becoming signifi-

cantly more rigorous and, as such, more assertive in establishing its autonomy from any external authority. The claim was that science's field of investigation had to do with natural phenomena that could be verified, not supernatural truths that were essentially unverifiable. The cultivation of a stricter empirical approach, which began to take hold, led to the scientific revolution heralded at the closing of the Renaissance by Francis Bacon (1561–1626) and René Descartes (1596–1650), who is called the father of modern philosophy.

But the Renaissance also spawned a persistent undercurrent of skepticism prompted by the suspicion that the spirit of innovation that the era so proudly celebrated had failed to replace the *old* with an improved and more reliable *new*. Among the many critical voices, that of the English lawyer and social-philosopher Thomas More (1478–1535), who assigned to his *Utopia* (meaning "no place" in Greek) his dream of a perfect society, and the humanist Desiderius Erasmus of Rotterdam (1466–1536), who, in his *Praise of Folly,* ironically uses the personification Folly to condemn the most deplorable aspects of his times, including the abuses of the clergy. Erasmus's hope that the Christian world would have returned to the holy simplicity of heart that the wisdom of the Scriptures taught paved the way for the Reformation. The man who best embodied the skepticism of the era was Michel de Montaigne (1533–1592), who consciously abandoned the pompous ground of philosophical disquisitions to limit to his single self the scope of his *Essays*. But the difficulty of pinpointing the essence of the "I" beyond the complex influence of external factors and the volatility of the human personality proved that the inner reality of man was as hard to chart as the mysterious vastness of the universe. In one of his *Essays,* entitled "On Cannibals," Montaigne criticized the haughty sense of superiority that the Europeans felt toward the native people who inhabited the lands of the New World that had been recently discovered. The fact that people whom the Europeans called barbarous possessed, in Montaigne's view, a moral uprightness that, despite the primitive nature of their society, appeared much greater than the one displayed in the Christian world, made him doubtful that Western civilization was as great as it claimed to be (the sangui-

nary fights between French Catholics and Protestant Huguenots that Montaigne witnessed in his own lifetime may have had a lot to do with the critical way in which he viewed his own world). He wrote, "We call barbarous anything that is contrary to our habits. Indeed we seem to have no other criterion of truth and reason than the type and kind of opinions and customs current in the land that we live." The comparison between the simple yet noble life of the native inhabitants of the New World (which anticipated Rousseau's view of the "bon sauvage") and the ails of the European society coupled with the realization that truth could never be absolute increased Montaigne's melancholic bent, as he expressed in his famous quote, *"Que sais-je?"* (What do I know?).

The sense of bewilderment that accompanied the late Renaissance only grew as history progressed. The most dramatic moment occurred when Charles Darwin, in the nineteenth century, revealed that, rather than springing into existence as fully developed Adams and Eves, we, just like all other living organisms, are only the outcome of a cumulative, opportunistic, and entirely mechanistic process based on evolution and natural selection. The discovery was hard to accept, principally because it proved that the mechanical laws of nature have absolutely nothing in common with the passionate, even romantic desire for order, meaning, and purpose that *our* logic demands. All that is to say, the more we push forward, the more we become aware of the insufficiency of our egocentric parameters; the more we progress, the more we are bound to accept that, rather than ultimate truths, what we are destined to find is only more complexity, ambiguity, and doubt.

In that sense, notwithstanding our many awesome achievements, our history can be defined as a very humbling experience. As the author James Barrie put it, "Life is a long lesson in humility." That means that each time we believe we have reached a summit of understanding, we realize how much our striving and forward thinking still have to accomplish.

Is that bad? Not necessarily. A crisis, as we know, is often also a great opportunity to reflect on past experiences in order to decide what lessons are more deserving of our attention and respect.

In other words, there is always a flip side to each coin. For example, we have learned that we are imperfect creatures: we crave great ideals, but our finiteness hardly ever allows us to fully realize what we dream. The flip side of the coin is precisely because we are frail, we need one another. That includes the more familiar other but also the less familiar one that the great diversity of our modern society includes. We have to overcome the tribal instinct to withdraw into the small corner of our provincial dimension to assign loyalty only to those who are and think like us—a tendency that has always been the greatest impediment to the progression of history.

Working at strengthening our collective self while expanding its parameters to include diversity in our union is as important as nurturing our single identity. One cannot exist without the other: civilization is a collaborative effort that demands the same care and responsibility we dedicate to ourselves.

As we have repeated over and over, the sin that since the dawn of time has been considered the greatest of all human shortcomings is hubris, which means both lack of humility and the ambition to think that one does not need the input of others to enrich the meager finitude of the self. In our times, so obsessed with the cult of celebrities and personalities, that lesson should not be forgotten. Narcissism and unbridled ambition, the Greeks warned, are like maladies coiled in the darkest part of the human spirit that, if left unchecked, can grow to completely overcome the balance and clarity of the mind. For that reason, the Greeks always feared tyrants or despots: people who, dismissing the value of collective wisdom and collaboration, arrogantly assumed that their talent alone was sufficient to rule society. The effects of such a malevolent attitude, the Greeks argued, can be disastrous, especially given the tendency that all autocrats have to become demagogues, ready to deform reality with untruthful words just to serve their selfish interests and their insatiable appetite for reverence and adulation.

As we have seen, hubris also characterized men's ambition to consider themselves superior to women. Besides erroneously thinking that women did not possess rationality, men made the mistake of

assigning greatness to a mind devoid of emotion and passion (qualities invariably associated with women). What modern science has discovered is that by defining in that way the ideal of rationality, masculine culture has in fact greatly reduced the overall understanding of how the brain actually functions. As advanced studies in psychology and neuroscience have proven, the traits once rejected as feminine, like intuition and emotion, are, in reality, among the most intrinsic and powerful qualities of what we call today rationality.

The same lesson could be applied to all those who have been chastised for being different—by ethnicity, culture, religion, sexual orientation, and so on. Divisions, walls, perimeters, boundaries: all that has been erected around the "I" to rigidly define its identity in contrast to some "Other" has proven to be, in the end, as ruinous as everything that remains too inflexible. To maintain its health the mind needs to nurture its capacity to grow. Accumulation of information and knowledge would not mean much if not followed by improvement and maturation. In other words: progress has value only if it expands and enhances our humanness.

One of the most meaningful passages of the Bible takes place when God asks Cain where Abel is, and Cain, who does not want to confess the murder of his brother, responds to God, "Am I my brother's keeper?" The answer is obvious: yes. We cannot expect to improve ourselves if we don't assume the responsibility of being our brothers' (and sisters'!) keepers.

Martin Luther King wrote: "We have learned to fly like birds and swim the sea like fish but we have not learned the simple art to live together as brothers." He was right: our most urgent task is to improve the simple art of living together by accepting the notion that identity always involves a singular as well as a plural notion. As W. H. Auden stated, "Civilization should be measured by the degree of diversity attained and the degree of unity retained." The most important lesson we can derive from history is that identity is built never on a monologue but always on the honest, respectful, and committed exchange of ideas that true dialogue represents.

ACKNOWLEDGMENTS

The first people I would like to acknowledge are the brilliant scholars listed in the bibliography. The many references to their books and articles that my work directly and indirectly draws upon represents my humble attempt to express, as best I could, the debt I owe to their immensely stimulating and ever-enriching lessons. To those lessons, I want to add the important contribution of Larry Siedentop, in whose book *Inventing the Individual: The Origins of Western Liberalism* I discovered the nineteenth-century French historian Fustel de Coulanges, whom I mention in the very opening pages of this work.

To that list of very special mentors, I would like to add the name of my editor, Gerald Howard—a man whose remarkable amount of intellectual acuity and ethical integrity would have certainly commanded the respect of our Greek and Latin forefathers. Having a person of such quality and gravitas as my editor has been, for me, a gift that no words could ever match.

A very special thank-you as well to the rest of the team at Doubleday: Rita Madrigal, production editor; Ingrid Sterner, copy editor, to whose laser-like precision and attention I owe the removal of the many sloppy imperfections; Sarah Porter and Nora Grubb, superefficient assistants to Gerald Howard; John Fontana and Maria Carella, who respectively designed the beautiful exterior and interior of the book; and the talented publicist Charlotte O'Donnell and marketer Sarah Engelmann.

Last but not least I must acknowledge my husband, Richard Aborn, who has never left my side during this long and arduous jour-

ney. Without his patient and loving encouragement, his implacable determination to never let me quit, and the unique guidance I received from his many smart suggestions, this book would never have been completed. Thank you, my darling: as always, the best experiences of my life have invariably found in you my most significant companion, supporter, adviser, and ally.

One very last thing: To fully appreciate the art that this book examines, I strongly advise the reader to check online for the color versions of the images. Here's to you, Wikimedia Commons, with all my gratitude!

BIBLIOGRAPHY

Abbagnano, Nicola. *Storia della filosofia.* Vols. 1 and 2. Turin: UTET, 1993.

Aeschylus. *Prometheus Bound, The Suppliants, Seven Against Thebes, The Persians.* Translated with an introduction by Philip Vellacott. London: Penguin Books, 1961.

Albertini, Rudolf von. *Firenze dalla repubblica al principato: Storia e coscienza politica.* 1955. Translated by Cesare Cristofolini. Preface by Federico Chabod. Turin: Einaudi, 1970.

Argan, Giulio Carlo. *Storia dell'arte italiana.* Vols. 1 and 2. 1968. Milan: Sansoni, 1975.

Aristotle. *The Complete Works of Aristotle.* Edited by Jonathan Barnes. Princeton, N.J.: Princeton University Press, 1984.

Auerbach, Erich. *Mimesis: The Representation of Reality in Western Literature.* Princeton, N.J.: Princeton University Press, 1973.

Augustine. *The City of God.* 2 vols. London: Dent, 1945.

———. *The Confessions.* Translated by Maria Boulding. New York: Vintage Books, 1997.

Averincev, Sergej. *L'anima e lo specchio: L'universo della poetica bizantina.* 1977. Bologna: Il Mulino, 1988.

Baldini, Antonio. *L'impero romano e la sua fine.* Bologna: Il Mulino, 2008.

Baldock, John. *Christian Symbolism.* Shaftesbury: Element Books, 1990.

Barbuto, Gennaro M. *Il pensiero politico del Rinascimento: Realismo e utopia.* Rome: Carocci, 2008.

Barolini, Teodolinda. *The Undivine Comedy: Detheologizing Dante.* Princeton, N.J.: Princeton University Press, 1992.

Baron, Hans. *The Crisis of the Early Italian Renaissance.* Princeton, N.J.: Princeton University Press, 1966.

————. *From Petrarch to Leonardo Bruni: Studies in Humanistic and Political Literature.* Chicago: University of Chicago Press, 1968.

Beard, Mary. *Confronting the Classics: Traditions, Adventures, and Innovations.* New York: W. W. Norton, 2013.

Beardsley, Monroe C. *Aesthetics: From Classical Greece to the Present.* Tuscaloosa: University of Alabama Press, 1966.

Beigbeder, Olivier. *Lessico dei simboli medievali.* 1979. Milan: Jaca Book, 1994.

Bernardo, Aldo S., and Anthony L. Pellegrini, eds. *Dante, Petrarch, Boccaccio: Studies in the Italian Trecento in Honor of Charles S. Singleton.* Binghamton: Center for Medieval & Early Renaissance Studies, State University of New York at Binghamton, 1983.

Bernheim, Pierre-Antoine, and Guy Stavridès. *Paradiso paradisi.* 1991. Turin: Einaudi, 1994.

Berti, Enrico. *In principio era la meraviglia: Le grandi questioni della filosofia antica.* Rome: Laterza, 2009.

Bishop, Morris. *The Middle Ages.* 1968. Boston: Mariner Books, 2001.

Blackburn, Simon. *Plato's Republic: A Biography.* New York: Grove Press, 2006.

Blumenberg, Hans. *La leggibilità del mondo.* 1981. Bologna: Il Mulino, 1984.

Boccaccio, Giovanni. *The Decameron.* Translated with introduction and notes by G. H. McWilliams. New York: Penguin Books, 1995.

Bodei, Remo. *Le forme del bello.* Milan: Il Mulino, 1974.

Boethius. *The Consolation of Philosophy.* Translated by V. E. Watts. Harmondsworth: Penguin, 1969.

Bonaventura da Bagnoregio. *Itinerario della mente verso Dio.* Translated by Massimo Parodi and Marco Rossini. Milan: BUR, 1994.

Bondanella, Peter. *The Eternal City: Roman Images in the Modern World.* Chapel Hill: University of North Carolina Press, 1987.

Bordone, Renato, and Giuseppe Sergi. *Dieci secoli di medioevo.* Turin: Einaudi, 2009.

Bourke, Vernon J., ed. *The Essential Augustine.* Indianapolis: Hackett, 1974.

Brague, Rémi. *The Wisdom of the World: The Human Experience of the Universe in Western Thought.* 1999. Translated by Teresa Lavender Fagan. Chicago: University of Chicago Press, 2003.

Brandeis, Irma, ed. *Discussions of the Divine Comedy.* Boston: D. C. Heath, 1961.

Braudel, Fernand. *La Méditerranée: L'espace et l'histoire.* 1977. Paris: Flammarion, 1985.

Briggs, Charles F. *The Body Broken: Medieval Europe, 1300–1520*. New York: Routledge, 2011.

Brown, Alison. *The Renaissance*. 1988. Harlow, U.K.: Pearson Education, 1999.

Brown, Peter. *Augustine of Hippo: A Biography*. Berkeley: University of California Press, 1967.

———. *The Rise of Western Christendom*. 2nd ed. Oxford: Blackwell, 2003.

———. *The World of Late Antiquity*. New York: W. W. Norton, 1989.

Bruyne, Edgar de. *L'esthétique du Moyen Âge*. Louvain, Belgium: Institut Supérieur de Philosophie, 1947.

Bull, Malcolm. *The Mirror of the Gods: How Renaissance Artists Rediscovered the Pagan Gods*. Oxford: Oxford University Press, 2005.

Burckhardt, Jacob. *The Civilization of the Renaissance in Italy*. Vol. 1. 1929. New York: Harper & Row, 1958.

Burke, Peter. *The Italian Renaissance: Culture and Society in Italy*. 2nd ed. Cambridge, U.K.: Polity, 1999.

Cahill, Thomas. *Mysteries of the Middle Ages: The Rise of Feminism, Science, and Art from the Cults of Catholic Europe*. New York: Nan A. Talese/Doubleday, 2006.

Campbell, Brian. *The Romans and Their World*. New Haven, Conn.: Yale University Press, 2011.

Campenhausen, Hans von. *Les pères grecs*. Paris: Orante, 1963.

———. *Les pères latins*. Paris: Orante, 1967.

Cantarella, Eva. *Pandora's Daughters*. Translated by Maureen B. Fant with a foreword by Mary. R. Lefkowitz. Baltimore-London: The Johns Hopkins University Press, 1987.

Cantor, Norman F. *Antiquity: From the Birth of Sumerian Civilization to the Fall of the Roman Empire*. New York: HarperCollins, 2003.

Cantor, Norman F., and Michael S. Werthman, eds. *Medieval Society, 400–1450*. New York: Thomas Y. Crowell, 1967.

Cardini, Franco. *L'uomo medievale*. Edited by Jacques Le Goff. Rome: Laterza, 1987.

Caroli, Flavio. *Il volto di Gesù: Storia di un'immagine dall'antichità all'arte contemporanea*. Milan: Mondadori, 2008.

Castelli, Patrizia. *L'estetica del Rinascimento*. Bologna: Il Mulino, 2005.

Castiglione, Baldassare. *The Book of the Courtier*. Translated by G. Bull. London: Penguin Books, 1976.

Chadwick, Henry. *The Early Church: The Story of Emergent Christianity from the Apostolic Age to the Foundation of the Church of Rome*. 1967. London: Penguin Books, 1988.

Chastel, André. *Art et humanisme à Florence au temps de Laurent le Magnifique: Études sur la Renaissance et l'humanisme platonicien*. Paris: Presses Universitaires de France, 1961.

―――. *L'art italien*. Paris: Flammarion, 1982.

―――. *Il sacco di Roma, 1527*. Turin: Einaudi, 1983.

Chenu, Marie-Dominique. *Saint Thomas d'Aquin et la théologie*. Paris: Seuil, 1959.

―――. *La théologie au douzième siècle*. Paris: Vrin, 1957.

Chesterton, G. K. *Saint Thomas Aquinas: "The Dumb Ox."* 1933. New York: Doubleday, 1956.

Chisholm, Kitty, and John Ferguson, eds. *Rome: The Augustan Age*. Oxford: Oxford University Press, 1984.

Christian, James L. *Philosophy: An Introduction to the Art of Wondering*. San Francisco: Rinehart Press, 1973.

Cicero. *On Duties*. Edited by Miriam T. Griffin and E. M. Atkins. Cambridge, U.K.: Cambridge University Press, 1991.

―――. *The Republic and The Laws*. Translated by Niall Rudd. Edited by J. G. F. Powell and Niall Rudd. Oxford: Oxford University Press, 2008.

―――. *Selected Letters*. Translated by P. G. Walsh. Oxford: Oxford University Press, 2008.

―――. *Selected Works*. Translated by Michael Grant. Baltimore: Penguin Books, 1960.

Clark, Gillian. *Late Antiquity: A Very Short Introduction*. Oxford: Oxford University Press, 2011.

Clark, Kenneth. *The Nude. A Study in Ideal Form*. Princeton, N.J.: Princeton University Press, 1956.

Clarke, M. L. *The Roman Mind*. New York: W. W. Norton, 1968.

Clement of Alexandria. *Le pédagogue*. Paris: Migne, 1991.

Cole, Joshua, Carol Symes, Judith Coffin, and Robert Stacey. *Western Civilizations: Their History and Their Culture*. 3rd ed. New York: W. W. Norton, 2005.

Colish, Marcia. *The Mirror of Language: A Study in the Medieval Theory of Knowledge*. New Haven, Conn.: Yale University Press, 1968.

Cook, William R., and Ronald B. Herzman. *The Medieval World View*. Oxford: Oxford University Press, 2004.

Corti, Maria. *Dante a un nuovo crocevia*. Florence: Sansoni, 1981.

———. *La felicità mentale*. Turin: Einaudi, 1983.

———. *Percorsi dell'invenzione: Il linguaggio poetico e Dante*. Turin: Einaudi, 1993.

Courcelle, Pierre. *Connais-toi toi-même: De Socrate à saint Bernard*. 3 vols. Paris: Études Augustiniennes, 1974–1975.

Cowell, F. R. *Cicero and the Roman Republic*. 1948. Harmondsworth: Penguin, 1968.

Curi, Umberto. *La cognizione dell'amore: Eros e filosofia*. Milan: Feltrinelli, 1997.

Curtius, Ernst Robert. *Letteratura europea e Medio Evo latino*. 1948. Florence: La Nuova Italia, 1992.

Damascène, Jean. *Le visage de l'invisible*. Translated by Anne-Lise Darras-Worms. Introduction by Monseigneur Christoph Schönborn. Paris: Migne, 1994.

Dante. *The Divine Comedy*. Translated by Allen Mandelbaum. New York: Everyman's Library, 1995.

Davy, Marie-Madeleine. *Initiation à la symbolique romane*. Paris: Flammarion, 1977.

Didi-Huberman, Georges. *Fra Angelico: Dissemblance et figuration*. Paris: Flammarion, 1995.

Dodds, Eric R. *The Greeks and the Irrational*. Berkeley: University of California Press, 1951.

D'Onofrio, Cesare. *Gli obelischi di Roma*. Rome: Bulzoni, 1967.

Duby, Georges. *San Bernardo e l'arte cistercense*. Turin: Einaudi, 1982.

———. *Lo specchio del feudalesimo: Sacerdoti, guerrieri e lavoratori*. Rome: Laterza, 1980.

———. *Storia artistica del Medioevo*. Translated by Giorgia Viano Marogna. Rome: Laterza, 1996.

Duby, Georges, Eleanor Levieux, and Barbara Thompson. *The Age of Cathedrals: Art and Society, 980–1420*. Chicago: University of Chicago Press, 1981.

Duffy, Eamon. *Saints and Sinners: A History of the Popes*. New Haven, Conn.: Yale University Press, 1997.

Durant, Will. *The Age of Faith*. New York: Simon & Schuster, 1950.

———. *Caesar and Christ*. New York: Simon & Schuster, 1944.

———. *The Life of Greece*. New York: Simon & Schuster, 1966.

———. *The Renaissance*. New York: Simon & Schuster, 1953.

Easterling, P. E., ed. *The Cambridge Companion to Greek Tragedy.* Cambridge, U.K.: Cambridge University Press, 1997.

Eco, Umberto. *Arte e bellezza nell'estetica medievale.* Milan: Bompiani, 1987.

———. *Il problema estetico in Tommaso d'Aquino.* Milan: Bompiani, 1970.

Eliade, Mircea. *Images et symboles.* Paris: Gallimard, 1952.

Elsner, Jaś. *Imperial Rome and Christian Triumph.* Oxford: Oxford University Press, 1998.

Evans, G. R. *Bernard of Clairvaux.* Oxford: Oxford University Press, 2000.

Everitt, Anthony. *Cicero: The Life and the Times of Rome's Greatest Politician.* New York: Random House, 2003.

———. *The Rise of Rome: The Making of the World's Greatest Empire.* New York: Random House, 2012.

Ferrucci, Franco. *Le due mani di Dio: Il cristianesimo e Dante.* Rome: Fazi, 1999.

Ficino, Marsilio. *Platonic Theology.* Cambridge, Mass.: Harvard University Press, 2004.

Fleming, David A., ed. *The Fire and the Cloud: An Anthology of Catholic Spirituality.* New York: Paulist Press, 1978.

Florenskij, Pavel. *Le porte regali: Saggio sull'icona.* 1922. Milan: Adelphi, 1995.

Focillon, Henri. *Moyen Âge: Roman et gothique.* Paris: Armand Colin, 1938.

Freccero, John. *Dante: The Poetics of Conversion.* Cambridge, Mass.: Harvard University Press, 1986.

Freeman, Charles. *The Closing of the Western Mind: The Rise of Faith and the Fall of Reason.* New York: Alfred A. Knopf, 2003.

———. *Egypt, Greece, and Rome: Civilizations of the Ancient Mediterranean.* Oxford: Oxford University Press, 1996.

Frye, Northrop. *The Double Vision: Language and Meaning in Religion.* Toronto: University of Toronto Press, 1991.

———. *The Great Code: The Bible and Literature.* San Diego: Harcourt Brace Jovanovich, 1982.

Fulcanelli. *Le mystère des cathédrales.* 1964. Rennes: Société Nouvelle des Éditions Pauvert, 1979.

Fumagalli, Vito. *L'alba del Medioevo.* Bologna: Il Mulino, 1993.

Fumagalli Beonio Brocchieri, Maria Teresa. *L'estetica medievale.* Bologna: Il Mulino, 2002.

Fustel de Coulanges, Numa D. *The Ancient City: A Study on the Religion, Laws, and Institutions of Greece and Rome.* 1864. Kitchener, Ont.: Batoche Books, 2001.

Garin, Eugenio. *Scienza e vita sociale nel Rinascimento italiano.* Rome: Riuniti, 1989.

———. *L'umanesimo italiano.* Bari: Laterza, 1952.

Giardini, Andrea, and André Vauchez. *Il mito di Roma: Da Carlo Magno a Mussolini.* Rome: Laterza, 2008.

Gibbon, Edward. *Decline and Fall of the Roman Empire.* Vol. 1. Harmondsworth: Penguin, 1994.

Gilson, Étienne. *Dante e la filosofia.* 1939. Translated by S. Cristaldi. Milan: Jaca Book, 1987.

———. *Introduction à l'étude de saint Augustin.* 1929. Paris: Vrin, 2003.

———. *The Mystical Theology of Saint Bernard.* 1947. Reprint, Kalamazoo, Mich.: Cistercian Publications, 1990.

———. *The Spirit of Medieval Philosophy.* 1936. Notre Dame, Ind.: University of Notre Dame Press, 1991.

Goldthwaite, Richard A. *Wealth and the Demand for Art in Italy, 1300–1600.* Baltimore: Johns Hopkins University Press, 1993.

Gombrich, Ernst H. *Norm and Form.* London: Phaidon, 1966.

———. *The Story of Art.* 1950. London: Phaidon, 1991.

———. *Symbolic Images: Studies in the Art of the Renaissance.* London: Phaidon, 1972.

Gottlieb, Anthony. *The Dream of Reason. A History of Western Philosophy from the Greeks to the Renaissance.* New York and London: W. W. Norton, 2016.

Grabar, André. *L'arte paleocristiana, 200–295.* 1966. Milan: BUR, 1991.

———. *Les origins de l'estétique médiévale.* Paris: Macula, 1992.

Graf, Arturo. *Miti, leggende e superstizioni del Medioevo.* 2 vols. Rome: Plurima, 1989.

———. *Le vie della creazione nell'iconografia cristiana: Antichità e Medioevo.* 1968. Milan: Jaca Book, 1988.

Grant, Edward. *God and Reason in the Middle Ages.* Cambridge, U.K.: Cambridge University Press, 2001.

Graves, Robert. *The Greek Myths.* London: Penguin Books, 1992.

Greenblatt, Stephen. *The Swerve: How the World Became Modern.* New York: W. W. Norton, 2011.

Guénon, René. *Il simbolismo della croce.* 1931. Milan: Rusconi, 1989.

Guthries, W. K. C. *The Greek Philosophers from Thales to Aristotle.* 1950. New York: Harper & Row, 1960.

Hadas, Moses, ed. *Complete Works of Tacitus.* New York: Modern Library, 1942.

Hadot, Pierre. *Esercizi spirituali e filosofia antica.* 2002. Translated by A. I. Davidson. Turin: Einaudi, 2005.

———. *Philosophy as a Way of Life.* Oxford: Wiley-Blackwell, 1995.

———. *Plotin ou la simplicité du regard.* Paris: Gallimard, 1997.

Hale, John. *The Civilization of Europe in the Renaissance.* New York: Macmillan, 1994.

Hamilton, Edith. *The Greek Way to Western Civilization.* 1942. New York: New American Library, 1948.

———. *The Roman Way to Western Civilization.* New York: New American Library, 1957.

Hamman, A. G. *L'homme image de Dieu.* Paris: Desclée, 1987.

Harrison, Thomas, ed. *Greeks and Barbarians.* New York: Routledge, 2002.

Haskins, Charles Homer. *The Rise of Universities.* 1923. Ithaca, N.Y.: Cornell University Press, 1959.

Heinz-Mor, Gerd. *Lessico di iconografia cristiana.* 1971. Milan: Istituto di Propaganda Libraria, 1995.

Herman, Arthur. *The Cave and the Light: Plato Versus Aristotle, and the Struggle for the Soul of Western Civilization.* New York: Random House, 2014.

Herodotus. *The Landmark Herodotus: The Histories.* Edited by Robert B. Strassler. Translated by Andrea Purvis. New York: Anchor Books, 2009.

Heschel, Abraham Joshua. *God in Search of Man: A Philosophy of Judaism.* New York: Farrar, Straus and Giroux, 1981.

Hesiod. *Theogony; Works and Days.* Baltimore: Johns Hopkins University Press, 2004.

Hibbert, Christopher. *Rome: The Biography of a City.* Harmondsworth: Penguin Books, 1987.

Holland, Tom. *Dynasty.* New York: Doubleday, 2015.

Hollander, Robert. *Allegory in Dante's "Commedia."* Princeton, N.J.: Princeton University Press, 1969.

Holscher, Tonio. *The Language of Images in Roman Art.* Cambridge, U.K.: Cambridge University Press, 1987.

Homer. *Iliad.* Translated by Robert Fagles. New York: Penguin Books, 1998.

———. *Odyssey.* Translated by Robert Fagles. New York: Penguin Books, 1996.

Hooper, Finley. *Greek Realities.* Detroit: Wayne State University Press, 1978.

————. *Roman Realities*. Detroit: Wayne State University Press, 1979.

Hughes, Robert. *Rome*. New York: Alfred A. Knopf, 2011.

Huizinga, Johan. *Autunno del Medioevo*. 1918. Introduction by Eugenio Garin. Rizzoli: BUR, 2016.

Jaeger, Werner. *Early Christianity and Greek Paideia*. Cambridge, Mass.: Belknap Press of Harvard University Press, 1961.

————. *Paideia. The Ideals of Greek Culture*. Vol. 1. *Archaic Greece: The Mind of Athens*. Oxford: Oxford University Press, 1986.

Janes, Dominic. *God and Gold in Late Antiquity*. Cambridge, U.K.: Cambridge University Press, 1998.

Jardine, Lisa. *Wordly Goods: A New History of the Renaissance*. New York: Doubleday, 1996.

Johnson, Paul. *The Renaissance: A Short Story*. New York: Modern Library, 2000.

Jones, W. T. A. *History of Western Philosophy*. Vol. 2, *The Medieval Mind*. 1952. New York: Harcourt Brace & World, 1969.

Judd, Gerrit P. *A History of Civilization*. New York: Macmillan, 1966.

Katzenellenbogen, Adolf. *The Sculptural Programs of Chartres Cathedral*. New York: W. W. Norton, 1964.

Kellogg, Michael K. *The Greek Search for Wisdom*. Amherst, N.Y.: Prometheus Books, 2012.

————. *The Roman Search for Wisdom*. Amherst, N.Y.: Prometheus Books, 2014.

————. *Three Questions We Never Stop Asking*. Amherst, N.Y.: Prometheus Books, 2010.

Kenny, Anthony. *Medieval Philosophy*. Oxford: Clarendon Press, 2005.

Kerényi, Carl. *Prometheus: Archetypal Image of Human Existence*. 1946. Princeton, N.J.: Princeton University Press, 1991.

King, Margaret L., ed. and trans. *Renaissance Humanism: An Anthology of Sources*. Indianapolis: Hackett, 2014.

King, Ross. *Michelangelo and the Pope's Ceiling*. New York: Penguin Books, 2003.

Kitto, H. D. F. *The Greeks*. 1951. Harmondsworth: Penguin Books, 1991.

Knowles, David. *The Evolution of Medieval Thought*. New York: Random House, 1962.

Kristeller, Paul Oskar. *Eight Philosophers of the Italian Renaissance*. Stanford: Stanford University Press, 1964.

————. *Renaissance Thought: The Classic, Scholastic, and Humanist Strains.* 1955. New York: Harper & Row, 1961.

————, ed. *The Renaissance Philosophy of Man.* 1948. Chicago: University of Chicago Press, 1956.

Lane, Melissa. *Greek and Roman Political Ideas.* London: Penguin Books, 2014.

Lane Fox, Robin. *The Classical World: An Epic History from Homer to Hadrian.* New York: Basic Books, 2006.

Larner, John. *Culture and Society in Italy, 1290–1420.* New York: Charles Scribner's Sons, 1971.

Leclercq, Jean. *L'amour des lettres et le désir de Dieu.* Paris: Cerf, 1957.

Legendre, Pierre. *Dieu au miroir: Études sur l'istitution des images.* Paris: Fayard, 1994.

Le Goff, Jacques. *La civilization de l'Occident medieval.* Paris: Flammarion, 2008.

————. *L'imaginaire medieval: Essais.* Paris: Gallimard, 1985.

————. *L'Italia nello specchio del Medioevo.* Turin: Einaudi, 1974.

————. *La naissance du purgatoire.* Paris: Gallimard, 1981.

Lombardo, Giovanni. *L'estetica antica.* Bologna: Il Mulino, 2002.

Lopez, Robert S. *The Three Ages of the Italian Renaissance.* Charlottesville: University of Virginia Press, 1970.

Lorch, Maristella de Panizza. *A Defense of Life: Lorenzo Valla's Theory of Pleasure.* New York: W. Fink Verlag, 1985.

Lubac, Henri de. *Le mystère du surnaturel.* Paris: Aubier, 1946.

Lucretius. *On the Nature of the Universe.* Translated by R. E. Latham. Revised by John Godwin. 1994. London: Penguin Books, 2005.

Machiavelli, Niccolò. *Discorsi.* With an introduction by Gennaro Sasso. Milan: BUR, 1996.

————. *Principe.* Edited by Giorgio Inglese. Turin: Einaudi, 1995.

MacMullen, Ramsay. *Constantine.* New York: Harper Torchbooks, 1970.

Mâle, Émile. *L'art religieux de la fin du Moyen Âge en France.* Paris: Armand Colin, 1952.

Manchester, William. *A World Lit Only by Fire: The Medieval Mind and the Renaissance.* New York: Little, Brown, 1993.

Marcus Aurelius. "Meditations." In *Marcus Aurelius and His Times,* 11–133. With an introduction by Irwin Edman. Roslyn, N.Y.: Walter J. Black, 1973.

Martin, Raymond, and John Barresi. *The Rise and Fall of Soul and Self: An*

Intellectual History of Personal Identity. New York: Columbia University Press, 2006.

Martin, Thomas R. *Ancient Greece: From Prehistoric to Hellenistic Times.* New Haven, Conn.: Yale University Press, 2000.

Martines, Lauro. *Scourge and Fire: Savonarola and the Republic of Florence.* London: Jonathan Cape, 2006.

Masson, Georgina. *The Companion Guide to Rome.* 1965. Woodbridge, Suffolk: Companion Guides, 1980.

Mazzotta, Giuseppe. *The Worlds of Petrarch.* Durham, N.C.: Duke University Press, 1993.

Mellor, Ronald. *The Roman Historians.* New York: Routledge, 1999.

———. *Tacitus.* New York: Routledge, 1993.

Michelangelo. *Complete Poems and Selected Letters of Michelangelo.* Edited by Creighton Gilbert. New York: Vintage Books, 1963.

———. *Rime.* Milan: Rizzoli, 1975.

Mills, Dorothy. *The Middle Ages.* New York: Memoria Press, 2012.

Monsacré, Hélène. *Les larmes d'Achille: Les héros, la femme et la souffrance dans la poésie d'Homère.* Paris: Albin Michael, 1984.

Montaigne, Michel de. *The Complete Essays.* Translated and edited with an introduction and notes by M. A. Screech. New York: Penguin Books, 1993.

Montanelli, Indro, and Roberto Gervaso. *L'Italia dei secoli bui.* Milano: Rizzoli, 1965.

———. *Storia di Roma.* Milano: Rizzoli, 1969.

Morris, Colin. *The Discovery of the Individual, 1050-1200.* New York: Harper & Row, 1972.

Nardini, Bruno. *Michelangelo: Biography of a Genius.* Florence: Giunti, 1999.

Nauert, Charles G. *Humanism and the Culture of Renaissance Europe.* 1995. Cambridge, U.K.: Cambridge University Press, 2006.

Nietzsche, Friedrich. *Basic Writings of Nietzsche.* Translated and edited by Walter Kaufmann. New York: Modern Library, 1968.

———. *The Gay Science.* New York: Random House, 1974.

Nolhac, Pierre de. *Pétrarque et l'humanisme.* 1907. Paris: Champion, 1965.

Oates, Whitney Jennings, and Eugene O'Neill Jr., eds. *The Complete Greek Drama.* New York: Random House, 1938.

Odhal, Charles M. *Constantine and the Christian Empire.* New York: Routledge, 2004.

Ohly, Friedrich. *Geometria e memoria: Lettera e allegoria nel Medioevo*. Bologna: Il Mulino, 1984.

Oldenbourg, Zoé. *The Crusades*. 1965. New York: Pantheon Books, 1966.

Ossola, Carlo. *Dal "Cortegiano" all' "Uomo di mondo."* Turin: Einaudi, 1987.

———. *Introduzione alla "Divina Commedia."* Venice: Marsilio, 2012.

Otto, Walter Friedrich. *Il mito*. 1962. Genoa: Il Nuovo Melangolo, 2000.

Ovid. *Metamorphoses*. Translated by Charles Martin. New York: W. W. Norton, 2005.

Pagden, Anthony. *Peoples and Empires. Europeans and the Rest of the World from Antiquity to the Present*. Phoenix, Ariz.: Phoenix University Press, 2002.

Panofsky, Erwin. *Idea: Ein Beitrag zur Begriffsgeschichte der älteren Kunsttheorie*. Berlin: Teubner, 1924.

———. *Renaissance and Renascences in Western Art*. Stockholm: Almqvist & Wiksell, 1960.

———. *Studies in Iconology: Humanistic Themes in the Art of the Renaissance*. 1939. New York: Harper & Row, 1967.

Pelikan, Jaroslav. *Christianity and Classical Culture: The Metamorphosis of Natural Theology in the Christian Encounter with Hellenism*. New Haven, Conn.: Yale University Press, 1993.

Pellegrini, Marco. *Il papato nel Rinascimento*. Bologna: Il Mulino, 2010.

Petrarca, Francesco. *Canzoniere*. Milan: Mondadori, 1996.

Petrarch, the First Modern Scholar and Man of Letters: A Selection from His Correspondence, 2nd ed., revised and enlarged. Translated by J. H. Robinson and H. W. Rolfe. New York: Greenwood, 1969.

Pieper, Joseph. *Guide to Thomas Aquinas*. New York: New American Library, 1962.

Piganiol, André. *Il sacco di Roma*. Novara: Istituto Geografico De Agostini, 1971.

Pindar. *The Odes of Pindar*. Translated by Richmond Lattimore. Chicago, Ill.: Chicago University Press, 1976.

Plato. *The Collected Dialogues of Plato, Including the Letters*. Edited by Edith Hamilton and Huntington Cairns. Princeton: Princeton University Press, 1961.

Plotinus. *Enneads*. Translated by Stephen McKenna. 2nd rev. ed. London: Faber & Faber, 1956.

Plumb, J. H. *The Italian Renaissance*. 1961. New York: Mariner Books, 2001.

Plutarch. *The Fall of the Roman Republic.* Translated by Rex Warner. Revised by Robin Seager. London: Penguin Books, 2005.

———. *Lives.* Edited by Arthur H. Clough. New York: Modern Library, 2001.

Pseudo-Dionysius the Areopagite. *Gerarchia celeste; Teologia mistica; Lettere.* Rome: Città Nuova, 1993.

Puliga, Donatella, and Silvia Panichi. *Roma: Monumenti, miti, storie della città eterna.* Turin: Einaudi, 2012.

Quacquarelli, Antonio. *Retorica e iconologia.* Bari: Istituto di Letteratura Cristiana Antica, Università degli Studi di Bari, 1982.

Rabil, Albert, Jr., ed. *Renaissance Humanism: Foundations, Forms, and Legacy.* Philadelphia: University of Pennsylvania Press, 1988.

Randall, John Herman. *The Making of the Modern Mind.* New York: Houghton Mifflin, 1940.

Rella, Franco. *L'enigma della bellezza.* Milan: Feltrinelli, 1991.

Richard, Carl J. *Greeks and Romans Bearing Gifts: How the Ancients Inspired the Founding Fathers.* Lanham, Md.: Rowman & Littlefield, 2008.

Rico, Francisco. *Il sogno dell'umanesimo: Da Petrarca a Erasmo.* 1993. Translated by Daniela Carpani. Turin: Einaudi, 1998.

Risset, Jacqueline. *Dante scrittore.* 1982. Milan: Mondadori, 1984.

Roberts, J. M. *The Pelican History of the World.* New York: Penguin, 1983.

Rossellini, Ingrid. *Nel trapassar del segno: Idoli della mente ed echi della vita nei Rerum vulgarium fragmenta.* Florence: Leo S. Olschki, 1995.

Rossi Monti, Martino. *Il cielo in terra: La grazia fra teologia e estetica.* Milan: UTET, 2008.

Rowe, Colin, and Fred Koetter. *Collage City.* Cambridge, Mass.: MIT Press, 1978.

Rubenstein, Richard. *Aristotle's Children: How Christians, Muslims, and Jews Rediscovered Ancient Wisdom and Illuminated the Dark Ages.* Orlando, Fla.: Harcourt, 2003.

Russell, Bertrand. *A History of Western Philosophy.* 1945. New York: Simon & Schuster, 2007.

Russell, Jeffrey Burton, ed. *Religious Dissent in the Middle Ages.* New York: John Wiley & Sons, 1971.

Ryan, Alan. *On Aristotle: Saving Politics from Philosophy.* New York: W. W. Norton, 2014.

Salkever, Stephen, ed. *The Cambridge Companion to Ancient Greek Political Thought*. Cambridge, U.K.: Cambridge University Press, 2009.

Salvatorelli, Luigi. *Sommario della storia italiana*. 1938. Turin: Einaudi, 1969.

Scaglione, Aldo, ed. *Francis Petrarch, Six Centuries Later*. Chapel Hill: Department of Romance Languages, University of North Carolina, 1975.

Schott, Rolf. *Michelangelo*. Translated by Constance McNab. New York: Harry N. Abrams, 1962.

Scigliano, Eric. *Michelangelo's Mountain: The Quest for Perfection in the Marble Quarries of Carrara*. New York: Free Press, 2005.

Sciuto, Italo. *L'etica nel Medioevo: Protagonisti e percorsi, V–XIV secolo*. Turin: Einaudi, 2007.

Scotti, Rita A. *Basilica: The Splendor and the Scandal: Building St. Peter's*. New York: Plume, 2007.

Segal, Charles. *Orpheus: The Myth of the Poet*. Baltimore: Johns Hopkins University Press, 1989.

Segal, Erich, ed. *Oxford Readings in Greek Tragedy*. Oxford: Oxford University Press, 1983.

Siedentop, Larry. *Inventing the Individual: The Origins of Western Liberalism*. London: Penguin Books, 2015.

Simson, Otto G. von. *The Gothic Cathedral*. 1956. Princeton, N.J.: Princeton University Press, 1974.

Smith, Morton. *The Ancient Greeks*. 1960. Ithaca, N.Y.: Cornell University Press, 1970.

Snell, Bruno. *The Discovery of the Mind: In Greek Philosophy and Literature*. New York: Dover, 1982.

Southern, R. W. *The Making of the Middle Ages*. 1953. New Haven, Conn.: Yale University Press, 1967.

Spitzer, Leo. *Classical and Christian Ideas of World Harmony*. Baltimore: Johns Hopkins University Press, 1963.

Steiner, George. *Grammars of Creation*. New Haven, Conn.: Yale University Press, 2001.

————. *Real Presences*. Chicago: University of Chicago Press, 1989.

Stewart, Andrew. *Classical Greece and the Birth of Western Art*. Cambridge, U.K.: Cambridge University Press, 2008.

Stokstad, Marilyn. *Medieval Art*. New York: Harper & Row, 1986.

Storoni Mazzolani, Lidia. *The Idea of the City in Roman Thought: From Walled City to Spiritual Commonwealth*. 1967. Translated by S. O'Donnell. Bloomington: Indiana University Press, 1970.

Storoni Piazza, Anna Marina. *Ascoltando Omero: La concezione di linguaggio dall'epica ai tragici.* Rome: Carocci, 1999.

Strayer, Joseph R. *Western Europe in the Middle Ages.* New York: Appleton-Century-Crofts, 1955.

Suetonius. *The Twelve Caesars.* New York: Penguin Classics, 1957.

Sypeck, Jeff. *Becoming Charlemagne: Europe, Baghdad, and the Empires of* A.D. 800. New York: Harper Perennial, 2007.

Tagliapietra, Andrea. *La metafora dello specchio: Lineamenti per una storia simbolica.* Milan: Feltrinelli, 1991.

Tarnas, Richard. *The Passion of the Western Mind: Understanding the Ideas That Have Shaped Our World.* New York: Ballantine Books, 1991.

Taylor, A. E. *Plato: The Man and His Work.* London: Methuen, 1960.

Terenzoni, Angelo. *L'universo simbolico della cattedrale: San Lorenzo di Genova.* Genoa: Alkaest, 1980.

Thucydides. *The Landmark Thucydides: A Comprehensive Guide to the Peloponnesian War.* Edited by Robert B. Strassler. Translated by Richard Crawley. New York: Free Press, 1996.

Tolnay, Charles de. *The Art and Thought of Michelangelo.* New York: Pantheon, 1964.

Toman, Rolf, ed. *The Art of the Italian Renaissance: Architecture, Sculpture, Painting, Drawing.* Königswinter: Ullmann & Könemann, 2005.

Trinkaus, Charles. *The Poet as Philosopher: Petrarch and the Formation of Renaissance Consciousness.* New Haven, Conn.: Yale University Press, 1979.

Van Doren, Charles. *A History of Knowledge.* New York: Ballantine Books, 1991.

Vasari, Giorgio. *The Lives of the Artists.* Oxford: Oxford University Press, 2008.

Vernant, Jean-Pierre. *Figure, idoli, maschere.* 1990. Milan: Il Saggiatore, 2001.

———. *L'immagine e il suo doppio: Dall'era dell'idolo all'alba dell'arte.* Milan: Mimesis, 2011.

———. *L'individuo, la morte, l'amore.* 1989. Milan: Raffaello Cortina, 2000.

———. *L'universo, gli dei, gli uomin: Il racconto del mito.* 1999. Turin: Einaudi, 2001.

Vidal, Jacques. *Sacré, symbole, créativité.* Louvain-La-Neuve, Belgium: Centre d'Histoire des Religions, 1990.

Virgil. *Aeneid.* Translated by Robert Fagles. New York: Penguin Books, 2010.

———. *The Georgics.* Translated by David Ferry. New York: Farrar, Straus and Giroux, 2005.

Viroli, Maurizio. *Machiavelli: Filosofo della libertà*. Rome: Castelvecchi, 2008.

Vitruvius. *Ten Books on Architecture*. New York: Cambridge University Press, 1999.

Wagner, David, ed. *The Seven Liberal Arts in the Middle Ages*. Bloomington: Indiana University Press, 1983.

Watkins, Renée Neu, ed. *Humanism and Liberty: Writings on Freedom from Fifteenth-Century Florence*. Columbia: University of South Carolina Press, 1978.

Wilfart, Serge. *L'esprit du chant: Le chemin initiatique du souffle et de la voix*. Paris: Albin Michel, 1999.

Wills, Garry. *Cincinnatus: George Washington and the Enlightenment*. Garden City, N.Y.: Doubleday, 1984.

Wind, Edgar. *Pagan Mysteries in the Renaissance*. New York: W. W. Norton, 1968.

Wolf, Norbert. *Romanesque*. Los Angeles: Taschen, 2007.

Wood, Neal. *Cicero's Social and Political Thought*. Berkeley: University of California Press, 1988.

Zanker, Paul. *Augusto e il potere delle immagini*. Turin: Bollati-Boringhieri, 2006.

INDEX

Page numbers in *italics* refer to illustrations.

ILLUSTRATION CREDITS

Unless otherwise listed, all illustrations are courtesy of Wikimedia Commons.

ABOUT THE AUTHOR

Ingrid Rossellini was born in Rome and educated there, and later received a B.A., master's, and Ph.D. in Italian literature from Columbia University, writing her dissertation on Petrarch. She has taught literature and Italian film at Columbia, New York University, Harvard, Princeton, and other universities. She lives in New York City with her husband and two children.